GALEN ROWELL

A Retrospective

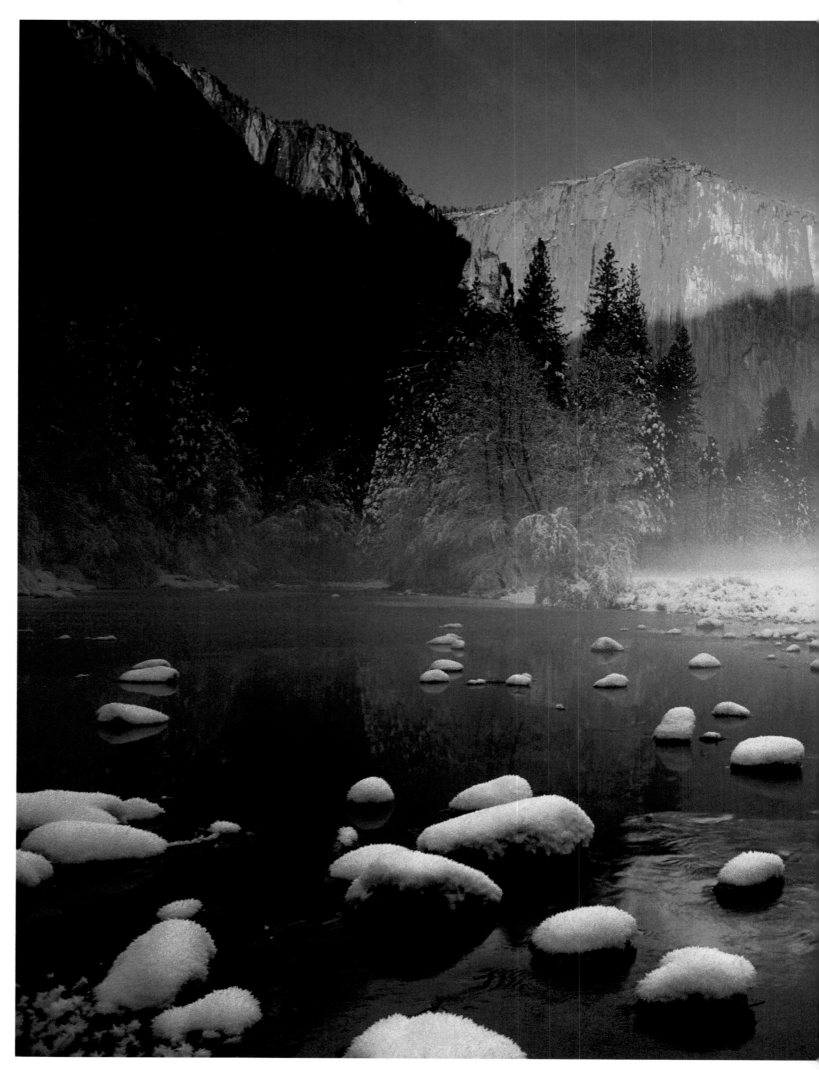

Winter Sunset, Gates of the Valley, Yosemite National Park, California, 1990

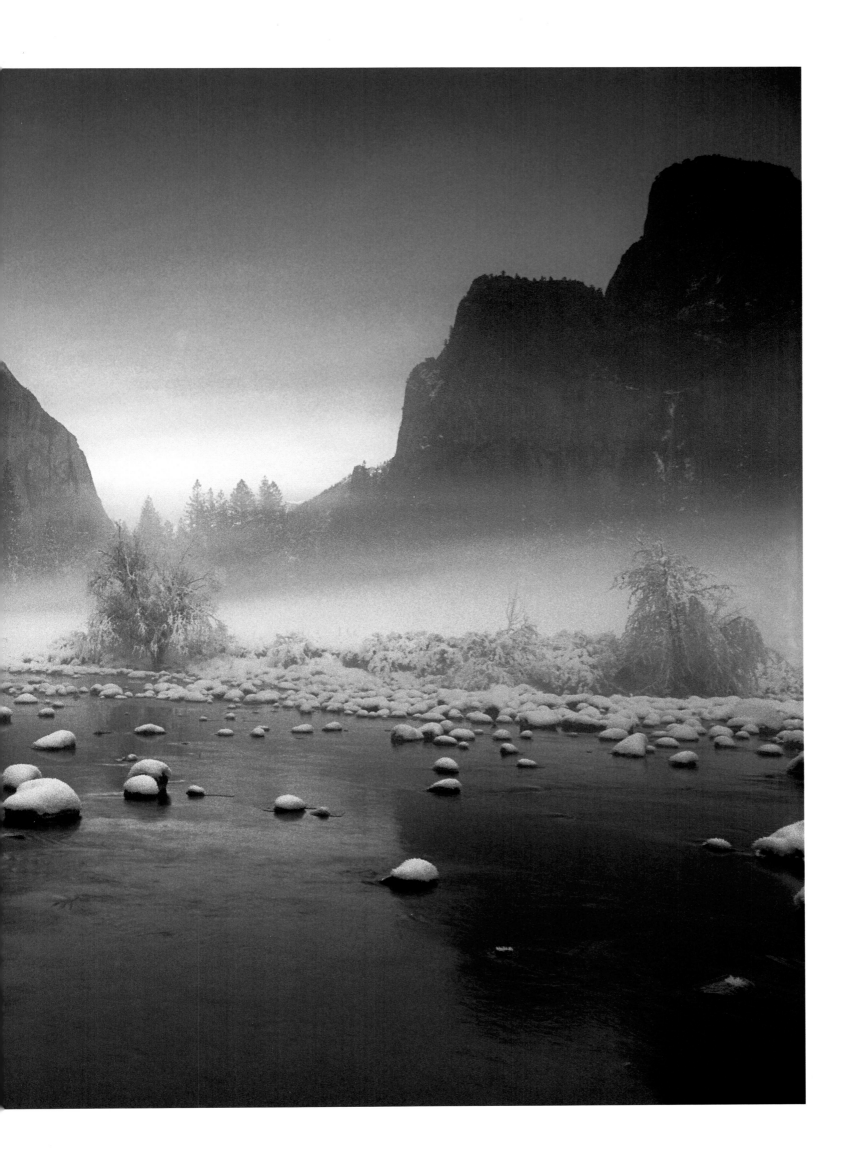

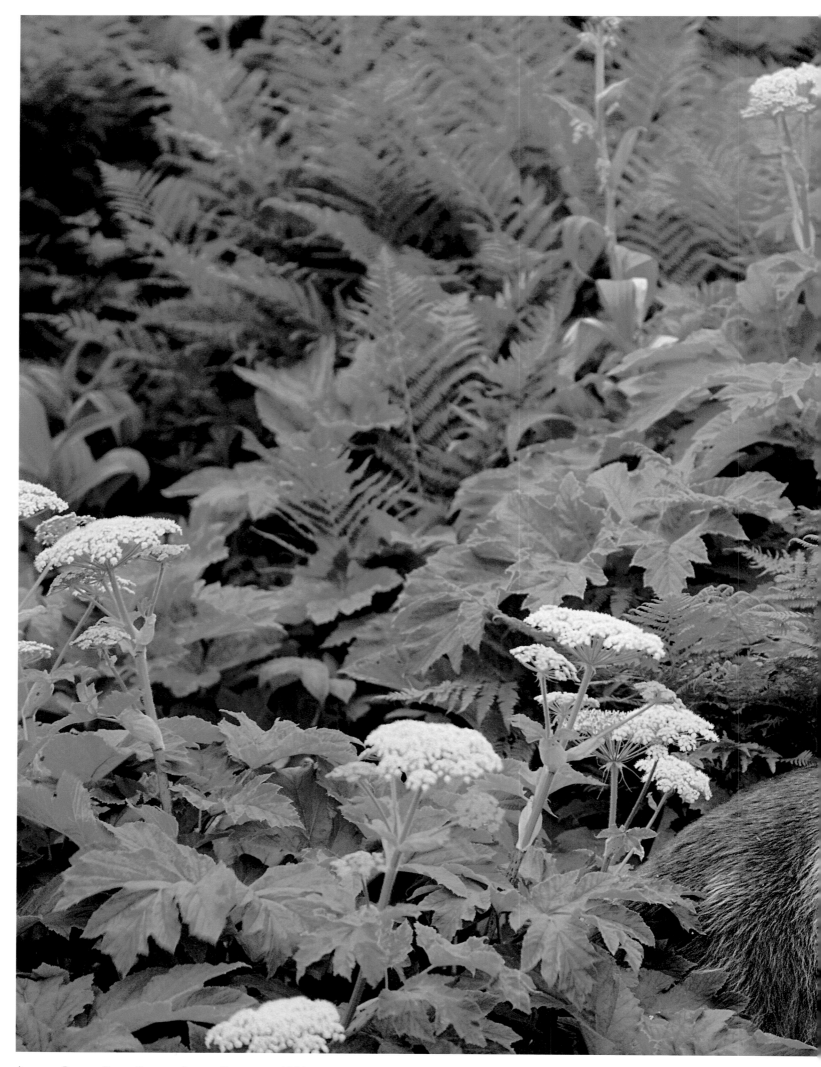

Alaskan Brown Bear, Chenik, Alaska Peninsula, 1991

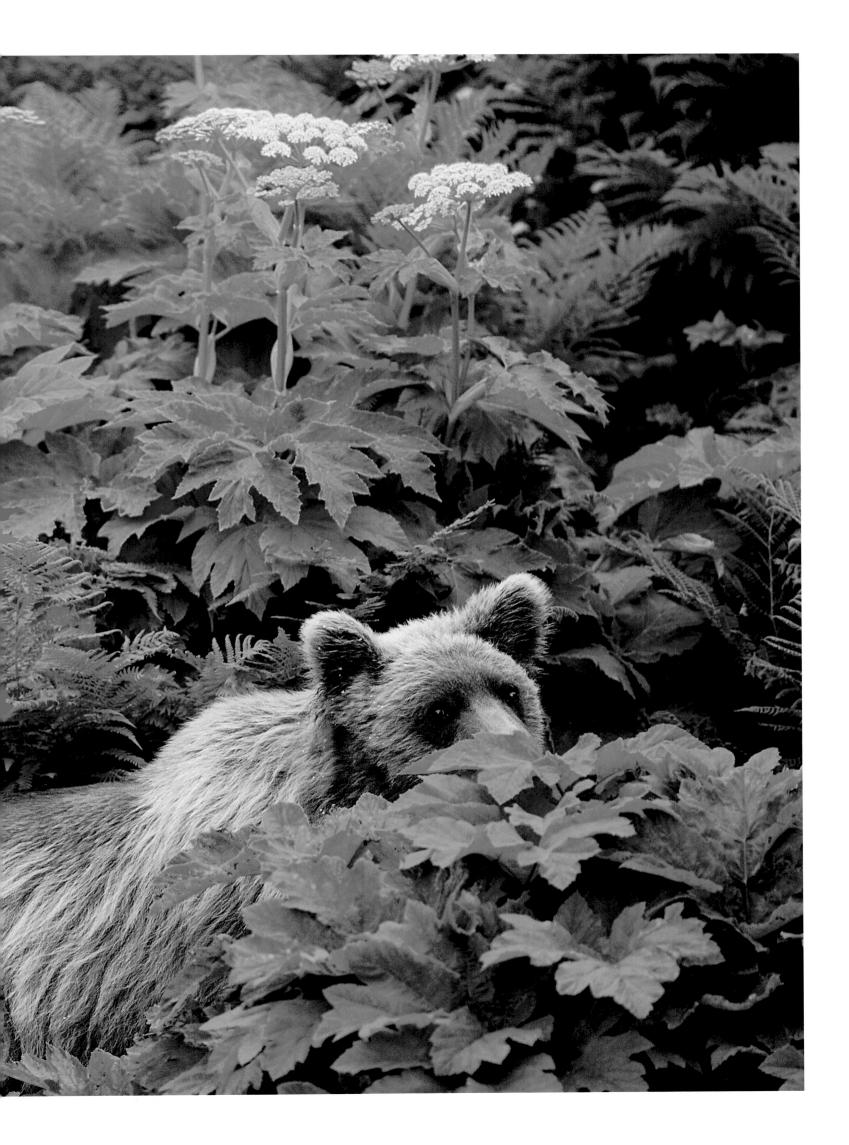

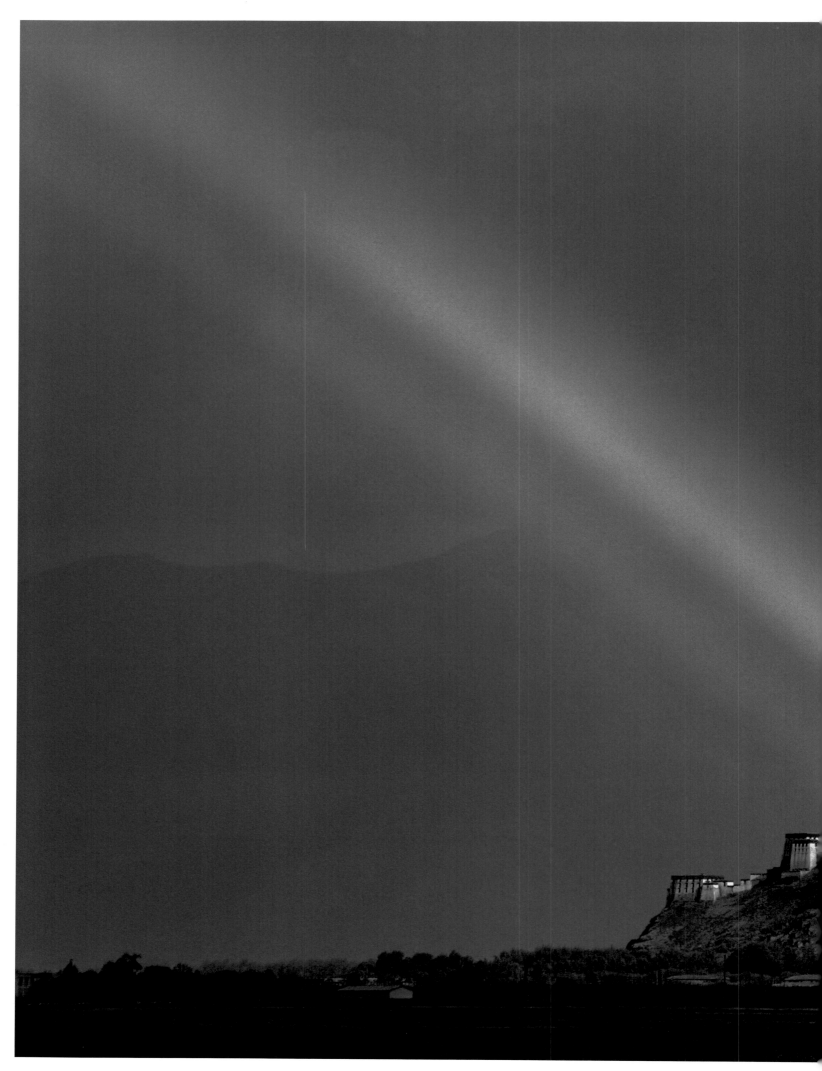

RAINBOW OVER THE POTALA PALACE, LHASA, TIBET, 1981

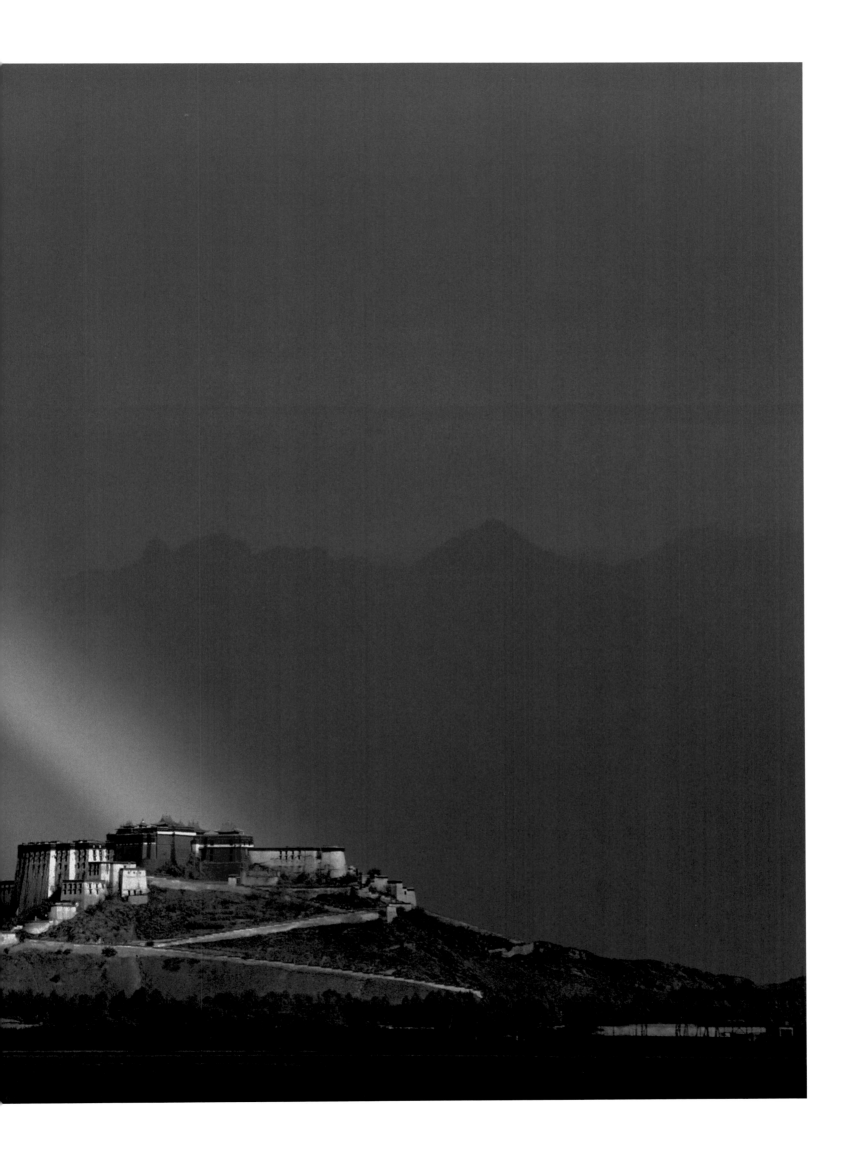

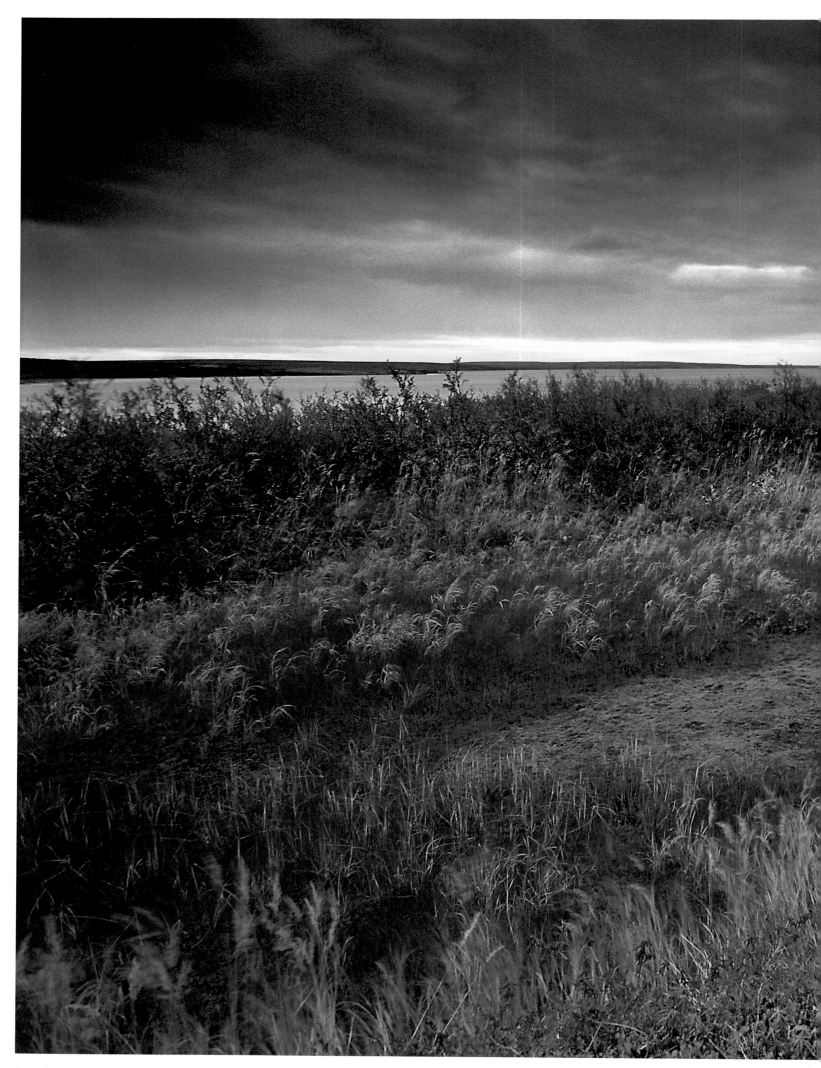

FALL COLORS AND DRY POND, THE BARRENS, NORTHWEST TERRITORIES, CANADA, 2000

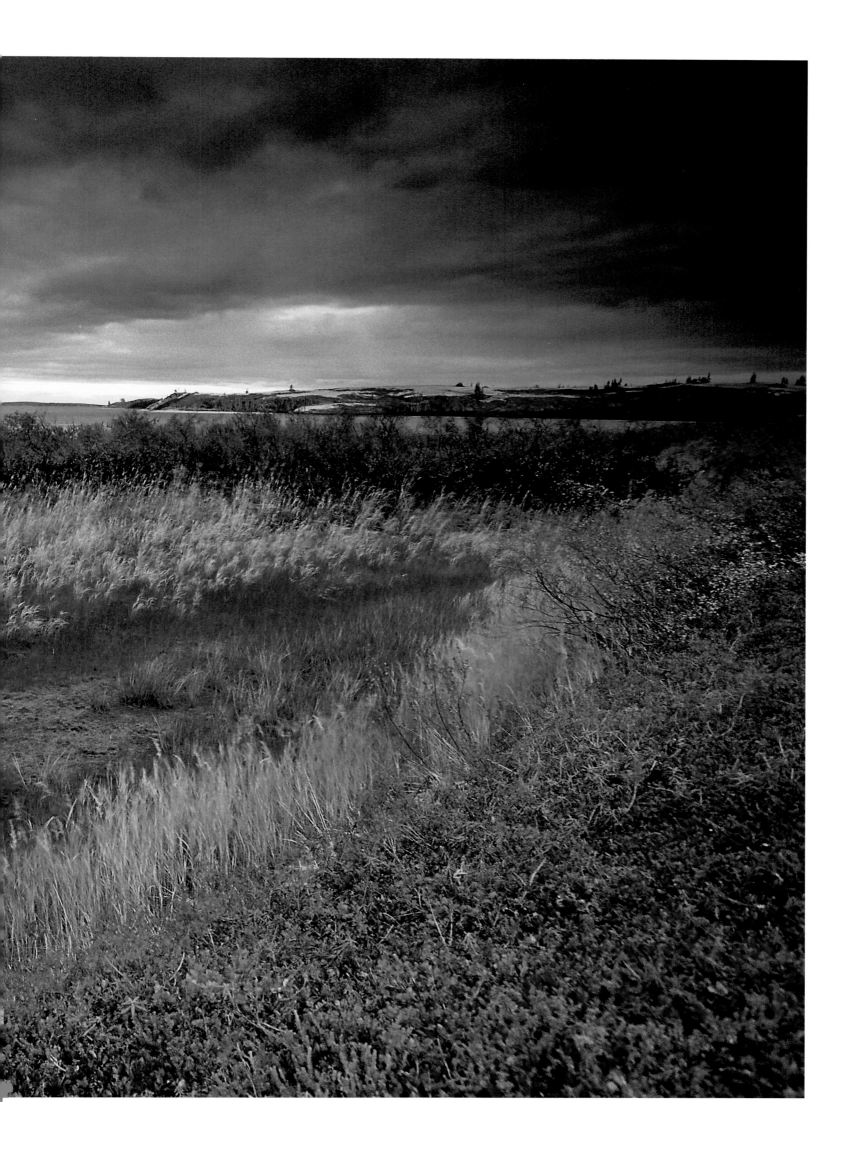

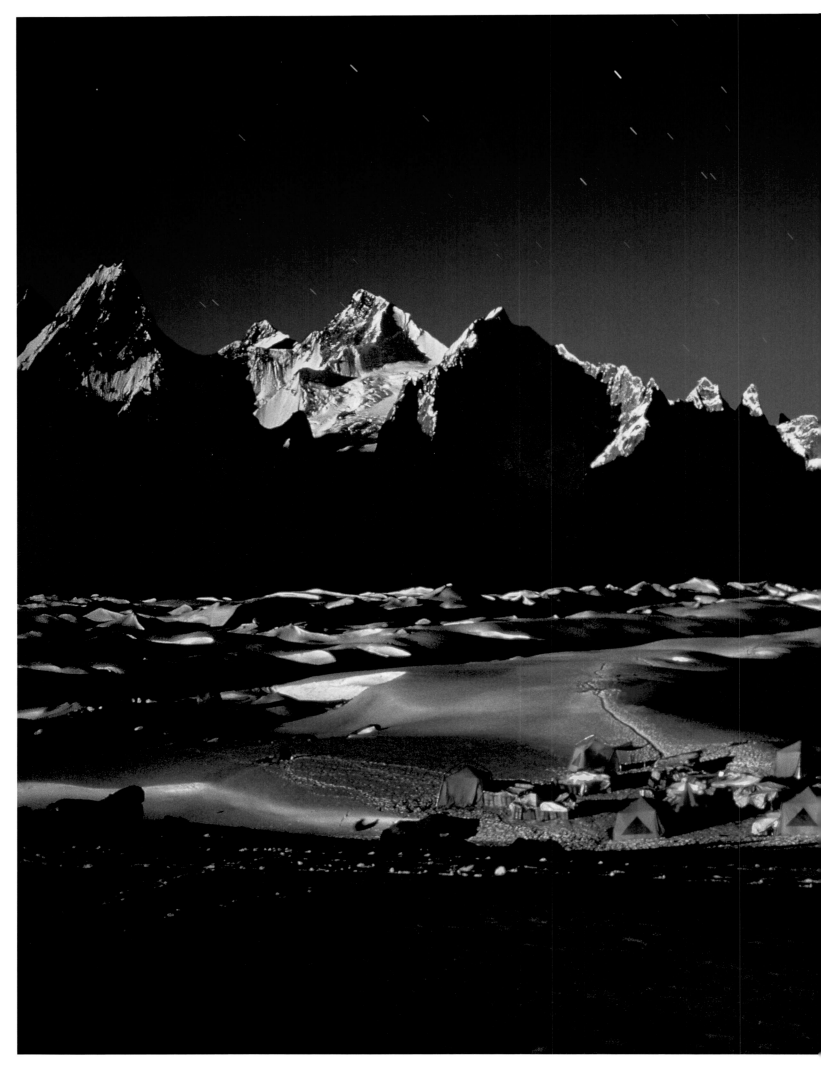

MOONLIGHT AT CONCORDIA, KARAKORAM HIMALAYA, PAKISTAN, 1975

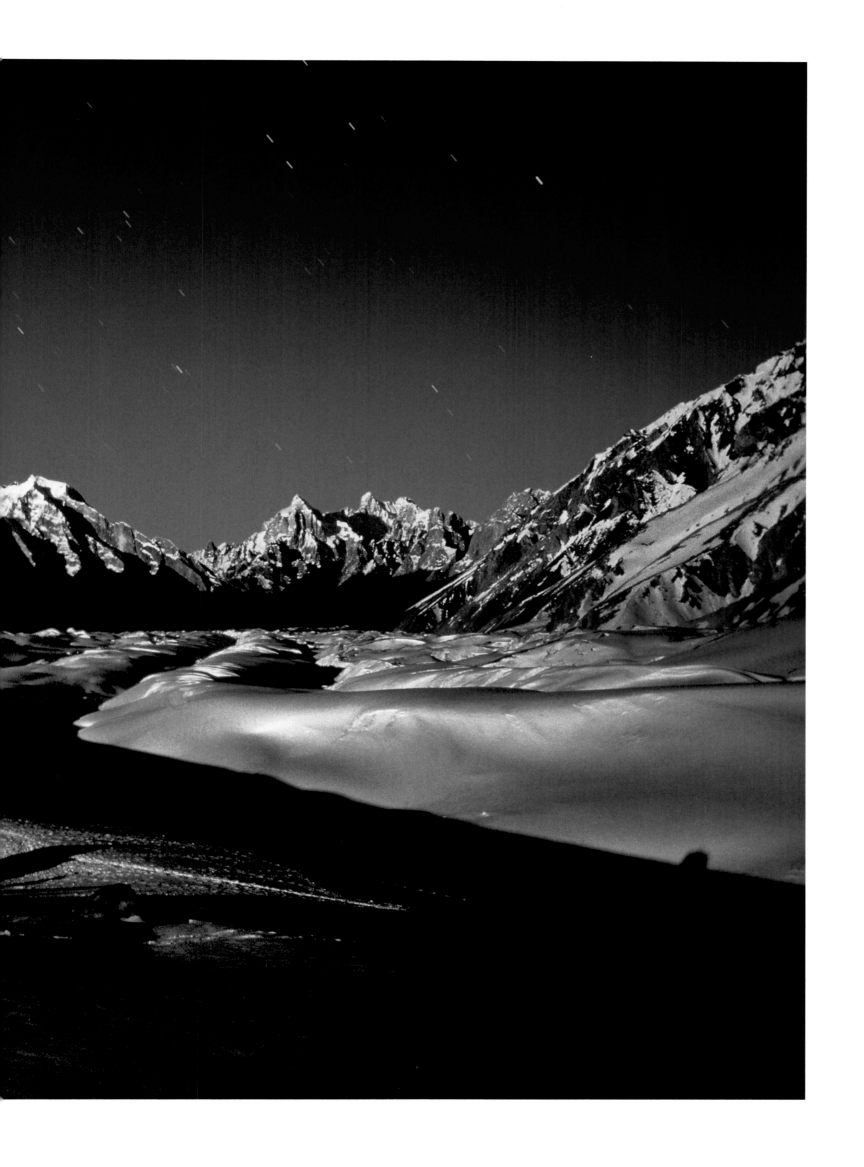

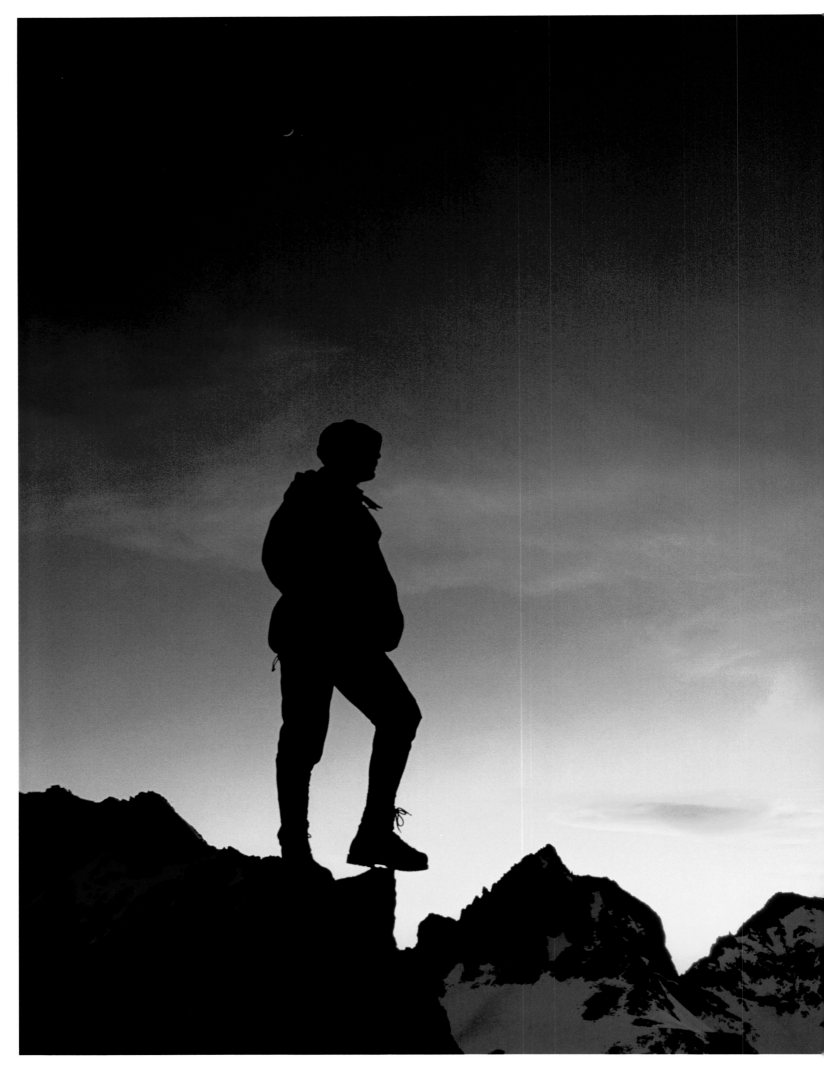

CONRAD ANKER ON MOUNT SILL, PALISADES RANGE, HIGH SIERRA, CALIFORNIA, 1997

GALEN ROWELL
A Retrospective

Compiled by the Editors of Sierra Club Books

SIERRA CLUB BOOKS
SAN FRANCISCO

In memory of the four vibrant individuals whose lives were tragically cut short
in a small plane crash on August 11, 2002, in Bishop, California:

Carol Ludwig MacAfee

Tom Reid

Barbara Cushman Rowell

Galen Avery Rowell

—Nicole Rowell Ryan and Tony Rowell

The Sierra Club, founded in 1892 by John Muir, has devoted itself to the study and protection of the earth's scenic and ecological resources—mountains, wetlands, woodlands, wild shores and rivers, deserts and plains. The publishing program of the Sierra Club offers books to the public as a nonprofit educational service in the hope that they may enlarge the public's understanding of the Club's basic concerns. The point of view expressed in each book, however, does not necessarily represent that of the Club. The Sierra Club has some sixty chapters throughout the United States. For information about how you may participate in its programs to preserve wilderness and the quality of life, please address inquiries to Sierra Club, 85 Second Street, San Francisco, California 94105, or visit our website at www.sierraclub.org.

Project directors: Linda Gunnarson and Helen Sweetland
Executive consultant for the Rowell family: Nicole Rowell Ryan
Book and jacket design: Jennifer Barry/Jennifer Barry Design
Consulting editors: Justin Black, Diana Landau, and
 Nicole Rowell Ryan
Photo editors: Jennifer Barry, Justin Black, Linda Gunnarson,
 Diana Landau, Nicole Rowell Ryan, Helen Sweetland
Digital image production: Justin Black
Production director: Tony Crouch
Layout production: Kristen Wurz

For more information about Galen Rowell and his fine prints, books, and stock image collection, visit www.mountainlight.com.

Published by Sierra Club Books
85 Second Street, San Francisco, CA 94105
www.sierraclub.org/books

Produced and distributed by
University of California Press
Berkeley and Los Angeles, California
University of California Press, Ltd.
London, England
www.ucpress.edu

SIERRA CLUB, SIERRA CLUB BOOKS, and the Sierra Club design logos are registered trademarks of the Sierra Club.

Library of Congress Cataloging-in-Publication Data

Galen Rowell : a retrospective / compiled by the editors of Sierra Club books ; foreword by Tom Brokaw.
 p. cm.
 ISBN 13: 978-1-57805-115-1 (alk. Paper)
 ISBN 10: 1-57805-115-0 (alk. Paper)
 1. Outdoor photography. 2. Nature photography. 3. Rowell, Galen A. I. Sierra Club Books.

 TR659.5.G35 2006
 779'.3092--dc22

 2006042319

Printed in the United Kingdom on acid-free paper

First Edition

10 09 08 07 06
10 9 8 7 6 5 4 3 2 1

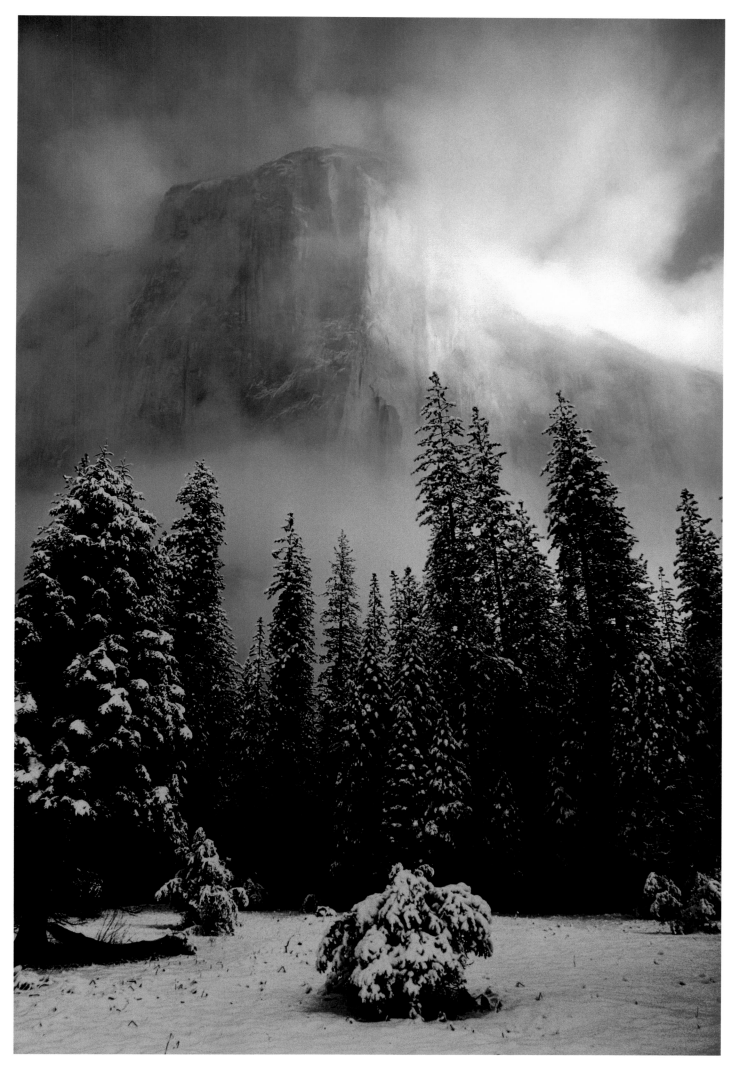

CLEARING STORM OVER EL CAPITAN, YOSEMITE, CALIFORNIA, 1973

Publisher's Note

In the summer of 2002, Sierra Club Books editor Linda Gunnarson and I were looking forward to Galen's return from his latest expedition, a challenging trek across Tibet's Chang Tang plateau with three fellow adventurers to find the calving grounds of the endangered *chiru* antelope. For several months Linda and I had been discussing the possibility of publishing a retrospective of Galen's photography, and we were anxious to see what he might think of such a project.

The time seemed right—not only because Galen had amassed an enormous and extremely impressive body of work and was enjoying unparalleled success in his field, but also because his recent relocation from the San Francisco Bay Area to his beloved eastern Sierra seemed to signal a new chapter in his creative life. We felt strongly that Sierra Club Books was the right publisher for such a retrospective, as our relationship with Galen went back more than twenty-five years. We were, after all, the publisher of his first solo effort, *In the Throne Room of the Mountain Gods* (1977), and eight more of his best-known works, including *Mountains of the Middle Kingdom* (1983), *Mountain Light* (1986), *The Yosemite* (1989), *Galen Rowell's Vision* (1993), and *Bay Area Wild* (1997).

Linda phoned Galen's office in early August to arrange a time for us to get together and learned that he had flown off to Alaska to conduct a photography workshop immediately on his return from the Chang Tang but would soon be back in Bishop. It was just a few days later that we learned the tragic news: Galen and his wife and business partner, Barbara, along with two friends, had perished in a small-plane crash while en route to Bishop.

Later that year, it was our great pleasure to meet Galen's children, Nicole Rowell Ryan and Tony Rowell, and to learn that they shared our vision for a retrospective of their father's work. We are deeply indebted to them for giving us the opportunity to realize our vision in the publication of this book, and for their kind cooperation and assistance at every juncture. We are especially grateful to Nicole, who partici-

pated in every aspect of developing this project, offering her unique insight and invaluable guidance as we attempted to distill the essence of Galen's work—and of his legacy.

Throughout the creative process, we have been privileged to work with a number of people who also worked very closely with Galen over the years. Designer Jennifer Barry's working relationship with Galen spanned almost twenty years and nine of his books, including *The Art of Adventure*, *My Tibet*, and *Bay Area Wild*. We join with the Rowell family in expressing our warm appreciation to Jenny, not only for her elegant design and beautiful layouts, but also for her broad knowledge of and experience with Galen's images—which made her an invaluable resource during the editing process—and her wise counsel on myriad decisions, both large and small. Nicole and Tony would especially like to thank Jenny for helping them navigate their way through the unfamiliar world of publishing.

Through the generosity of the Rowell family, we were fortunate to have the staff of Mountain Light, the gallery and image-licensing business established by Galen and Barbara in 1985, as a resource during the development and production of this book. We are especially grateful to Justin Black, general manager and curator of Mountain Light, for the knowledge, skill, and passion he brought to his many roles on this project. A long-time colleague of Galen's, in whose "eye" for color and proof-correcting skills Galen put his full trust, Justin was instrumental in researching and editing photographs, creating digital masters for many of the images, and reviewing and correcting all rounds of color proof for the book. We also extend our thanks to the rest of the staff at Mountain Light, especially to image collection manager Dean Stevens and photo researchers Barbara Laughon and Nancy Finch for their roles in researching and organizing the photographs, and to Mountain Light Gallery sales

manager Rochelle Miller for her role in arranging the retrospective exhibitions that will coincide with the release of this book. Justin, in turn, would like to acknowledge Bob Cornelis, of Color Folio (Sebastopol, California), for making exceptional drum scans of Galen's original film, and Kraig Bancroft, for assisting Galen in the creation of digital masters for many of his images.

Sierra Club Books' copublishing partner, the University of California Press, was the publisher of two of Galen's classic works, *My Tibet* (1990) and *Poles Apart* (1995). Galen was very pleased with the production and printing of both books—a credit to the skill and careful oversight of Anthony Crouch, the director of design and production at UC Press. We were extremely fortunate to have had Tony oversee the production and printing of this retrospective, as well—and we extend our special thanks to him for the extra time and care he has so generously given this project.

We were delighted that UC Press engaged freelance publicist Sam Petersen to head up the publicity and promotion efforts on this retrospective—not only because she's one of the very best in her field, but because she, too, has had plenty of firsthand experience on Galen Rowell projects. As a member of the Sierra Club Books staff in the 1980s and 1990s, she helped promote four of Galen's books, including *Mountain Light,* and as a freelancer for UC Press, she handled publicity on *Poles Apart.* We couldn't have asked for a more talented or passionate advocate for Galen's work.

All the members of the retrospective editorial team here at Sierra Club Books worked directly with Galen, too—including myself. (One of my first perks on being named publisher a decade ago was the opportunity to work with Galen on the final rounds of color proof for *Bay Area Wild,* and on the subsequent paperback edition of the book.) Freelance editor Diana Landau worked with Galen on a number of his early books—notably *High & Wild* and *Mountains of the Middle Kingdom*—when she was on staff at Sierra Club Books in the late 1970s and early 1980s. We are very grateful to her for lending this project her considerable editorial talent, both in the early rounds of photo editing and in helping to shape the essays of many of our distinguished contributors.

Linda Gunnarson, who worked with Galen in the mid-1980s on both *Mountain Light* and the revised edition of *In the Throne Room of the Mountain Gods,* deserves special recognition as the principal director of this project—a Herculean task, given the size and scope of the book and the number of team members and contributors. An editor of extraordinary talent and sensitivity, she shaped the book according to her own strong vision but somehow also managed to hear and honor the divergent views of the many stakeholders. Few editors could have performed her role with such grace and aplomb.

We join the Rowell family in expressing our deepest gratitude to those who contributed essays, remembrances, and other text to this volume: John Ackerly, Conrad Anker, Jon Beckmann, Justin Black, Tom Brokaw, Ed Cooper, Bert Fox, Andy Grundberg, Bob Hansen, Jane Kinne, Frans Lanting, David Muench, Rick Ridgeway, Doug Robinson, Robert Roper, Steve Roper, George B. Schaller, Dean Stevens, Steven D. Werner, and Gordon Wiltsie. We are extremely grateful for the time, insights, and stories they shared.

Nicole Rowell Ryan and Tony Rowell also wish to thank their mother, Carol Rowell, for her support and assistance throughout the project; Frans Lanting, Chris Eckstrom, Jane Kinne, and John Agnone, for their friendship and guidance in the initial transition as they began to take on their father's work; and Justin Black and the staff of Mountain Light, both past and present, for helping to build and maintain a stable foundation for this book and for Galen's legacy. Nicole would also like to thank her husband, Ray, for his patience, support, and assistance through the entire process.

For all of us who have participated in this project, it has been a privilege and a labor of love—but it has also been a tremendous challenge. In every one of the thousands of decisions we made, we tried to consider what Galen would have wanted, and at every stage in the process his absence was keenly felt. It is our fondest hope that the book you now hold in your hands would have pleased him.

— Helen Sweetland
May 2006

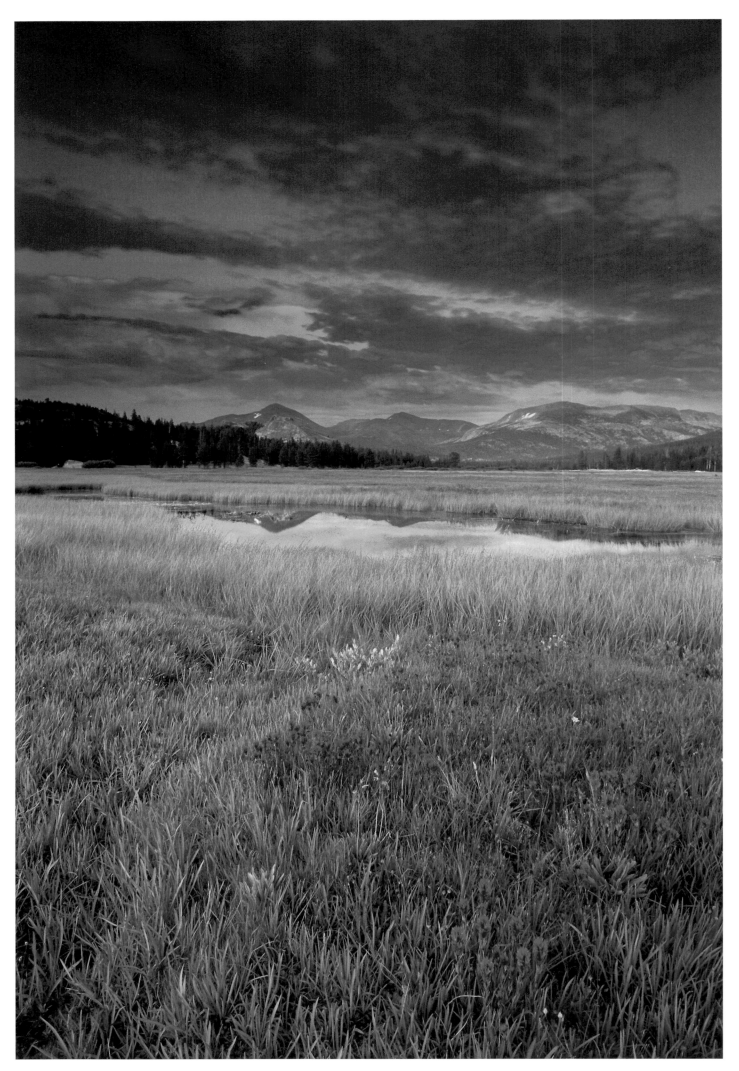

LEMMON'S PAINTBRUSH AT SUNSET, TUOLUMNE MEADOWS, YOSEMITE, CALIFORNIA, 1999

Contents

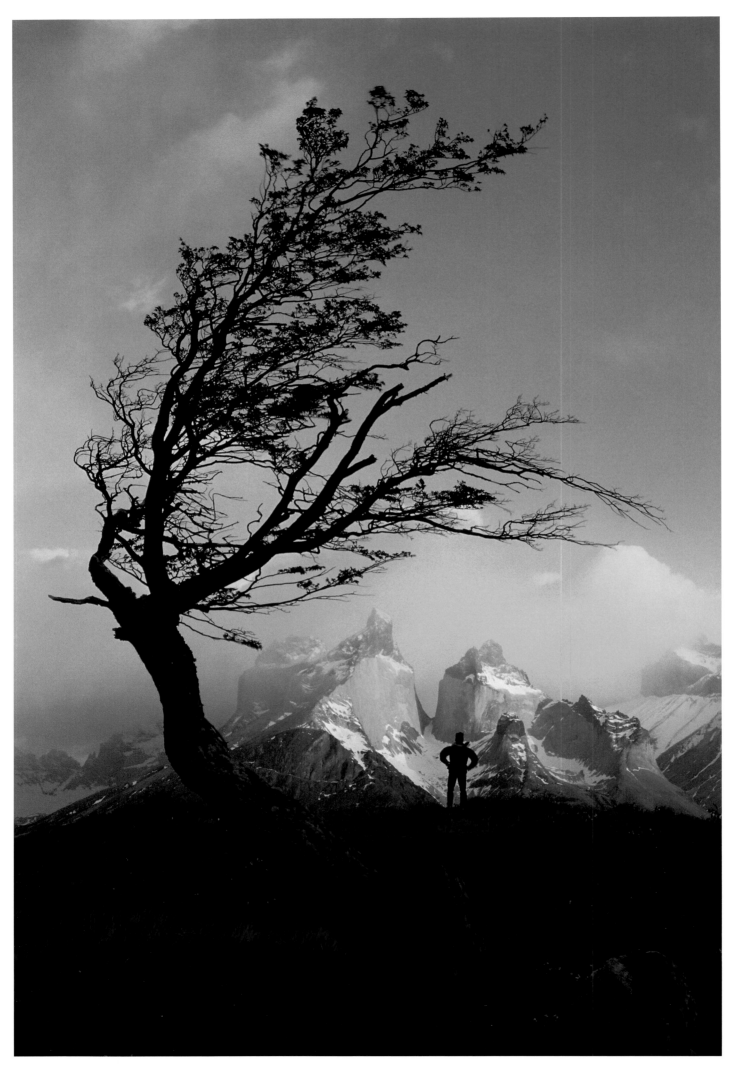

SELF-PORTRAIT AT DAWN, TORRES DEL PAINE, PATAGONIA, CHILE, 1985

Foreword

by Tom Brokaw

Galen Rowell was a man who went into the mountains, into the desert, to the edge of the sea, to the last great wild places in the world to be absorbed by their grace and grandeur. That is what he did for himself. For the rest of us, he shared his vision with—click—the release of a shutter, creating photographs as timeless, as stunning, and as powerful as nature itself.

I first discovered Galen during my own initiation into California's wild and scenic places, especially Yosemite National Park. After my early trips into the Sierra I returned longing for a reminder of what I had experienced. I came upon a young mountaineer who had explored California's Range of Light much more intensely and always with camera at the ready. Galen's evocative photographs became a fixed part of my home and office, windows on a world I wanted to return to again and again.

Over the years we became friends, and I watched with admiration the evolution of his work and his personal commitment to the wonders of nature in all of their forms. His photographs represented a personal odyssey as well as a panorama of nature in its purest and most untamed state.

Galen was a gifted athlete, a superb rock climber, and a man of few words, a shy, self-effacing presence, but his photographs were great, soaring symphonies not just to the majesty of towering mountains or long, raw coastlines but also to the intricate relationship of rock and wind, ice and snow, surf and sand, sun and fog, to the shaping of those places.

He understood that nature in all of its glory and heart-stopping capacity truly is an intricate tribute to the many forces, seen and unseen, that shape the world around us.

Moreover, as you will see again and again in his work, the place of man in these surroundings is at best a mute witness to the awesome presence of, say, Himalayan peaks that reach through the clouds and form their own universe. Ironically, he was able to capture that relationship between man and nature precisely because he was able get to places others could not or would not. His legs were as important as his eye in taking us to these remote and wild places.

In his pilgrimage to ever more distant and wilder places, Galen's appreciation of the urgent need not just to celebrate what he was seeing but also to nurture and conserve it became more and more evident in his photographs. The majestic polar bear, up close and personal. The graceful

curve of a ram's finely textured horn. The far reaches of western Tibet, where an all-but-extinct herd of small antelope make their home in hidden crevasses of time.

Creatures and also cultures of far-off lands marked his work in the most indelible way. When I first went to Lhasa I walked to a distant point just so I could re-create in my mind Galen's stunning photograph of a rainbow touching down on the Potala Palace, the spiritual home of the Dalai Lama. I also quickly understood how the essence of Tibet could be forever enshrined in a photograph of a few prayer flags fluttering in the high and mystical altitudes of that holy land.

I could go on about Galen's photographs, but they speak so eloquently for themselves that my words become superfluous, a kind of author's conceit. Instead, I invite you to see the world through Galen's eyes and, equally important, through his life. He was a rare and inspirational figure in his family, to his friends, in his mountaineering culture, and in the world of conservation and environmental consciousness. Throughout his growing fame and recognition he remained true to his personal ethos of living lightly on the land, doing the hard things well and with humility, and sharing with the rest of us his passion for the wild and magnificent through the permanence of his photographs for the ages.

His untimely death saddens us still, but his presence is forever fixed in his remarkable life and photographs.

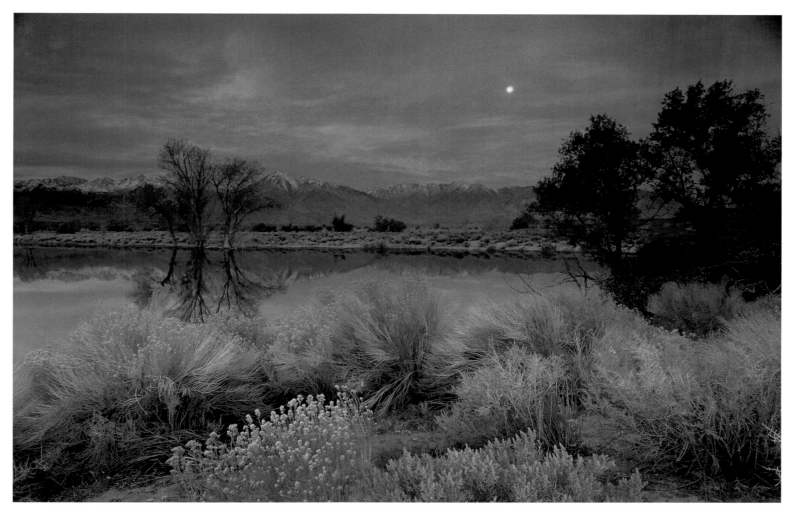

CLOUDY AUTUMN MORNING IN THE OWENS VALLEY, NEAR BISHOP, CALIFORNIA, 2001

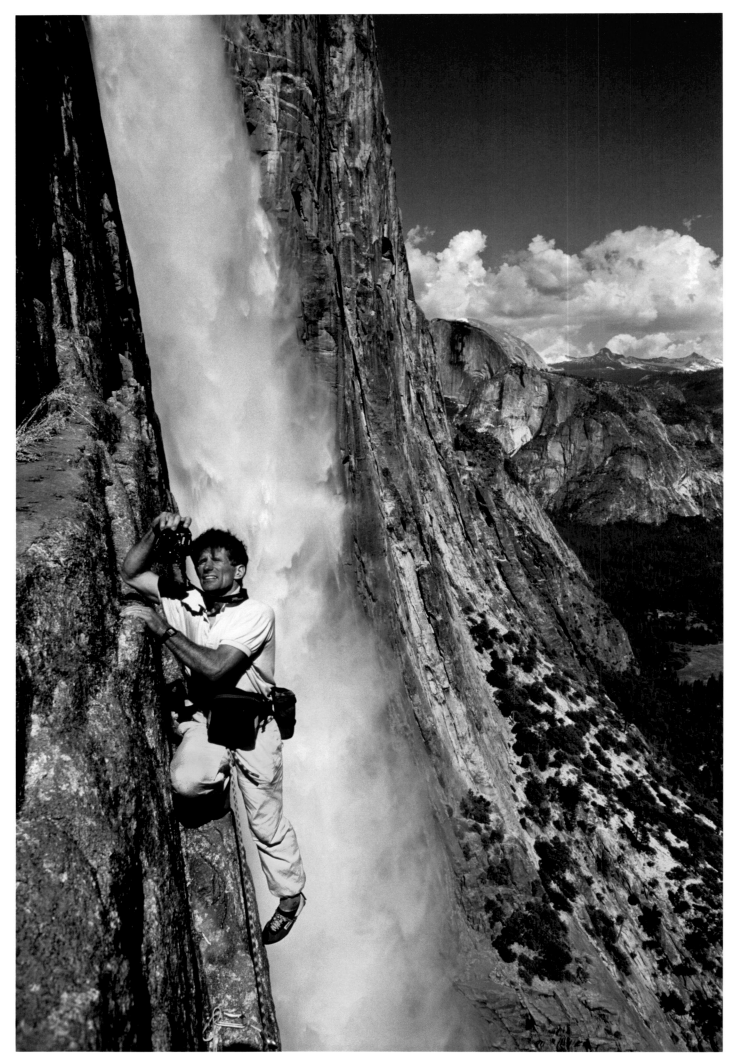

GALEN ROWELL CLIMBING BESIDE YOSEMITE FALLS, YOSEMITE, CALIFORNIA, 1992

Sierra Son

by Robert Roper

In 1972, a young rock climber with a wife and two small children sold the auto repair shop he owned in Albany, California, and boldly declared himself an adventure journalist. He had been documenting his own climbs, in and near Yosemite Valley, for nearly a decade at that point, although to say his record of paid publication justified selling the garage would be an exaggeration. The move made sense more as a clearing of the decks for more fun, more free exploration of Sierra rock walls, than as high commerce. In this way it was like many gestures being made by young Americans at the time: quitting law school to become a carpenter, studying sitar instead of biochemistry.

By the end of that year, though, Galen Rowell, formerly of Rowell Auto Service, had a book contract (for *The Vertical World of Yosemite,* an anthology of essays by climbers). While most of the leading figures of Yosemite's "golden age"—men like Royal Robbins, Yvon Chouinard, Tom Frost, and Chuck Pratt—were backing off from serious climbing, Galen was on the verge of a prodigious outburst of accomplishment, in the Sierra Nevada and in every other sizable mountain range in the world, an outburst that became a career that became an astonishment. But for a fatal crash in a friend's light plane, he would no doubt be at it still, in his mid-sixties, soloing Mount Whitney before breakfast, sneaking back to the Karakoram for "one last" splendid granite spire.

Surely he was not the only Valley climber of the 1960s who dreamed of turning his passion for the crags into something that paid the bills. The trick was to find an outlet that allowed you to do the thing you loved while lifting you out of the proud poverty of Yosemite's Camp 4, the legendary gathering spot for climbers, into a grown-up life of scope and opportunity. The choices weren't obvious. Gifted writers like Steve Roper, author of *A Climber's Guide to Yosemite Valley* and an exact contemporary of Galen's, or Pratt, or Allen Steck, wrote well about what they liked to do, but rock climbing as a subject appealed to only a coterie audience, those willing to seek out specialist publications like the *American Alpine Journal* or the Sierra Club–supported *Ascent.* For someone like Galen, who turned twenty in 1960, who was still nominally in college (at the University of California, Berkeley) in the early sixties but about to make his foray into auto repair, it was hardly even possible to dream. The figure of the globe-trotting adventure journalist, publishing in glossy

magazines, writing serious books with one hand while taking iconic action shots with the other, an acquaintance of heads of state and world religious leaders, hadn't been invented yet.

Which is to say: Galen himself had not arrived.

Later, he recalled how embarrassed he was to tell people how little he had earned from his first text-and-photo packages. Then a professional "accident," of the sort he had been preparing for half-unconsciously his whole life, transpired. "In 1973 I agreed to help Dewitt Jones," he wrote in *Mountain Light* (1986), "with coverage of a climb in Yosemite for *National Geographic*. We were to shoot any climb of our choice, which would then be considered for inclusion in a major story

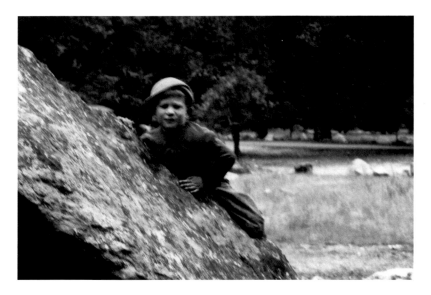

A young Galen scrambling on a Camp 4 boulder during a family visit to Yosemite National Park, California, 1945

on the national park. . . . Dewitt was called off on another assignment [and] he set it up for me to submit my portfolio (which didn't exist) to Bob Gilka, *Geographic*'s legendary director of photography."

Gilka liked what he saw, however sketchy. Since about 1963 Galen had been taking photos to document his climbs using a small Kodak Instamatic with a Schneider lens. Later he invested in a Nikkormat FTn, almost as lightweight as the Kodak. An admirer of Ansel Adams, he had once seen the great photographer at Olmsted Point in Yosemite and had resolved never to use a large-format camera in the wilderness himself—it was "far too limiting for the . . . material I wanted to photograph." With Gilka's blessing, Galen enlisted two partners and successfully climbed Half Dome without placing any new pitons, a cutting-edge effort for 1973, and "the exposed film went to Washington for processing and editing while I bit my nails in California. . . .

"Then, in what seemed a whirlwind," he wrote, "I was . . . given an unexpected cash bonus and a new assignment to write text for what had . . . become a separate article on the climb." It ran as the cover story for the June 1974 issue of *National Geographic:* "Climbing Half Dome the Hard Way," the first installment in one of the great collaborations of freelancer and magazine in the *Geographic*'s history.

~

Although later he maintained he had bought that first Instamatic to show people how cool climbing was, Galen in fact came from a family richly imbued with the romance of the High Sierra and already adept in the basics of outdoor photography. It was a Berkeley family, one with deep roots by California standards, and furthermore a family of intellectuals, one able to accommodate, though in no way likely to produce, a son who would spend his life fixing cars. Galen probably got his first camera from his aunt Marion Avery, a birdwatcher and outdoorswoman, and with the Brownie she gave him he won a photo contest while still in elementary school. His maternal grandfather, Lewis B. Avery, superintendent of the Oakland schools, had once been a surveyor along the

North Dakota–Canada border, and in 1916 he took his wife and four of his five children on an epic journey in an open touring car to Yosemite. Of the Valley itself, his youngest daughter, Margaret, said, "It was one of the spectacular moments of my whole life. Marion and I stood there in absolute wonder at it. . . . My sister Priscilla merely looked at it and said, 'Why yes. But it looks just like the *Geographic* pictures of it.'"

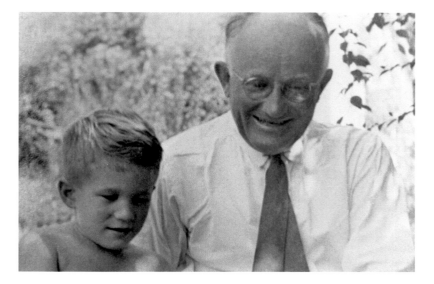

Galen and his father, Edward Zbitovsky Rowell, reading together, Berkeley, California, late 1940s

Margaret, then sixteen, was a strong hiker. In her eighties, she would recall that the "Yosemite Falls trail was a long hard one but, oh, we did that. We did everything. . . . It left such an impression on me that I have never forgotten it. It was a love I simply cannot tell you about."

She told Galen about it. She was his mother, and in 1943 she took him there for the first time, when he was just two. Throughout his childhood the Rowell family—mother, son, and father Edward, a Berkeley professor of speech and philosophy, himself an active photographer—often spent vacations at the famous Sierra Club backcountry camps. Margaret was a professional cellist, a master teacher who performed for twenty years on stage and radio and who directed NBC's popular Standard School Broadcasts, classical music programs heard throughout the West. For Galen's sixth birthday she made a model of Yosemite Valley using rocks they found in Berkeley's Tilden Park—this one for El Cap, this one for Half Dome, this one for the Royal Arches, and so forth—and then, being Rowells, they took a photo of it.

As a cellist, Margaret was a close associate of Casals, Rostropovich, and Piatigorsky. Dr. Albert Einstein, son of *that* Albert Einstein, lived in the house behind the Rowells' on Miller Avenue in Berkeley, and for fifteen years Einstein came by to play duets with Margaret almost every morning. It was a household of high culture, in other words, but, again, it was not only that; Galen, of whom his mother, the refined musician, noted that he was "rambunctious . . . from the very beginning . . . [not] the cuddly kind of baby that I'd always expected," was largely allowed to have his superactive way.

It may be there was simply no way to stop him. He was fond of climbing up on the living room fireplace and sitting on the mantel. He learned how to read on his own, and by the age of ten he was obsessed with geology, as his Avery grandfather had been. By the age of twelve he had read the *Harvard Book of Geology* and knew it back to front, his mother recalled, and he had become a fanatic rock collector. "I think that's where his climbing actually started, from his getting the minerals and letting himself down the side of . . . cliffs on . . . Grizzly Peak [in the Berkeley Hills]" to gather them. "I would say goodbye to him and sit in the car,

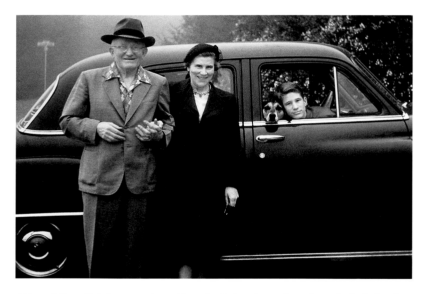

Edward Rowell, Margaret Avery Rowell, Galen Avery Rowell, and Flash the dog, Berkeley, California, 1950s

and not see him till he came up again on the ropes." One summer, she shipped hundreds of pounds of rocks home for him from the East Coast, where he had spent a vacation collecting them. Not every mother would do that, not even every lover of Yosemite.

While still a college girl, Margaret had joined her sister and five other young women on a springtime trek, with mules, into the snowbound High Sierra. They continued their journey over the course of three years, returning to the mountains in the summer and in the end traveling nearly two hundred miles along what would one day be the John Muir Trail. In the process they made the first women's ascent of the Hermit, a sharp granite peak near Evolution Valley. There was photographic evidence of this multiyear exploration in a scrapbook that Margaret kept and that Galen, as a young boy, pored over, noting the mules, the granite summits, and the lakes that the group had visited.

"Thirty-seven years later," he wrote in *High & Wild* (2002), "I returned to my mother's scrapbook for another look before skiing the trail in winter." Recalling one of the Sierra Club trips she had taken him on, he wrote, "Her son . . . felt as if he had entered paradise when the narrow trail beneath his feet delivered him into that primeval world of lakes and flowers set between sharply-etched peaks of rock and snow. As he watched his mother joyfully reunite with her youth and the natural world, the boy began a lifelong love affair with the High Sierra."

~

The Sierra Club camps: freedom, fun, exploration. Both Galen and his mother remembered these gatherings with intense, lifelong pleasure, and in his mother's opinion "that *really* was the beginning of everything for him": his fascination with geology, his prodigious ability to cover wild terrain. She recalled that "[o]n our 1957 Sierra Club trip," which had been based near Devil's Postpile, "one of the [three] people who first climbed the face of Half Dome was one of our assistant cooks. . . . Anybody who climbed Half Dome, to me, was a hero [and] I must have passed some of that on to Galen.

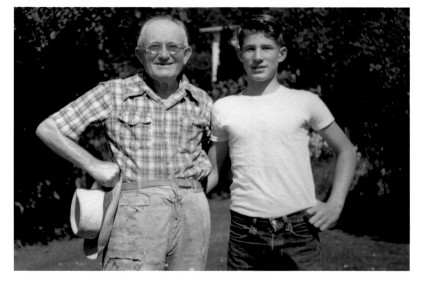

Edward Rowell with a teenage Galen on the front lawn of their home, Berkeley, California, 1954

"I used to get up every morning at 4:30 [to help in the kitchen]. When it came time to go back, another climber on the staff [Mike Loughman, noted climber and future author of the instructional classic *How to Rock Climb*] said he would take Galen back with him, cross country. That meant no trails of any kind . . . sixty miles or so" back to Yosemite Valley, from deep within the High Sierra.

"I was frightened. . . . But in this fellow's hands, yes. So the two of them started off across the mountains. I, in fear and trembling, didn't hear a thing until I was to meet him at a Greyhound Bus depot, quite a number of days later, in Oakland," the plan being for Loughman to bring Galen down from the park after their long trek. "There he was, all by himself and able to do it. . . . From then on he was a mountaineer."

Dick Leonard, a pioneer of Yosemite climbing in the 1930s, was a family friend. And David Brower, the most important environmental leader since John Muir and the Sierra Club's

longtime executive director, also lived in Berkeley, just a block and a half from Galen, who, as a college boy with a souped-up car, "disturb[ed] the peace of his work in his home office." Galen would later claim Brower as a "phantom mentor." He would say the same about Leonard, a Sierra climber who "had used his law degree to initiate new ways of protecting wildlands."

About Brower, Galen recalled, "[M]y father told me over lunch that . . . our neighbor was the most respected lobbyist in the country because he boldly spoke the truth. . . . Although I was

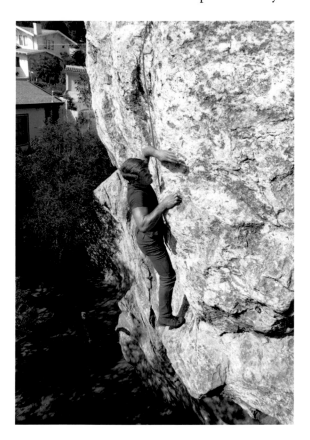

Galen at Indian Rock, the popular training site for many notable Bay Area climbers, Berkeley, California, 1969

deeply impressed with Brower, I never pursued a personal friendship. . . . I thought, at first, that I was too young and, a few years later, that his looks of disapproval of my driving were more than I wished to deal with."

Brower and the wilderness ethos he personified—and his toughness as a protector of threatened places, his indomitability in political struggles—were profoundly instructive to the hot-rodding future advocate for Tibet and other endangered zones. Not only was Brower a savvy and effective force in Washington, but he had "conceived, edited, and produced the Exhibit Format Series of outsized photo books" for the Sierra Club. Well before Galen thought of himself as a professional photographer, these books had a liberating effect on his idea of what photography was and might accomplish in the world. Brower had worked with Eliot Porter and Ansel Adams on career-hallmark volumes, and the titles produced during his tenure at the Sierra Club—among them *Not Man Apart: The Big Sur Coast, The Last Redwoods, Gentle Wilderness: The Sierra Nevada, "In Wildness Is the Preservation of the World,"* and *This Is the American Earth*—still represent a compelling photographic ideal.

Another Brower-produced book, *Everest: The West Ridge,* by Tom Hornbein, told the story of a contentious American expedition to Mount Everest in 1963, during which one faction of climbers reached the summit by the well-known South Col route, while another stubbornly pushed through on the terrifying West Ridge, an achievement to rank with the greatest climbs ever by Americans. A similar contentiousness would mark the 1975 American expedition to the world's second-highest peak, K2 in Pakistan—Galen's first voyage out of North America. The book he wrote about this

memorable fiasco, *In the Throne Room of the Mountain Gods* (1977), is a refreshingly frank, often comical account of the maneuvering and backstabbing among the ambitious climbers and photographers invited on the gargantuan expedition. (In the end, no one got anywhere near the summit, despite the assistance of more than six hundred porters.) Here, in the first book he wrote, and mostly photographed, himself, are the qualities that distinguish all of his best work, beginning with an intense interest in history and ethnography. The college dropout appears to have read absolutely

everything about K2 and the Karakoram Range. His knowledge of Baltistan, of nineteenth- and early-twentieth-century explorers, of high-altitude zoology and botany, is broad and deep yet modestly displayed, and his photographs suggest the full range of what would become his mature interests: the mountains themselves, great snowy titans; human faces as they reveal character and context; ancient folkways; rare flora and fauna; climbing action; plus sunlight, starlight, and moonlight—light, light, light.

With *Throne Room,* Galen was well launched, and his level of accomplishment as writer-photographer began the swift ascent that would soon rival, then eclipse, his reputation as a pure climber. *As* a climber, however, he always remained extraordinarily active. The *American Alpine Journal* is the annual record of mountaineering accomplishment worldwide, and for more than thirty years (1968–2000), as Steve Roper wrote in a perceptive profile at the time of Galen's death, the *Journal* carried an article or note by Rowell in all but two of its issues. From this

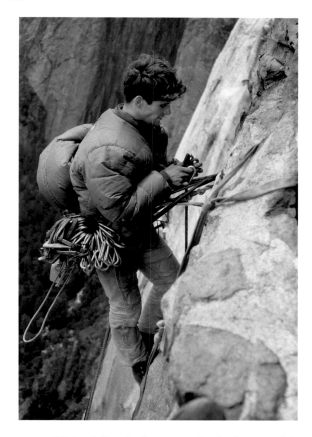

With a full rack of pitons on the third ascent of the Salathé Wall of El Capitan, Yosemite, 1967

evidence alone we know that Galen was keeping busy, but the truth is that he was climbing more, in more remote places, and more inventively than almost any other mountaineer of his era. This does not mean that he attempted as many 8,000-meter peaks as Reinhold Messner, or that he made as many North American first ascents as Fred Beckey (with whom Galen climbed the Great White Throne in Zion National Park in 1967). But his career spans all kinds of climbing, from sun-warmed boulders to the highest, iciest summits, and from the beginning there was a dynamic principle evident in everything he did: climb *this* so that you can then go *there;* prepare in *this* way so that when your life takes you where you've dreamed it might go, you will be ready.

Since boyhood, he had entertained hyper-real fantasies of adventure and exploration; often these visions were provoked by books that his father read to him at bedtime, natural histories such as Carl Akeley's African narratives, John Muir's accounts of wilderness treks, and William Beebe's pioneering works of oceanography. The idea that the world has been fully accounted for, that the great figures of the past have spoken for all its interesting geography, seems to be something he never accepted. Thus, after that cross-country trip with Mike Loughman, after being taught the rudiments of climbing with ropes and pitons, he found that "the experience [of climbing in a wilderness] felt very different than practice sessions on Bay Area rocks. . . . [M]y life was forever changed [and] when I went out on [Berkeley's practice crags] it was with the sole objective of acquiring enough skills to climb Yosemite's greatest walls."

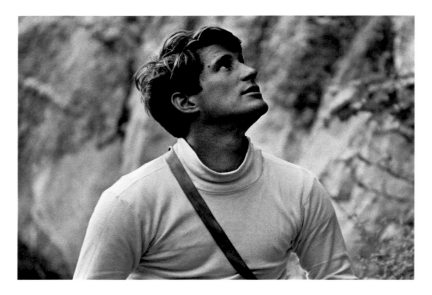

Belaying Eric Beck on the first pitch of the north face of Lower Cathedral Rock, Yosemite, California, 1965

In 1963, preparing for his own explorations, he made a repeat ascent of the northwest face of Half Dome with a young partner, Paul Berner. That same year he climbed the Steck-Salathé route on Sentinel Rock with Layton Kor, one of the "gods" of American big-wall climbing—someone who could have gotten any partner he wanted but who chose Galen because he was phenomenally strong, endured when things got hard, and, basically, because he was willing. By then Galen had climbed hundreds of lesser routes (he would one day have twenty Yosemite Valley first ascents), and he had a reputation for knowing how to get up a climb, how to make it happen.

David Wilson, twenty years his junior, who went on hundreds of climbs with him in the 1980s, commented, "It wasn't the raw speed [that made Galen successful], just that he kept going. He exceeded all specs for his body. The good climbers don't think of down, they think of going up. . . . He sort of had the feeling that he would prevail, no matter what, and you knew that you would too, that you weren't going to bail if you were with Galen."

In the years of his emergence as a climber, he memorably partnered with Warren Harding, another Valley god and leader of the first ascent of El Capitan (1958). In 1970 they made the first ascent of Half Dome's south face, a project begun five years earlier and pursued, as time, weather,

and skill allowed, in stages. "When I befriended Warren," Galen later wrote, "I couldn't help but compare his abilities to my own. He was sixteen years older, and I was by far the better free-climber. . . . Yet I recognized that Warren had something that couldn't be measured on . . . shorter climbs."

Both Harding and Kor were "splendidly anti-intellectual," Galen noted—Kor a bricklayer from Colorado, Harding a construction worker and highway surveyor. They were large personalities and "exceptions to the group of climbers with deep-seated fears about climbing the big walls who

lived all year in Yosemite," Galen later wrote. "Layton remained apart from the mental agony that characterized Camp 4, making jokes with short punch lines to poke fun at those who took life too seriously. When [Royal] Robbins made a multi-day first ascent on . . . Sentinel Rock, he wrote that the sunrise was 'better than Mozart.' Layton climbed a new route next to Robbins's, returned to Camp 4, and described the sunrise as 'not as good as Fats Domino.'"

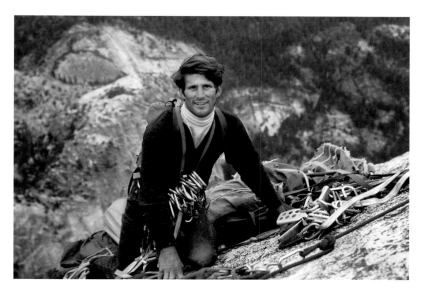

On the summit of Yosemite's Half Dome, after completing the first ascent of the difficult south face with Warren Harding, 1970

From his late teens, in an attempt to distinguish himself from his cultured, academic background, Galen had been looking for something different—a new attitude, one that would serve him well in the long run, that would carry him high and beyond. "Yosemite climbers," he wrote, "tended to intellectualize and philosophize a way of life that they considered to be closer to an art than a sport. . . . We were students of the written word, and our abilities to project ourselves into imagined situations were finely honed. When Royal Robbins, the greatest wall climber . . . wrote about taking two long leader falls on insecure pitons on the first ascent of Arches Direct, we privately vowed never to climb that route or anything that resembled it."

But *he* needed to climb things like it if his boyhood dreams of exploration were to be more than dreams. "Somewhere in the back of my mind I feared death on Sentinel, and I made a mental inventory of my possessions," Galen wrote of his 1963 ascent of the Steck-Salathé route with Kor, "and what my parents would think and who would call them. But I feared not doing Sentinel far more than death." From Kor and Harding, he learned a curious thing: how *not* to project yourself into situations, just get on with them, get on with tasks that were, basically, too terrifying to think about. Do them in as good a

style as seemed possible, but by all means do them, even if the way you did them violated "unwritten Valley codes that forbad publicity, use of fixed ropes, and attempting big routes beyond your level of experience." Either do them or be crippled, held down by your own too-active brain.

And when his generation of climbers, including even the gods, was pretty much finished with climbing, with audacious big-wall routes, when their names had gone down in the record books and they had moved on to other things, Galen was just getting started. Just in case there was

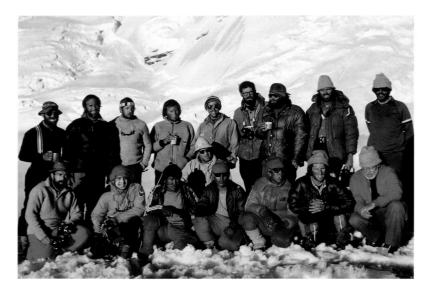

Galen (front row, second from right) and other members of the successful American Nun Kun Expedition, Ladakh, India, 1977

more to come for him, more adventure, he had trained on the hardest walls he could find and had survived outrageous epics—notably a late-winter ascent of El Cap in 1966—and had ticked off an impressive number of backcountry first ascents, because opportunities to explore unknown rock had become rare in the Valley.

In the early seventies, he made his first trips to Alaska: an attempt on the Moose's Tooth in 1972 and a first ascent of the southeast face of Mount Dickey in 1974. And his remarkable expeditions to Mount McKinley—first cir-

cumnavigation and first one-day ascent, both in 1978—inaugurated a period of intense activity, full of international travel, climbing, photographing, writing, and, always, exploring.

∼

Galen's first marriage, to the former Carol Chevez, ended in 1977, the year *Throne Room* was published (the divorce came a year later). The couple's two children, Nicole, then thirteen, and Tony, nine, would live with their mother. They had been raised as "base camp" kids, both remember, accompanying their parents on Galen's early trips to Alaska and Canada. When Galen traveled to K2, though, he went alone. Carol had helped him with earlier projects, and when he undertook to write *In the Throne Room of the Mountain Gods* she helped again by transcribing hundreds of pages of expeditionary journals and by serving as his "most patient critic throughout fifteen months of writing," as he gratefully wrote in the book's acknowledgments.

The expeditionary journals—containing unvarnished, moment-to-moment impressions taken on the mountain—went far toward making this a groundbreaking work, one of the most

truthful adventure narratives yet written by an American. Galen was always fortunate in the creative assistance he received from the women he trusted most, beginning with his mother, Margaret, and certainly including Carol, as well as Jo Sanders, his companion on later trips to the Himalaya and to China. Sanders, who worked for Mountain Travel U.S.A., helped organize several of his international expeditions, and she was involved in developing his book *Many people come, looking, looking* (1980).

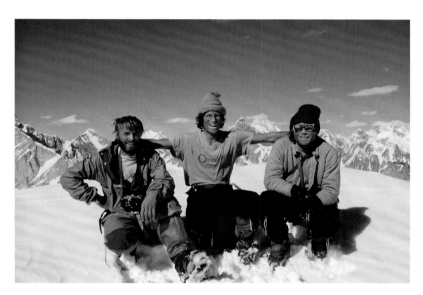

John Roskelley, Galen, and Kim Schmitz on the summit of Great Trango Tower after the first ascent, Karakoram Himalaya, Pakistan, 1977

In 1981 Galen met Barbara Cushman, a promotions executive at The North Face outdoor equipment and clothing company. "I had sought him out," she wrote almost twenty years later, "just after I returned from directing a North Face catalog shoot. . . . I wanted to publish stories by well-known adventurers who regularly used our products. The marketing department suggested I call Galen Rowell. . . . They bet me that he would never let me use his name in our catalog without a big endorsement fee." (Galen did let her use his name and, to judge from ensuing events, he almost certainly did so without asking for a fee.)

Just a few months later they married. Barbara, a multitalented, high-energy clothing designer, photographer, and all-around achiever, offers us a rare glimpse of what life is like with a true force of nature: "Galen was a splendid combination of brains and athletic ability. He didn't smoke or seem to have any vices, other than climbing. . . . The day we returned from our honeymoon, he started writing *Mountains of the Middle Kingdom,* which was due in six months. He wrote from early morning to late at night and was too busy to spend time with me when I came home from work. . . . A week after we were married, I felt more alone than I had ever felt when I was single."

The first year together was hard, "but," she adds, "life was certainly exciting." Eventually she became his partner, critic, editor, and planner, her organizational skills and inventiveness indispensable to the growth of Mountain Light Photography, Inc., the company they founded in 1985 to market Galen's images. And the marriage, stormy and loving and creative, thrived. "Our trips were not vacations," she wrote. "We didn't lie around on beaches. . . . Instead, our married

life had become a parallel work machine, seven days a week from early morning into the wee hours. . . . I tried to match his work ethic . . . but no matter how hard I worked, he managed to work harder. He would accept impossible deadlines from publishers and set himself up for a time crunch. . . . Week after week I would hear him say, 'This is the worst week ever. As soon as it's over, things will calm down.'"

Things did not. In the years when they were first getting to know each other, the writing/climbing/photographing phenomenon known as "Galen Rowell" took mature form. A partial itinerary for Galen covering the years 1977–83 includes ascents of Nun Kun, Thorungtse, and Great Trango Tower, in, respectively, India, Nepal, and Pakistan (all done in a single year); four expeditions to China and Tibet, which reopened to Westerners in 1980; a six-week traverse of the Karakoram Himalaya on skis, from the Indian border nearly to Afghanistan; the first ascent of Cholatse, the last unclimbed peak in the Everest region; the first one-day ascent of Mount Kilimanjaro, Tanzania; and an attempt on Everest by the West Ridge.

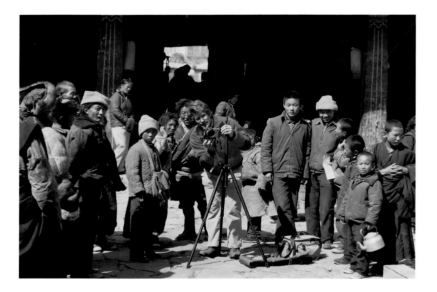

Drawing a crowd of curious Tibetan pilgrims while photographing at Jokyang Monastery, Lhasa, Tibet, 1983

The trips to China, described in *Middle Kingdom,* were deeply ambitious, amounting to a wholesale rediscovery of the region by a Westerner. "I was lucky enough to join the first American expedition ever allowed to climb" in the People's Republic, Galen wrote, but, "I returned home in such a state of confused humility that I didn't even write a magazine article." What caused this unusual reticence was a classic explorer moment: realizing the depth of his own ignorance about a vast bit of the earth's geography, a domain that had somehow fallen off the maps. "Our Chinese hosts had few answers to our questions," he wrote. "I realized that rarely were they denying me; they simply didn't know." He concluded that "no foreign writer had recently seen as much of China's mountain regions as I. . . . I was in a position to create the very book I had not been able to find before my journeys."

While in China, he made a first ski descent of Mustagh Ata in far western Sinkiang. He climbed, trekked, and photographed in six major ranges, including the vast Tian Shan, and studied

the Uyghur and Golok peoples, among others. He climbed Anye Machin, a fabled peak once thought to be taller than Everest. The Golok people, Tibetans of the far eastern plateau, excited his strong interest; they were "unconstrained . . . [w]ild-looking men [who] ride through the hills with carbines and modern AK-47 rifles . . . [and] live year-round in black tents made of yak hair. . . . The communes beneath Anye Machin have no Chinese members."

Almost casually, Galen climbed to the North Col of Everest with a single companion, Harold Knutson, a marathon-running geologist. The climb was not a stunt, although they climbed to 21,000 feet in running shoes (the North Col is 24,000 feet): as always, Galen wanted to demonstrate the freedom that came with shunning large expeditions, all the clumsy infrastructure of support. After K2 in 1975, big expeditions were out for him, for environmental as well as practical reasons, and his goal was to do exciting climbs with a few dependable, salty, highly skilled friends. In the late 1970s through early 1980s these included Kim

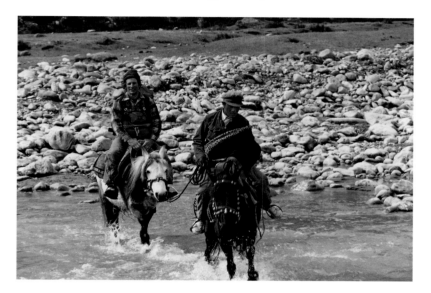

Crossing a tributary of the Yellow River on the way to making the first ascent of Anye Machin, Tibet, 1981

Schmitz, John Roskelley, and Ned Gillette, three of the finest outdoor athletes of the era.

As his daughter, Nicole, recalls, "My dad never looked successful on paper till many years later," despite his considerable earnings from magazine assignments, books, catalog shoots, public shows, and work as a mountain guide. "Basically, he was funding his adventures," she says. When Barbara entered the picture, her splendid business skills brought structure to their lives and to the enterprise of Galen Rowell. She tempered, if never quite overcame, his tendency to want to climb and shoot and just leave it at that, trusting that the business would thrive on its own. Within a few years, they were making investments in real estate that secured their prosperity well beyond the funding of adventures, and Mountain Light grew and evolved into what many consider the premier outdoor photographic enterprise in North America.

Mountain Light is an image-licensing business, a gallery, and more. Under Barbara's influence Galen became more consciously and actively a teacher; he began offering photography workshops that proved wildly popular, and in 1987 he began writing a monthly column for

Outdoor Photographer magazine, whose publisher, Steve Werner, came to see him as "the archetypal photographer/adventurer" and as someone whom "a great many people wished they could be." The column, "Photo Adventure," was the most popular in the magazine's history. It fed interest in the workshops, which in turn fed into the sale of fine prints of Galen's images through the gallery. Housed at first in a storefront in Albany, then in a grander facility in nearby Emeryville, Mountain Light is now based in downtown Bishop, on the Sierra Nevada eastside, in a former bank building on South Main Street.

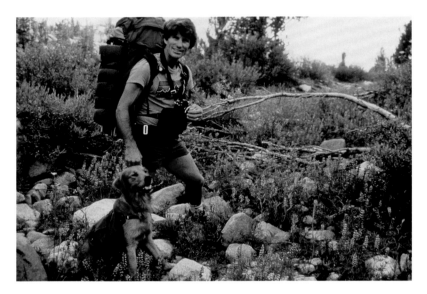

Galen and his golden retriever, Khumbu, on a backpacking trip in the Sierra Nevada, California, 1984

~

By the mid-1990s Galen's books, column writing, feature articles, workshops, slide shows, print sales, and licensing of rights were creating something far larger than a sum of parts. His warm, opinionated presence deepened, and he projected a casual charisma. His photographic style became an identifiable brand, and his products addressed and attracted an ever-growing fan base. At around the same time, changes in digital printing technology made the production of high-quality prints much less time-consuming, and an aspect of Mountain Light's business that had been of marginal importance became highly valuable.

A decade earlier, in 1983, Galen had had three major gallery shows in a single month—at the Smithsonian, the California Academy of Sciences, and Manhattan's International Center of Photography. Although his earlier books are full of powerful images (for instance, *Many people come, looking, looking,* 1980), "the photographs [seen between covers] were tied to external purposes in order to illustrate a place, an adventure, a . . . mood," he wrote. "These limitations vanished [in the shows]. . . . [I]mages that I had formerly associated with particular places and times took on isolated, fanciful qualities" when seen for themselves, on their own terms, on gallery walls. With *Mountain Light: In Search of the Dynamic Landscape* (1986), what might be called the Rowell High Style emerged, a style more iconic than documentary. In workshops he gave at the time, he tried to explain to students what he was aiming to do: "Early in my career, I might have given up photography entirely had it not been for an occasional image that far exceeded my expectations.

Most of the time I had no idea what I had done right. . . . Sometimes film and human imagination work together to produce . . . images that are more powerful than reality . . . 'dynamic landscapes,' photographs that combine a personal vision with splendid natural events."

Moreover, "One of the biggest mistakes [you] can make is to look at the real world and cling to the vain hope that next time [the] film will somehow bear a closer resemblance to it. . . . If we limit our vision to the real world, we will forever be fighting on the minus side of things, working only to make our photographs equal to what we see out there, but no better."

He wasn't talking about colorizing images, or digitally enhancing them. (He had strong objections to digital manipulation of images of the natural world, especially if those manipulations went undisclosed.) No, his argument was with the idea of the photographer as passive receptor, as mere recorder of scenes, and he spoke often of the effort of *imagining* shots before taking them, planning for the hours of magical light in a day: dawn and

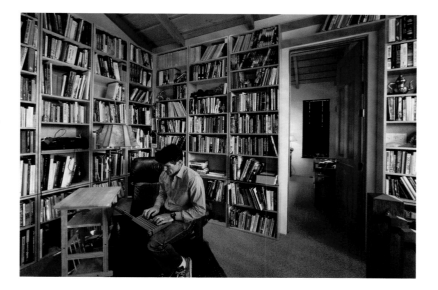

Galen working on a manuscript in the library of the Rowells' home in the Berkeley Hills, California, 1995

sunset. The stories of his athletic or acrobatic engagement in a landscape are many; one example, from the actor-director Robert Redford, comes from a 1982 trip to Nepal that Redford took with Barbara and Galen: "On a late afternoon somewhere around 15,000 feet . . . we stopped, an extra sense signaling [to Galen] that high above us on a steep hillside was a mountain tahr, scarce and elusive. . . . I had no clue. [Galen] loaded his camera with blurring intensity, never taking his eyes off the animal that I still had trouble finding. Then Rowell was gone. . . . I watched as he stalked the reluctant animal, moving with great speed and agility at an altitude that doesn't allow for it. . . . Finally I saw that the man and animal were practically face to face—a great sensitivity prevailed as Galen shot picture after picture."

About his affinity for the revelatory, the symbolic, and the magnificent in outdoor photography, Galen wrote, "The very sight of a beautiful nature image is enough to make most critics wince or flounder. How should the work be judged? Susan Sontag, one of the wisest critics . . . described in her book *On Photography* how 'the convention has arisen that photographic seeing is

clearest in offbeat or trivial subject matter,'" natural magnificence having somehow been defined as inevitably clichéd.

"I have considerably more faith in human visual perception," Galen countered. "It takes conscious effort to deny the emotional power of fine nature imagery in favor of subjects 'chosen because they are boring or banal,' as Sontag says, citing . . . close-ups of cigarette butts that were exhibited at the Museum of Modern Art in New York."

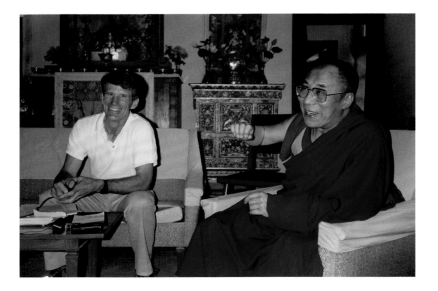

His Holiness the Dalai Lama watching a presentation of Galen's Tibetan wildlife photographs, Dharamsala, India, 1989

No apologies, and no doubts. For Galen, the high-mountain realm was full of meaning and beauty, and his task as he saw it was to explore and to reveal those dimensions. "Now I know that the combinations of light and form I seek . . . are virtually infinite," he wrote, "and that I will always have new and inspiring subject matter to pursue."

Influenced by David Brower's Sierra Club books, Galen aspired to be published in the same spirit and with the same skill. In addition to his many titles published by Sierra Club Books, which constitute the core of his life's work, are large-format volumes from the Mountaineers, Collins Publishers, and University of California Press. For the National Geographic Society, he was a principal contributor to another eight volumes of photographs. A definitive bibliography has yet to be compiled, but it will be extensive: over thirty books, probably hundreds of articles combining text with photos, his *Outdoor Photographer* columns, thousands of published shots, calendars, postcards, instructional videos, audiocassettes.

Galen seems to have been born for his moment in time. An outdoor adventurer, he arrived at the dawn of an era of adventure travel, with many new publications covering subjects, such as rock climbing and high-altitude exploration, that formerly had been defined as far outside the mainstream. Steve Werner notes other Rowell-friendly developments of the period: super-lightweight expedition gear and apparel, making it possible to be a self-contained and rapidly moving world traveler, and refinements to the 35mm single-lens-reflex camera, with its battery-powered strobes and through-the-lens metering. All a matter of good luck, certainly. But in considering even a rough

count of Galen's mountaineering expeditions—more than forty in only thirty years—the question arises as to whether the era simply *had* to produce the gear and conditions that he required, to answer his uncommon energies.

Tibet, his greatest subject, shows us the professional writer/photographer, the student of cultures, and the world explorer operating all at once. In *Mountains of the Middle Kingdom* he offers an account of the Tibetan struggle for independence far more nuanced than the usual Western version of Chinese oppression and Tibetan victimization; still, his sympathies are with the Tibetans, with their cultural uniqueness, and by the end of the 1980s, when he produced *My Tibet* with the Dalai Lama, he had been defying China's authorities for a decade. As the leader of the first American group allowed to visit the Tibetan backcountry, he had witnessed the degradation of "one of those remaining legendary wild places, such as the Serengeti Plain, the Galapagos Islands, and Yosemite Valley, that must be preserved for their own sake for everyone," as he later wrote. Here was a battle worth fighting.

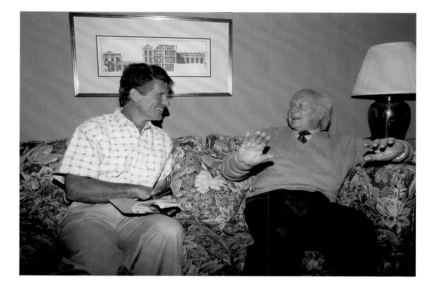

Interviewing Heinrich Harrer, Eiger Nordwand first ascensionist and author of Seven Years in Tibet, *New York City, 1991*

His interest in Tibet went back, as with his other passions, to childhood, and to his childhood reading; on a wilderness trip in 1955 he had encountered Heinrich Harrer's best-selling memoir, *Seven Years in Tibet,* the story of a world-class mountaineer of tremendous drive, a pioneering photojournalist, an explorer in every inch of his being. It would be too simple to say that Galen found the template for his own active life in Harrer's, but "I was in awe of both his adventures and his will to succeed," he wrote, and when invited to write an introduction to a new book of Harrer's, he noted, "I was thrilled to accept. . . . His legacy had influenced me in so many ways that I felt I was seeing a long-lost friend when I was introduced to an eighty-year-old man in a business suit. . . . Our one-hour breakfast interview ended at dinner."

For Galen, Harrer was "this century's greatest adventurer." David Brower was the century's "greatest American environmental activist," as John Muir—another rock-climbing prodigy, self-educated polymath, and poetic-but-precise depicter of wilderness—was the former century's.

These and a few other "phantom mentors" are a recurring presence in Galen's books and essays, invoked with profound respect and amused enjoyment, as he makes clear to us the wellsprings of his own ambitions. That he carried their lives' meanings so far forward into our own era, while having, as they appear to have had, a hell of a good time, may instruct and inspire the next.

~

Galen's work as an environmentalist—or, more exactly, a preservationist—was as long-lived as his

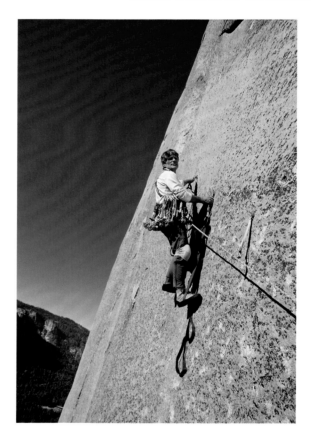

At fifty-seven, the oldest person to climb The Nose route on El Capitan in a single day, Yosemite, 1997

career. In his first feature article for *National Geographic,* about climbing Half Dome without placing new pitons in the rock, the need to protect a marvelous natural resource—the granite itself—is central to the presentation. Schooled in Yosemite, he was never *not* conscious of the benefit that can come from one man's efforts, of the great victory over time and waste that can sometimes be won: "When I first read [Muir] I had just hitchhiked home . . . after the most Muiresque adventure of my young life," he wrote, referring to his sixty-mile cross-country jaunt as a boy. "Since then I have come to appreciate that my modern experiences [are] a direct consequence of John Muir's life. . . . After Muir became well-known to the American public, he applied the weight of his fame and the muscle of his prose" to preservation. As a result, "Yosemite Falls in spring still booms with 'the richest, as well as the most powerful, voice of all the falls in the Valley.'"

He expressed his love for Yosemite in many ways, perhaps most usefully through work with the Yosemite Fund, which finances hundreds of projects, great and small, in the park. No mere sitter on an august council of directors—although he was that, too—Galen served on the fund's projects review committee, arguing nuts and bolts and dollars and cents year after year, for proposals ranging from trail repair to the reintroduction of yellow-legged frogs into backcountry lakes. Jerry Edelbrock, vice president of the Yosemite Fund, remembers Galen's presence at annual review meetings: "He always got up *very early.* . . . He would've been out for hours already, running miles on the trails and taking dawn photographs, by the time the rest of us rolled out of bed. Because of his intense interest in everything and because he served actively with so many organizations, there was a wonderful cross-

referencing going on. . . . He brought insights and knowledge to the process that no one else could, no one, anywhere."

A lover of wild places, but also of wildness in people—of wild ways of life. "We went on a trip in the Sierra," recalls Dick Duane, a longtime friend of Galen's and also his attorney, "a climbing trip, with mules to haul all the gear. It wasn't quite right, you know, from a certain point of view, using mules on the John Muir Trail, but Galen loved wild guys as well as wild places, and he was damned committed to keeping the pack stations going. He liked the packers, admired their life. He was the farthest thing from a sensitive-tree-hugger-don't-touch approach to the wilderness. . . . He loved the places where he could have adventures, and anything that threatened that he did something about."

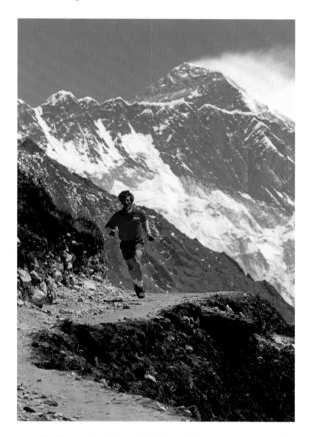

Trail-running beneath Mount Everest at 18,000 feet, Khumbu Himal, Nepal, 1998

To tally all he did may never be possible. Steve Karlin, the director of Wildlife Associates, an organization in Northern California that nurses and houses injured wildlife, met Galen in the course of providing animals for a Nikon video Galen was shooting. "He said, 'I like what you're doing. I'd be honored to be on your board.' That was the start of over twenty years of quiet commitment from Galen, most of it behind the scenes. . . . I always thought he was a little shy, still saw himself as a car mechanic, would rather be with his climbing buddies. But he moved in circles of powerful, influential people because of how good he was, and he brought me in to meet people I never would've in a hundred years, who then started supporting us. He'd call and say, 'Barb can't make it to this fund-raiser tonight. There's a lot of money here—you wanna be my date?'"

The World Wildlife Fund's Bruce Bunting recalls a similar pattern of continuous support of a most useful kind: "He was on our National Council, but it went way beyond that. All our major campaigns in the Himalayas got a tremendous boost [from what Galen did]. . . . He'd go in and shoot and help document what we were about. . . . Often there was a magazine article involved, and he'd donate images for us to use as we wanted. A lot of photographers don't do that. His pictures and the *National Geographic* carried tremendous weight with the governments involved, who got behind us. . . . Then you'd take Galen's shots and go to the MacArthur Foundation [for financing]."

A visitor to all seven continents, an intimate chronicler of their wildest, most threatened places, Galen brought back news of what must not be lost. Moreover, his sense of urgency, and his generosity with time, concern, and donated work, increased even as his life grew more complicated and the shouldering of new causes became more difficult to work out. Difficult, but for him not impossible. The funds established to honor his memory—the Rowell Award for the Art of Adventure, the Rowell Fund for Tibet, the Galen Rowell National Trails Fund—suggest his endur-

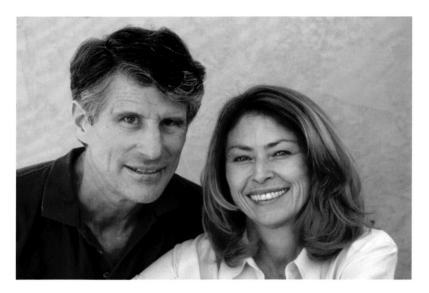

Galen Avery Rowell and Barbara Cushman Rowell on a rare vacation, Anza-Borrego Desert, California, 1999

ing centrality to efforts to preserve but also to enjoy wilderness. Says Dick Duane, "He was an interesting combination of hardcore climber who just wanted to get away to do the things he loved with the guys he loved, and someone willing to do the hard work, to sit on the boards, use power and make himself institutionally significant. A very, very rare one."

~

At the age of sixty-one, Galen was back in Tibet one last time with three trusted pals— Rick Ridgeway, Conrad Anker, and the young climber-photographer Jimmy Chin—on assignment for *National Geographic* again and equipped to move fast, to cover great expanses of rugged terrain. The remarkable story that Galen shot and Ridgeway wrote for the magazine, about their search across 275 miles of high Asian steppe for the calving grounds of the *chiru,* an exotic antelope, was another Rowell classic, calling attention to environmental threats while bringing more of the wild world into sharp focus.

All agreed it was the hardest thing they had ever done physically: hauling their own supplies on fat-tired rickshaws for seven weeks, at an average altitude of nearly 17,000 feet. For Galen, that made it harder than his alpine-style climb of Fitz Roy, in Patagonia, when he bivouacked standing up on a tiny ledge just below the summit, singing and dancing all night to keep from freezing; harder than his winter ski traverse of the Karakoram Himalaya, 285 miles hauling up to 120 pounds; harder than his one-day ascent of McKinley, made a month after smashing out his front teeth in a near-fatal fall on the same mountain; harder than (to go way back) his first climb of El Cap, also in wintry conditions, when he lost twenty-five pounds in six days trapped on the great wall.

Given that he had so much to compare it to, to say that this was the hardest meant something. He does not appear to have been slowing down at the end. The year before, he had moved with Barbara to Bishop from the Bay Area, Barbara having recognized the downtown bank building as a marvelous potential new home for Mountain Light. Here on the Sierra eastside, in "my favorite place on earth," as Galen wrote, where the "diversity of light and landforms amidst a favorable climate . . . is simply unbeatable," he could climb, run trails, ski, ramble among the peaks, and take photos practically right out his front door.

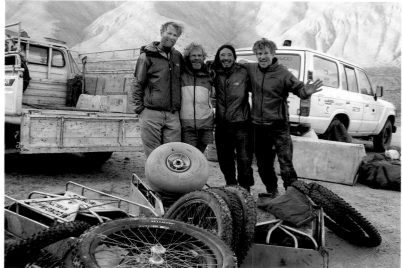

Only days after returning from Tibet, he flew to Alaska to conduct a photo workshop while sailing the Bering Sea. Afterward, Barbara and he planned to fly on to China, to check on a project they were developing there, but in the end they realized they didn't have to, so they flew back home to California. A private plane met them at the Oakland Airport for the short hop across the Sierra. They took off just after midnight. Fifty minutes later, two people night-fishing near the Bishop airport saw the lights of

The Chang Tang team at the end of their successful 275-mile trek across the Tibetan Plateau to locate the calving grounds of the endangered chiru, *2002*

a small plane, heard the strong hum of its engines. As they watched, the plane's bank angle increased radically, reaching between seventy and ninety degrees. Then, as the National Transportation Safety Board's report quietly notes, "the airplane descended rapidly."

The publisher Wynne Benti, who works in Bishop, has recalled how charged Galen was to be living in the Sierra again, scene of his earliest mountain adventures. "He [would stop] by now and then to chat," Benti wrote. "Once he came by after day-hiking to the summit of White Mountain Peak," a ramble that involved over 13,000 feet of vertical gain because Galen took a wrong canyon descending from the top in deep snow, then had to retrace his steps. "Often he climbed Whitney's east face and was back by noon," Benti recalls.

"On my way to and from Bishop," Benti also remembers, "I sometimes saw him photographing . . . through the cottonwoods and poplars, alone and completely absorbed in his work." No doubt he was on to something new, some new revelation of form and light; the possibilities were infinite, he had discovered, and there was good work left to be done.

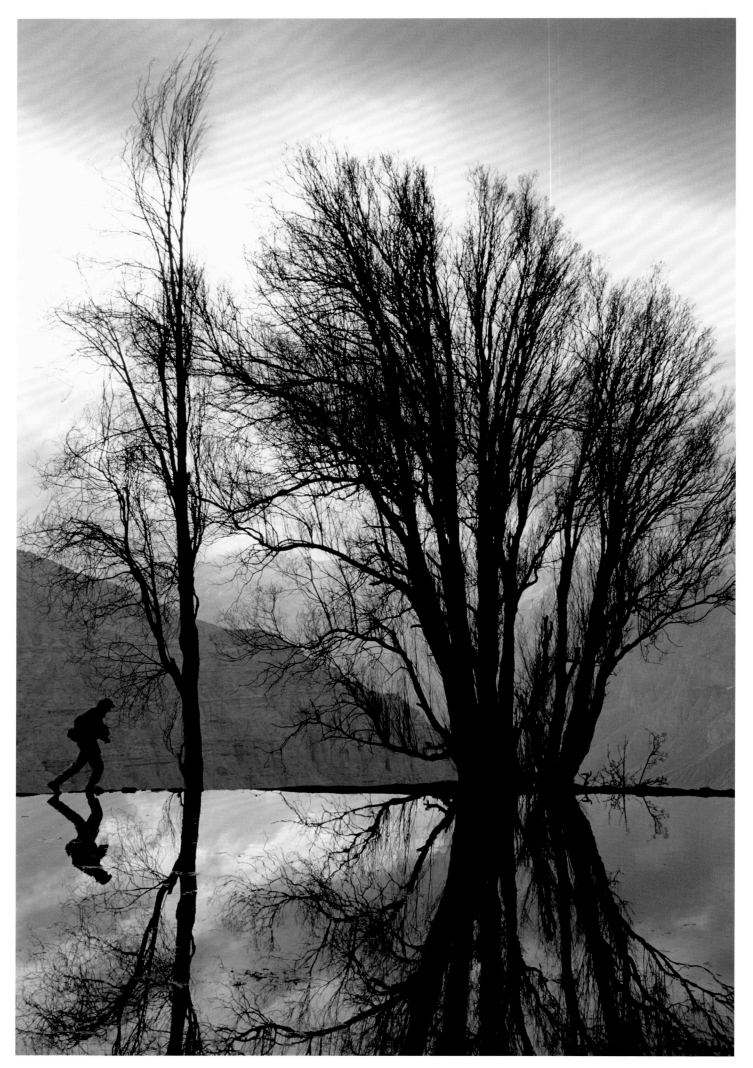

Pond near Tsele, Kingdom of Mustang, Nepal, 1993

Galen Rowell, Light Traveler

A Photography Critic's Perspective by Andy Grundberg

Over the last twenty-five years photographers and their commentators have often likened the activity of picture taking to fly fishing. The fly fisherman, like the photographer, sets himself and his equipment at ready, stands in a promising spot, and casts about, hoping to score a strike. The anticipation of success calls for considerable patience, which is often as not unrewarded.

This of course describes only a certain kind of photographer, the kind who chooses to be tethered to a tripod and to trust that good fortune will appear. Other photographers function more like mountain climbers, actively and often nimbly seeking a better view, traveling light yet trusting their equipment to save the day, risking failure as part of the equation of finding their own meanings. Galen Rowell, who was a mountain climber, was this kind of photographer.

One of his great heroes, Ansel Adams, was of the former kind, but the combination of majestic mountain views and environmental advocacy binds them together. Like Adams, Rowell was a tireless writer on two primary subjects: photography and the natural world. As visual artists they carried the blessing and burden of knowing natural beauty intimately, which led them to want to show it to as wide an audience as possible and to preserve it for the future.

Adams's great secret is that he was mainly a roadside photographer. Although he took uncounted pack trips into the backcountry of Yosemite and elsewhere, many of his greatest pictures—"Clearing Winter Storm," "Moonrise, Hernandez," "Snake River and Grand Tetons"— were taken within a hundred feet of his car. This does not subtract from the glory of what he showed us, but it does suggest that his view of nature is essentially disembodied.

Rowell's work is different because, as a climber, he usually was in intimate contact with his subjects. His "Half Dome" is not a distant edifice but a living, breathing (and dizzying) presence. Many of his best pictures show human beings and nature together, suggesting that their coexistence is possible and permits a notion of beauty to survive. His photographs are occasioned more by contestation than appreciation, since he often had to struggle against the natural terrain to arrive at unexpected, vertiginous vantage points; the presence of the photographer, implicit or explicit in Rowell's images but always denied in Adams's, is part of what gives the work its special meaning.

In terms of mountain photography, the only other photographer to whom Rowell might be usefully compared is Bradford Washburn. Washburn, whose career of more than sixty years is in strong contrast to Rowell's tragically abbreviated one, specialized in exquisitely detailed black-and-white images of snow-covered mountains, many of them bird's-eye views shot with a bulky, large-format aerial camera. Like Adams, Washburn loved the tonal range and simplicity possible with black-and-white materials; unlike his better-known contemporary, he was also a mountaineer who loved his subject for its visceral as well as visual qualities.

Rowell, a new spirit of the next generation, chose to forgo black-and-white film and large-format cameras. For him 35mm equipment and color slide films were the ideal: relatively light and portable, precise, and capable of rendering gorgeous variations of light and weather, especially on surfaces of rock and snow. While he admired Adams as the essential photographer-environmentalist and Washburn as a visual perfectionist—he even called Washburn's pictures "sacred art"—he had no desire to bear the twin burdens of the kind of equipment they used and their aesthetic legacies. He struck out on his own.

In the magazine *Outdoor Photographer,* published only a few months before his death in August 2002, Rowell wrote that his aim was to be a participant in the scene and not merely an observer: "Wanting to take a light camera with me when I climb or do mountain runs has kept me using exclusively 35 mm. By trying to get the most out of 35 mm I've learned to pursue technical quality while at the same time using a camera system that is incredibly versatile from ultra-wide angle, to extreme telephotos, to flash fill, and use of graduated neutral-density filters. What I mean by photographing as a participant rather than observer is that I'm not only involved directly with some of the activities that I photograph, such as mountain climbing, but even when I'm not I have the philosophy that my mind and body are part of the natural world."

Still, he hewed to the belief of Adams, Alfred Stieglitz, Edward Weston, and others that a photograph should do more than capture reality; ideally it was, in his words, "a visualization in my mind's eye," one that could exceed normal perception. *Visualization* and its elaborated partner, *previsualization,* were exactly the words used by these older photographers to explain their desire to intensify the meanings of their photographs, to find a visual counterpart to their experience of the world. Often they would manipulate their subjects, isolating them in the frame or changing tonalities in the process of developing and printing to make the final image match their intentions.

Rowell, working in color, also was able to intensify the visual appeal of his subjects, although he always insisted, like his forefathers, that his aim was only to reproduce what he saw. Foremost, he chose to use Kodachrome film, a transparency (or slide) film that excels in reproducing brilliant colors crisply and cleanly. Some of the colors it produced proved too brilliant and intense for some eyes, since they seemed to exceed the true colors found in nature, but Rowell recognized and appreciated the film's picturesque qualities. He called Kodachrome "the color film of the century." (This allegiance only went so far, though; later in his career he found Fuji's Velvia film more to his taste.)

But he recognized that even Kodachrome was not always perfect. So he took to using graduated neutral-density filters to maintain a properly exposed sky while keeping the lower landscape area rich in tone. A polarizing filter helped him record greens; underexposure helped with reds. In short, like his predecessors he bent his craft to his materials and to his pictorial goals, which were always aimed at letting the viewer experience the power of the scene as he felt and experienced it. Notions of science or of documentary truth, while indisputably important to Rowell's intellectual being, figured little in this aesthetic equation; impact and wonder did.

Given the impact of his best work, one wonders why he would profess that "[m]y mountaineering skills are not important to my best photographs." This disavowal, from his column in the April 2002 issue of *Outdoor Photographer,* seems almost like Babe Ruth saying that his swing was not that important to his baseball career. Without his skills as a climber Rowell would never have been in position to make many of his most awe-inspiring photographs. Whether roped up on the side of a 20,000-foot-high peak or simply bivouacked for a day on a glaciated plain, he benefited from being outside and alert to changes in light and atmosphere. Having the luxury of a variety of lenses that can change the viewpoint from pinpoint to superwide only added to the richness of the possibilities. And the sensitivity to light and other photographic skills honed in the mountains came to mark all of Rowell's photographs, even those taken from the sides of interstate highways.

But in another way his statement makes sense. His passion for the mountains, not his mountaineering skills, provided the real fuel for his photography. One could argue whether his firsthand, close-up experience of them made for better landscapes at a distance, but there is no denying that at any range he could imbue them with qualities of majesty and timelessness. Mountains, in Rowell's pictures, are the standards against which we might measure ourselves, the obdurate others of human existence.

Rowell's first big career break came from a story about a Yosemite climb that was published in *National Geographic,* and he became a frequent contributor to that magazine and to Sierra Club books and calendars. This was, in one sense, a devil's bargain. His pictures came to represent the pinnacle of mountain photography to a broad audience, but they also were left open to being rudely dismissed as "Geographic" or "Sierra Club" pictures. Rowell wanted them to break the mold, to succeed in the way Ernst Haas's abstract color photographs in *Life* in the 1950s had redefined their genre. Yet he rose to the defense of "postcard photography," proclaiming its populist virtues to be as important as its aesthetic ones.

What distinguished Rowell's photography, however, was not its relation to pictorial convention or to its opposite, invention, but the pictures' symbiotic relationship to narrative. Rowell was a storyteller par excellence, and if any of his pictures could be said to be postcards, then what's written on the back of the card cannot be disregarded. "All my most powerful messages about the fates of wild places that I care about need to have words as well as images," he wrote in his monthly column in *Outdoor Photographer*. He was in this sense a journalist, using camera and pen as implements to inscribe a single message.

Rowell's career ended at the beginning not only of a new century but also of a new era for photography. Color films, including his beloved Kodachrome and Fuji's Velvia, to which he turned in the 1990s, are being upstaged by computer chips in the backs of digital cameras. Already publishers are taking anonymous fifty-year-old Kodachrome slides and presenting them in books as vintage objects that fascinate because they look so antique. Fortunately, both for these bone pickers and for Rowell's legacy, the color in Kodachrome film is remarkably long-lasting (and in any case many of Rowell's best images have been digitally archived). His aesthetic of the picturesque, of beauty so intense that it shocks, should persevere even longer.

Photography at birth was a medium of light, and many photographers then and in recent years have made light the subject of their images. Rowell, with his 35mm equipment and adventurous spirit, was someone who both traveled light and traveled with the light. His faith in the revelatory powers of light as it appears on film coincided with a deep conviction in the power of images to reflect the aspirations of the human spirit. If we take his pictures to be visualizations of what he saw as the magnificence of the natural world, then we might also see them as metaphors for our own perfectibility.

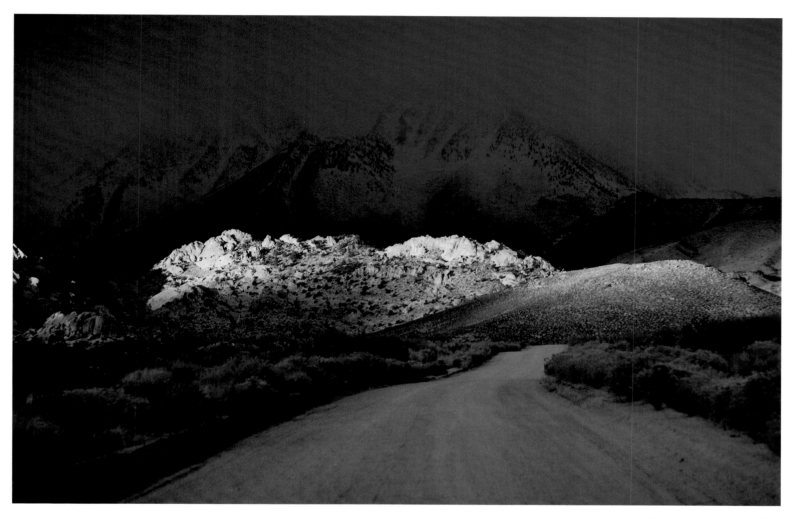

BUTTERMILK ROAD, EASTERN SIERRA, CALIFORNIA, 1971

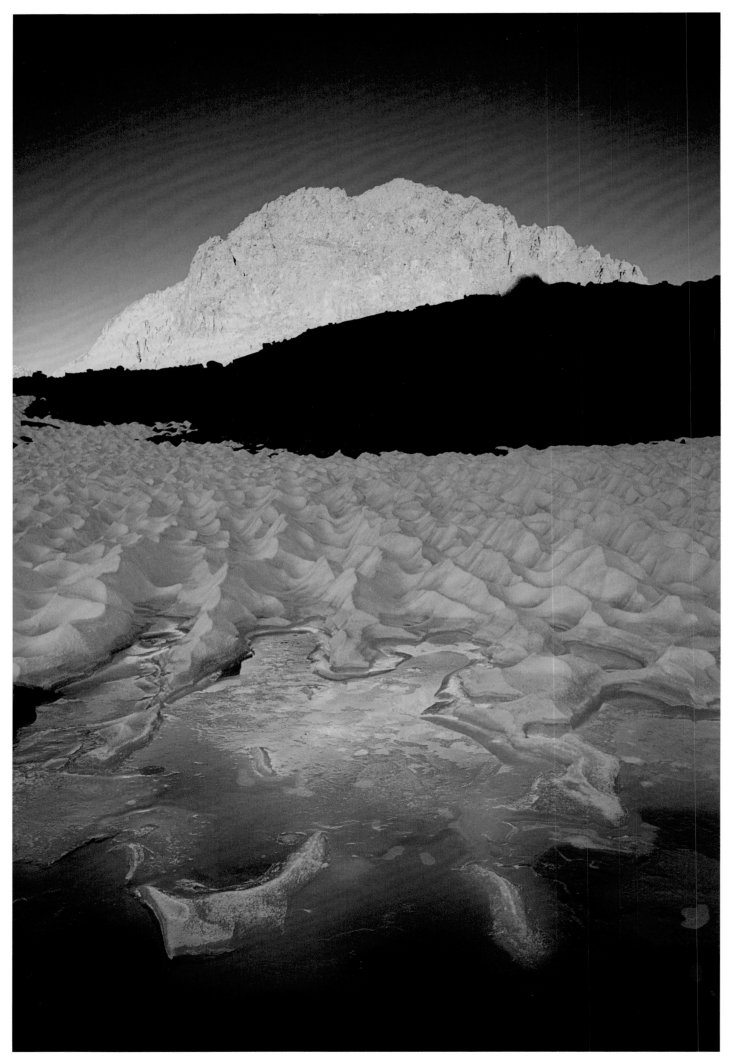

Late-summer Snow under Mount Williamson, High Sierra, California, 1983

THE MOUNTAIN PHOTOGRAPHER

"My interest in photography did not begin with books or mentors, or with any burning desire to see the world through a camera. It evolved from an intense devotion to mountains and wilderness that eventually shaped all the parts of my life and brought them together. Photography was never simply a hobby or a profession for me. Once I began taking pictures, it became an integral part of my life."

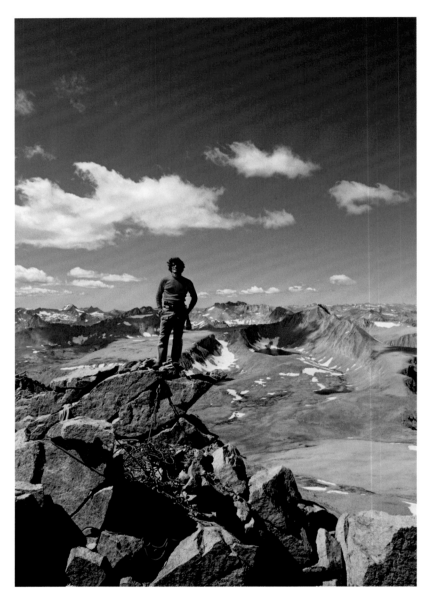

Self-portrait on the Summit of Mount Tyndall, High Sierra,
California, 1983

Climber with a Camera

by Doug Robinson

I knew Galen Rowell best in the days when he was mainly a climber—a climber who happened to carry a camera. We were young and bursting with energy that only a big range of mountains seemed to quell. Especially Galen. We did first ascents together up the steeper sides of High Sierra peaks and an epic ski traverse of the Ruby Mountains in eastern Nevada. The camera always came along. And like the guy behind it, Galen's Nikon was never subtle or unobtrusive. Right from the start there was an in-your-face quality to his lens that pointed toward an inevitable boldness in the photos.

I met Galen in Yosemite but really came to know him in the eastern Sierra. When I moved there in the late 1960s, Galen often would show up in the middle of the night to sleep on my floor, departing at dawn toward the peak of the moment. There was a creative surge in alpine climbing going on then, on ice and on rock, and of all the climbers pushing it, Galen was the most prolific.

He saw the era this way, as noted in the second edition of John Moynier and Claude Fiddler's *Climbing California's High Sierra:* "In the late sixties and early seventies, I made about seventy-five new climbs in the High Sierra. Often a trip to do one virgin face in a very remote area would result in a glimpse of five others to put on my list. I was, of course, not the only one involved in this 'golden age' of technical climbing in the Sierra high country, and by the mid-seventies my list of objectives had dwindled considerably."

All through this creative decade, Galen carried his Nikon. It's tempting to say "of course." But not so fast: this guy is still unknown. Sure, he's had a handful of photos published—in *Ascent,* for instance, which is very high-toned and literary, with graphic qualities reminiscent of Ansel Adams's work, but has a tiny circulation on the West Coast and pays next to nothing. So Galen is a Chevy mechanic, supporting his two kids out of a small shop near the bay in Albany, wiping the grease off his hands before he dares touch a camera. He closes the shop on Friday afternoon to begin his typical "thousand-mile weekend" to the eastern Sierra. At the end of that commute, around midnight, he often detours up the Bishop Creek Road, twenty miles out of his way, to crash at my cabin, then arise at dawn and go climbing.

But to climb a remote High Sierra wall, first you have to get there. That night drive is only the preamble. So load up the backpack with the gear you need just to survive above timberline. Now throw in the climbing equipment: another twenty-five pounds of rope, clanking hardware, and specialized rock shoes. Then heft it once, staring up the trailless, brushy tangle of George Creek. From here you can't even glimpse the prize: an unclimbed face of Mount Tyndall. Okay, now load your Nikon and film. Pause to agonize for a moment over glass: beautiful crisp lenses, but heavy. Multipurpose zoom lenses haven't been invented yet, and anyway won't be as critically sharp. You need at least two lenses—a 24mm and a 105mm lens are his standbys—and maybe another. This is a first ascent, after all. Now squirm your shoulders into the huge load, rub your sleepy eyes, and start uphill.

Galen wrote often of simple readiness in alpine photography: seeing a blaze of light and grabbing it on film. Fair enough, but it only works if you're in position for the moment and toting the right piece of glass. Which all begins with lugging around your camera, hours and days of toiling uphill, sweating into the sagebrush before you even glimpse the alpine zone. That went on year after year, up one trailless canyon after another, before his first book—or even his first *National Geographic* article—was published.

Most of those early slides never made it out of his basement in Albany. "C'mon, you gotta see this," he would say. We'd dash through the house with a nod to Carol and the kids, and head for the basement, where climbing gear was strewn in dark corners and a bare bulb illuminated his slide sorter. He already had a way of shuffling thirty-six slides from hand to hand, as agile as a Las Vegas dealer, and squinting through each one in passing. All the while he would be talking animatedly about the shot he sought—some remote wall of virgin granite.

In 1972 Galen made his big career move. He sold the auto shop, figuring he had about a year to make it as a photojournalist. Luck was with him. *National Geographic* happened to be putting together a feature on Yosemite, and they would try Galen out with a follow-up story about climbing one of its big walls. So the next summer found Dennis Hennek and me roping up at the base of Half Dome, with Galen gleefully snapping photos.

Half Dome was a safe project—both Galen and Dennis had climbed the face before—until Dennis and I added a twist by committing the team to the emerging style of "clean" climbing. That meant using only natural rock anchors and aluminum wedges inserted with two fingers to secure us to the face and safeguard against falls, instead of the traditional but rock-scarring steel pitons

driven by a heavy hammer. We had not exactly shared with Galen the decision to leave our hammers in the Valley until we were too high on the wall to retreat conveniently. After three days on the wall, Half Dome became the world's first all-clean big-wall climb. When Galen's slides landed on the desk of the *Geographic*'s photo editor, it became the cover story. And barely a few months after that issue appeared, the clean-climbing revolution swept through the climbing world.

His first book was published that same year, 1974. Pulling together stories we had written for each other, *The Vertical World of Yosemite* became the first coffee-table volume to focus on the insular world of climbing in Yosemite, which had recently begun to be noticed by climbers from across the country and overseas. No one before had thought to show climbing to the world outside. Now our personal world in Yosemite cracked open to a wider audience, illuminated by Galen's journalistic eye and his introductions to each piece, and boldly jumping out of the photos. Galen's color shots were prominent but nicely balanced by the work of other photographers in black and white.

Galen was starting to be seen as a photographer, as the guy squinting over the rim of a Nikon. Behind that eye, though, was a head teeming with ideas. Galen groused that "the many magazines I had worked for never let me say what really motivated my work." It wasn't just scenery: "My interest was not only to record images of little-known places or adventures," Galen wrote, "[but] to provide a different perspective . . . of the activities that form the basis of wilderness exploration: mountain climbing, backpacking, skiing. And thinking."

And thinking. Not choosing a lens, and not waiting for the light. Thinking. This was exactly the Galen I knew, in the raw innocence of his salad days, goofy with the excitement of ideas. More truly himself then than the mature guy staring out of a camera ad. For the moment, wild landscape was his foreground, and his sharpest lens was wild ideas.

It was the campfire talk, reflecting those ideas and projecting their implications, that set Galen apart and kept me coming back for more of his company. His mind ranged as widely as his feet. Fascinated by the prospect of anchoring modern humankind in its evolutionary origins, he eagerly read the new theories of primate behavior from Konrad Lorenz and Desmond Morris. Did our passion for climbing hail from a simian past? Were we just expressing an ancient adaptation to vertical niches in the environment? If so, did that make our steep play really a way of prancing onto the fields of dominance? And if that was true, then how come there weren't more women hanging around a bunch of dirtbag climbers living like gypsies?

You can glimpse this curiosity about behavior behind Galen's success at photographing animals in the wild. In his wonderful *High & Wild* (1979), there is a remarkable passage—along with arresting shots—in which he describes watching mountain goats at play on a steep granite wall in the Canadian Arctic. Awed at first by their sheer climbing skill, he comes to realize that one of the goats seems to be showing off. He periodically stops climbing—maybe to be sure Galen is still watching?

By the late 1970s, Galen's prospects were beginning to spiral outward to larger landscapes. He eventually went on to all continents and both poles, and as he did the cameraman overtook the climber. But the camera work remained forever shaped by climbing and the Sierra landscape. There's the clean vertical sweep of Yosemite granite, with a climber rampant, poised in total focus on moving upward. And the moment of discovery, coming over the last rise into an alpine garden ringed by peaks. He managed to make that climber's point of view at once intimate and expansive, so that it rings of Sierra footfall even as he reveals the Canadian Rockies or the Karakoram Himalaya.

After pretty thoroughly scouring the world, from Tibet and Nepal to both poles, Galen came back to live in Bishop, in the shadow of the Sierra, saying this was his favorite place on earth. Returning here and moving in at last, Galen seemed to be having a second childhood. Or maybe it was a still-lingering adolescence. Consider this entry in Mount Whitney's summit register just ten months before he died: "Name: Galen Rowell. Residence: Bishop. Age: 61. Comments: Via East Buttress from Whitney Portal 2 hrs. 53 min."

The summit of Whitney is 6,200 feet above the Whitney Portal roadhead. There is no formal trail up the rocky North Fork under the East Buttress. Most climbers rope up for the last thousand feet of the buttress, which goes at 5.7 or 5.8. Then again, most climbers would feel brimful to pull off this climb and the long descent in a full weekend. Galen often took such jaunts early in the day before settling in to work. It is a fitting last glimpse of a guy who had traveled a full great circle of the globe to return here. Full circle indeed.

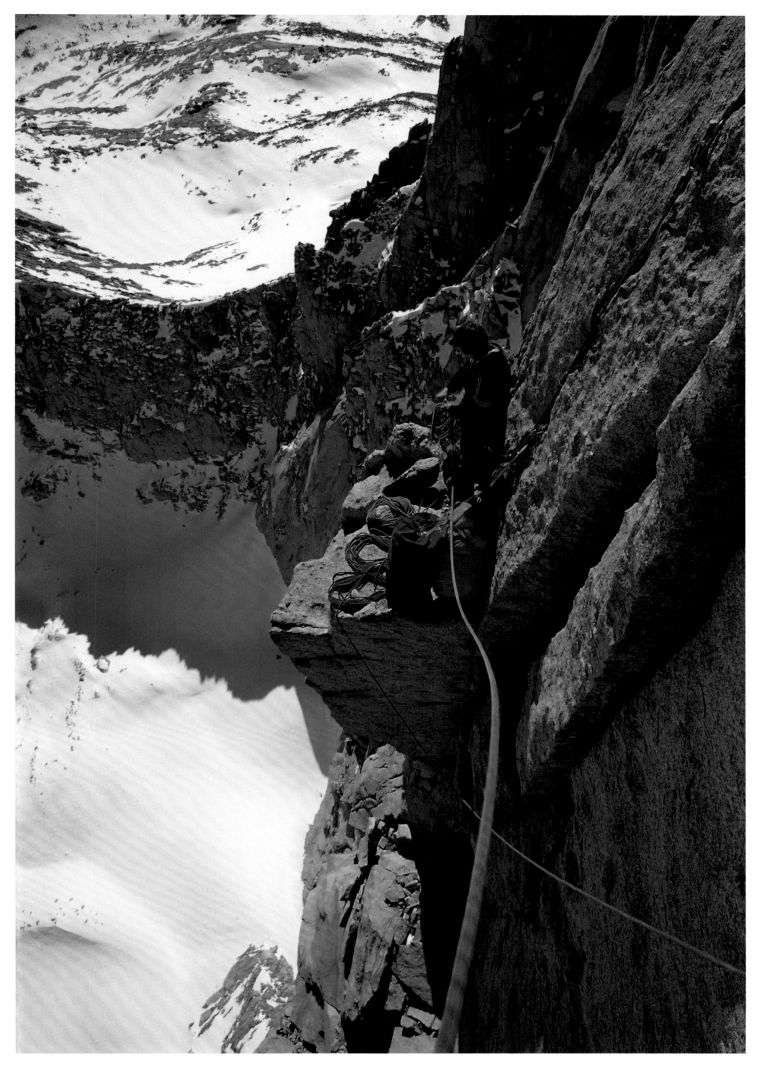

CHRIS VANDIVER ON THE FIRST FREE ASCENT OF THE EAST FACE OF KEELER NEEDLE, MOUNT WHITNEY, CALIFORNIA, 1972

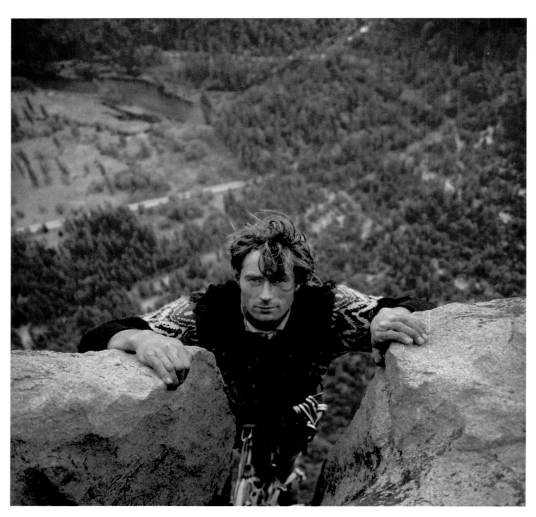

LAYTON KOR TOPPING OUT ON THE THIRD ASCENT OF THE SALATHÉ WALL OF
EL CAPITAN, YOSEMITE, 1967

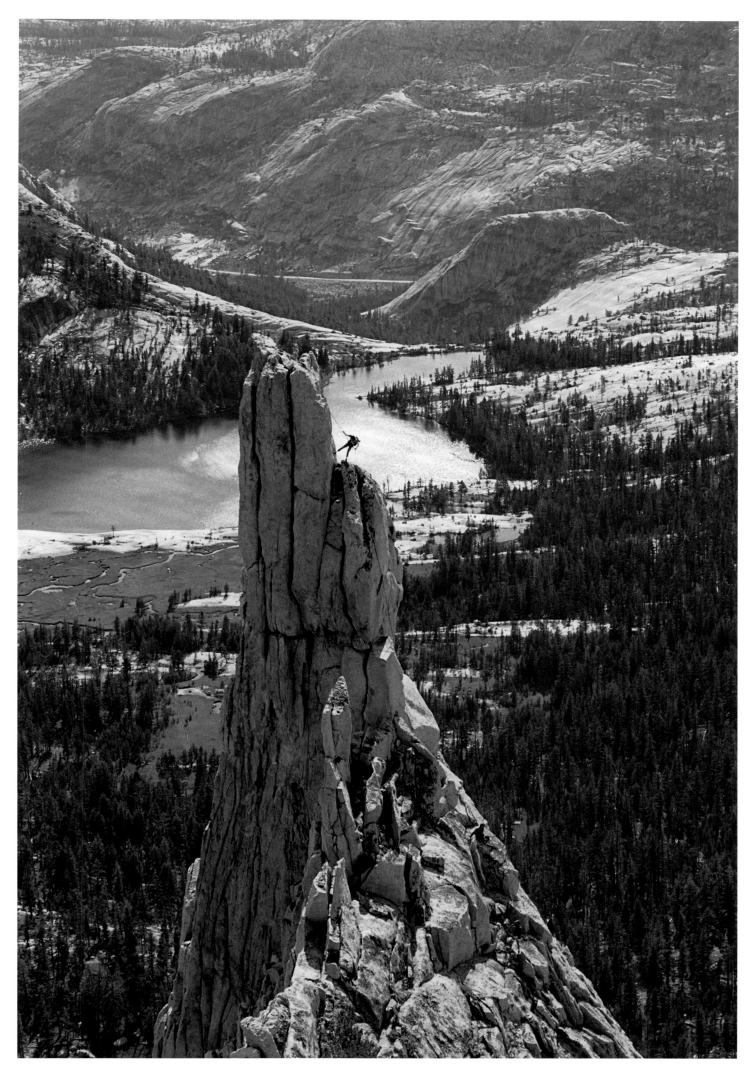

CLIMBERS ON EICHORN PINNACLE, CATHEDRAL PEAK, YOSEMITE, CALIFORNIA, 1987

Moonset at Sunrise, Wheeler Crest, Eastern Sierra, California, 1972

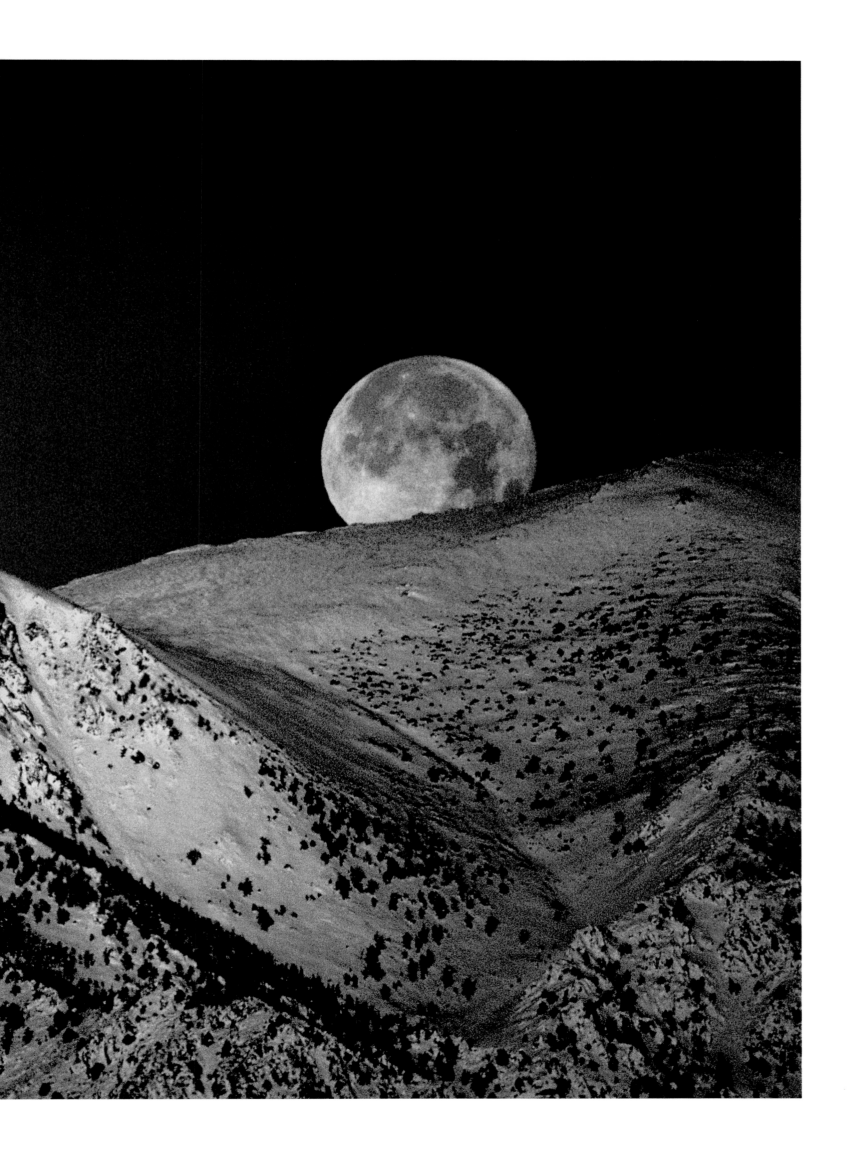

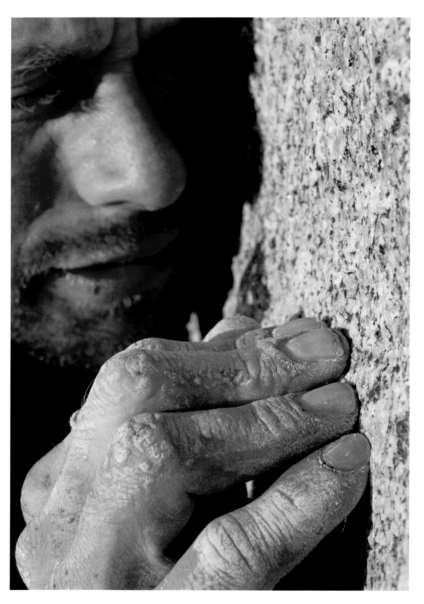

TODD SKINNER ON THE FIRST ASCENT OF THE GREAT CANADIAN KNIFE, CIRQUE OF THE UNCLIMBABLES, NORTHWEST TERRITORIES, CANADA, 1992

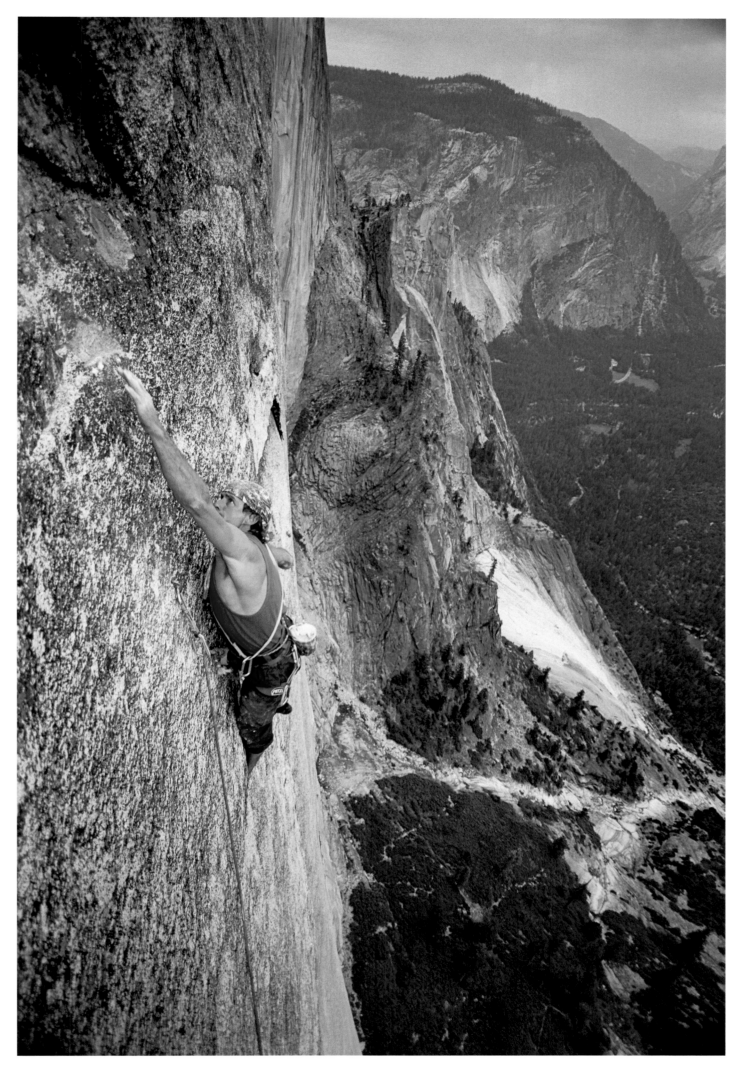

TODD SKINNER ON THE FIRST FREE ASCENT OF THE DIRECT NORTHWEST FACE OF HALF DOME, YOSEMITE, 1993

EXPOSURE

Warren Harding, famed wild-man climber, ascends a rope on a hot summer's day. In this photograph, taken in November 1968, Galen captures Warren's strength and intensity. The photographer, secure in his position, has taken the time to compose that rarest of climbing shots: a memorable scene looking down, not up. Most "hero" photos of this era were boring, posed photos, looking upward at the leader's butt, conveying no real sense of the fragile position of the climbers.

Here also is the feeling of exposure, also rare in early climbing shots, where the background is often fuzzy or uninteresting. Here we sense we are up in the air, maybe not very high but high enough so that the perfectly focused ground reminds us of the seriousness of the venture.

Just a few years earlier Galen would not have been able to take this shot, being too busy belaying Warren with both hands. If a photo were needed, then a quickie one-hand shot would have to suffice. But new techniques in climbing had changed the way photographers could work. Instead of laborious belaying, the leader could simply tie off the rope to his secure anchors and let the second person ascend this rope using the new mechanical devices called Jumars (the dull gray "clamps" gripped tightly here by Warren). The upper climber, freed from belaying, could eat, doze, sort gear—or take photos at leisure.

Here, on Half Dome's 2,000-foot south face (the opposite side of the famous sheer wall visible from Yosemite Valley), Galen and Warren had spent many a day working on their bold new route. Plenty of time to take photographs.

Warren was most famous for his first ascent of the 3,000-foot-high Nose of El Capitan in 1958, an epic lasting eighteen months. But he also accomplished many other noteworthy routes, several done with Galen. Their masterpiece was the first ascent of this "back side" of Half Dome. They battled the featureless wall over five climbing seasons before success came on their sixth attempt, in 1970. Of their five retreats, the most dramatic came during the climb pictured here. A sudden storm had trapped the pair high on the wall. Soaked and freezing, they spent several days in their crude hanging shelters, with ice forming on their ropes. Galen later wrote about the scene: "[H]ours of small powder avalanches . . . numb fingers and toes . . . skin like purple prunes. . . . [A]nother night; another morning . . . colder . . . still storming. . . . I am nervous and vocal. . . . Warren, the bastard, is calm. . . . I want to try descending. . . . Warren wants to wait it out. . . . I don't want to die without a fight." Rescuers, helicoptered to the summit in clearing but frigid weather at nightfall, rappelled to the pair at midnight and saved their lives.

As a co-editor of *Ascent,* the Sierra Club's mountaineering magazine during the 1960s and 1970s, I had many meetings with Galen to discuss his submitted photographs. He gave us some splendid ones over the years, and we were thrilled to get such rare, high-quality shots, so different from the standard of the day. I used to ask him about his secret. "Get up early," he would always reply, "and be up high."

—Steve Roper

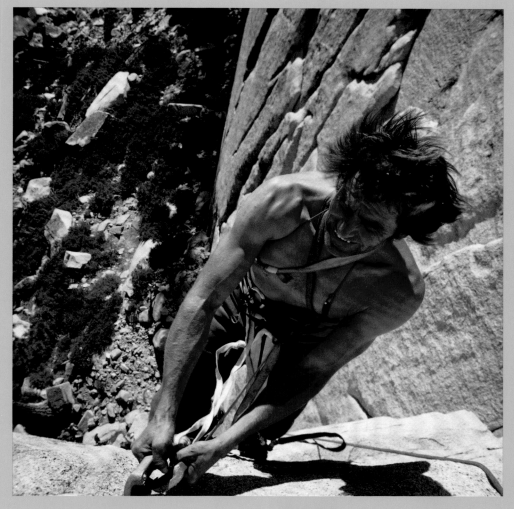

Warren Harding on the South Face of Half Dome, Yosemite, 1968

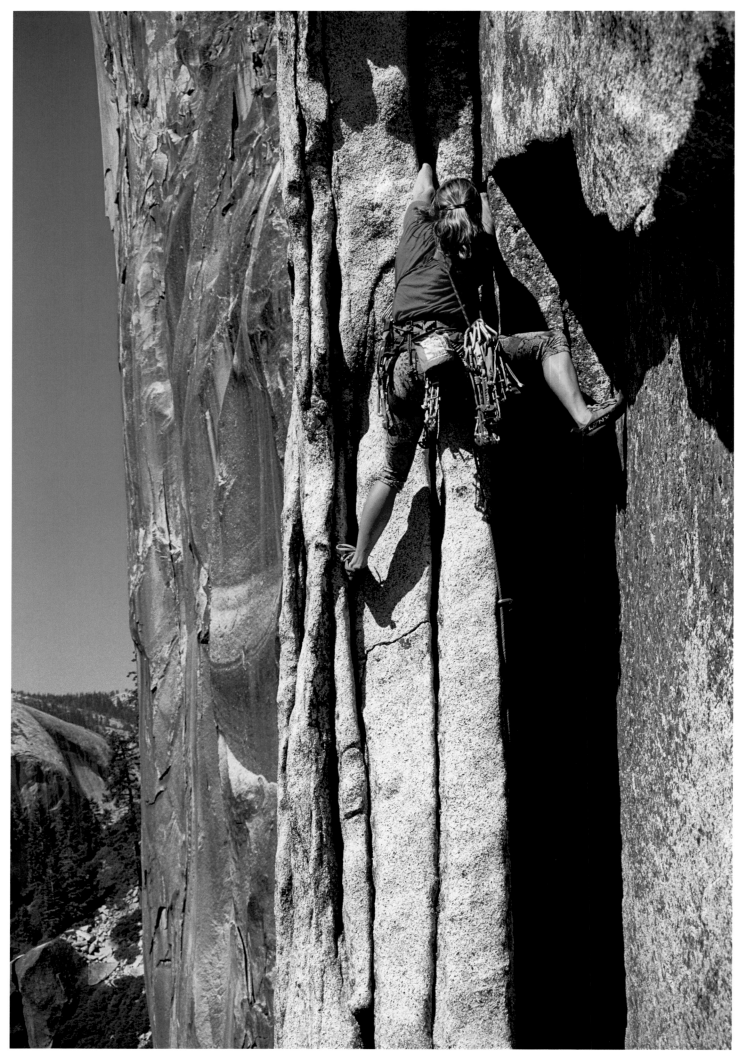

NANCY FEAGIN ON THE FIRST FREE ASCENT OF THE DIRECT NORTHWEST FACE ROUTE, HALF DOME, YOSEMITE, 1993

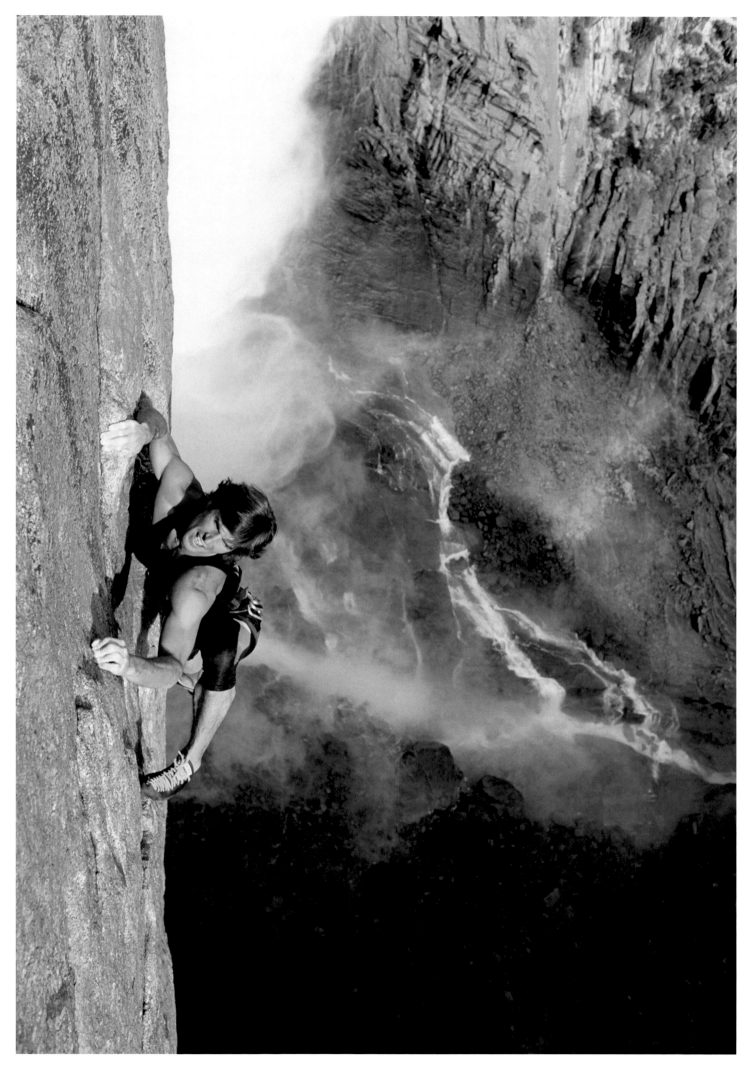

RON KAUK CLIMBING BESIDE YOSEMITE FALLS, YOSEMITE, 1991

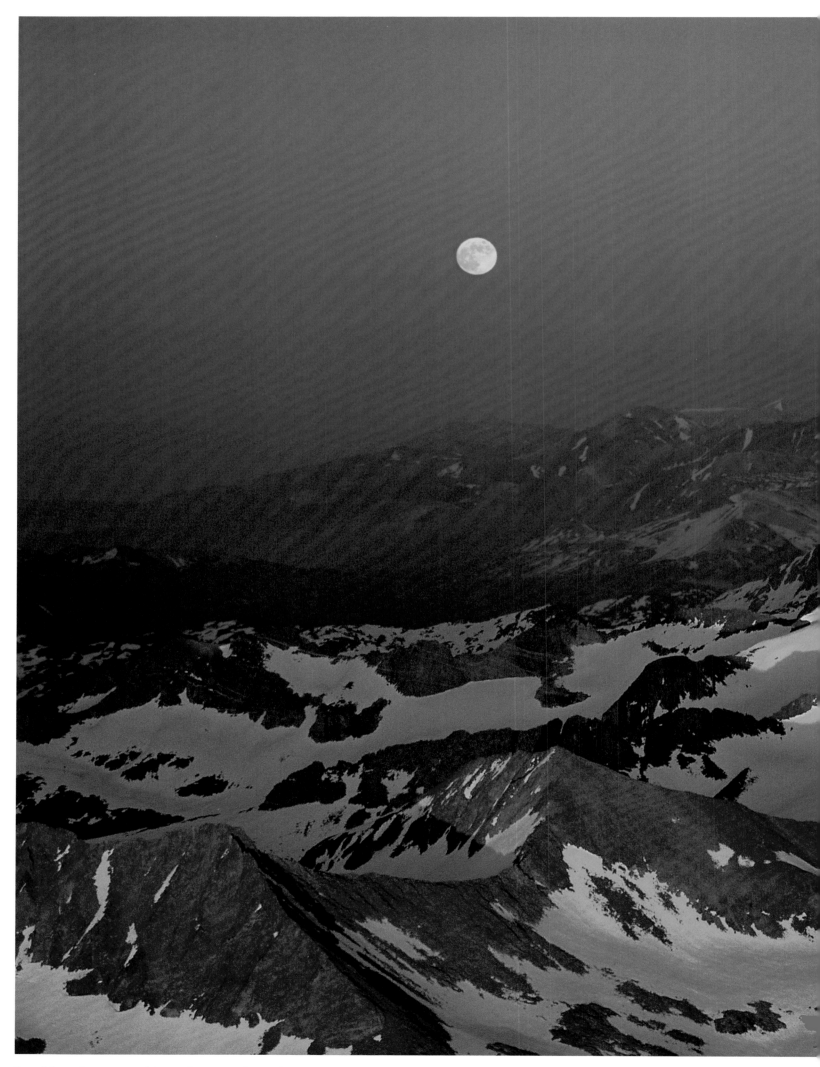

FULL MOON RISING OVER MOUNT LYELL AND LYELL GLACIER, YOSEMITE, 1993

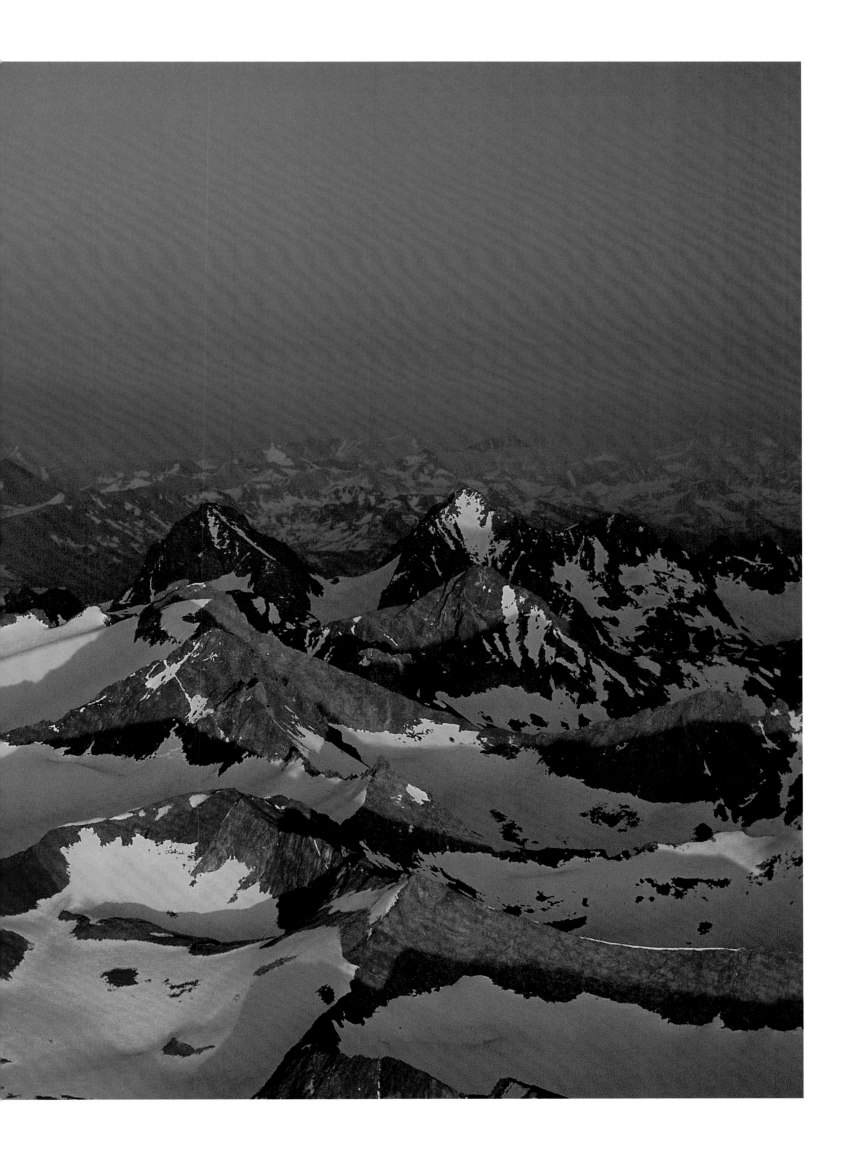

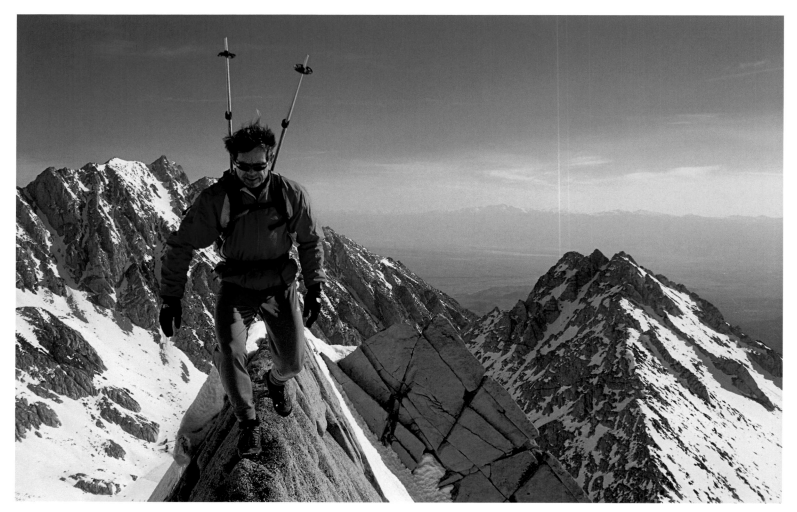

PETER CROFT ON THE NORTHEAST RIDGE OF MOUNT HUMPHREYS, EASTERN SIERRA, CALIFORNIA, 2001

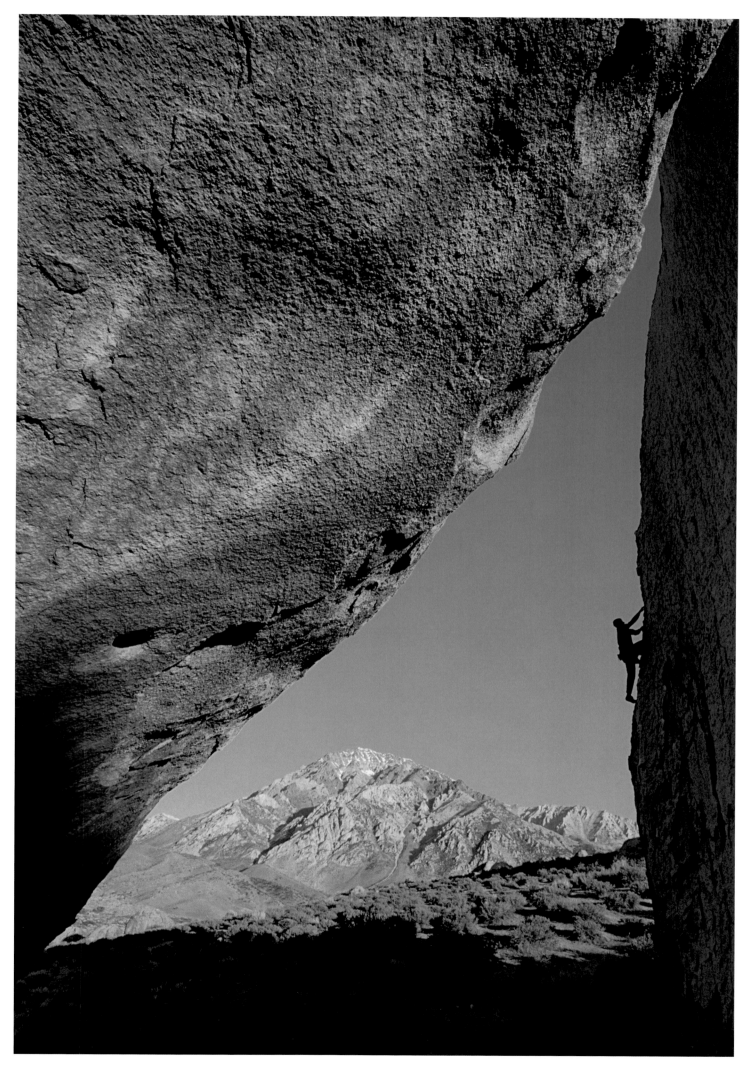

CHRIS MCNAMARA CLIMBING AT DAWN, BUTTERMILK BOULDERS, EASTERN SIERRA, CALIFORNIA, 2001

HUMANS IN THE MOUNTAIN LANDSCAPE

I was privileged to meet Galen early on, in 1962 to be exact, before he made a name for himself. He was then just shifting to mountains and photography from his earlier interests: cars (his favorites were black Chevy Nomad station wagons) and pranks (he was proud of his ingenuity in being able to engineer an annoying neighbor's armchair into a tree).

At a time in my life when I was down and out financially, Galen let me crash on the couch of his apartment in Albany for as long as I wanted and allowed me to store my photographic equipment safely in his father's house in the Berkeley Hills.

One immediately sensed intensity and determination on meeting Galen. To me, they were manifested in his eyes, the windows to the soul. He was willing to learn from anybody and able to absorb large amounts of information, then apply that knowledge to whatever project he was undertaking, whether it was writing, photography, or climbing. Galen was friendly with people of all stripes and worked well with "establishment" corporate types, which greatly fostered his success.

I very much admired his photographic technique, so different from mine. I worked slowly and deliberately, most often with a view camera. Galen moved quickly with 35mm gear to capture the moment. His creative use of different lenses and lighting in the mountain environment was masterful, and it was a style he developed on his own.

Where I feel he really broke new ground was in photographing humans in the mountain landscape. This was an outstanding theme of Galen's mountain photography, and nobody did it better. Looking at his published photos, I noticed that he somehow managed to highlight human figures in his shots in a way I hadn't seen before. These images looked carefully planned, and no doubt some of them were—but they were planned "on the fly," with his ability to quickly evaluate lighting, camera angle, and lens and factor in existing weather conditions.

This view of the sun's diffraction fringe outlining the figure of Peter Croft, Galen's frequent climbing companion in his later Sierra adventures, is a superb example of his style. Moving quickly to get into a position to take a photograph like this is often very difficult in the mountains, and the sun moves with surprising rapidity, especially when the photographer is working with telephoto lenses. One has to know exactly what effect one is striving for and how to achieve it, which Galen certainly did.

—*Ed Cooper*

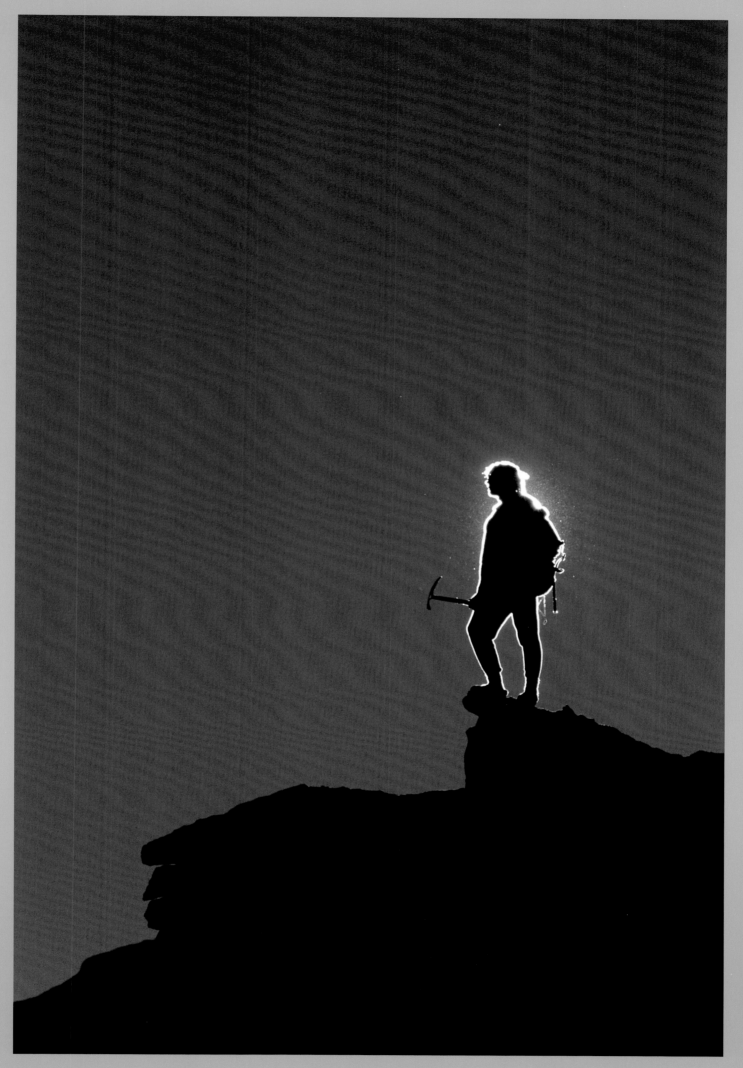

PETER CROFT WITH DIFFRACTION FRINGE ATOP MOUNT DARWIN IN THE EVOLUTION PEAKS, HIGH SIERRA, CALIFORNIA, 1997

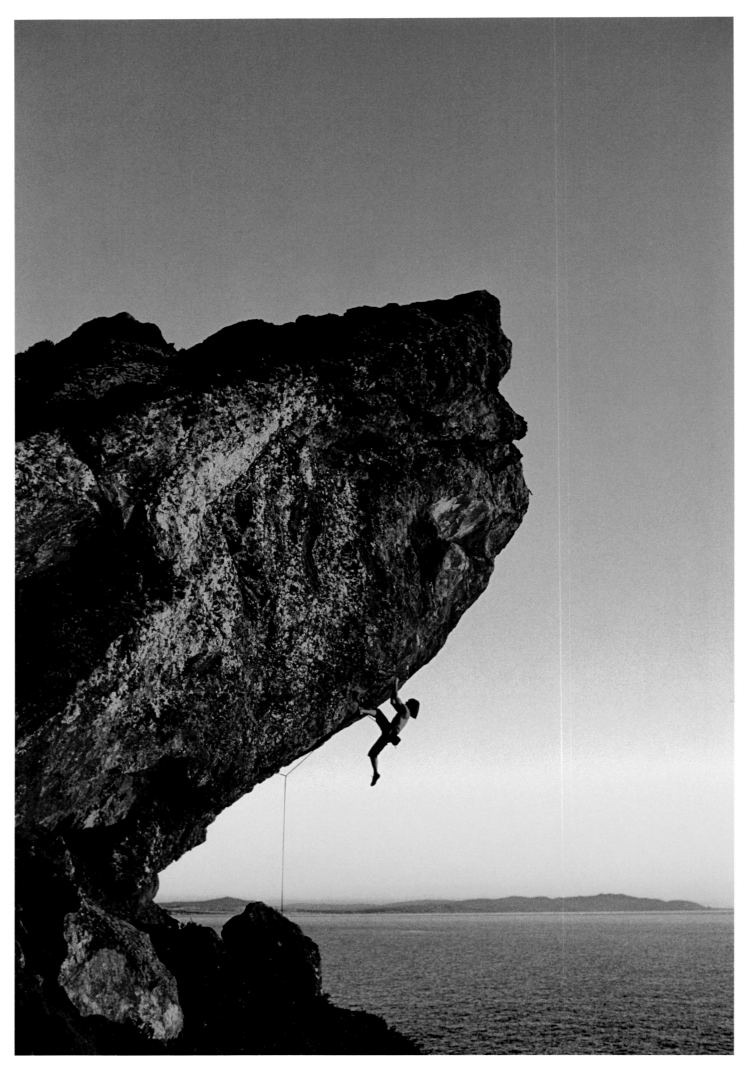

RON KAUK ON ENDLESS BUMMER NEAR MICKEY'S BEACH, MARIN COUNTY, CALIFORNIA, 1990

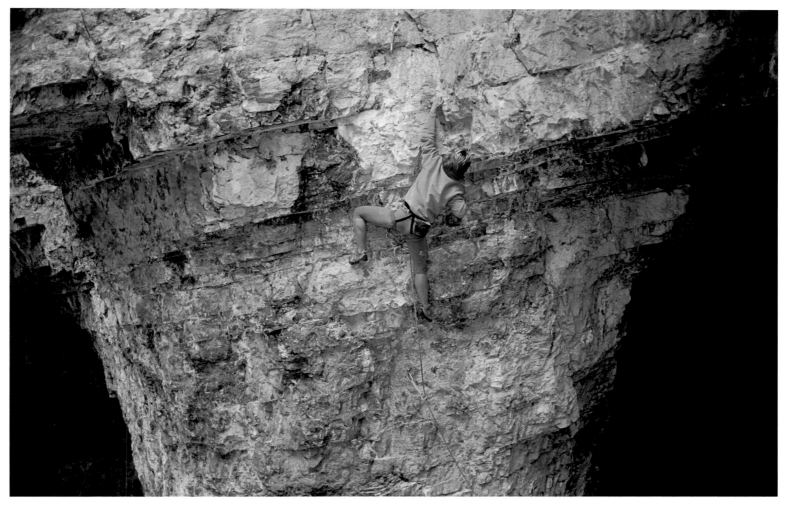

Lynn Hill in Hell Cave, American Fork Canyon, Utah, 1996

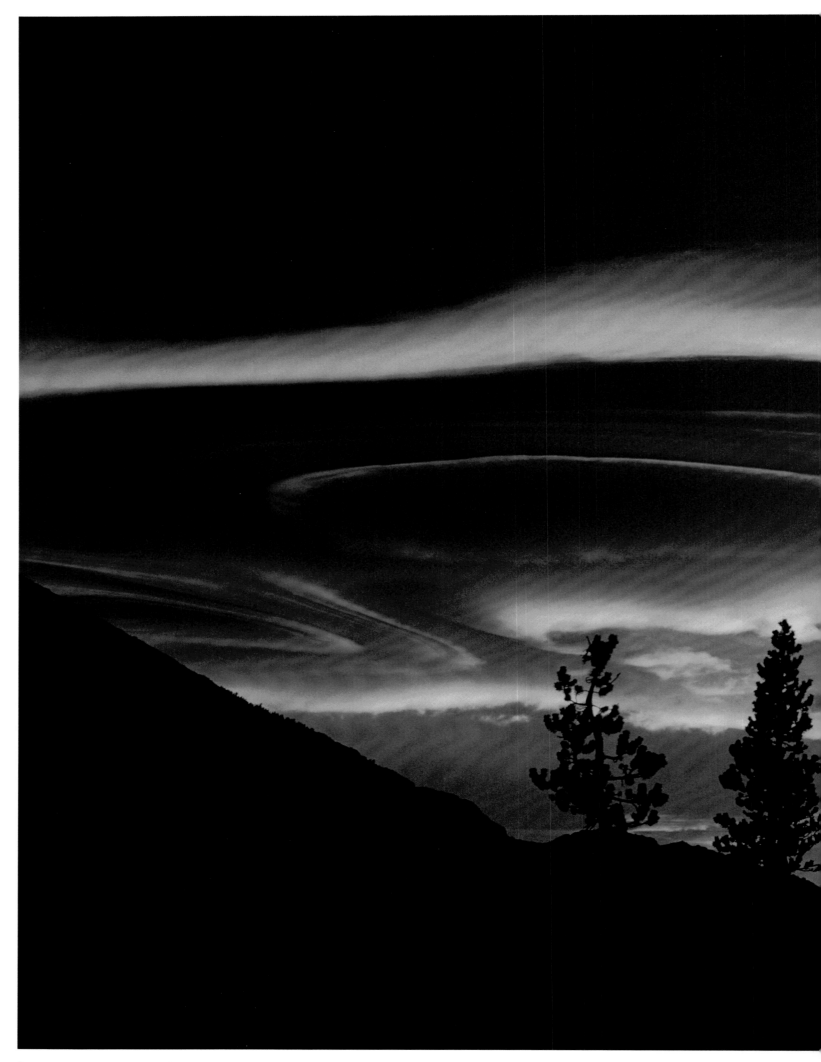

Self-portrait at Sunrise on Tioga Pass, High Sierra, California, 1973

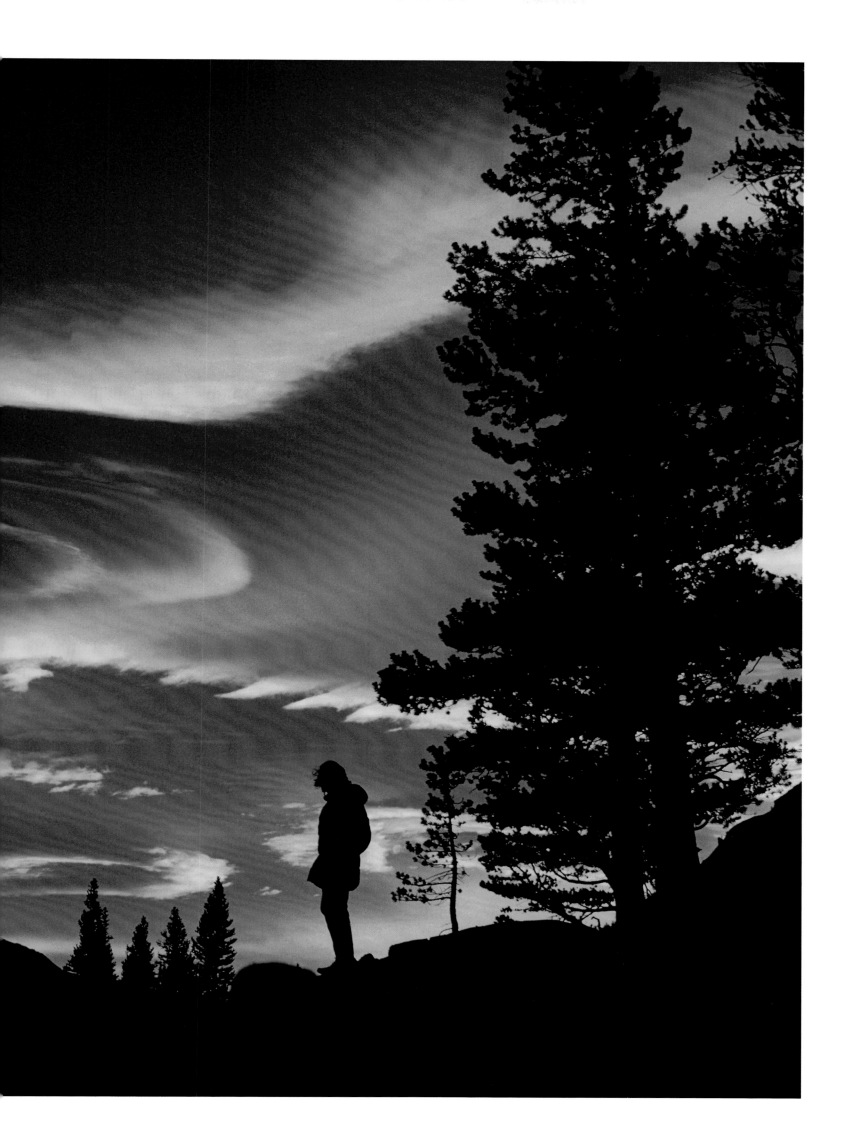

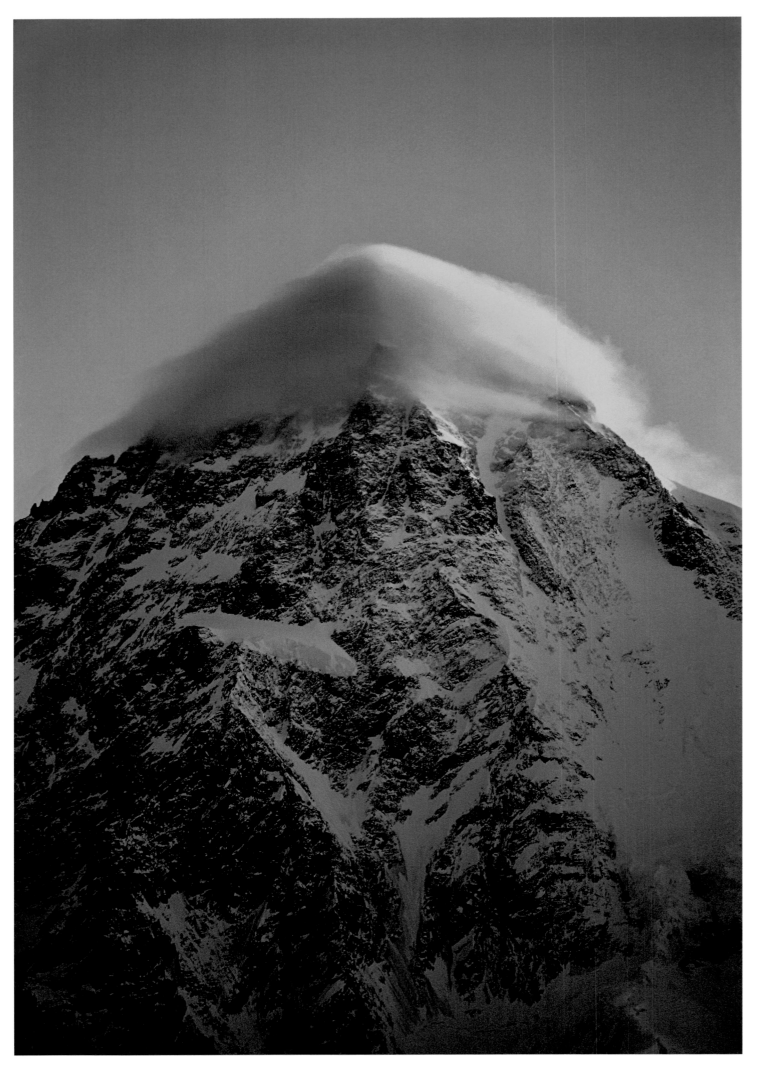

Cloud Cap on K2, Karakoram Himalaya, Pakistan, 1975

EXPEDITION CHRONICLES

"For many people in the world, the landscape before us would be foreboding.

For us, it had been a gradual ascent from the unknown into the familiar. Beyond the last villages

we no longer saw strange human alterings of the scene, but rather the workings of nature common

to all the world's alpine areas: glaciers, rivers, . . . clouds, granite, blue sky, raindrops,

wildlife, and friends who shared our passions. We were home again."

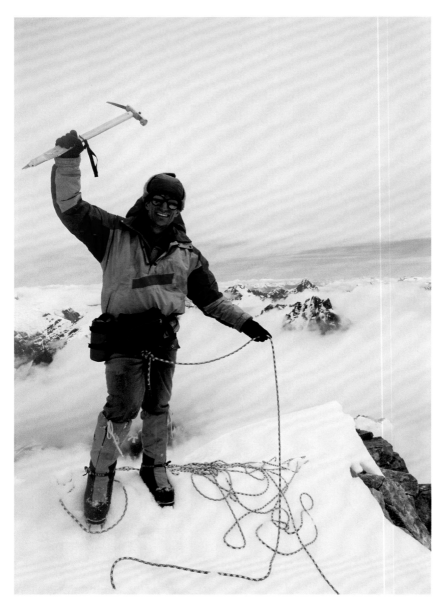

GALEN AT CERRO BARROS ARANA SUMMIT AFTER THE FIRST ASCENT WITH
DOUG TOMPKINS, CHILEAN PATAGONIA, 1990

PHOTOGRAPHY AS A STATE OF GRACE

by Jon Beckmann

Revisiting Galen's writing and photography, especially in his books published in the late 1970s and early 1980s during my tenure at Sierra Club Books, reminded me what an unusual figure in the mountaineering world he was. There were of course the spectacular photos, but there was also writing of depth and complexity and his experiences of mountains that went far beyond physical achievements. I see now how hard it is to fit him and his work into any conventional category.

By his own account, Galen did not until in his twenties envision a career as a photographer, a chronicler of expeditions, and an explorer who roamed the world's wild places. But in 1973 some of his photos came to the attention of *National Geographic,* and the magazine commissioned him to depict climbing in Yosemite Valley. His fellow climbers were against it, fearing it would bring down hordes of wannabes. Galen agreed reluctantly but preferred to photograph climbs that minimized the hardware used and intrusions into the rock. It became his style to add layers of secondary themes, often environmental, to the obvious subject of his writing and photography. His first book, *The Vertical World of Yosemite,* which he edited and to which he contributed photographs, emerged from the *Geographic* piece.

In 1975 Galen joined an expedition to climb K2, the world's second-highest mountain, and was asked to write the book about it. Unfortunately, the expedition was unsuccessful—in many ways a disaster. Writing a publishable book was almost as challenging as the climb itself. Galen was up to it, and in *In the Throne Room of the Mountain Gods* he developed what would become his signature approach to documenting expeditions. There was much history, of mountaineering in general and attempts on K2 in particular; there was background on the local cultures. And his photography, while full of splendid mountainscapes and climbing action, also depicted the people and wildlife of the region, solving the problem of making a failed expedition interesting by heavily excerpting from the team's diaries, which, to their credit, they permitted. All the fears, jealousies, bickering, criticisms, frustrations, all the warts of the expedition were exposed. The book was hailed as the first really honest chronicle of a mountaineering expedition, and Galen's star as an outdoor photojournalist began to ascend.

The book also featured another theme of his expedition chronicles: conservation. Galen came to question the wisdom of large expeditions—this one had more than six hundred porters and tons of equipment—because of their damaging effects on the environment. Toward the end of the book, after his gorgeous photos of the Karakoram Himalaya and its inhabitants, is a black-and-white picture of a campsite simply entitled "Turd Field."

Before K2, Galen had made many climbs and traverses in North America. He collected these experiences in a book titled *High & Wild,* published in 1979 and subtitled *A Mountaineer's World.* True to his nature, the inhabitant of that world was not the stereotypical mountaineer. In his introduction, Galen talked about "the new age of mountain exploration." Classical mountaineering had scientific and exploratory goals or the glory of a first ascent; in Galen's world, joy—the act of climbing with the simplest of tools, the sort of frolicking he observed in wild mountain goats on a steep rock face—was the real satisfaction. Never the kind of climber pejoratively deemed a "peak bagger" by his peers, he always sought a special challenge, such as the notoriously difficult face of the Great White Throne in Zion National Park or a ski expedition not up but around Mount McKinley. The book and its title captured the beauty and exhilaration of such adventures.

During the 1980s, Galen made innumerable forays into wild places the world over. He explored China, developing an enduring passion for Tibet; photographed wildlife in Africa; climbed to 26,500 feet on the West Ridge of Everest; made a first-ever ski traverse of the Karakoram; climbed in the Japan Alps, Nepal, and Kashmir; explored Siberia's Lake Baikal; reached the summit of Fitz Roy in Patagonia; and trekked in Greenland. A sumptuous selection of photographs from these experiences is featured in *The Art of Adventure,* published in 1989.

In 1980 and 1981, Galen traveled through eight Chinese provinces on four treks and expeditions, a feat notable not only for its ambition but because from 1949 to 1980 China's mountains were closed to outsiders. Galen's account of his experiences was stunningly produced by Yolla Bolly Press and published by Sierra Club Books in 1983 as *Mountains of the Middle Kingdom: Exploring the High Peaks of China and Tibet.* Again refusing to be typecast, Galen warns in the preface: "This is not a mountain book. Nor is it a travel narrative. It is a *rediscovery* of mountain regions lost in history, created by a blend of past and present, exploration and politics, mountains and people." Diving into research on a scale he hadn't previously attempted, he produced a book that, more than any other, showcases his trademark synthesis of mountaineering, history, natural history, and politics, accompanied by images of places and people the world had never seen. He

opens with a carefully researched description of a Westerner he called "the father of adventure travel," who trekked to an unknown China in the thirteenth century in search of the secret of silk: Marco Polo. It was the kind of touch that makes his writing so special.

On its dust jacket, *Middle Kingdom* featured what is probably Galen's most famous photograph, "Rainbow over the Potala Palace, Lhasa, Tibet." To get this great shot, he had to chase the rainbow to exactly the right place and seize the right light to make the photograph. If he hadn't so positioned himself, he would have had a good shot but not a great one.

In 1986, Galen published *Mountain Light,* a book that focused on his photographic vision and method while displaying his most spectacular photos taken over two decades. Perhaps its most striking theme was his conviction that the act of photography possessed a moral component. He wrote: "Photographs can lie as surely as words, and just as with writing, making a photograph implies that the photographer understands what his photograph says." He abhorred fakery and manipulation, boldly speaking up in the early controversies over nature photographers using digital cloning.

He referred to "dynamic vision" and an ability to see like a camera, so that the image of a subject had clarity in his mind before he hit the shutter release. It was as if he needed to be in a state of grace in order to achieve the best record of whatever he chose to shoot.

Galen's philosophy acknowledged the role of luck in getting great shots, but he also knew that you had to do more than just show up. His mountaineering skills and extreme fitness brought him to his subjects of exotic landscapes, people, and wildlife, but the power of his photography depended on more than athletic skills. His lifelong passions for the natural world and photography are an outstanding example of coevolution. The skills needed to ascend a sheer granite wall in Yosemite and to capture in an instant—through a car window, no less—a stunning, composed image of a secretive wild lynx in Alaska are vastly different, but they found a unity in Galen.

Over the following years, Galen made many more expeditions and published many more books. His efforts to protect wild places by revealing their beauty only increased.

I remember one late afternoon, several decades ago, leaving a celebration of one of Galen's chronicles at the Sierra Club offices after wine and cheese (probably more wine than cheese). As we stood outside the brick-faced building, our publicity director jokingly suggested climbing the wall. Galen flashed a big grin and started up, joined by the publicist trying to get more than a foot off the ground. He nimbly ascended about fifteen feet and came back down. That was the spirit he sought in climbing, trekking, and skiing: just for the joy of it.

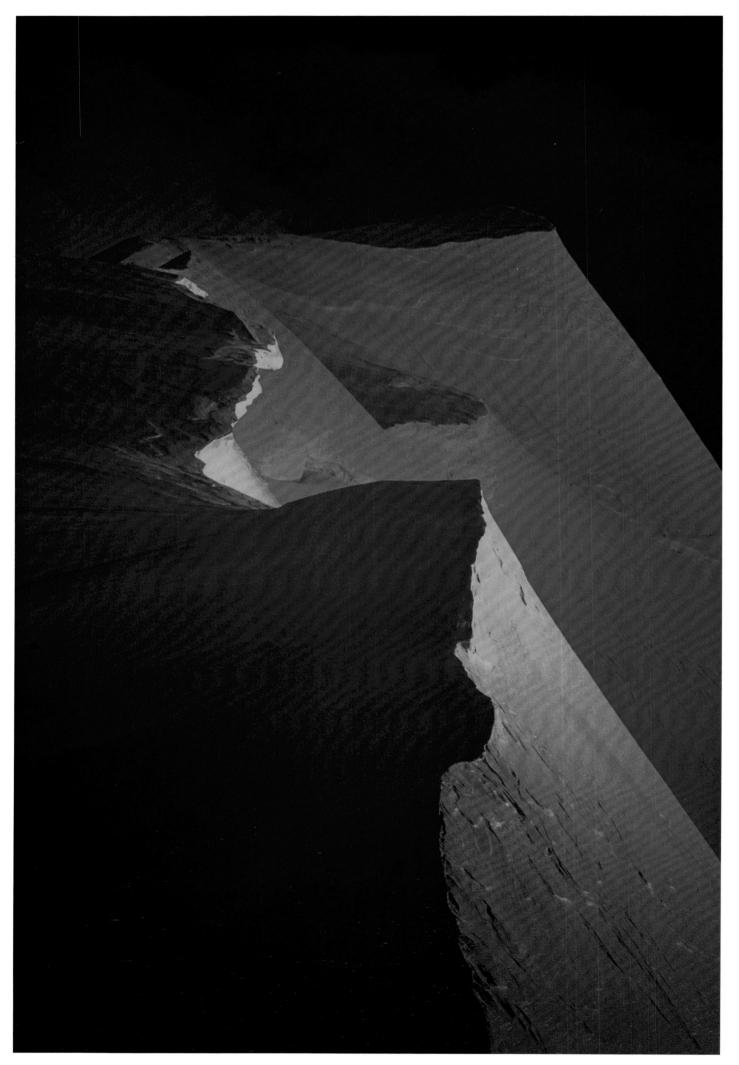

Alpenglow on Corniced Ridge, Denali (Mount McKinley), Alaska, 1979

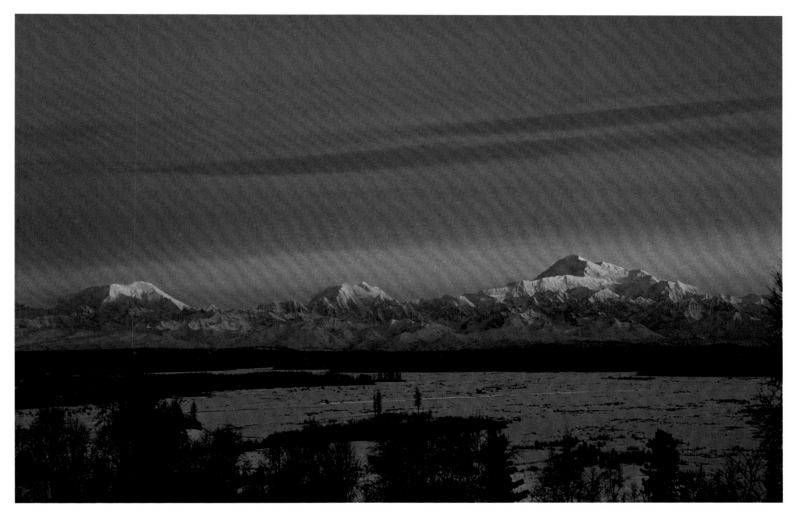

WINTER SUNRISE ON DENALI, ALASKA, 1991

A VERY PRIVATE PARTY

Galen Rowell's picture of a lit cabin at twilight on Alaska's Ruth Glacier is an alluring call to the wild. In a soundless, chilling, crystalline world, behind frosty windows, his fellow travelers revel in what look like the comforts of home. The image transcends reality—floating above the crunch of his boots in the snow and the chatter from within the cabin to offer us entry into the solitude of the place.

Through this picture he invites us to escape what we know to what we can only imagine. Such is Galen's talent—to provide visual opportunities to explore ourselves through his images of the natural world.

Galen understood the power of his photography, and he talked about his images as "illustrations of the possibilities of photography rather than studies of place and mood." Possibilities indeed! Once he sets nature's stage within his camera frame, he introduces a patch of color or the flash of a fleeting moment or a shaft of light, which projects the viewer into introspective reflection. His explorations become ours.

For his evocative cabin photograph, Galen left the surprise birthday party Alan Bard had orchestrated for Ned Gillette to record an incongruous moment when the noise of merriment echoed through a cathedral of silence. From their blurry shapes I can almost see the thumping good time the celebrants are having. And I'm reminded of backcountry hikes I've taken where the sound of wind rushing over a falcon's wings would startle me. From nature's solitude I seek solace, and I find it in his picture.

In *Mountain Light,* Galen wrote that a version of this image was used to advertise a well-known brandy. The ad that appeared in national magazines and on billboards showed a couple drinking brandy, a studio setup, superimposed in the cabin window.

Though I knew Galen from our frequent telephone conversations, I must confess that I never met him. He was days away from a scheduled picture editing session at *National Geographic* in late August 2002 when he and Barbara perished. Just weeks earlier he had completed his first assignment for the magazine in thirteen years and was over-the-top giddy to begin reviewing his pictures from the Chang Tang plateau of Tibet. He and three companions had pulled handcarts 275 miles across the 17,000-foot-high plateau searching for the birthing grounds of the *chiru;* he chronicled their trek through land so inhospitable that fifty-year-old trees grew no larger than livestock dung piles.

Now, alone, I opened nearly two hundred boxes of Galen's 35mm transparencies and selected images that told his story of their monthlong journey. I then met with expedition leader Rick Ridgeway, and together we fashioned Galen's pictures into a visual narrative published in the April 2003 issue.

As I look back on that piece, I see how Galen's photography is a touchstone for both creator and viewer. The risk of discovery quenched his thirst to push beyond the known world. And his photographic records offer us the opportunity to join him.

— *Bert Fox*

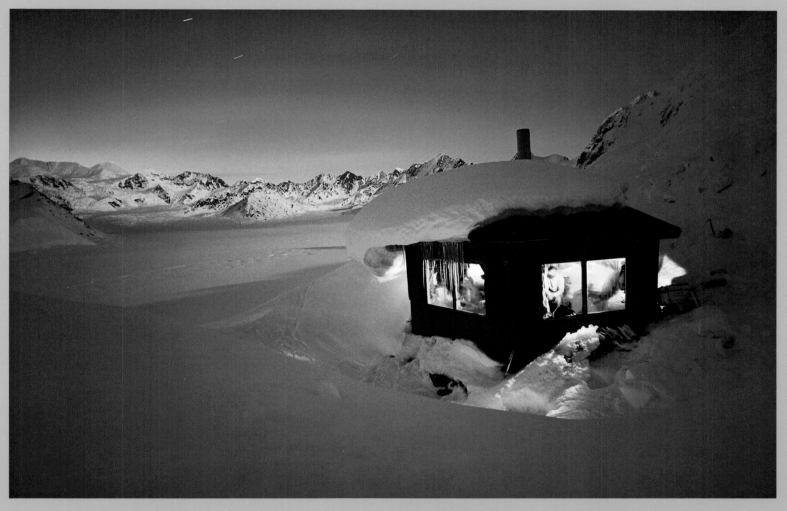

CABIN IN THE DON SHELDON AMPHITHEATER, ALASKA RANGE, ALASKA, 1978

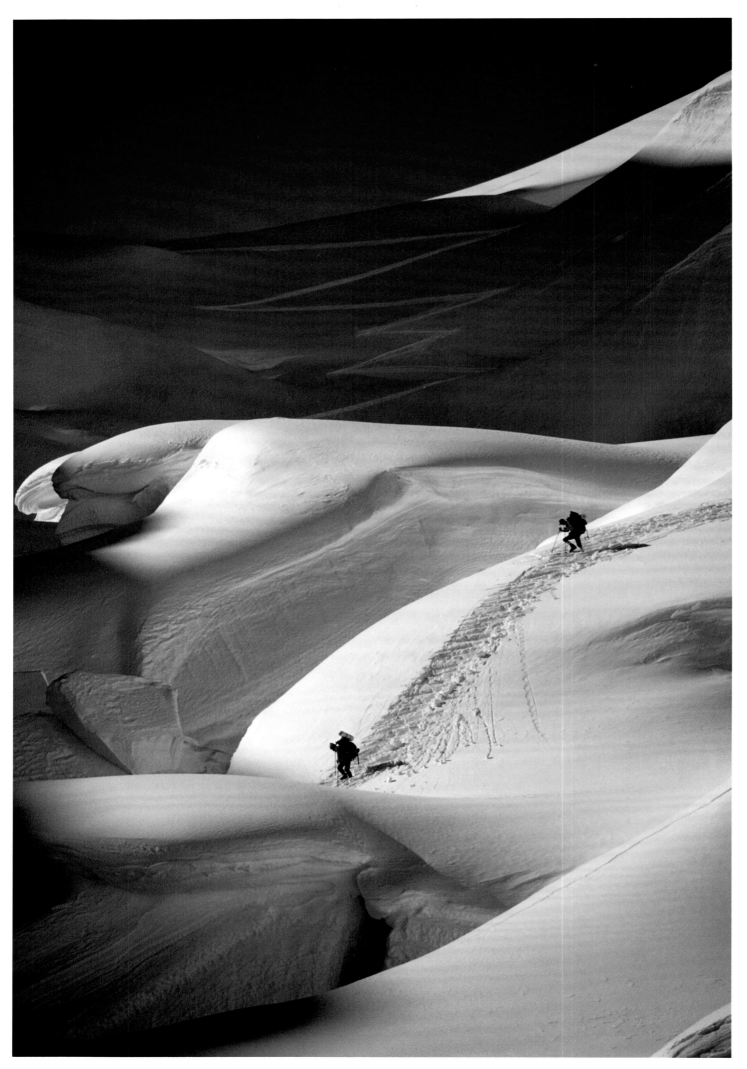

DESCENDING THE RUTH GLACIER, ALASKA RANGE, DENALI NATIONAL PARK, ALASKA, 1978

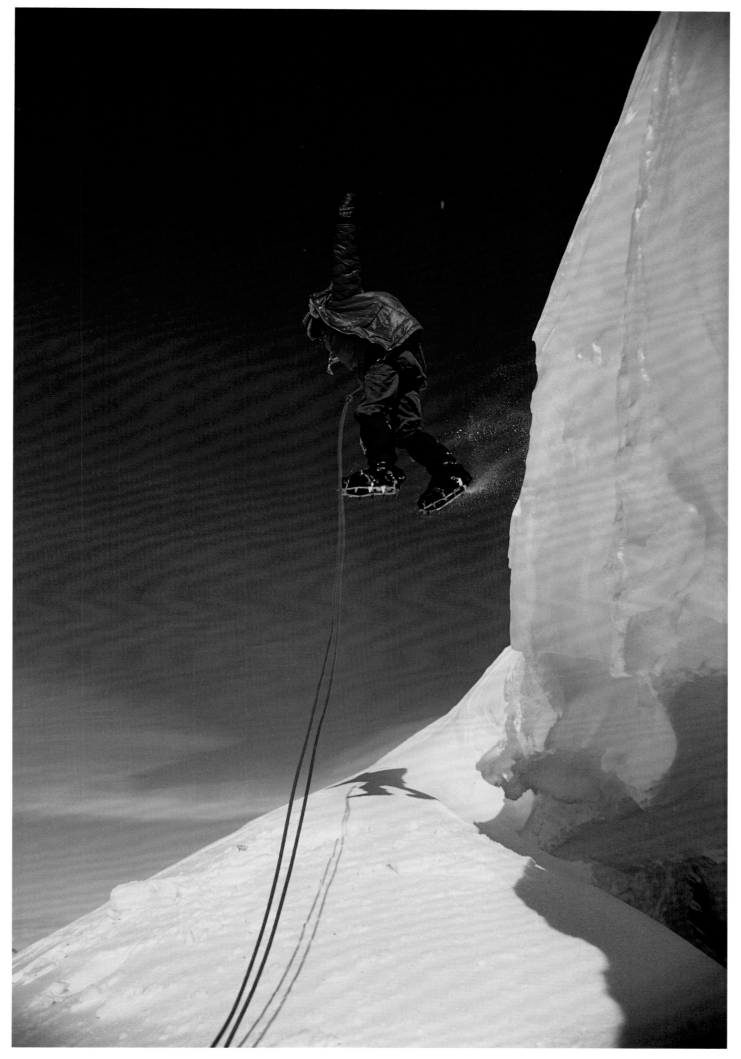

DOUG WEINS JUMPING A CREVASSE AT THE HEAD OF THE PETERS GLACIER, ALASKA, 1978

Northern Lights over Winter Camp in the Brooks Range, Alaska, 1994

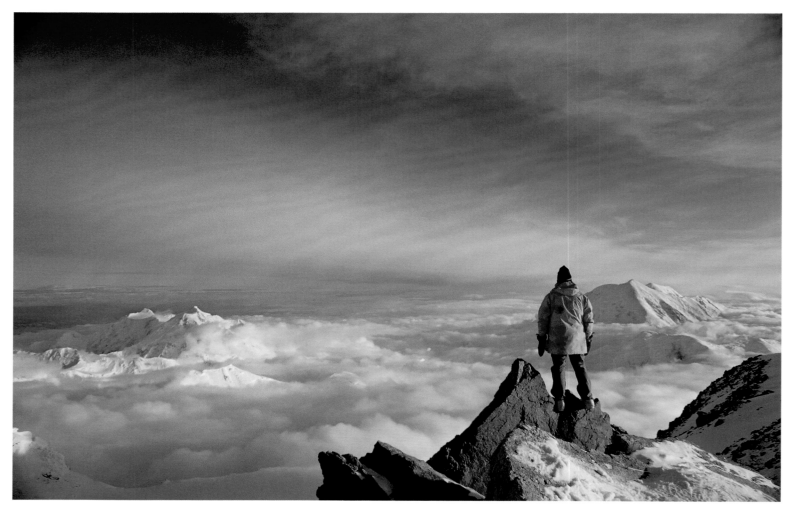

VIEW FROM 16,000 FEET ON DENALI, ALASKA, 1979

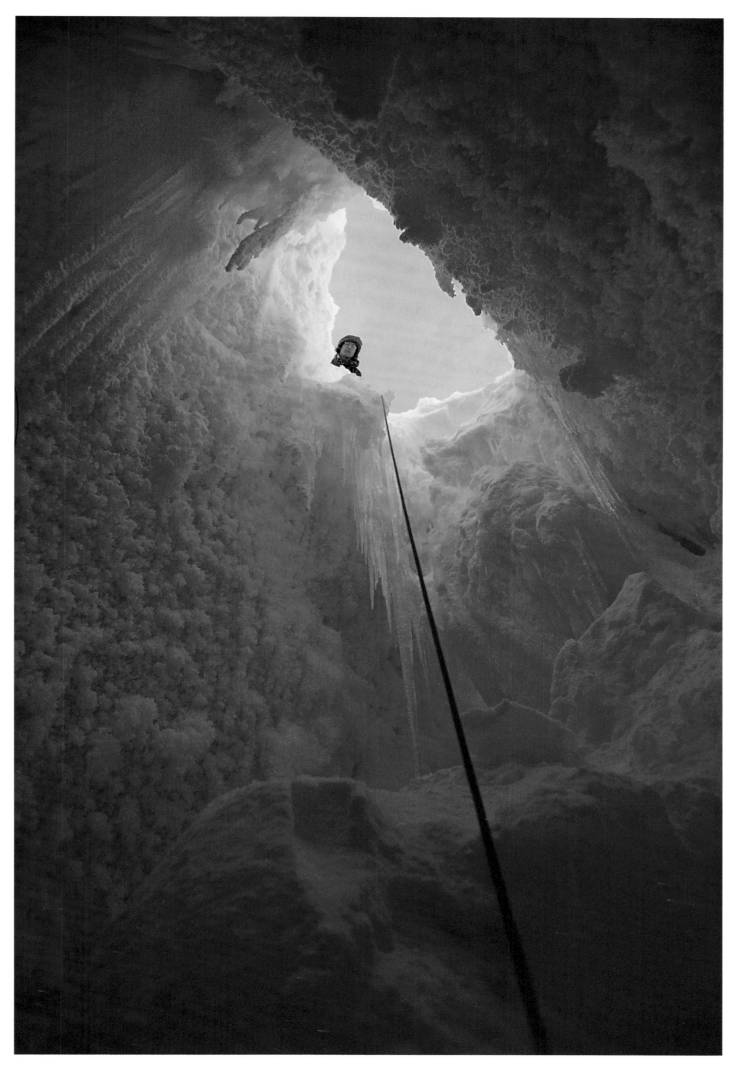

View from Inside a Crevasse after a Fall, Mount Dickey, Alaska, 1974

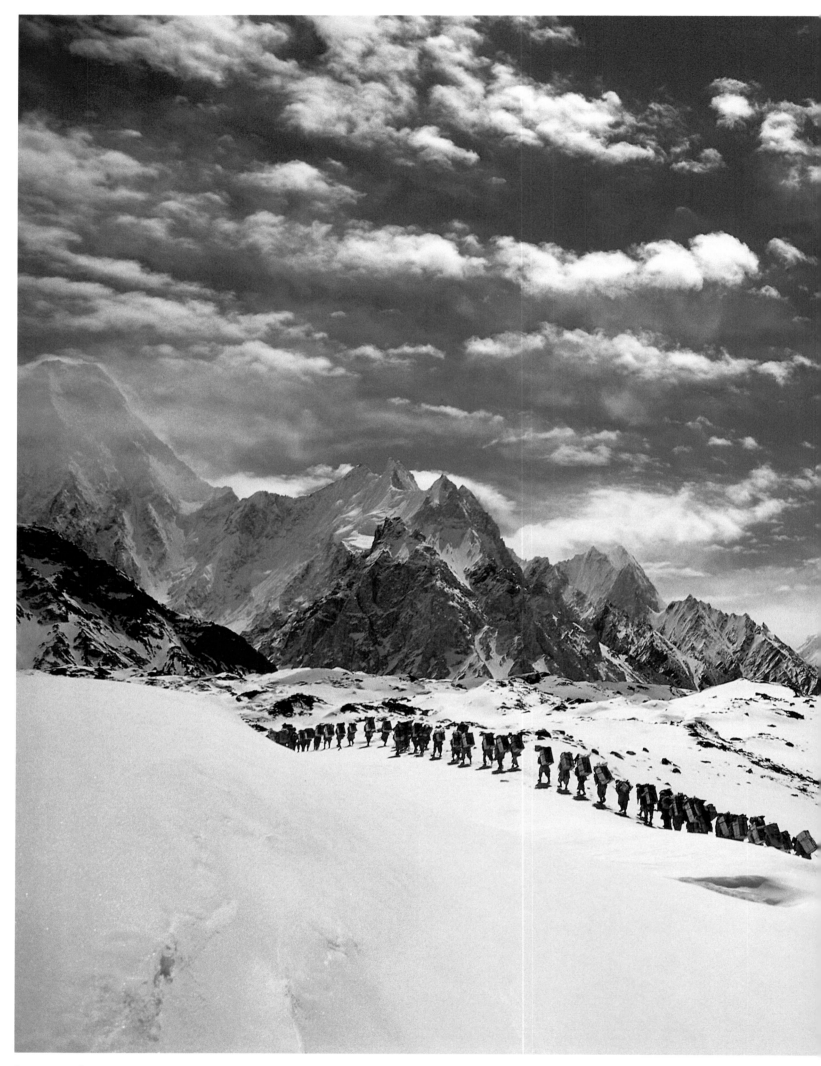

Porters at Concordia, American K2 Expedition, Karakoram Himalaya, Pakistan, 1975

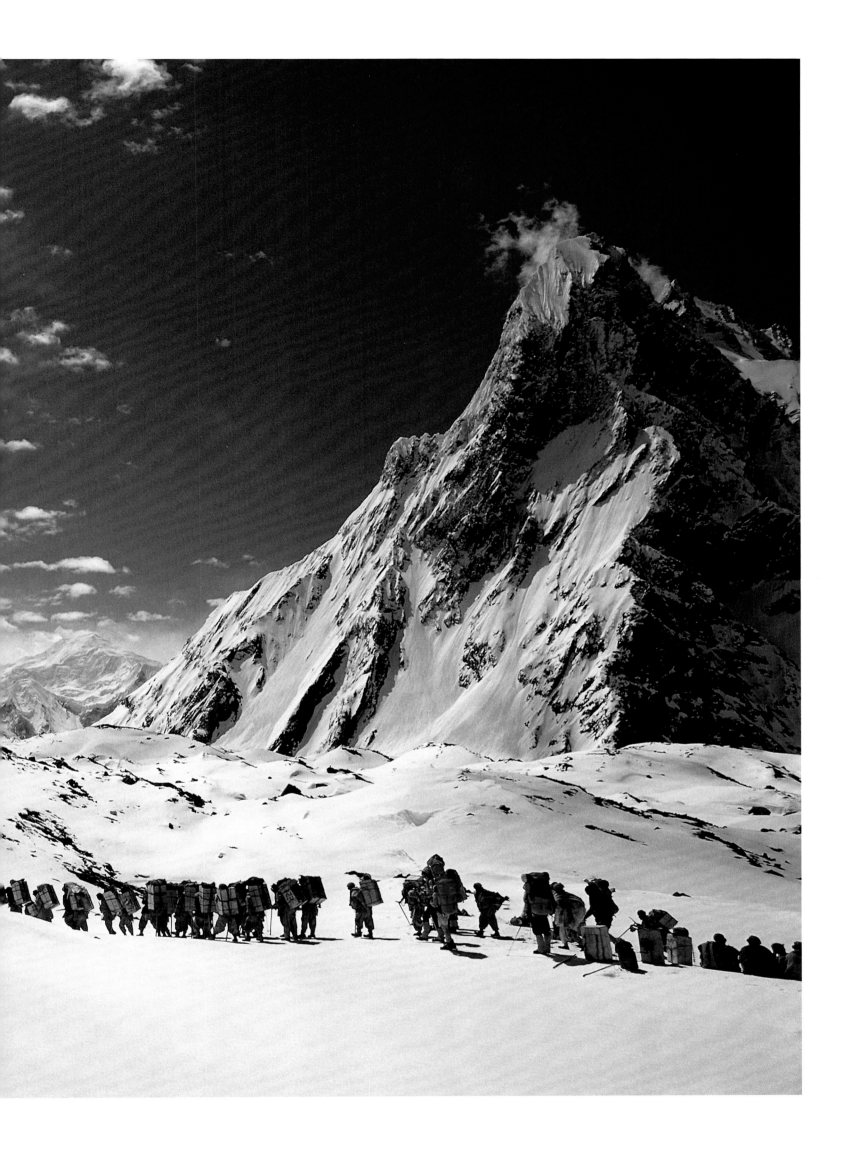

GREEN GRASS AT URDUKAS

During an expedition to K2, the world's second-highest mountain, I spent three months living on glaciers in a frigid, sterile world. On the long walk out I finally stepped from ice to Urdukas Camp, a traditional stopping place among giant boulders set in rolling meadows filled with wildflowers. We had left Urdukas in May when it was under several feet of snow. When we returned, we found a paradise beyond our wildest hopes.

Our gear was wet from a storm, and as we spread it out to dry on firm ground with no ice underneath, I noticed that Leif Patterson's face wore a glow of joy. I wanted to make a photograph that would capture his look, but I wasn't sure how to go about it. I took out my 105mm lens, which I used for portraits, and began watching Leif intently. He was not comfortable posing, so it had to be a candid shot. Nothing seemed to work for me. Gradually I moved farther back until Leif became part of the landscape of green grass and snowy horizon.

I wanted a photograph of Leif at Urdukas that would express both our expedition's relief and his personal joy over our return to the living world. I thought about it for a while and realized that if anything would work on Leif it would have to be a direct, forthright approach. I composed an image on a tripod with a polarizer to bring out the clouds and greenery, then said, "Leif, show me how it feels to be here among the flowers."

Leif turned toward me and spontaneously opened his arms with a look of peaceful ecstasy. I took this photograph, and the instant passed. . . .

Because the expedition failed to climb K2, [*National Geographic*] decided not to run the story. All the images were returned to me, and this one came to be published more often than any other photo from the trip.

—*Galen Rowell, from* Mountain Light

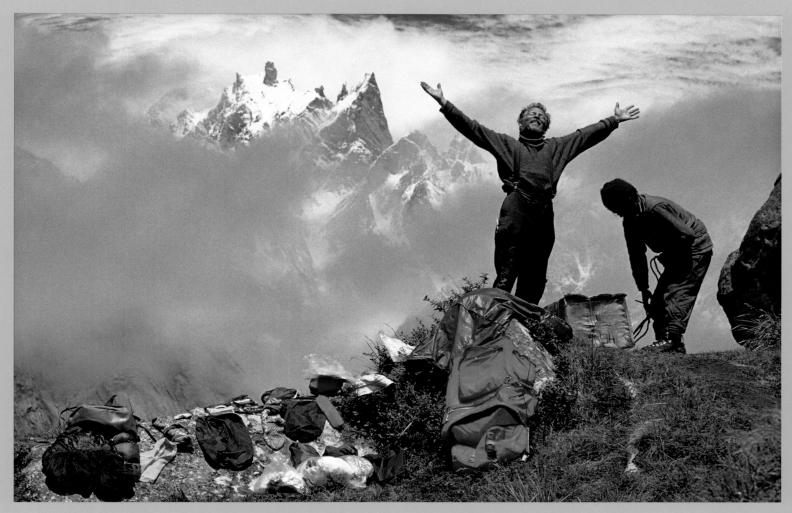

LEIF PATTERSON CELEBRATING THE RETURN TO GREEN GRASS, URDUKAS, KARAKORAM HIMALAYA, PAKISTAN, 1975

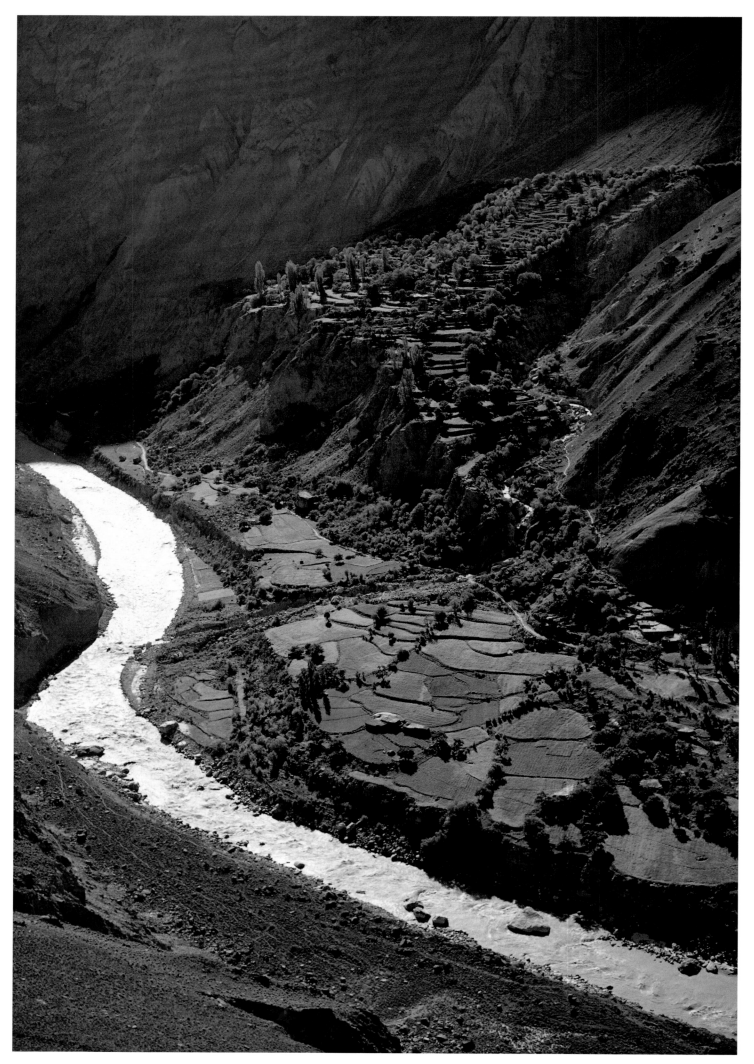

TERRACED VILLAGE OF BIANGO, BRALDU VALLEY, PAKISTAN, 1984

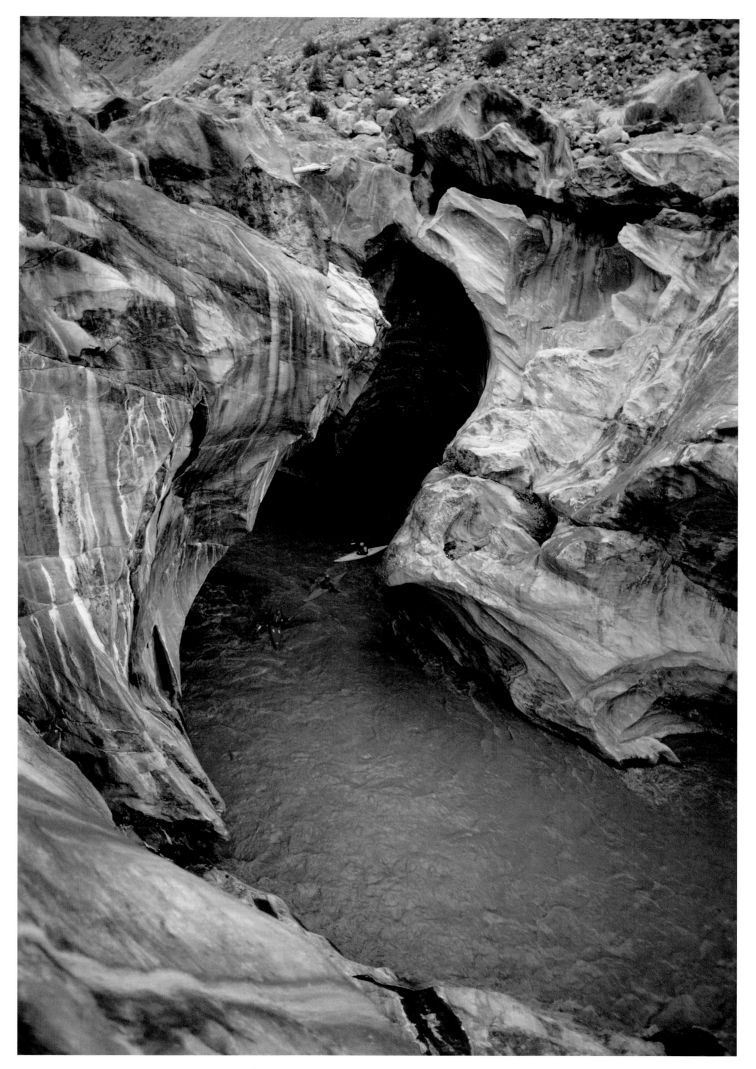

American Kayakers on the First Descent of the Braldu River, Karakoram Himalaya, Pakistan, 1984

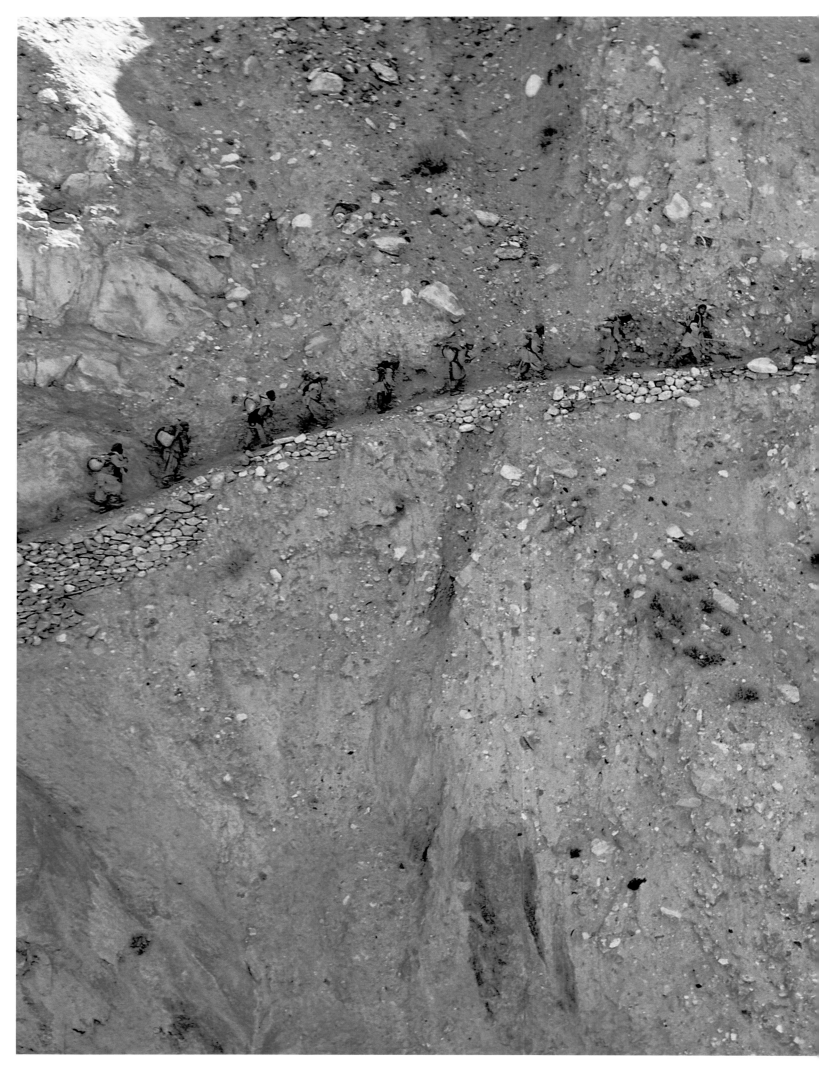

Porters Traverse the Braldu Gorge, Karakoram Himalaya, Pakistan, 1975

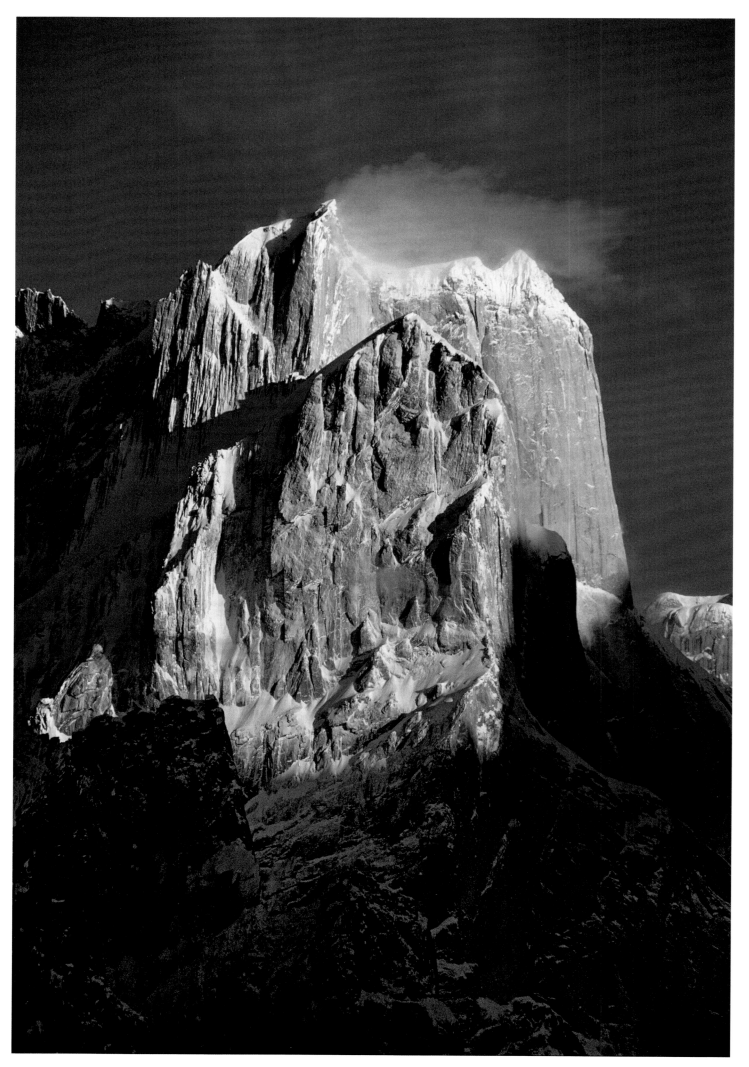

TRANGO TOWERS AS SEEN FROM URDUKAS, KARAKORAM HIMALAYA, PAKISTAN, 1975

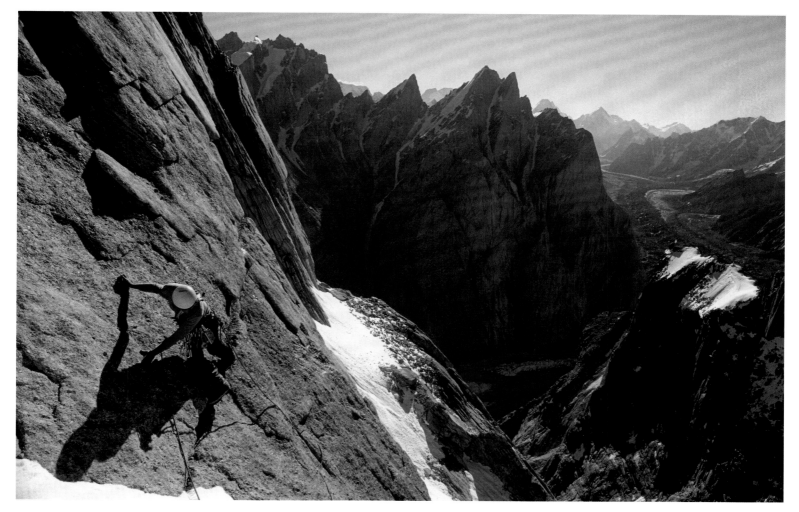

Kim Schmitz on Great Trango Tower, with the Grand Cathedral and Baltoro Glacier in the Distance, Karakoram Himalaya, Pakistan, 1977

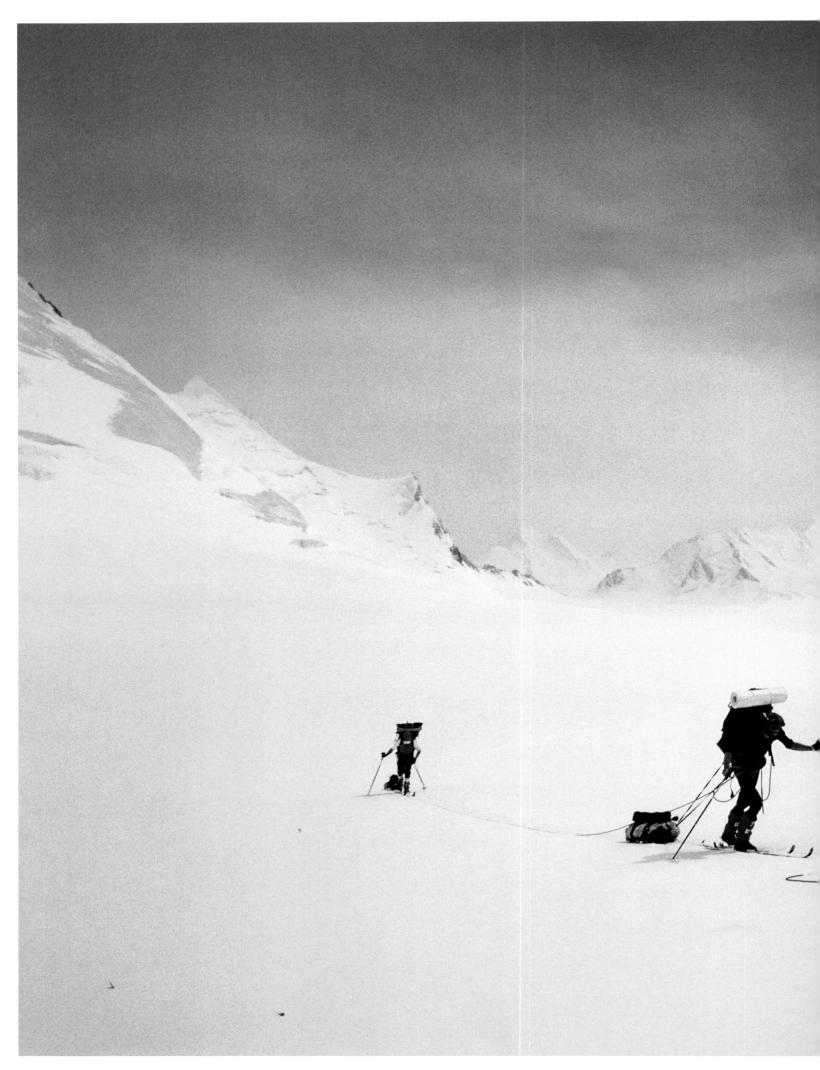

Ned Gillette, Kim Schmitz, and Dan Asay Hauling 120-pound Loads on the 285-mile Winter Karakoram Ski Traverse, 1980

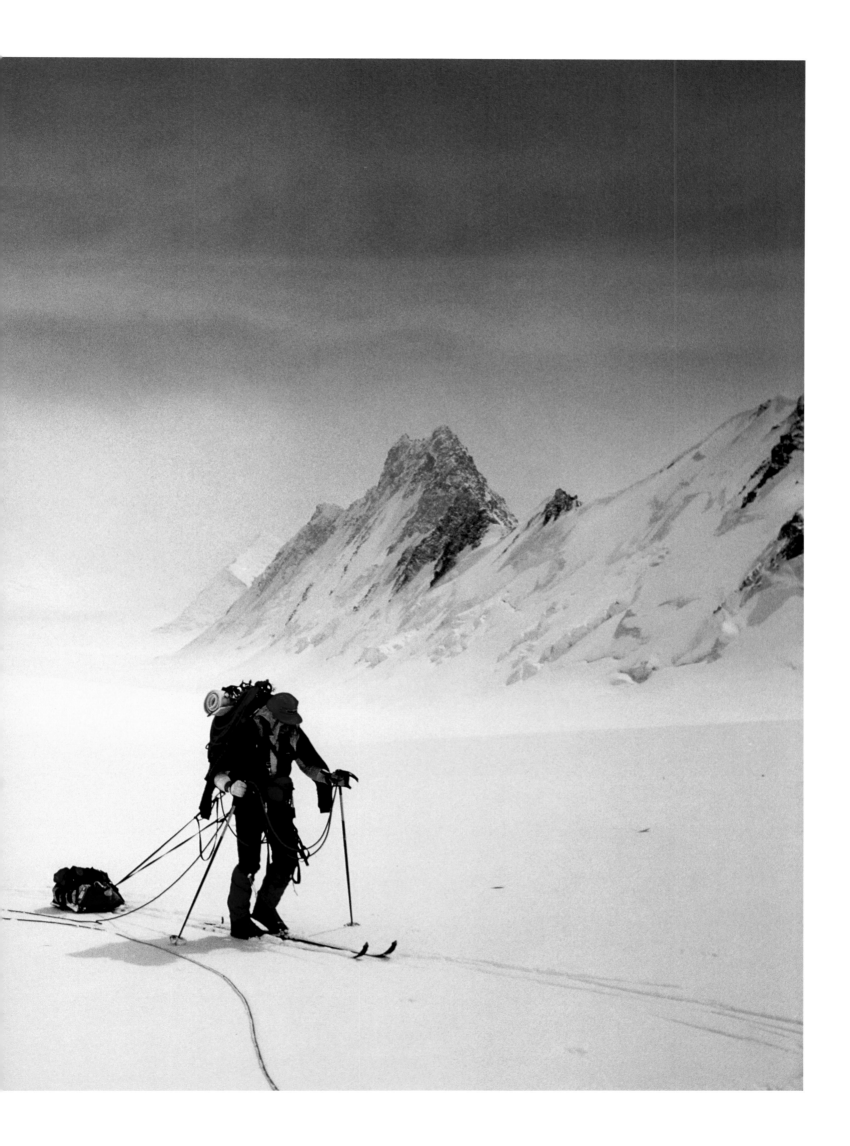

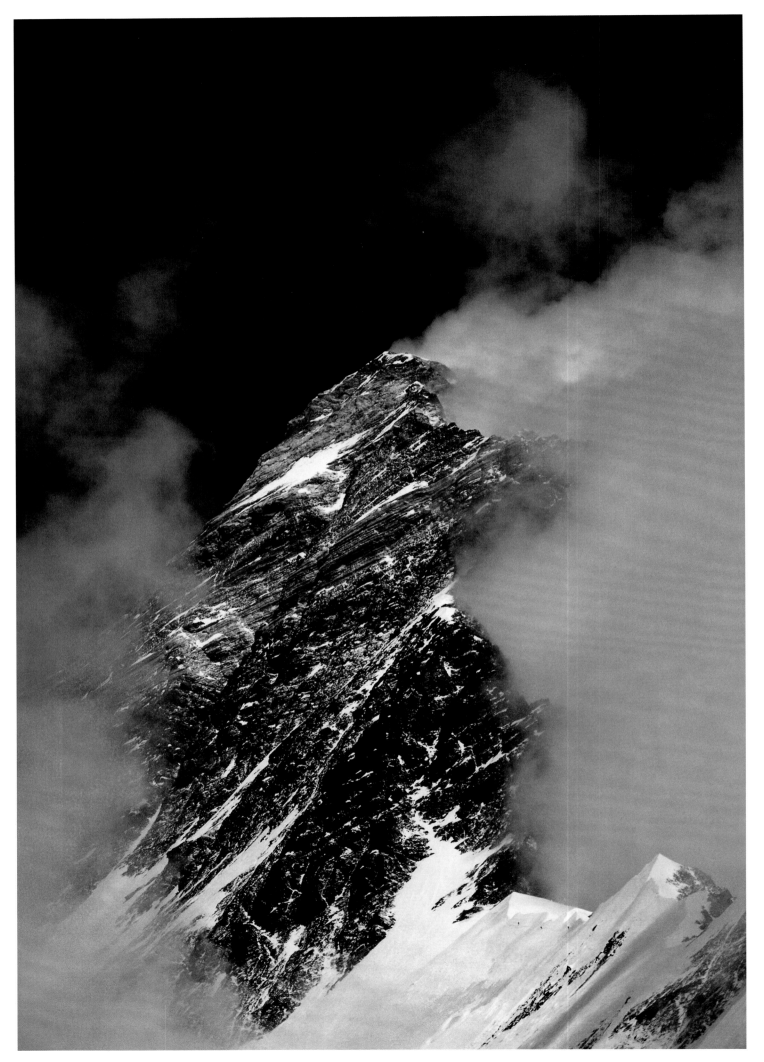

THREE CLIMBERS AT 24,500 FEET, WEST RIDGE, MOUNT EVEREST, TIBET, 1983

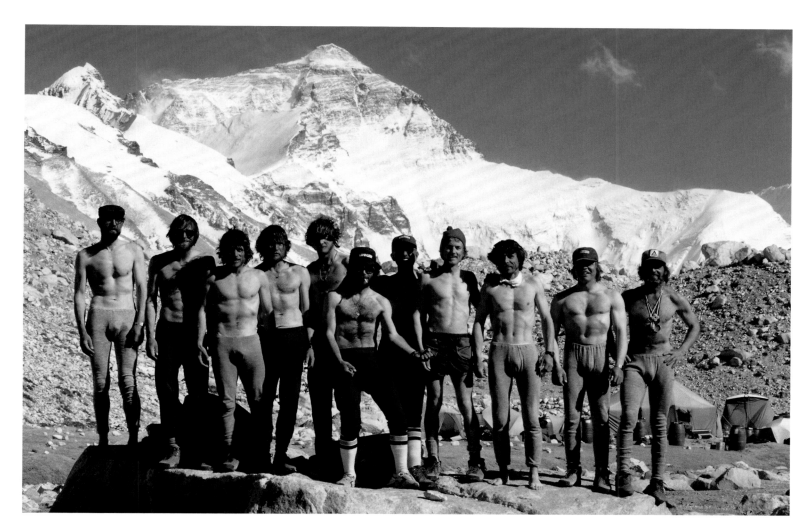

THE 1983 AMERICAN EVEREST WEST RIDGE EXPEDITION (GALEN IS THIRD FROM LEFT), TIBET, 1983

The Annapurna Himal from Austrian Camp, Nepal, 1987

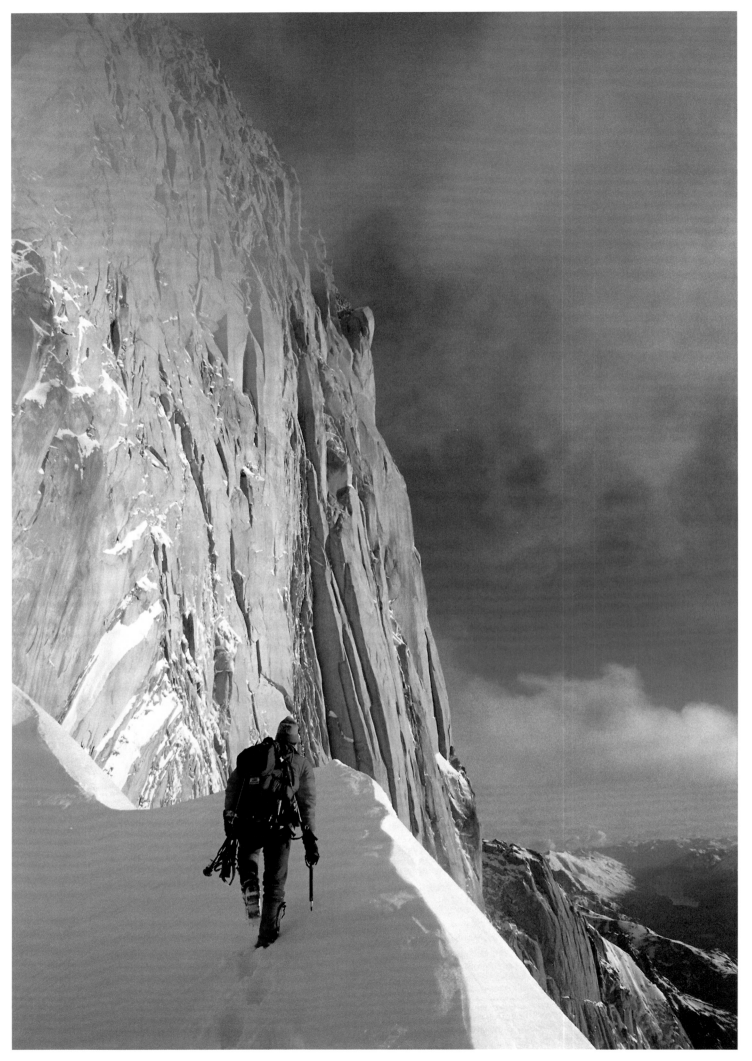

Mike Graber Approaching the Southwest Buttress of Fitz Roy, Patagonia, Argentina, 1985

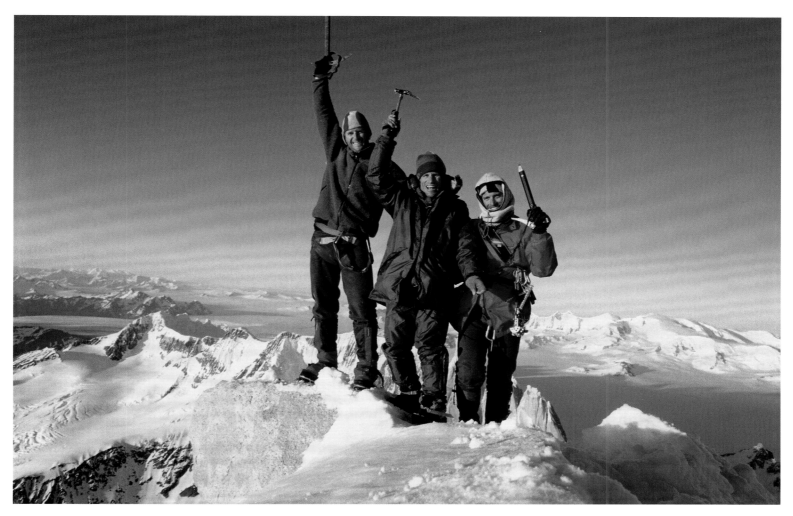

DAVID WILSON, GALEN, AND MICHAEL GRABER GREET THE MORNING SUN ATOP MOUNT FITZ ROY, PATAGONIA, ARGENTINA, 1985

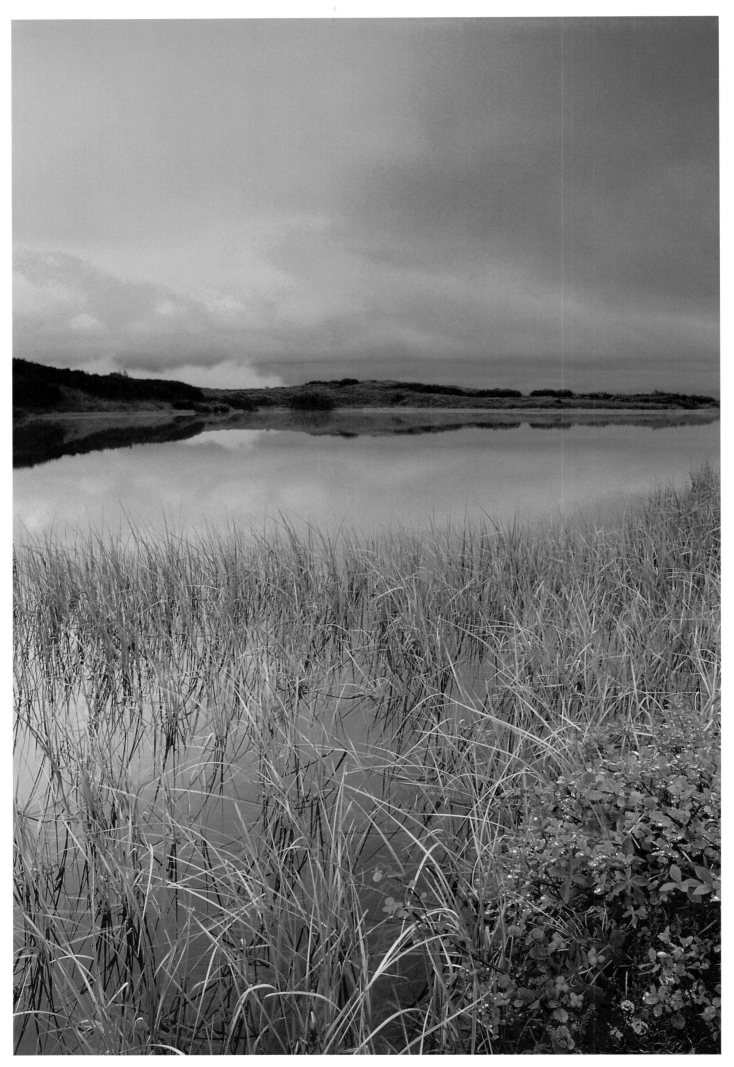

Reflection Pond, Denali National Park, Alaska, 1986

Conserving the Wild

"My fascination with the relationship between preserved areas

and those who have gone out of their way to save them dates back to childhood.

Over the course of hundreds of visits to wildlands on seven continents, I have yet to find

any place saved strictly by the vote of a democratic majority or the benevolence of

a government. Passionate individuals have always played a leading role."

GALEN VISITING ANCIENT ALERCE TREES THREATENED BY LOGGING, NEAR
PUERTO MONTT, CHILE, 1990

SAVING THE LAST STRONGHOLDS

by George B. Schaller

Galen and I first met by chance in Rawalpindi, Pakistan, in April 1975. He was with a team intent on climbing K2, and my friend Pervez Khan and I were also traveling to the Karakoram, to evaluate the region for a potential national park. My diary notes that Galen "chatted with me about wildlife." I was impressed with his interest in natural history because his name was familiar to me only as a climber of sheer rock walls. In the mountains, he joined me for a day's ramble among villages to inquire about snow leopards, ibex, and other species that roam the heights. His roving mind and passionate desire to absorb everything were evident, as was his "delight of discovery of a new country, its people, and its high wilderness," in his later words. Although our interlude was brief, we connected on an emotional level: each in our own way celebrated the grandeur of nature and had a personal commitment to remote wild places.

We met occasionally in the United States after that. In our separate travels, it seemed we were following each other's footsteps to various majestic peaks around the world—Denali [Mount McKinley], Annapurna, Mustagh Ata, Anye Machin. Sometimes he reached a mountain first, frequently to climb it, or I had arrived earlier to search for wildlife around its base. I envied some of his ventures, and he longed to experience mine, for, as he wrote in *Many people come, looking, looking,* "I'd rather have seen a snow leopard than have climbed Nun [Kun]." We discussed a joint trip but it never happened. Instead, his books made me part of his experiences.

Galen felt that beauty is the basis of nature photography, whether it is a sublime scene of the Trango Towers in the Karakoram rising out of mist or a gnarled bristlecone pine in California's White Mountains. His artistic imagination could transform a vision of the moment into evocative and enduring art. Ever in search of a dynamic scene, he used his technical knowledge, patience, constant readiness, and intuition to respond to any subject that touched his emotions. By communicating his "feelings about mountains and wild places," he offered us unique glimpses of reality. He always searched for the fleeting, magical light at dawn and dusk to provide the delicate colors, mood, and mystery that enhance the response in our hearts and minds. Some of his images are so powerful that they seem to evoke our own dreams and memories—a glowing ice pool among

shadowed snow fields, a crescent moon edging along a black cliff. Although I have seen the Potala Palace in Lhasa many times, Galen's photograph of a rainbow arching down onto its golden roofs has imposed itself so forcefully on my memory that it almost seems as if I had witnessed the spectacle.

Many of Galen's photographs create a visual harmony that appeals to our sense of beauty and arouses compassion. They bear witness to the diversity of life, raising awareness and forging bonds with a mountain peak, Tibetan nomad, bear, owl, or other subject. Such images help us to see and care for natural treasures that are beyond our usual perceptions. By unveiling the riches of mountain landscapes, by influencing our views of wilderness in this country and elsewhere, his photographs have had an immense impact on conservation—far greater, for example, than mere written reports. They become in effect touchstones of special moments for future reflection, serving as a clarion call to action for this and later generations to protect such natural wonders.

The root of Galen's passion was a deeply held belief in conservation, something both explicit and implicit in many of his photographs. Early in his career he objected to marring cliffs with pitons while climbing. On his expeditions he "worried about the effects we had on the villages" and about the "destructive torrent" of tourists who use up firewood and other resources. Indeed, his conservation message became ever more insistent. Two of his books, *Many people come, looking, looking* (1980), about the Nepal Himalaya, and *Bay Area Wild* (1997), about preserving wildlands near San Francisco, where he was raised, deal primarily with environmental problems and our universal responsibility to protect this planet. Living up to his imperative, Galen gave generously of his time to various conservation organizations including the Sierra Club, the World Wildlife Fund, and the Yosemite Fund.

Galen has been characterized as an archetypal adventure photographer, that label conveying someone tough, disciplined, and living at the edge. Of course he was, but this limited view ignores his intellectual depth, broad knowledge, personal integrity, and generosity, and especially his great talent as a writer. Photographs, no matter how evocative and acute in their intensity of perception, can do little more than arouse emotion. Words are essential to fuse subjective feeling with objective vision and provide context to any scene. While most outdoor photographers collaborate with a writer, Galen usually wrote his own text and did so superbly. He blended the history of a place, including its explorers, climbing background, and local cultures, with descriptions of his companions, interviews, wildlife observations, anecdotes, and photographic comments. He offered philosophical insights and emotional responses: for example, asking himself

in *Mountains of the Middle Kingdom,* "Why was time alone on a mountain so inestimably precious to me?" Galen's expedition accounts would be illuminating even without photographs. But in combining images and words, several of his books attain the quality of greatness. I know of no photographer who has so deeply and perceptively articulated his personal vision to give context, form, and feeling to the pictures. To my mind, Galen was the most accomplished photojournalist of the past three decades, and we are fortunate that he devoted his life and art to creating enduring images and words on behalf of the natural world.

In photographing Tibet, Galen strove to create "a visual record of one of the earth's unique wild places," as he wrote in *My Tibet.* It is fitting that his last expedition involved a trek with several mountaineers, led by Rick Ridgeway, across the vast expanse of the Chang Tang plateau in the northwestern Tibet Autonomous Region. Furthermore, the expedition's purpose was to follow a migratory route of the endangered *chiru,* or Tibetan antelope, to its unknown calving grounds. Tibet, mountains, exploration, conservation—the journey had everything that spoke to Galen's heart. Once again his photographs defined and inspired a conservation initiative and added to our perception of a unique upland.

My wife, Kay, and I had done research on *chiru* in the Chang Tang. After Galen's return, in July 2002, we visited him and Barbara at their home in Bishop, California, to discuss the expedition. Also there was Rick Ridgeway, already at work on the expedition account; it was later published as *The Big Open,* an excellent book featuring Galen's photographs and a strong conservation message. The team had found the calving grounds near the Kunlun Mountains along the northern edge of the Tibetan plateau. Armed with this information, the local government has placed guards near the calving grounds to protect the animals from poachers, and it is considering the establishment of a reserve. Such a reserve would be a living monument to the memory of Galen, who did so much to preserve the beauty of our planet.

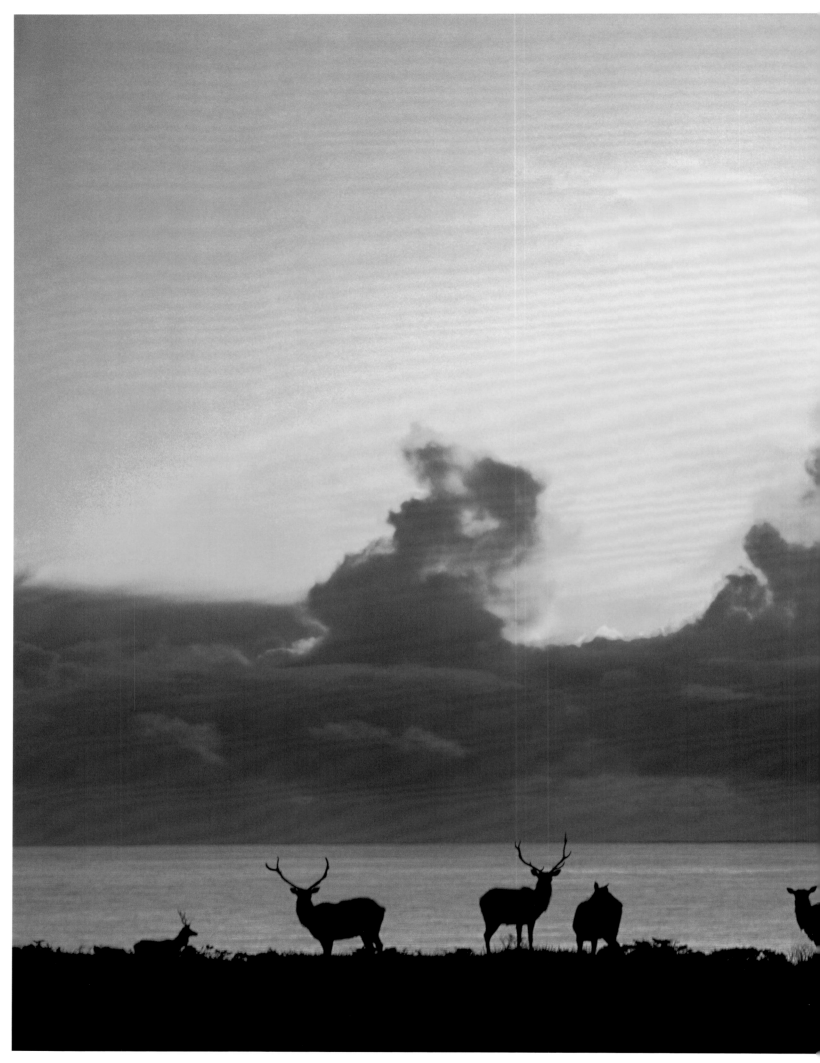

TULE ELK AT SUNSET, POINT REYES NATIONAL SEASHORE, MARIN COUNTY, CALIFORNIA, 1996

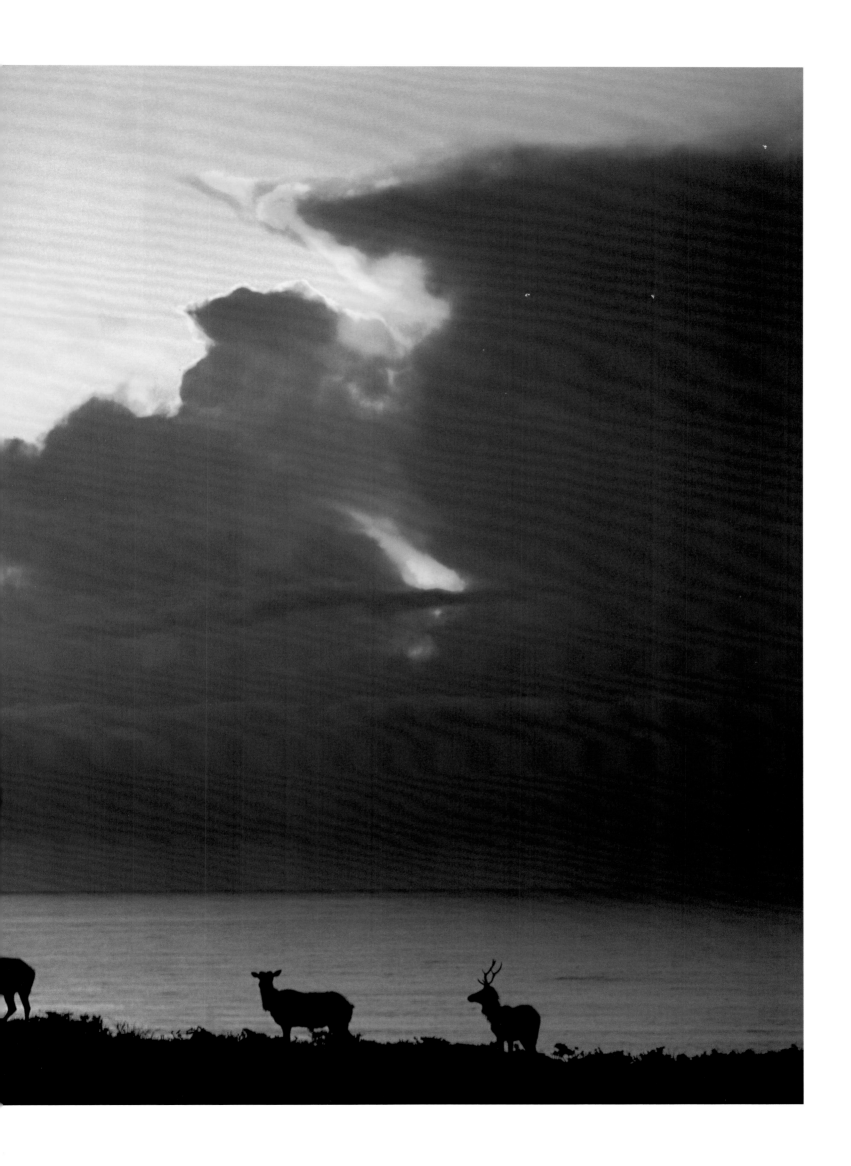

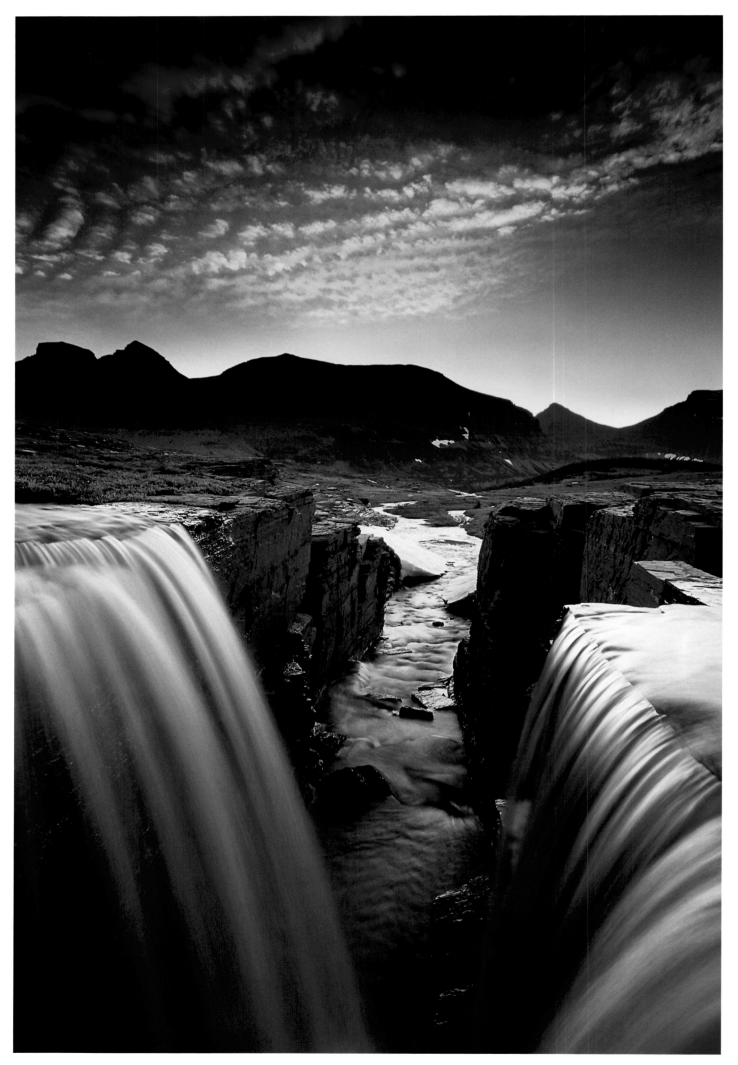

DOUBLE FALLS AT DAWN, GLACIER NATIONAL PARK, MONTANA, 1997

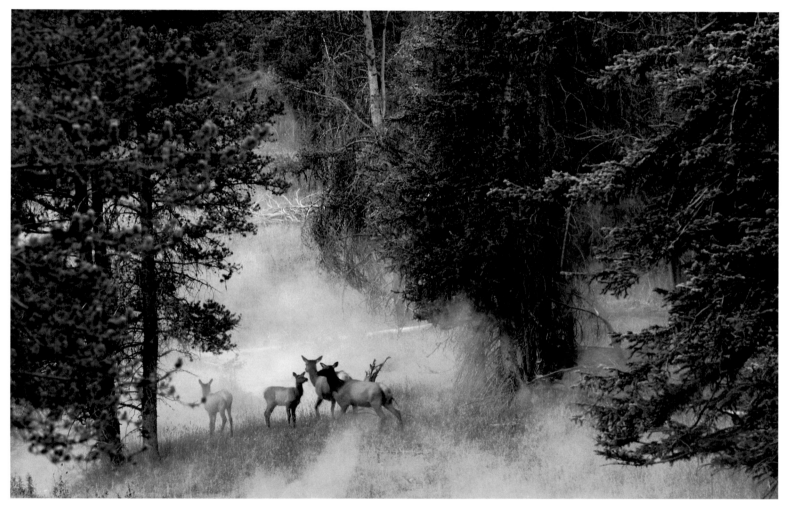

ELK IN HOT-SPRINGS MIST, YELLOWSTONE NATIONAL PARK, MONTANA, 1997

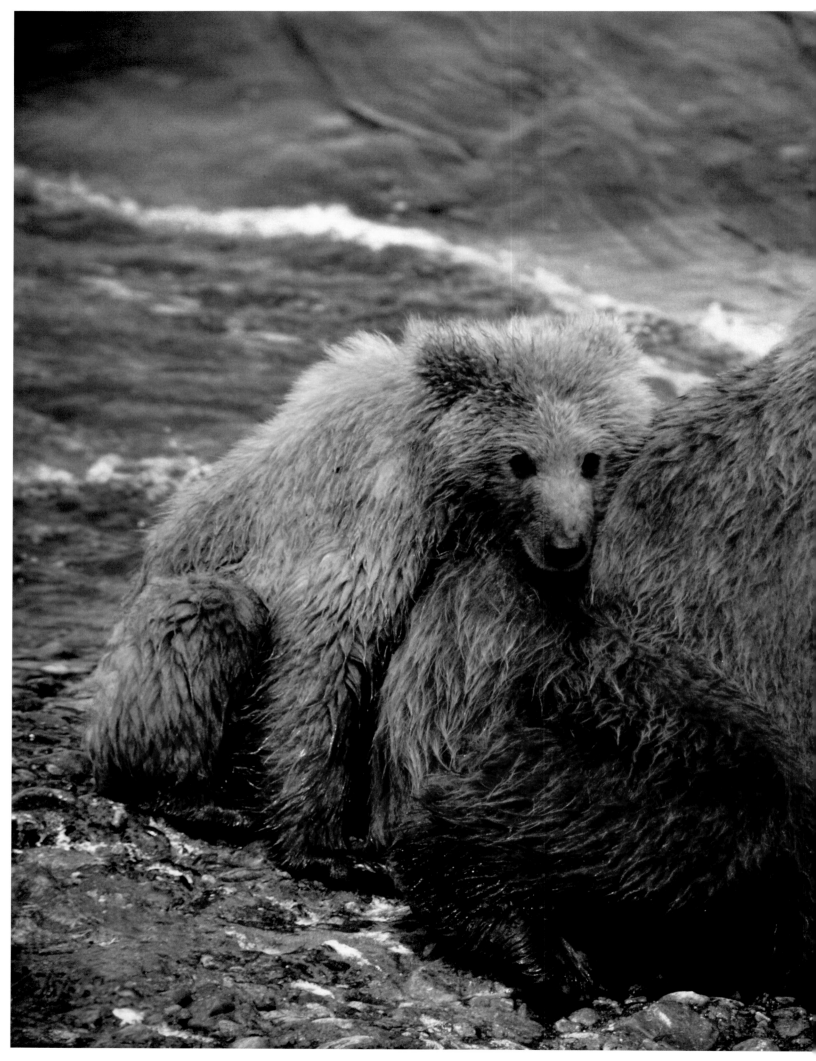

ALASKAN BROWN BEAR MOTHER AND CUB, MCNEIL RIVER, ALASKA, 1979

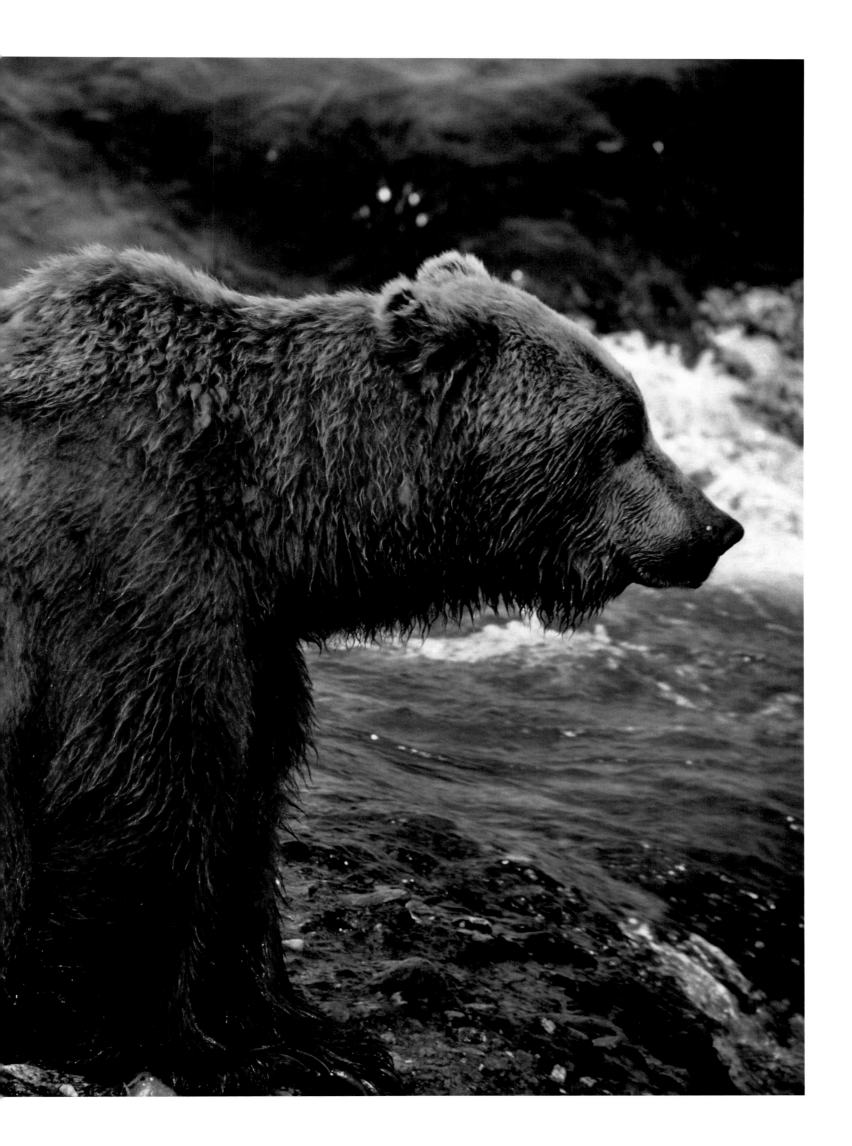

SEEING IS BELIEVING

This photo represents a rare moment when, as Galen's ten-year-old daughter, I was able to say to my father, "I told you so." We were driving on a national park road near Mount McKinley in Alaska. As we pulled away from a ranger station, I exclaimed that I had just seen a lynx jump into the bushes. My father provided me with numerous reasons why it couldn't have been a lynx. The argument continued down the road as I described the animal in detail. Although my description was accurate, my dad's better judgment told him it was not likely. He said there was too much daylight and we were too close to the ranger station.

As we came around another turn, I hollered out, "There! That's what I saw!" Acknowledging the sighting, my dad halted the car, hushed us all, and, reaching with his camera all the way across my mom's lap and out the passenger side window, captured this amazing image. The lynx appeared to be frozen in time. Actually it was intently watching a snowshoe rabbit that was paralyzed by our presence. Seconds after the shutter closed, the lynx bounded back into the brush with the rabbit in its mouth.

My dad liked to use this image to show how to distinguish photos of truly wild animals from those of captive ones. He said that this lynx showed the lean strength of an animal struggling to survive in the wild. If you look closely at shots of captive animals, you will see that the animals often have sagging bellies, excess weight, and less muscle tone than those in the wild. He felt strongly that images of captive animals should be identified as such to avoid giving a false image of wild animals.

Over the years it disturbed me to hear onlookers at various exhibits and slide shows claim that the photo was staged. I experienced that wild moment, and I am still amazed by the image my dad was able to capture in an instant, while leaning out the side window over his family.

—*Nicole Rowell Ryan*

Lynx in Alpine Flowers, Teklanika River, Alaska Range, Alaska, 1974

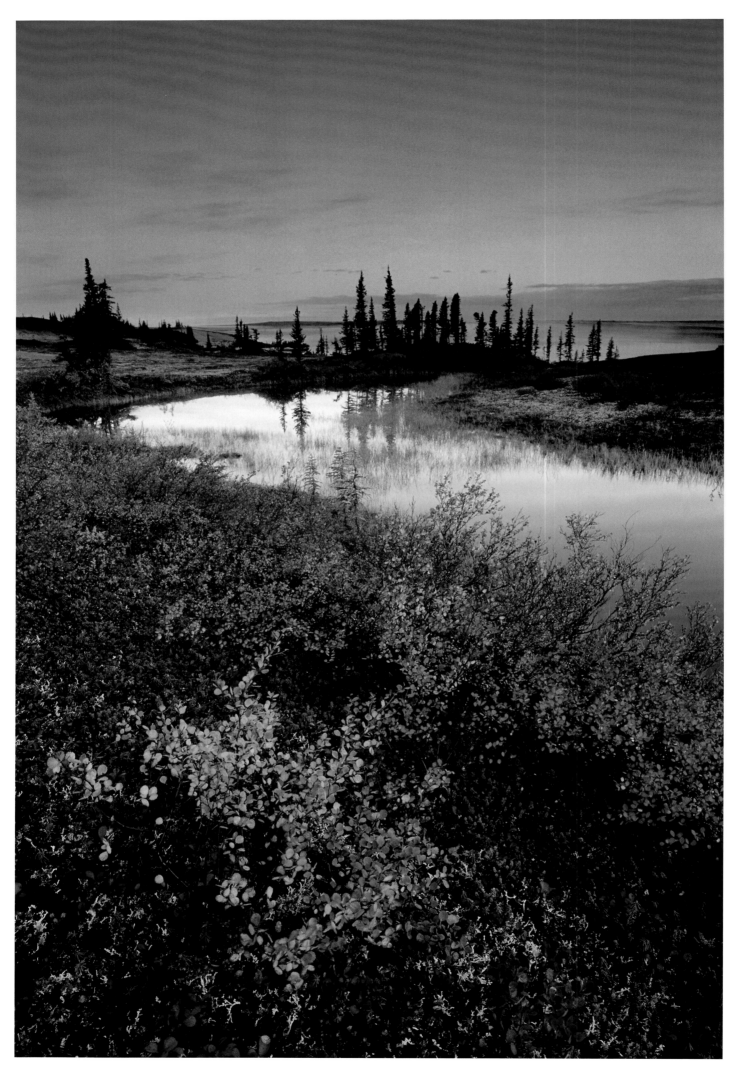

Twilight over a Pond in the Barrens, Northwest Territories, Canada, 1998

CARIBOU MOSS AMIDST BEARBERRY LEAVES IN THE BARRENS, NORTHWEST TERRITORIES, CANADA, 1998

ARCTIC FOX IN A BLIZZARD, NEAR CHURCHILL, MANITOBA, CANADA, 1993

RED FOXES NEAR CHENIK LAGOON, ALASKA PENINSULA, 1991

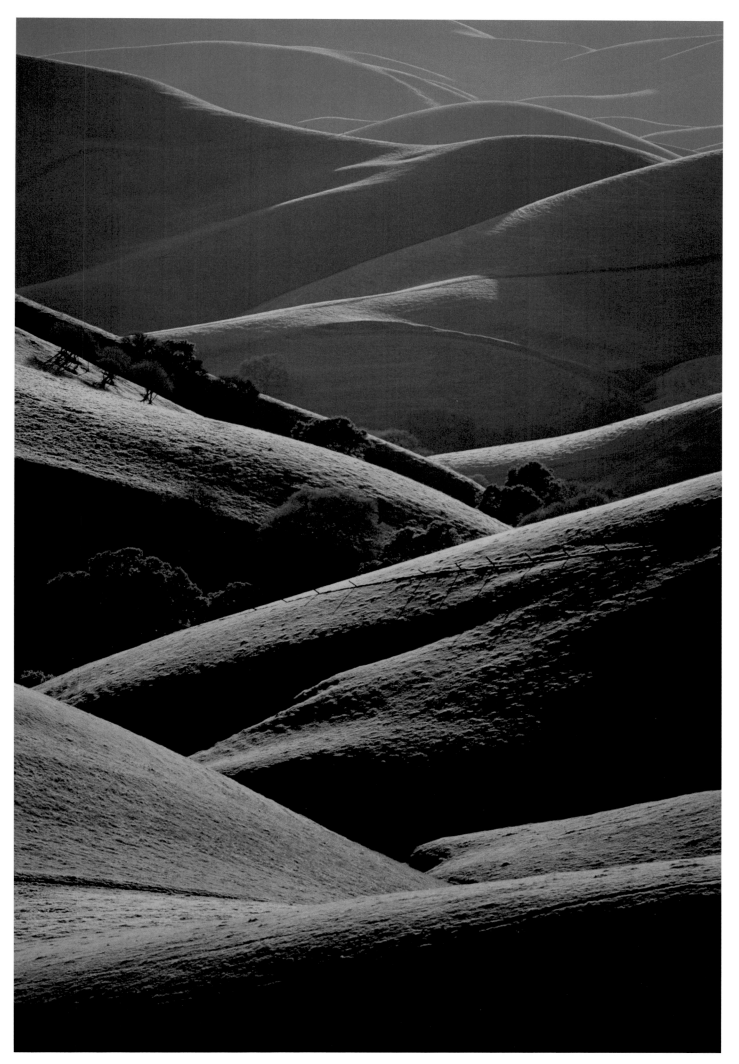

SPRING ON MOUNT DIABLO, CONTRA COSTA COUNTY, CALIFORNIA, 1982

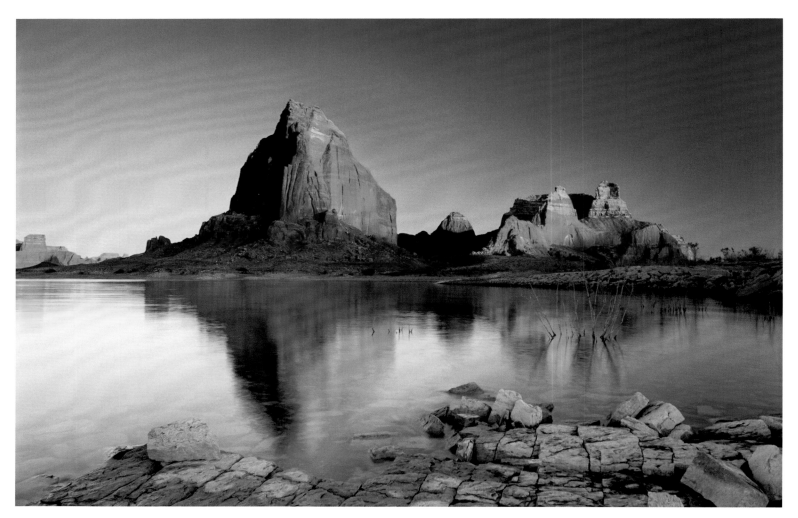

SUNRISE AT PADRES BUTTES, LAKE POWELL, ARIZONA, 2000

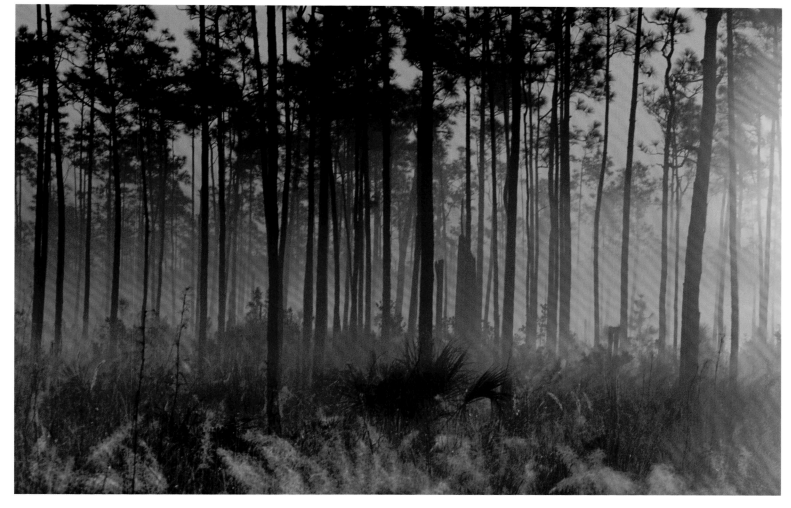

MISTY DAWN IN THE PINELANDS, EVERGLADES NATIONAL PARK, FLORIDA, 1998

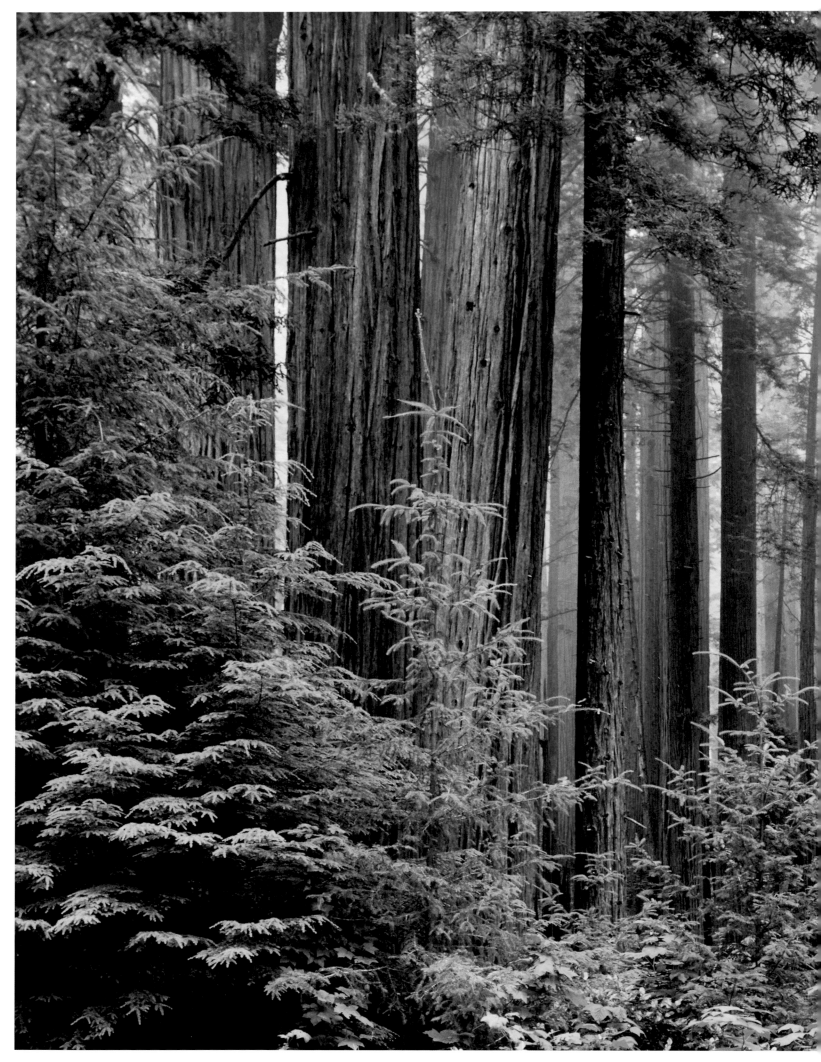

Prairie Creek Redwoods, Redwood National Park, California, 1984

At Home in Yosemite

One morning Galen walked into my office in Yosemite and asked if I wanted to cruise the Valley with him during a clearing winter storm. Being Galen's camera assistant for a day appealed to me more than my desk work, and we hit the road. Galen loved to act immediately on a seemingly wild idea or take advantage of an opportunity, especially if it was provided by Mother Nature. A clearing storm in Yosemite Valley presented such an occasion.

Watching Galen in action was like watching a kid open presents on Christmas morning. His giddy enthusiasm was infectious as we made our way from place to place, taking photos at locations well known to Galen but off the beaten track for me and others.

Galen was a member of the board of the Yosemite Institute, for whom I was then working as campus director. In addition to sharing his connection to and affection for Yosemite through his photography, Galen was devoted to the idea of exposing young people to Yosemite's wonders by using the park as an outdoor classroom. The institute was introducing thousands of school kids from across the country to Yosemite through complete immersion during whole weeks of hiking and outdoor instruction with young naturalists.

Later I would work with Galen on the council of the Yosemite Fund. His special contribution to that organization was in helping to restore and protect the park's landscapes and wildlife through strategic placement of grants. Unafraid to question assumptions and standard practices, Galen brought a unique perspective to the fund's project review process. During his field trips in Yosemite and throughout North America, Galen gained valuable information on bighorn sheep, peregrine falcons, black bears, and trail and habitat management practices. His rigorous inquiry and research provided the funding committee with intelligence that led to success and averted a couple of spectacular blunders.

Only a handful of people have explored Yosemite so thoroughly that the entire region is as familiar as their own house. Fewer could convey that intimacy in words and images. Galen, of course, reached this exalted level of knowledge, which he shared through pictures such as this one. Even in the cold depths of winter, Galen found warm light, inviting middleground details, and an uplifting granite wall that beckons rather than intimidates the viewer. He captured on film the gentle wilderness of Yosemite that John Muir described so well in prose, presenting in the still image a moving landscape that conveys natural beauty of the highest order—approachable and welcoming. For Galen, Yosemite was a playground for the body, a wellspring for the senses, and food for the soul—a place in which one is fully alive.

—*Bob Hansen*

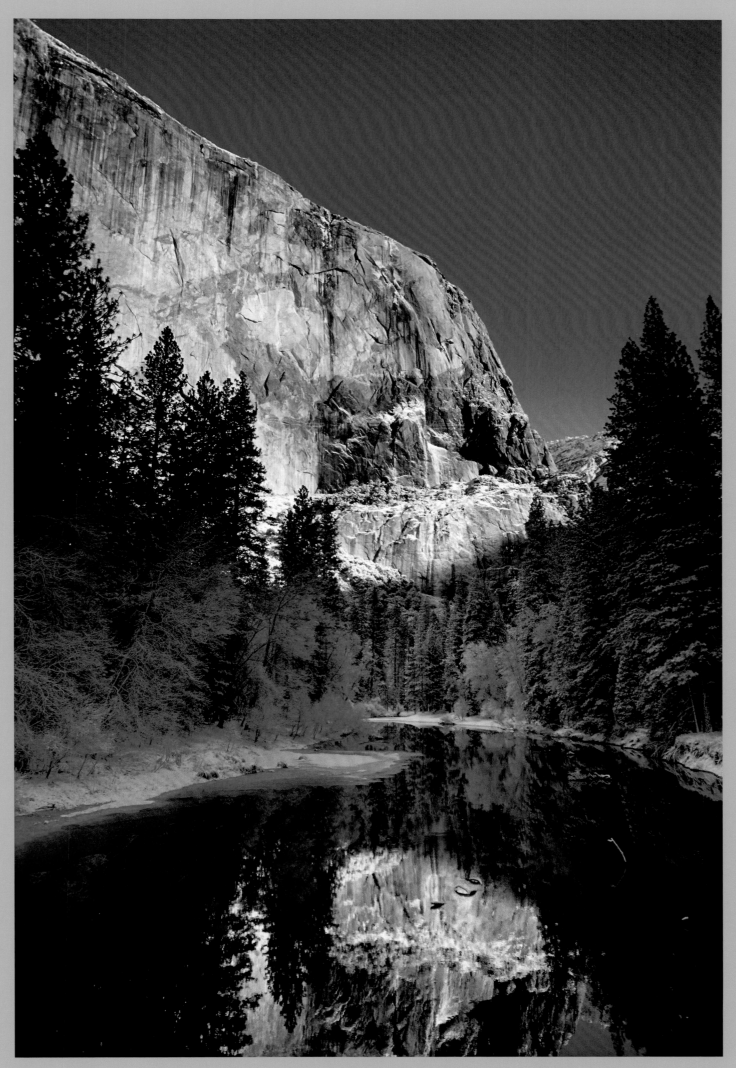

Merced River in Winter, Yosemite Valley, California, 1987

Winter in the Patriarch Grove, White Mountains, California, 1974

CALIFORNIA GULLS IN LAST LIGHT, MONO LAKE, CALIFORNIA, 1974

PEREGRINE FALCON AT A MORRO BAY EYRIE, BIG SUR COAST, CALIFORNIA, 1990

RIM OF NGORONGORO CRATER, TANZANIA, 1999

LIONS AT PLAY, MASAI MARA, KENYA, 1982

MALE *CHIRU* WITH YEARLINGS, CHANG TANG PLATEAU, TIBET, 2002

KIANGS (TIBETAN WILD ASSES), WESTERN TIBET, 1987

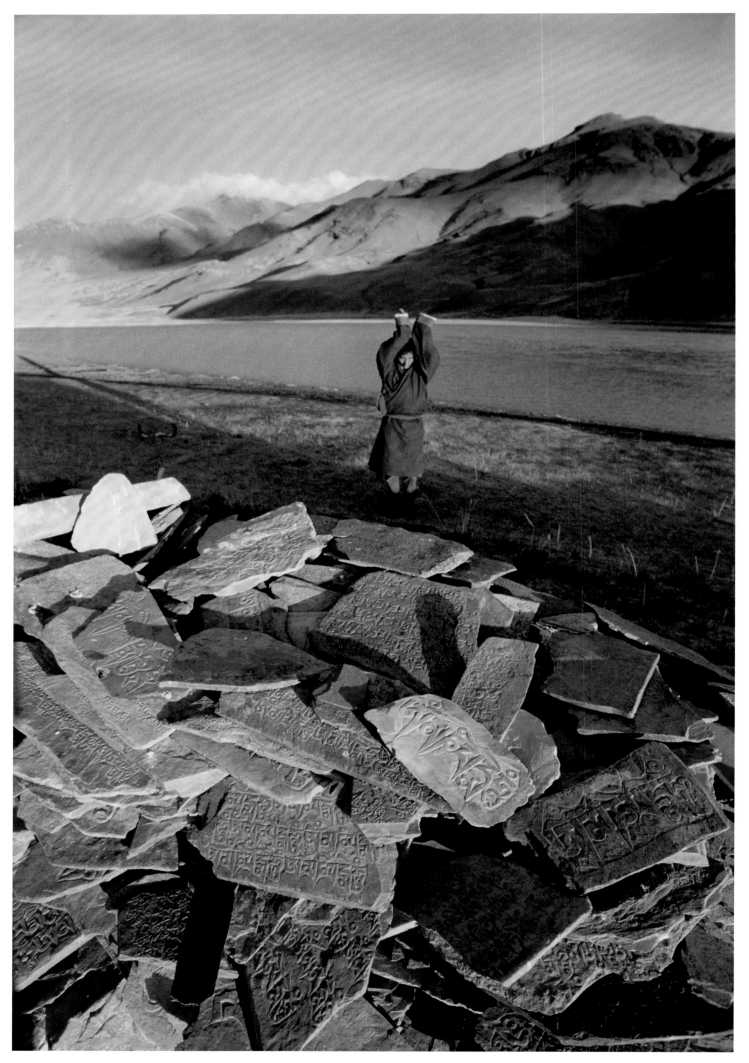

Pilgrim Praying at Mani Wall beside the Tsangpo River, Tibet, 1987

THE ASIAN KINGDOMS

"The Himalaya has been described as a place where four worlds meet. . . .
The interminglings of language and race from these cultures seem almost infinite in possibility
until yet another diversity is added: foreign travelers from the beginnings of history."

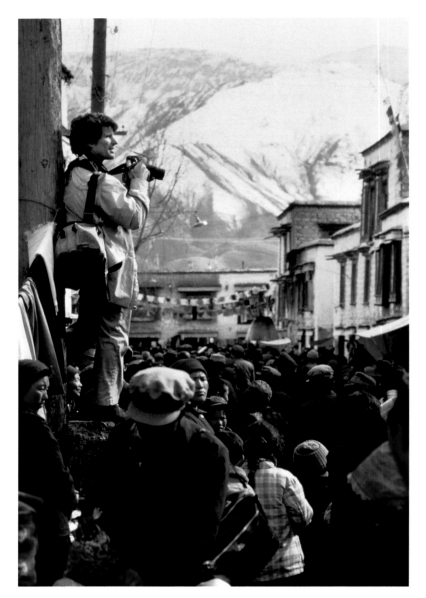

GALEN IN THE FIELD, LHASA, TIBET, 1983

EXPLORER AND ADVOCATE

by John Ackerly

Galen's extraordinary career of exploration in the highlands of Asia began in a typical way. He was invited to join a 1975 mountaineering expedition with a rare and lofty goal—K2, the world's second-highest peak. But Galen was anything but a typical mountaineer. Although he loved to climb and climb hard, his interests and concerns were much broader, and it was in Asia that Galen's life as a writer and explorer blossomed.

K2 was Galen's first trip out of North America, and it would be the last of its kind. Never again would he be part of an expedition so large that it needed more than six hundred Balti porters to try to put nine Americans on a summit. This experience drove Galen's determination to climb in small groups and to become part of the cultures he visited rather than disrupting them. And in a more literal sense, Galen finished growing up here, for upon his return to base camp, a manila package from his mother was waiting, informing him that his ninety-year-old father had passed away. The envelope held his father's ashes, and he scattered them there, under the shadow of K2.

From that expedition Galen produced one of his best books: *In the Throne Room of the Mountain Gods* is remembered as a candid look inside the dynamics of a large expedition full of even larger egos. As one commentator recalled, Galen "gives us something less heady than heroes; he gives us messy, recognizable, full-blooded reality." But the book is also an erudite survey of literature about K2 and its cultural and natural environs.

After K2 Galen embarked on scores of expeditions to the Himalaya in India, Nepal, and Pakistan. He began working closely with organizations promoting sustainable tourism (before it was called ecotourism) and environmental and cultural conservation strategies. In between technical climbing expeditions, he and Barbara and Barbara's brother, Bob, did a monthlong trek around Annapurna to promote the newly formed Annapurna Conservation Area Project, which was featured in one of Galen's many *National Geographic* articles.

As Galen's experience in Asia deepened and his reputation grew, he seemed to find his own voice as a powerful advocate on behalf of environments and cultures he saw as being under assault, especially in Tibet. He strove to perform a balancing act among his drives to explore

remote areas, keep getting visas and access, build support among major institutions, and document and publicize environmental threats. This was an ongoing struggle from his first visit to Tibet in 1981 until his last expedition there in 2002. He occasionally succumbed to censorship—but never without resistance. In 1990 he wrote: "If I had to do it all over again, there is only one thing I would have done differently. I wouldn't have compromised the story of Tibet's environmental destruction as much as I did. Then, I was worried about going back. Now I simply want to tell the story."

And tell the story he did. Galen broke wide open the debate over Tibet's environment, which spurred scores of activists, academics, and environmental organizations to get involved. When Andre Carothers, the editor of *Greenpeace* magazine, asked me who could pen a cover story on Tibet, the answer was easy. In between running a growing photo agency at Mountain Light, still making difficult ascents in the Sierra, and writing other essays and columns, Galen somehow found time to write a groundbreaking piece. "The Agony of Tibet," published in March 1990, documented the rapid depletion of Tibet's wildlife after the Chinese invasion, which brought rapacious logging and the construction of China's principal nuclear weapons plant on the northeastern Tibet plateau.

Later in 1990, Galen coauthored *My Tibet* with the Dalai Lama, giving an even greater boost to the movement by focusing on both the environment and human rights abuses in Tibet. When Galen first proposed the collaboration—pairing his photographs with the Dalai Lama's commentaries on them—it sounded a bit presumptuous. But their first meeting at the Dalai Lama's home in exile, in Dharamsala in northern India, was a great success. Galen found that the Dalai Lama's infectious enthusiasm and love for wildlife matched his own. And from then on the Dalai Lama considered Galen one of the most effective advocates for Tibet's culture and natural treasures.

With the publication of *My Tibet,* Galen became a high-profile advocate for the pro-Tibet movement in the West, though he had a far more nuanced and complex view of Tibet than many of his new fans realized. Seven years earlier, in *Mountains of the Middle Kingdom,* Galen had written even more extensively on Tibetan history, showing an understanding that eluded most Western journalists as well as China scholars. Here his exhaustive reading and research shone, and he worked his way through modern Tibetan history as he would work up a difficult rock climb—with care, audacity, and intelligence. He did not hesitate to criticize both Beijing and Dharamsala, but always

with empathy for the Chinese and Tibetans—each caught in systems and mind-sets prone to exaggeration, distortion, and the omission of troublesome truths.

Galen deeply believed that his greatest contribution lay in taking astounding photos of what should be preserved in Tibet. For many of us, his photographs form our mental pictures of the country. Among the thousands made there, his image of a rainbow over the Potala Palace, taken on his very first trip, remains one of his most iconic. I never traveled with Galen in Tibet, but when we climbed together in California it was easy to see how hard he worked and how he loved to be out at dawn and dusk, pushing himself to capture more fully the beauty in which he loved to immerse himself.

Ultimately Galen became known less as a great Himalayan climber than as a sensitive observer and passionate advocate for the Himalaya. After he met Barbara Cushman, this advocacy was very much a team effort; she became his partner in keeping up the many relationships that Mountain Light and their Himalayan work depended on. In the early 1990s, Galen was incredibly active, speaking at conferences, doing articles and exhibits on Tibet, generously sharing his Tibet photos. Over and over he would waive his speaking and photo-licensing fees for noncommercial uses, sometimes over Barbara's objections. He wanted his books to reach politicians. The International Campaign for Tibet, whose board of advisors he co-chaired, worked with him to get his books to every member of Congress and to key officials in the Bush and Clinton administrations.

Galen was intensely aware of those who had come before him, and he often wrote about early explorers whom he admired and learned so much from, such as Heinrich Harrer and Eric Shipton. He was equally aware of those coming after him and his responsibility to encourage the next generation. Jimmy Chin, a young climbing photographer who accompanied Galen, Rick Ridgeway, and Conrad Anker on Galen's last expedition to Tibet, recalls how Galen took him under his wing. Galen called that trip to Chang Tang the "ultimate expedition." It combined everything he loved: wildlife conservation, a punishing physical regimen, a challenging photo assignment, the company of great friends who could laugh and be trusted in the most dire circumstances—and the lure of remote, rarely explored Himalayan landscapes that had seized his soul so many years earlier.

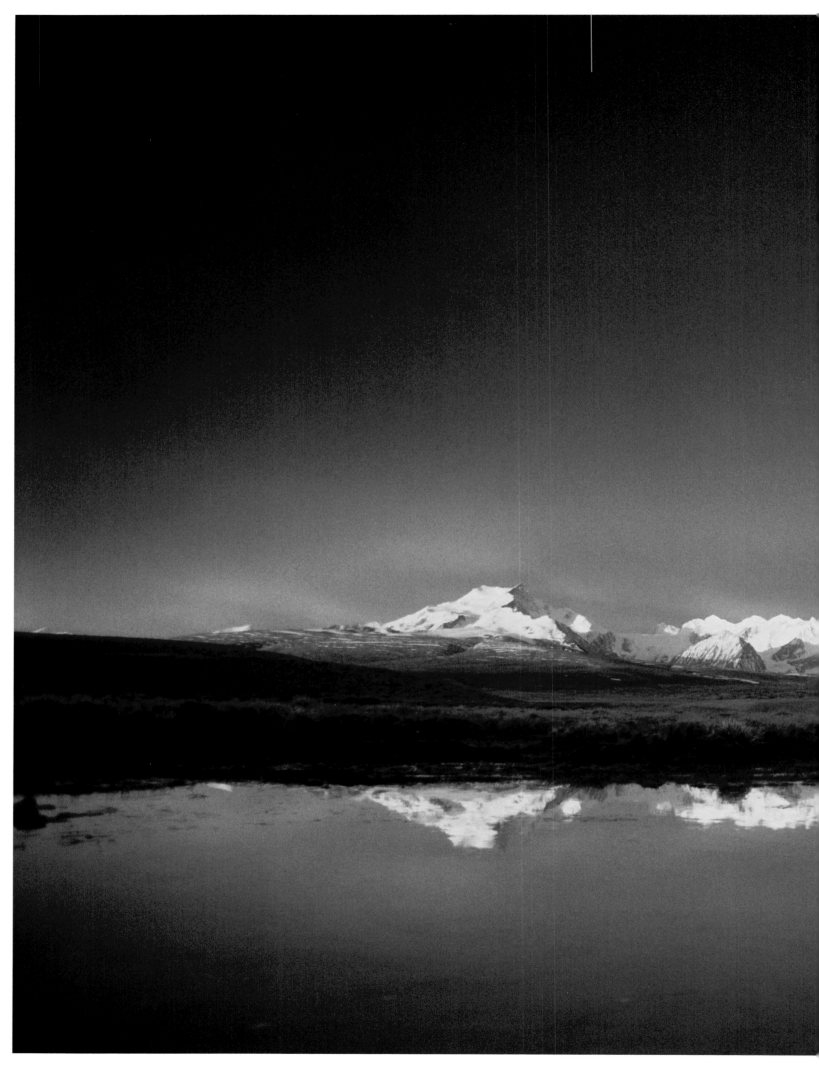

SUNRISE ON KANGBOCHEN FROM PEKHU TSO, TIBET, 1988

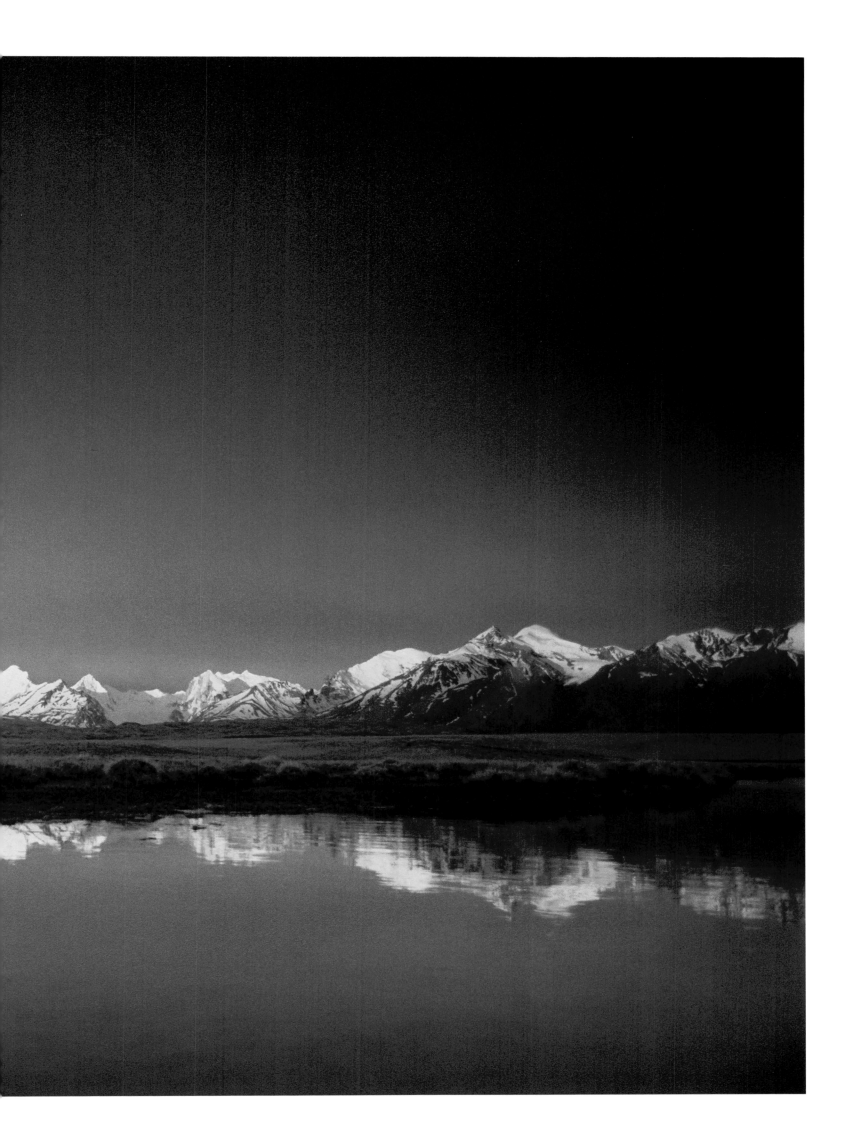

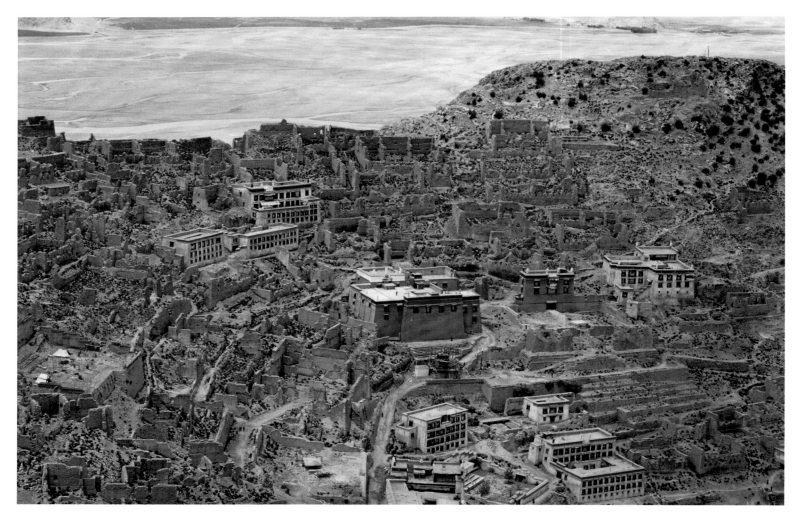

GANDEN MONASTERY, NORTHEAST OF LHASA, TIBET, 1987

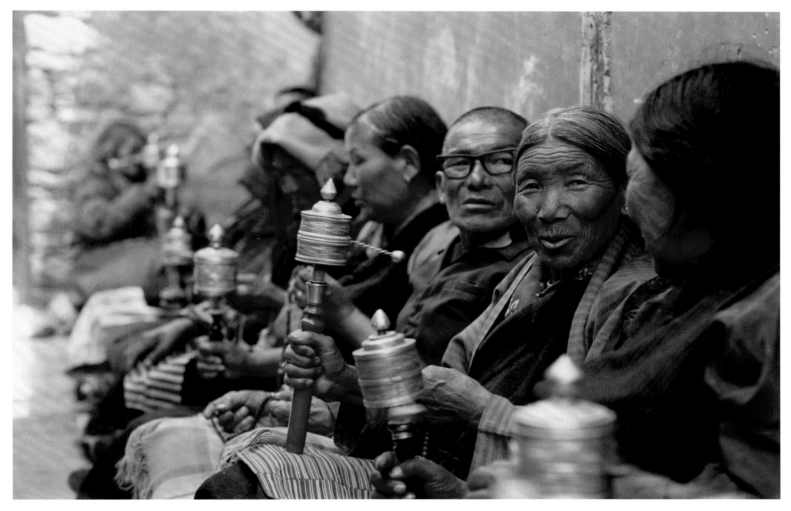

PILGRIMS PRAYING AT NECHUNG TEMPLE, LHASA, TIBET, 1988

SEEING THE BIG PICTURE

This photograph is from a series of varied compositions that Galen took from the same vantage point. It's particularly memorable to me because we tried many times over the years to make a cover for *Outdoor Photographer* magazine from several of the outtakes, but none could ever be made to fit the necessary design and spatial requirements. Then finally in 2005 we found this particular one to be the right one. This image is also special because Galen and I had a long conversation about the location and the story behind the shot at a time when I was planning a trip of my own to the Mount Everest region. This striking image contrasts a rarified view of Everest with the graphic silhouette of the monastery and monks—all in absolutely classic mountain light.

Digging deeper, I would say that it is quintessentially representative of the photographer. First, because its central subject is a peak that Galen visited as both a climber and expedition leader but one that he never personally summitted. With modern summit quests so overcommercialized, Galen's selection of climbs speaks to his sheer individualism where personal goals were concerned. To Galen, Everest had a grander significance than that of a mountaineer's trophy. Here it is seen in the context of the region's people and culture—a vivid tapestry that became a major influence on him and, I think, compelled him to become more a photographer than a climber. Galen took a great many photographs of high, cold, unpeopled places, but as time went on the journalist, environmentalist, and activist began to overshadow the mountaineer-athlete. To feel most passionately about a place, you need to have affection for the land, the people, and the creatures.

Of course, Galen's physical talents helped support his artistic endeavors, whether hanging on a granite wall to photograph fellow climbers or making his last monumental trek in search of the Tibetan *chiru*. His athleticism was perhaps his most important photographic tool. In a profession that revolves around being in the right place at the right time, Galen could simply be in more places with more energy, more often. The question always seems to come up: Was he a climber who photographed or a photographer who climbed? There is no separating the two, but I believe the photographer and artist had a slight advantage. When Galen told me the story behind this picture, all his focus was on the composition, the happenstance, and the location's place in the larger picture of Tibet.

—*Steven D. Werner*

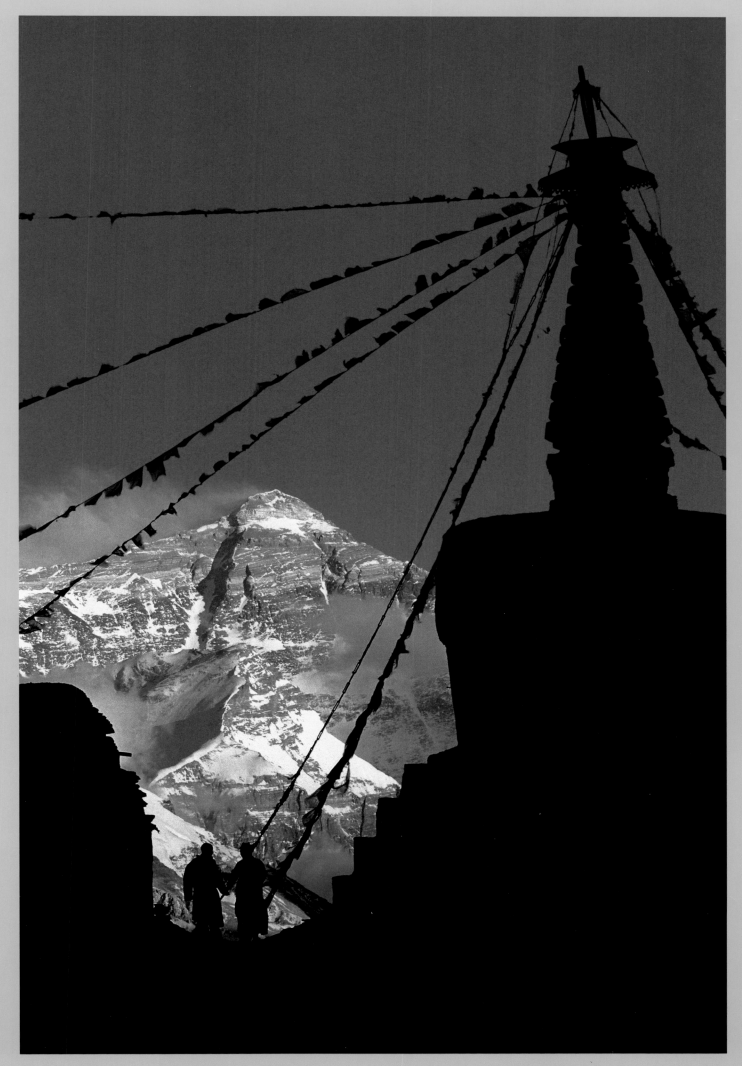

MOUNT EVEREST AND RONGBUK MONASTERY, TIBET, 1988

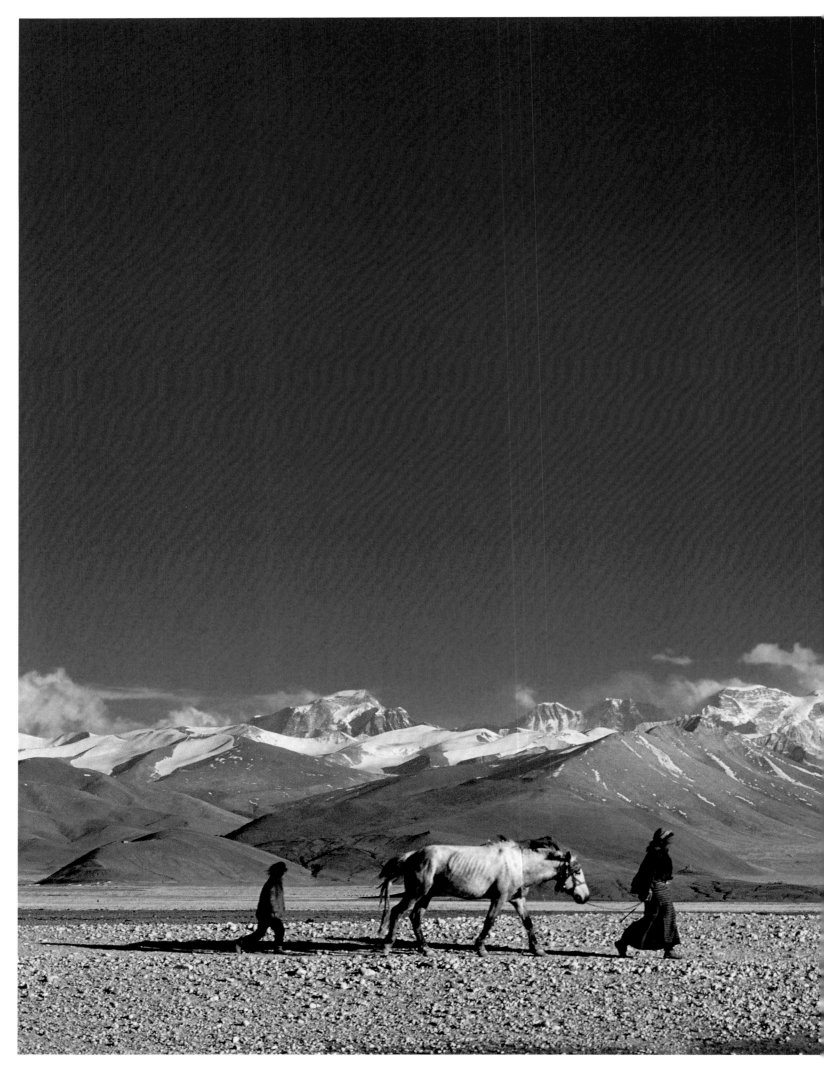

EVENING ON THE TINGRI PLAIN BELOW CHO OYU, TIBET, 1988

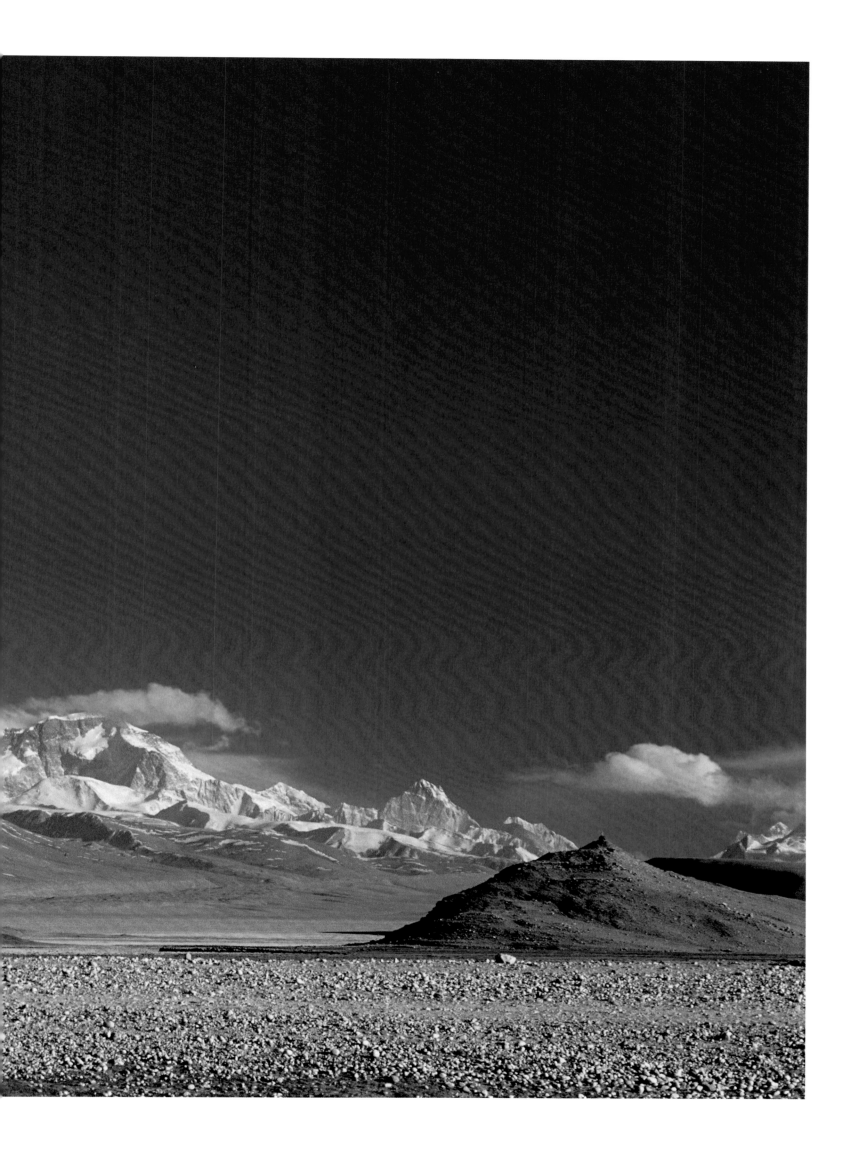

Pilgrims on a Ritual Circuit around Sacred Mount Kailas, Tibet, 1987

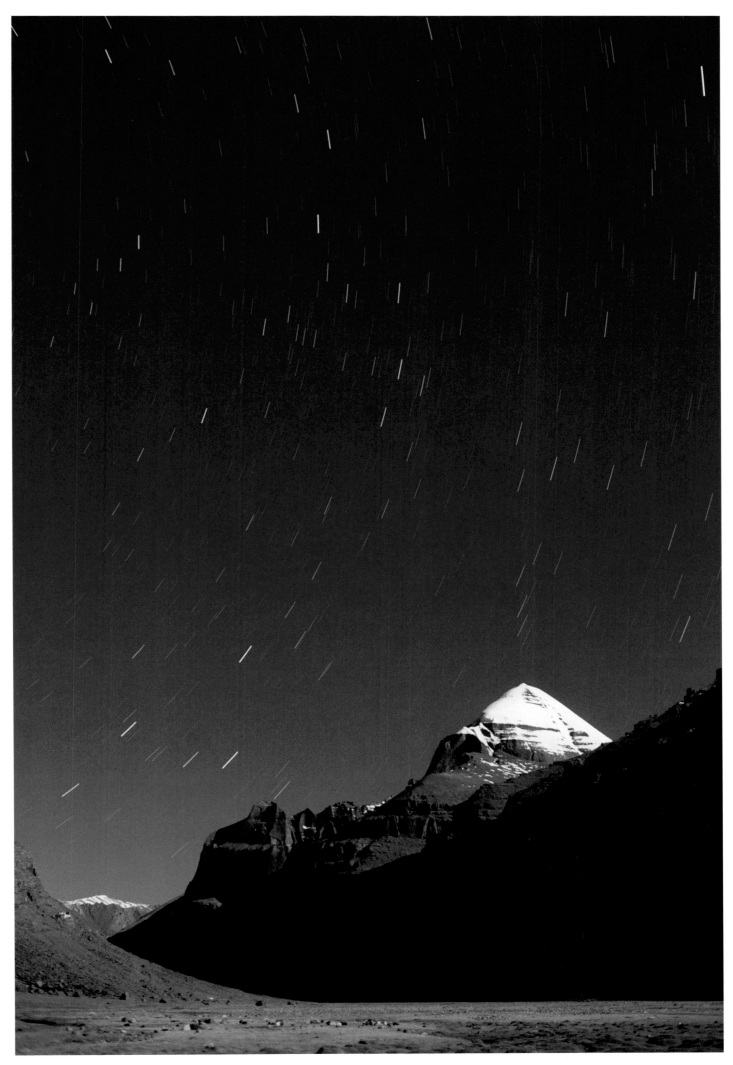

STAR STREAKS OVER MOUNT KAILAS, TIBET, 1987

GILDED WALL PAINTING OF BUDDHA, RONGBUK MONASTERY, BELOW MOUNT EVEREST, TIBET, 1988

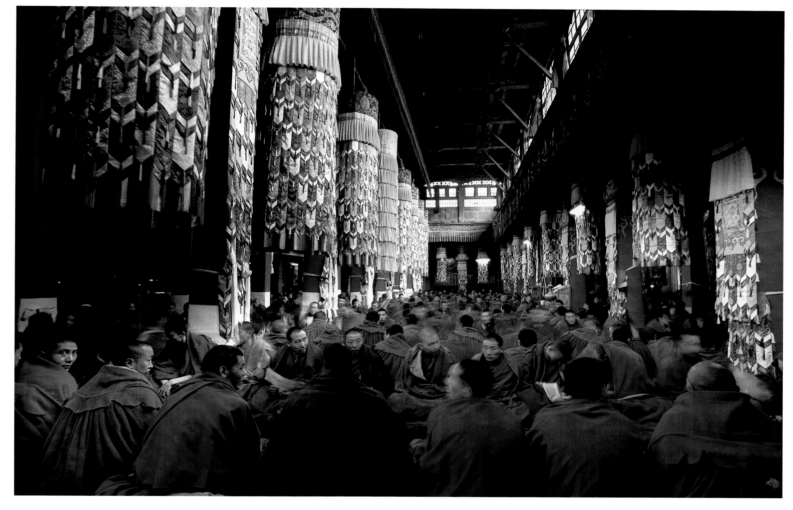

MONKS AT DREPUNG MONASTERY, LHASA, TIBET, 2002

PILGRIMS AT A MOUNTAIN SHRINE

I am running uphill with a Golok rider close at my heels. Half a mile above me is a hilltop shrine, a cluster of rock piles, poles, and cloth flags. A low sound that seems born of the earth itself grows ever louder as I draw near. At first I do not realize that it is coming from behind me. It speeds up when I speed up, slows down when I slow down. The Golok rider is chanting in rhythm with my footsteps.

My lungs feel ready to burst with each stride. I can only run here at 15,500 feet because I am acclimatized from climbing to the North Col of Everest last month and to the top of Anye Machin last week.

Now my goal is just to reach the hilltop, lie down, and rest. I feel the euphoria of oxygen debt as I push hard up the final grade. The Golok doesn't stop at the top as I expect; he moves ahead of me, dismounts from his horse, and leads it briskly along a well-worn path. I follow him on three complete circles of the shrine with its two-hundred-foot wall of intricately carved mani stones [making this photograph on the move].

Just when I think things are going well, the Golok turns serious. I stand very still as he draws a long knife and holds it to my face. He cuts a lock of my hair; then one of his own; finally one from his horse. He ties them to a rope on one of the poles as an offering to the gods. . . .

Now as Chong Hun and I circle the shrine for the last time, he stops to pray. I recognize a series of Tibetan characters on a flag, point, and say, "Om mani padme hum," a universal prayer that transcends the separate dialects of the Goloks and Lhasa Tibetans. Chong Hun's face lights up. When I mention the holy places I have been to in Tibet—Drepung, Jokhang, Tashilhunpo, Gyantse, Rongbuk—he proudly gestures that he has visited those places also. . . . [I]t is clear that he is deeply moved.

—*Galen Rowell, from* Mountains of the Middle Kingdom

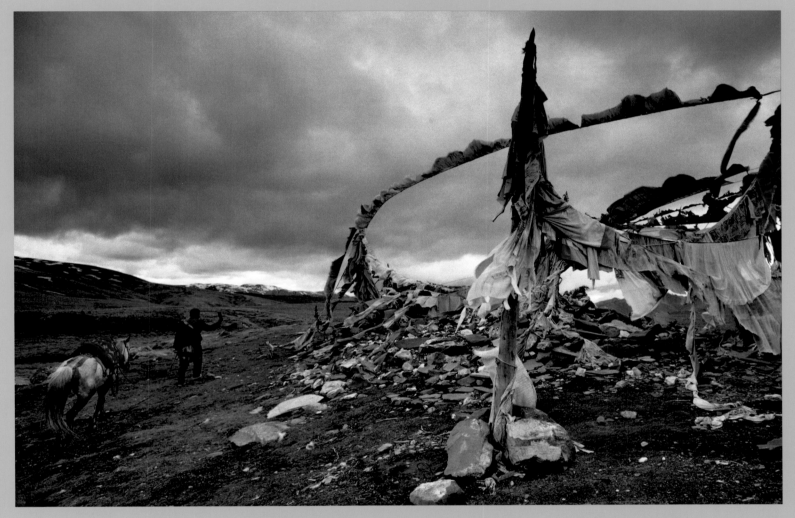

GOLOK RIDER AND HOLY SHRINE, ANYE MACHIN, TIBET, 1981

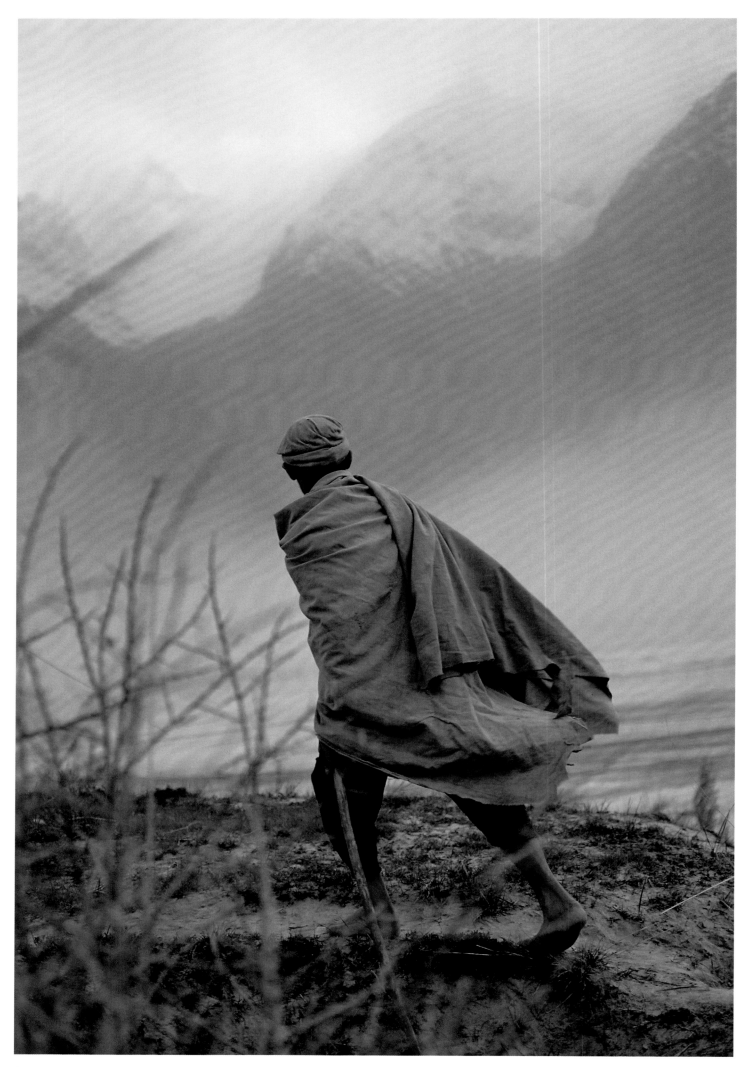

BALTI IN DUST STORM, KARAKORAM HIMALAYA, PAKISTAN, 1975

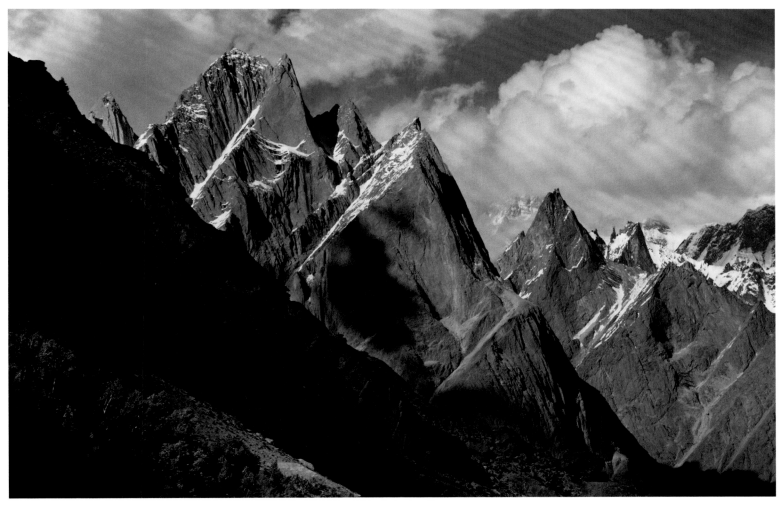

THE GRAND CATHEDRAL, BALTORO GLACIER REGION, KARAKORAM HIMALAYA, PAKISTAN, 1975

GIRL IN WINDOW, SRINIGAR, VALE OF KASHMIR, INDIA, 1977

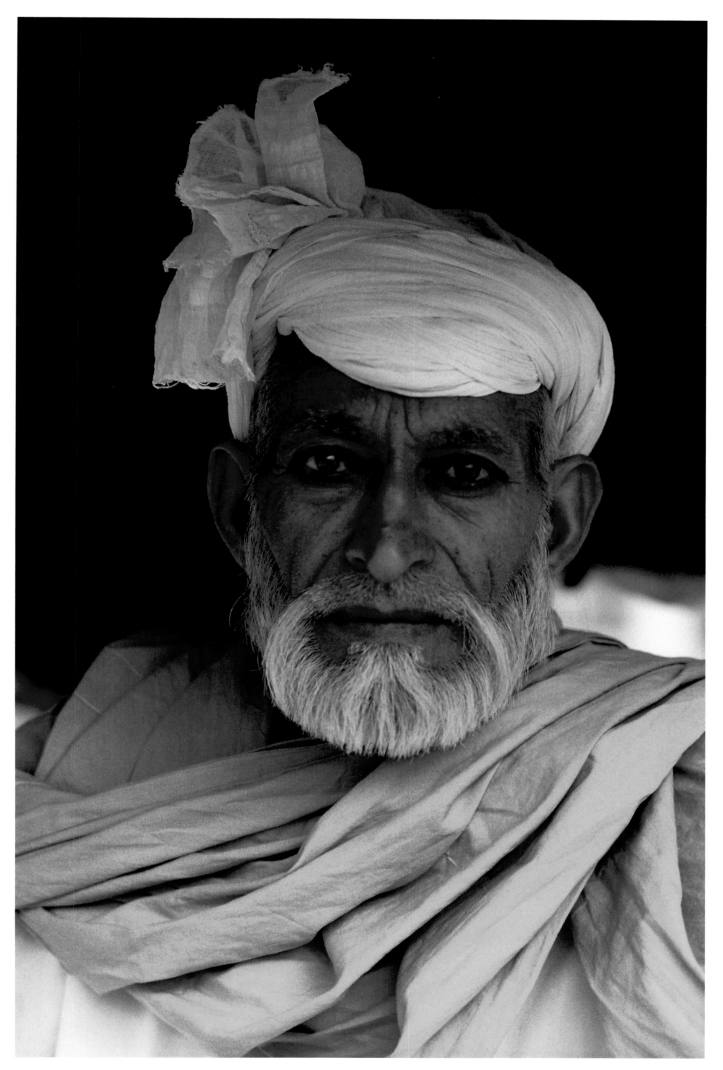

PUNJABI MERCHANT, NORTHERN AREAS, PAKISTAN, 1975

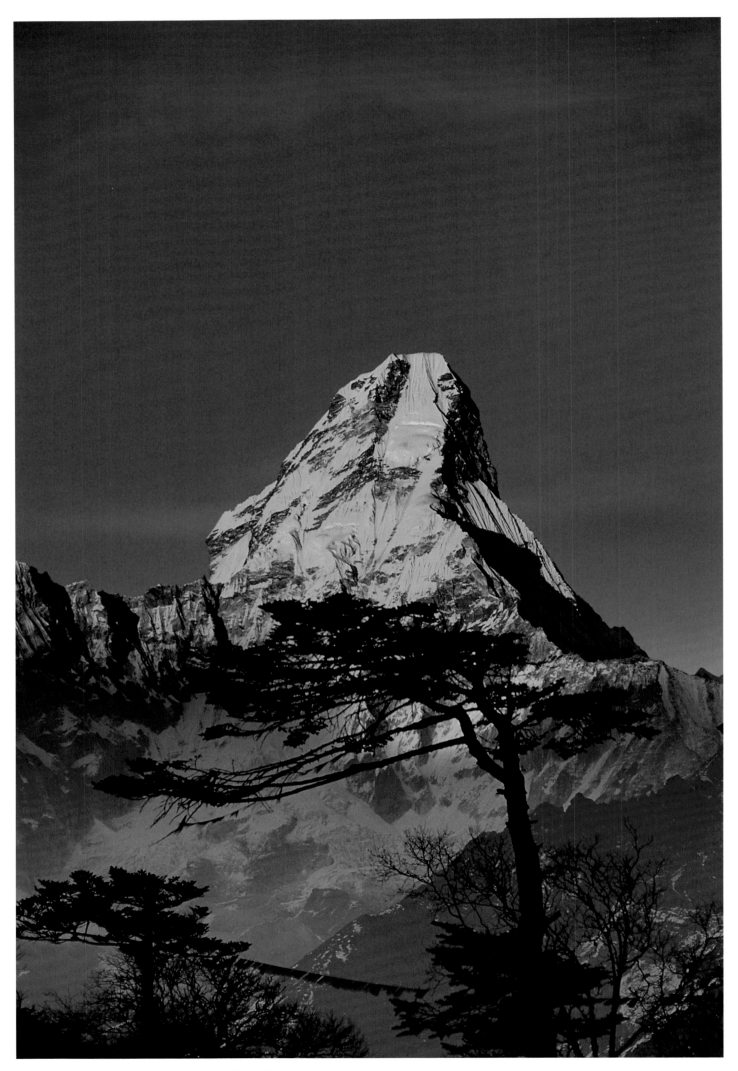

AMA DABLAM FROM KHUMJUNG, KHUMBU HIMAL, NEPAL, 1998

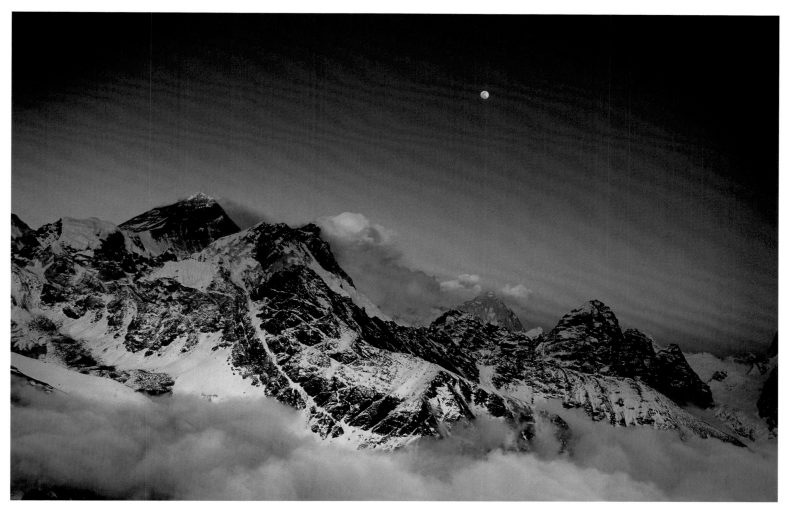

MOON OVER EVEREST, LHOTSE, AND MAKALU AT SUNSET FROM GOKYO RI, KHUMBU HIMAL, NEPAL, 1998

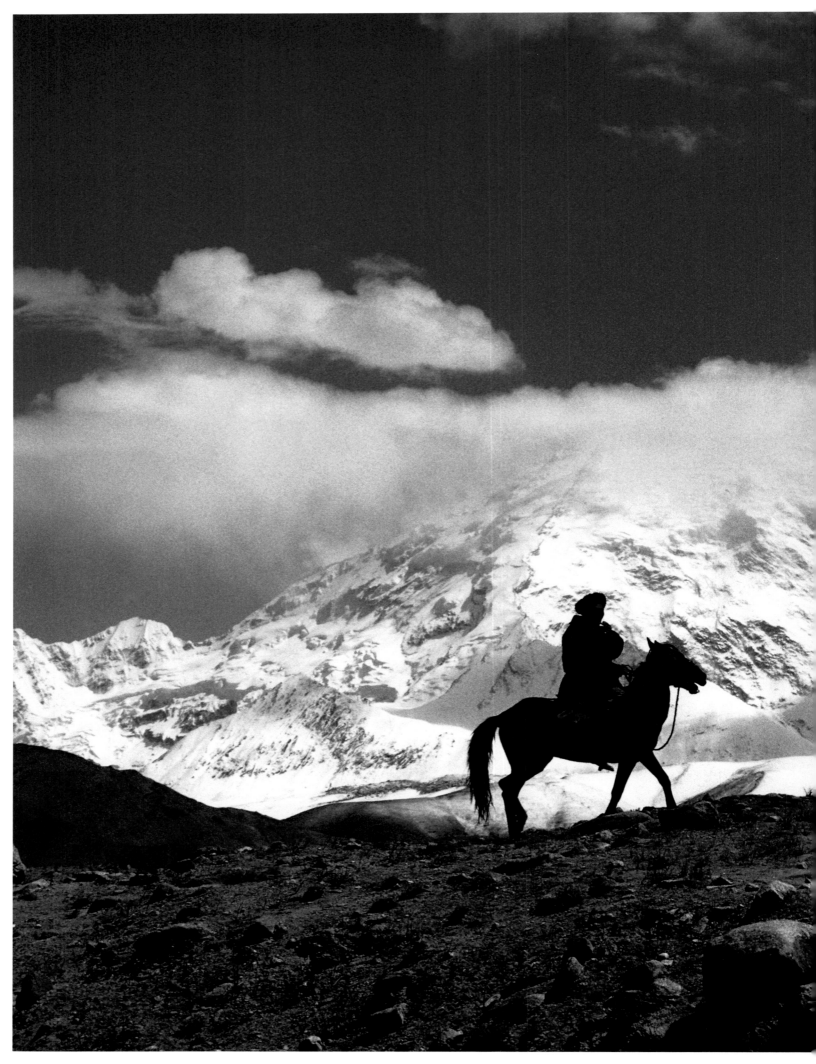

KIRGHIZ HORSEMAN UNDER MUSTAGH ATA, CHINA, 1980

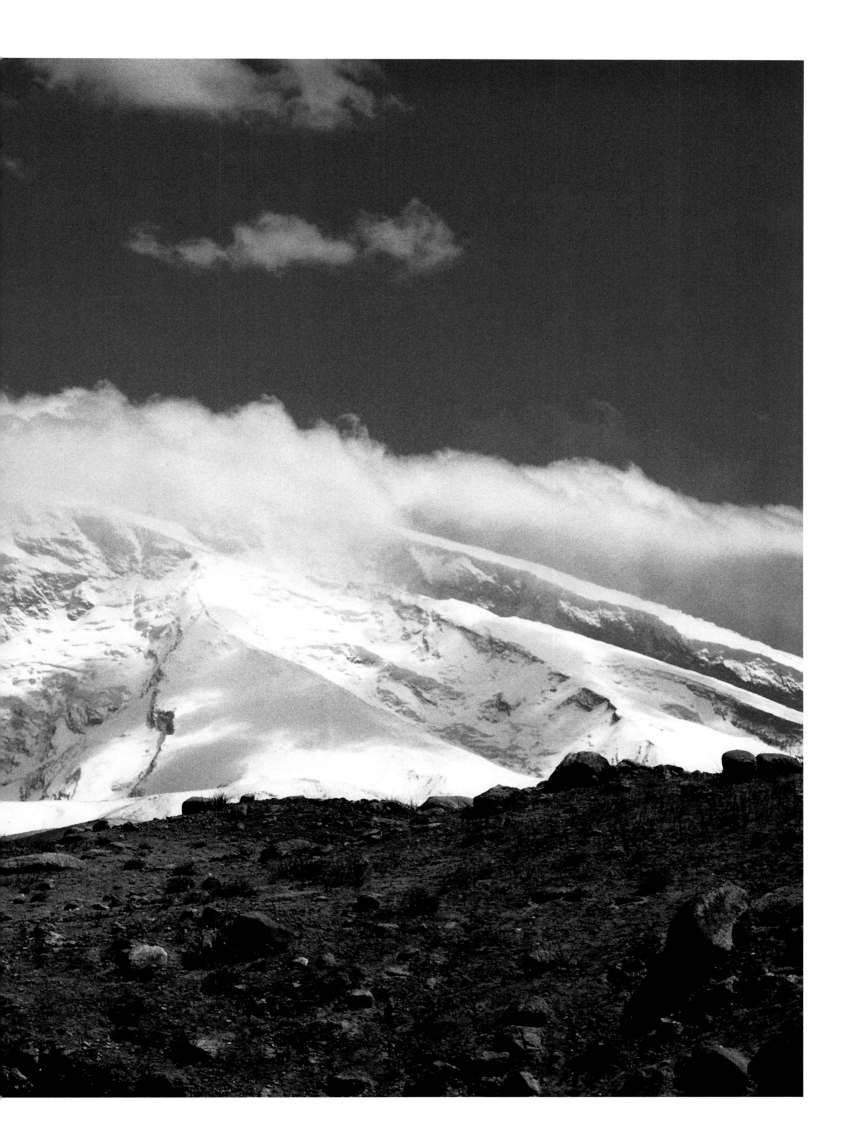

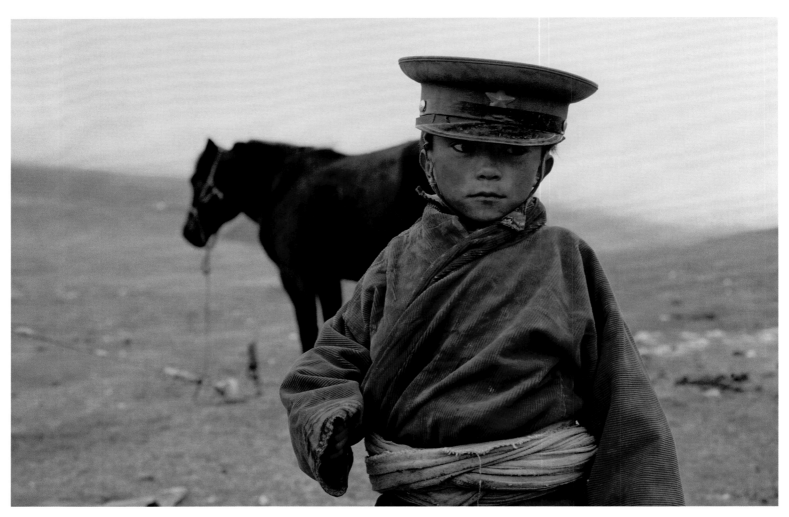

GOLOK BOY WEARING PEOPLE'S LIBERATION ARMY HAT, QINGHAI PROVINCE, CHINA, 1981

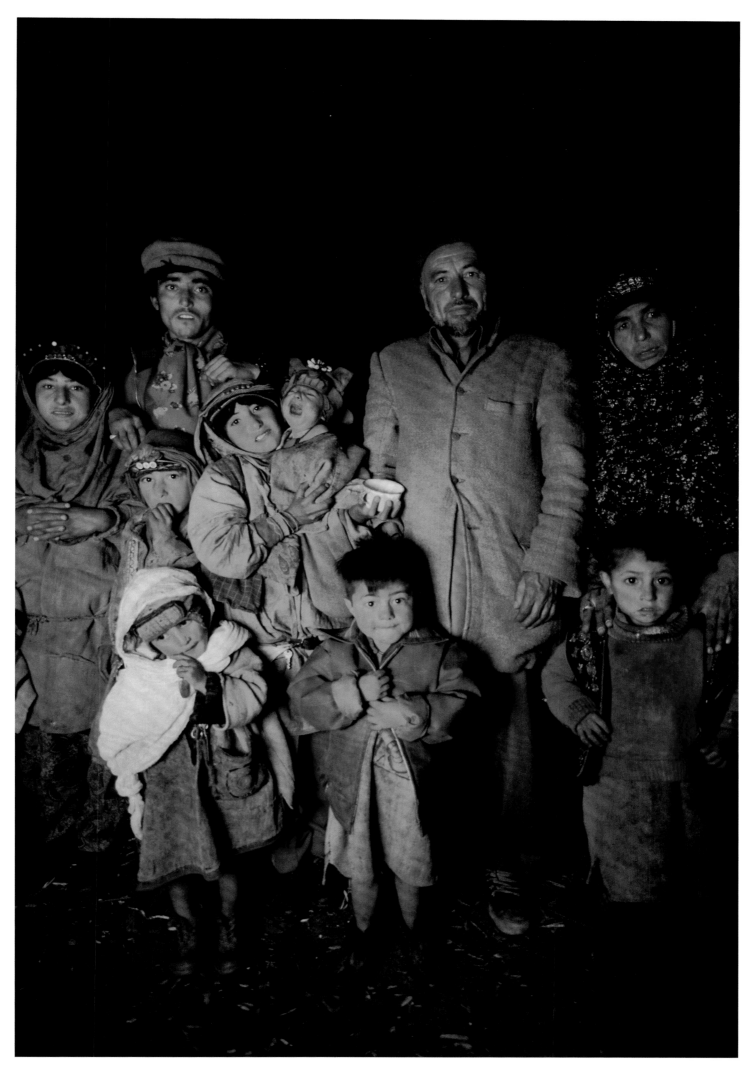

HAJI MAHDI, HEADMAN OF ASKOLE VILLAGE, WITH HIS FAMILY, PAKISTAN, 1984

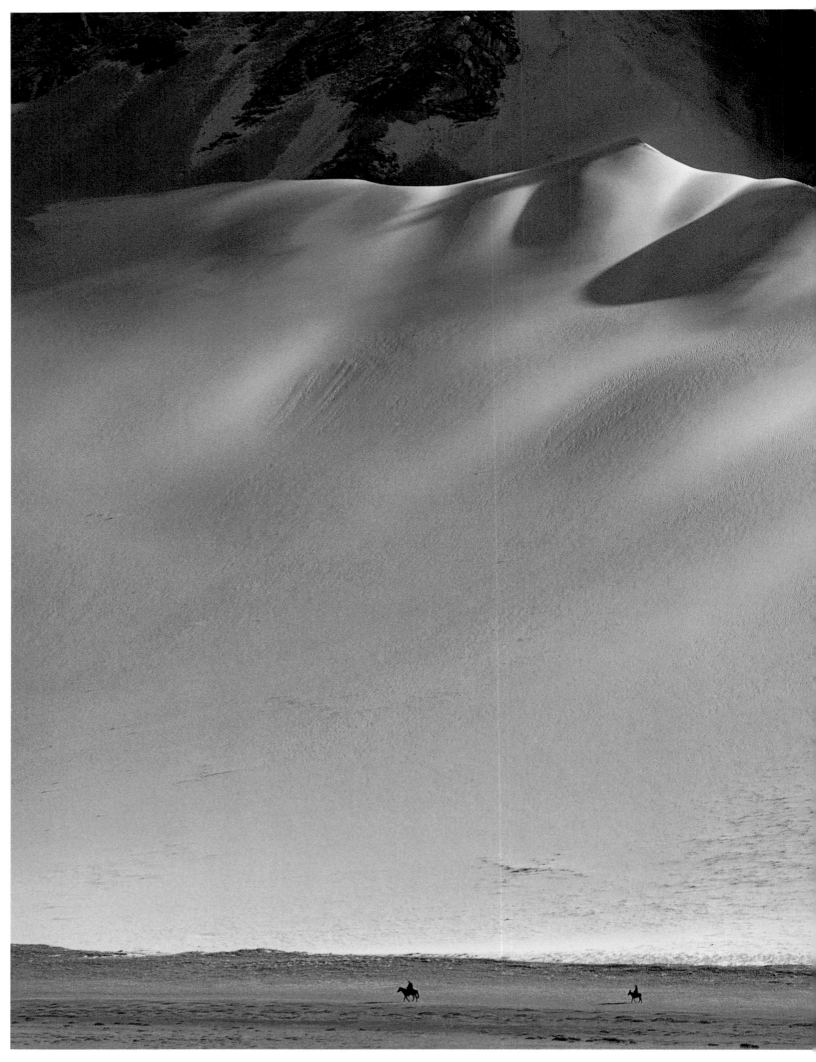

HORSEMEN BENEATH A GIANT SAND DUNE ALONG THE ANCIENT SILK ROAD, PAMIR RANGE, CHINA, 1980

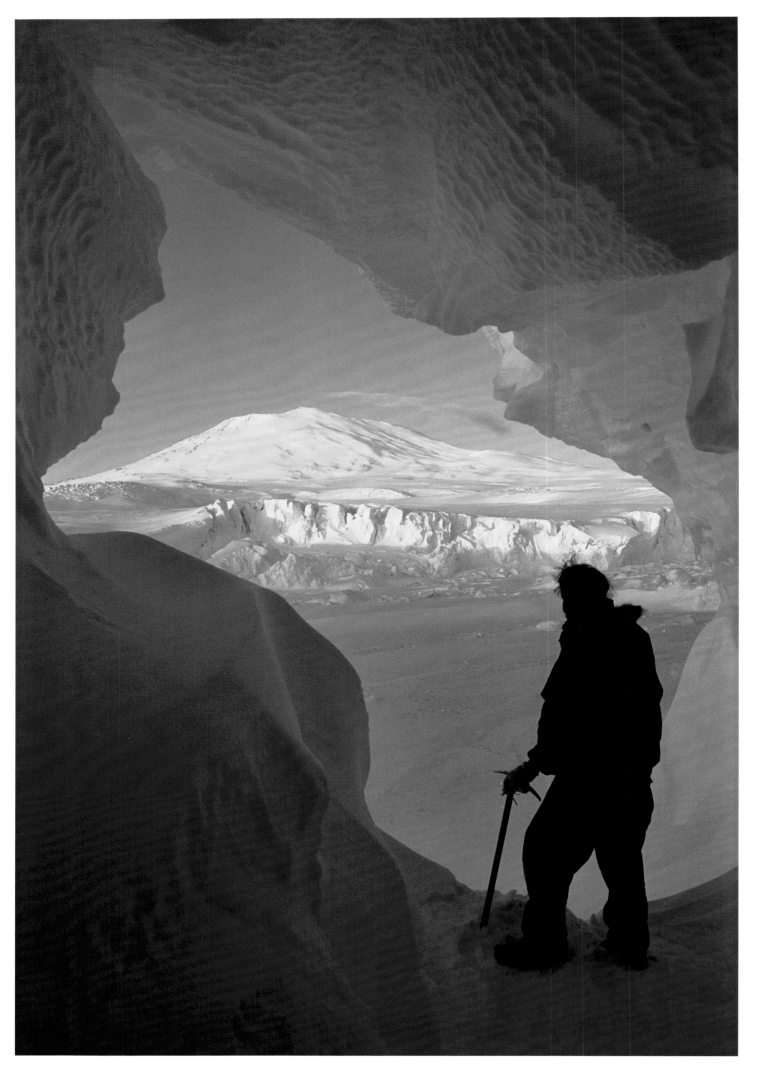

ICE CAVE BELOW MOUNT EREBUS, ROSS ISLAND, ANTARCTICA, 1992

TO THE ENDS OF THE EARTH

"As last frontiers, the polar regions are still perceived as wastelands; we should keep in mind, however, that many of the nineteenth century's 'useless wastelands'—Death Valley, Mono Lake, Monument Valley—have undergone a complete reversal in public perception and are now considered places of wild beauty to be set aside for posterity."

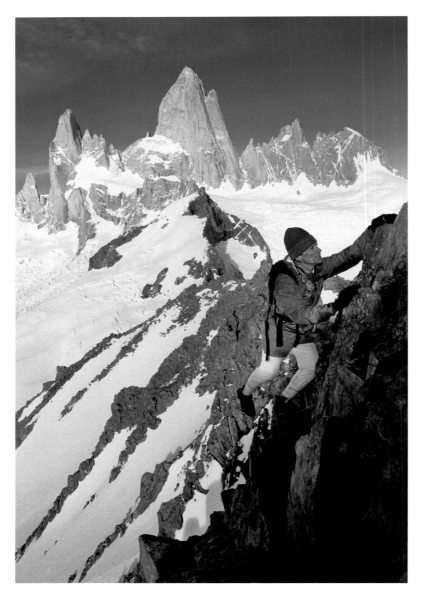

Self-portrait on Cerro Madsen, beneath Fitz Roy, Patagonia, Argentina, 1998

Icon of Adventure Photography

by Conrad Anker

By the time I was a young Yosemite climber, Galen Rowell was a man of legend, and just being in the presence of such a luminary filled me with awe. We first met in 1985 at a gathering in Tuolumne Meadows, where Galen spoke with passion and conviction about the places he loved.

I didn't register on his radar then, but ten years later, when he and Barbara hosted an environmental symposium at their Mountain Light studio, Galen and I drifted into climbing talk. We found ourselves bound by mutual friends, common climbs, and a not-so-secret belief that good fun can be found only through discomfort and hardship. For the next three years we met regularly to train on Bay Area trails and boulders and to climb in his favorite Sierra haunts. He used his generations-deep knowledge of the eastside Sierra to ferret out old routes to be done free or in a day. Immense energy infused his climbing to create journeys that challenged his capabilities. The Sierra, though majestic in its own right, was training for the greater ranges.

A glance at Galen's life chronology reveals the amazing span of his travels. The historian in him had to experience every single mountain region in China. The climber couldn't rest until he'd had a taste of Patagonian rock. And the explorer, who felt part of a current stretching back to Peary and Scott, eventually made it to both the earth's poles. From Tanzania to Pakistan, Antarctica to Greenland, Siberia to Ecuador, Botswana to Las Vegas, the South Pacific to the French Alps, Galen covered the gamut of human experience in the natural world like no other photographer. To me, his quest for knowledge is best exemplified by forays in Tibet during the 1980s to explore its many ranges.

In 1975 Galen was part of the American K2 expedition, his first Himalayan journey. Galen enjoyed the mountain and bonded with the Balti people, yet he felt that the large team and its attendant dynamics detracted from the experience. Aside from this and one alpine-style Everest expedition, he traveled in small groups, a style rooted in his Sierra escapades. Perhaps the big expeditions taught him that large numbers dilute the mountain experience. His most significant adventures were grand objectives shared with small, tight-knit groups.

Four expeditions stand out as testimony to the light-and-fast mentality Galen adopted. Each of these landmark adventures was small, ambitious, and bold. That they were all successful says much about Galen's foresight and dedication.

The south face of Mount Dickey is a sheer, 5,000-foot granite wall. When Galen, David Roberts, and Ed Ward made the first ascent of this Alaska giant in 1975, it was a step forward in technical difficulty and commitment. Thirty years later the route is respected as a test piece. In typical Alaskan fashion, the climb was plagued by storms, whiteouts, and rotten rock, but for Galen the difficulty was central to the achievement. He was grateful, he wrote in *High & Wild,* that the possibility of rescue didn't exist on this remote peak. "How many men, how many planes, how many changes would it take to destroy our remote experience in this alpine sanctuary?"

In 1977, Galen, Kim Schmitz, John Roskelley, and Dennis Hennek scaled the Great Trango Tower, a wonderful spire he had eyed on the K2 expedition. Done alpine style, their first-ascent route became the most popular way up this magnificent peak. In 1980 Galen returned to the Karakoram in midwinter with Schmitz and Ned Gillette to traverse the Saltoro, Biafo, and Baltoro glaciers on skis. This journey was a departure from standard peak-bagging, with success measured in distance covered. It also proved to be the most demanding of Galen's expeditions, with miles of arduous sled hauling in freezing conditions. And in 1982 Galen teamed up with Roskelley, Vern Clevenger, and Bill O'Connor for another first ascent, alpine style via the southwest ridge, of Cholatse, a 6,400-meter peak in the Khumbu Himalaya. This stunning peak stands like a knight in relation to the king of mountains, Everest—and had been the region's last virgin summit.

In their remote locations and raw intensity, these four climbs defined the generation in which I came of age, and Galen's visual record of them defined the genre of adventure photography. He set a high bar for future photographers to aspire to.

As Mountain Light demanded more of Galen's time, his personal expeditions became shorter and less intense. Yet he still dreamed of "big trips" with challenges so demanding that one leaves the human cognitive space and becomes an animal bent on survival.

Every Memorial Day the town of Telluride, Colorado, hosts Mountain Film, a gathering of people involved with adventure, the environment, and culture in film. Between screenings and speakers, there are chances to connect with friends and plan future adventures. In 2000 Rick Ridgeway, David Breashears, Galen, and I met with our families for lunch. Rick had just returned from the Chang Tang plateau of Tibet and shared his experiences. Galen said visiting Chang Tang was one of his life goals. David added that the eminent wildlife biologist George Schaller was trying to track the endangered *chiru,* or Tibetan antelope, there. Before the waitperson brought the check, we had planned a trip for two years hence. Following Schaller's lead,

we would track the western *chiru* herd on their migration path to establish the whereabouts of their calving ground.

In late May 2002 the four of us departed San Francisco for Lhasa. David was unable to take part, so we had invited Jimmy Chin, a young American-born Chinese photographer, who, with his calm personality and language skills, became a valued member of the team. Our journey would entail a long walk north, crossing two mountain ranges in a high-altitude desert with no resupply points. If we did everything just right, we would meet a driver in the Taklimakan desert just as our food ran out. If we screwed up, we would be in the middle of nowhere without help.

We left Lhasa and traveled back in time. Towns gave way to villages, which eventually gave way to nomadic settlements. We each had a rickshaw made of mountain bike components to pull our supplies. The enormity of our task soon became obvious as the land became so harsh that even the nomads avoided it.

Chang Tang was different from the camp-based expeditions we were familiar with. Each day we had to strike and set camp, adding three or four hours of effort to an already tiring day. Besides the challenge of altitude, we were always low on water: finding and transporting it was the focal point of each day. Despite the extreme effort, Galen remained upbeat and focused on his photography, seeing every potential image through the lens of his mind. I imagine him calculating the exposure, aperture, and focus for a million images each day. Of these only a select few warranted pulling his camera out, but I marveled that he could muster the energy for this work on top of the sheer effort of travel.

On this, Galen's last expedition, he made it a point to mentor and pass on his knowledge to a younger photographer. Galen and Jimmy were immersed in a seven-week photo workshop. He shared tips on light, bracketing, angles, lenses, film, and timing; he imparted practical advice on how to get film past obstinate security personnel, how to best edit for a submission, and how to care for your all-important equipment. It was touching to see this relationship blossom during the course of pulling glorified yard carts across the barren Tibetan plateau.

One measure of our expedition's success was that Galen felt it had been one of his finest. We survived together as a team and witnessed one of our planet's miracles, the migration of an animal species. Our data would add to the knowledge needed to protect the *chiru*. To me Galen remained the icon of adventure photography, yet we had grown to be close friends as well. His energy for life, as he set off to capture one last image with the sun low on the horizon, will be with me always.

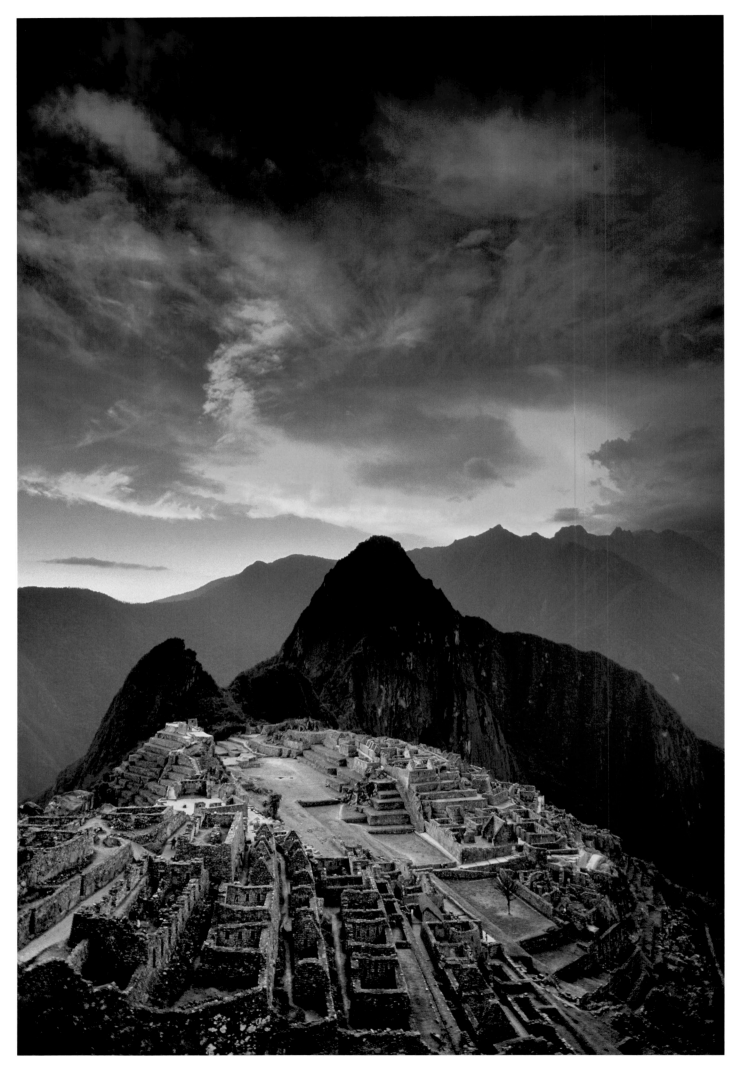

SUNSET OVER MACHU PICCHU, PERU, 1995

Northern Lights over the Barrens, Northwest Territories, Canada, 1998

A PASSION FOR THE WILD

In 1997 I joined my father on an expedition to the Canadian Arctic to camp and photograph at the northern reaches of Baffin Island. We set out on a five-day trip from the subsistence village of Pond Inlet in a small, open boat, accompanied by an Inuit guide and his son. Near Bylot Island, my father spotted a mother polar bear and her twin cubs. "Polar bears! Right there on the left," he yelled, overflowing with excitement. He had our guide navigate us to the shoreline.

Adrenaline ran high as my father quickly scrambled for his camera gear and began snapping pictures as the bears tried to climb a rocky cliff. Failing, the mother took up a perch with her offspring in a rocky alcove, from which she watched us intently. I followed my dad's lead and jumped off the bow of the boat onto some slippery rocks onshore, our little boat pounding against the rocks all the while.

My father made it clear that we shouldn't walk directly toward the animals and should have little or no eye contact with them. To my amazement, we were able to work our way to within a couple hundred feet of the protective mother and her cubs. As we quickly set up our cameras and tripods, my dad stopped for a moment to say, matter-of-factly, that if the mother were to charge us, we should leave all our equipment and race for the boat.

In the next few minutes—which seemed an eternity to me at the time, heightened by my nervousness and excitement—we shot through several rolls of film. Whenever the mother bear raised her nose to sniff our scent, I felt uneasy, while my father couldn't seem to get enough of the moment. "It's unbelievable! Just amazing!" he said again and again. I was struck by the fact that, although he had stacks of polar bear photos in his files, he was as excited about this encounter as if it were his first sighting. He had seen polar bears traversing ice and flat land, and from large

POLAR BEAR MOTHER ATTEMPTING TO LEAD HER CUBS UP A CLIFF, BYLOT ISLAND, NUNAVUT, CANADA, 1997

tundra vehicles filled with camera-wielding tourists set up for just those times when hardening ice permits the bears to cross a specific patch of ground that affords easy picture taking. But this was entirely different: a sighting of bears unhabituated to human presence, a sighting electrified by the intensity of the mother bear's instincts and my father's passionate response to the wild.

—*Tony Rowell*

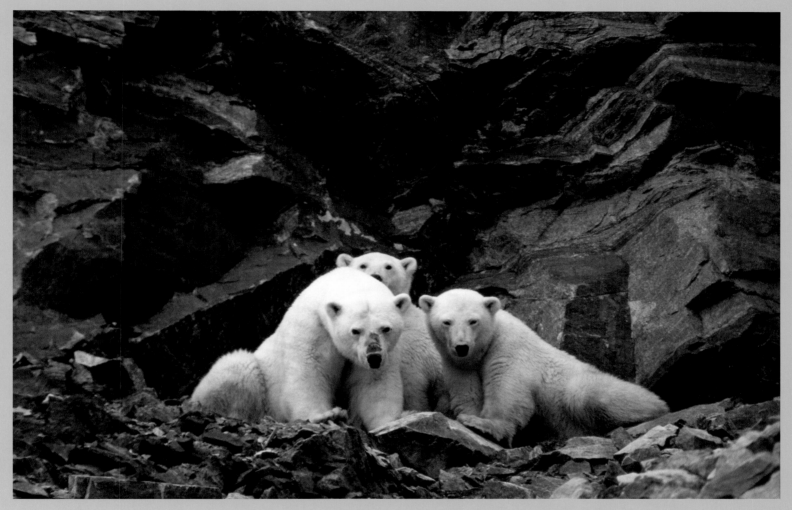

Mother Polar Bear and Offspring on a Ledge, Bylot Island, Nunavut, Canada, 1997

Rare Ivory Gull, Northeast Greenland National Park, Greenland, 1996

Sandfrage Flowering in Ice-free "Arctic Riviera" of Peary Land, Northeast Greenland National Park, Greenland, 1996

LUPINES BENEATH TORRES DEL PAINE, PATAGONIA, CHILE, 1998

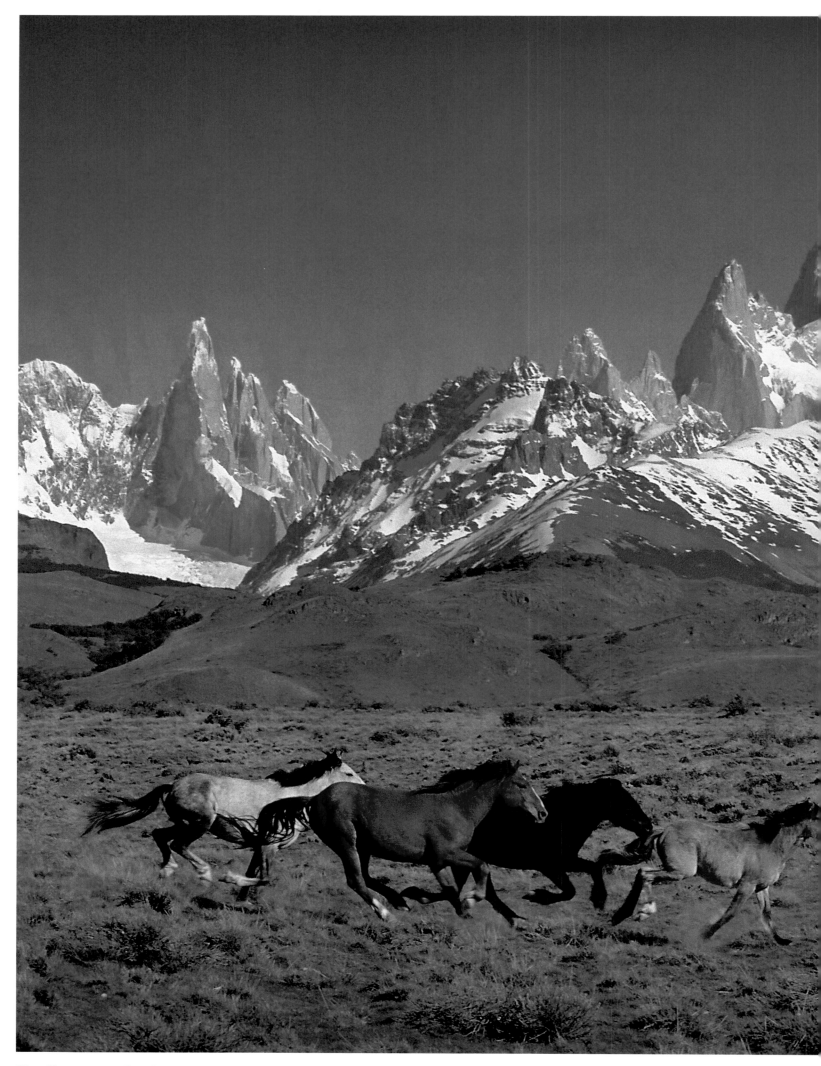

WILD HORSES BELOW FITZ ROY, PATAGONIA, ARGENTINA, 1985

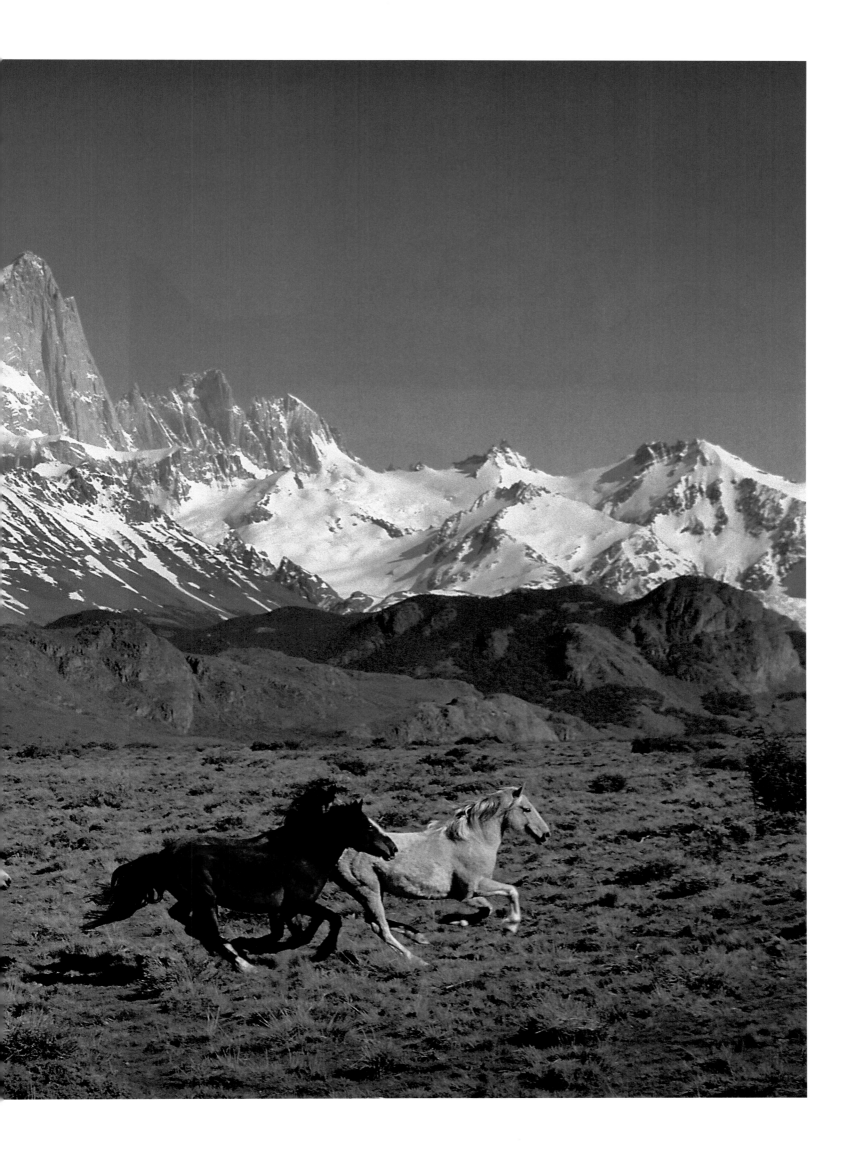

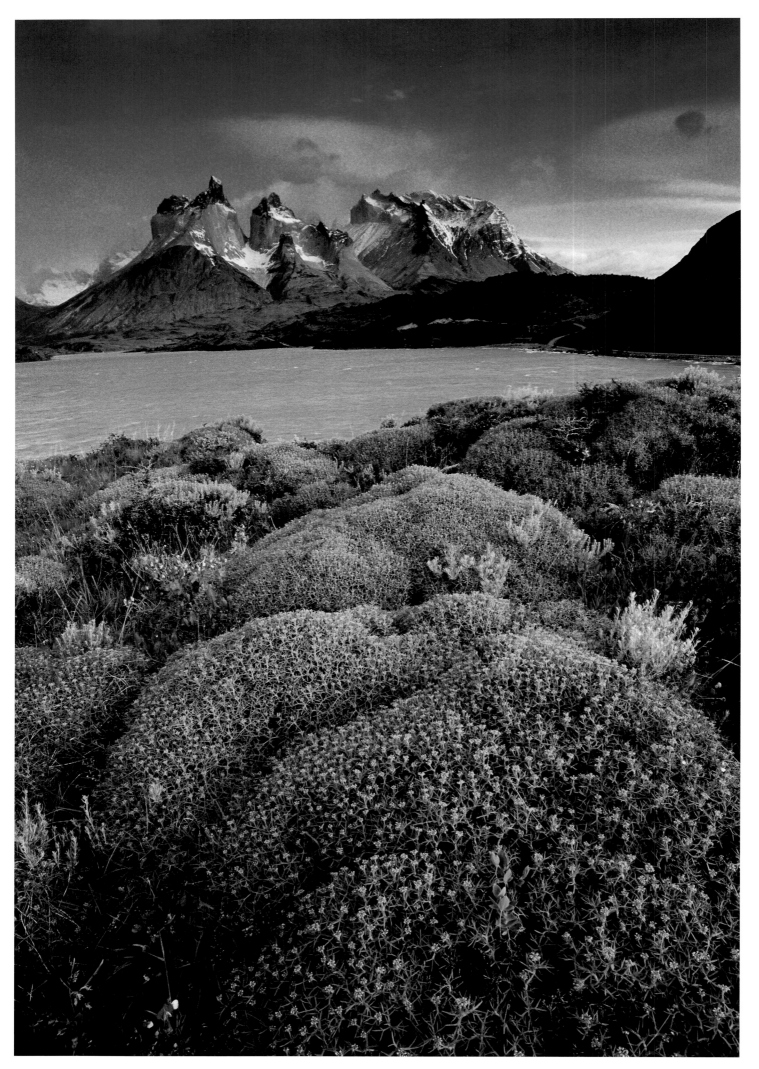

Cuernos del Paine at Dawn from Lago Pehoe, Patagonia, Chile, 1991

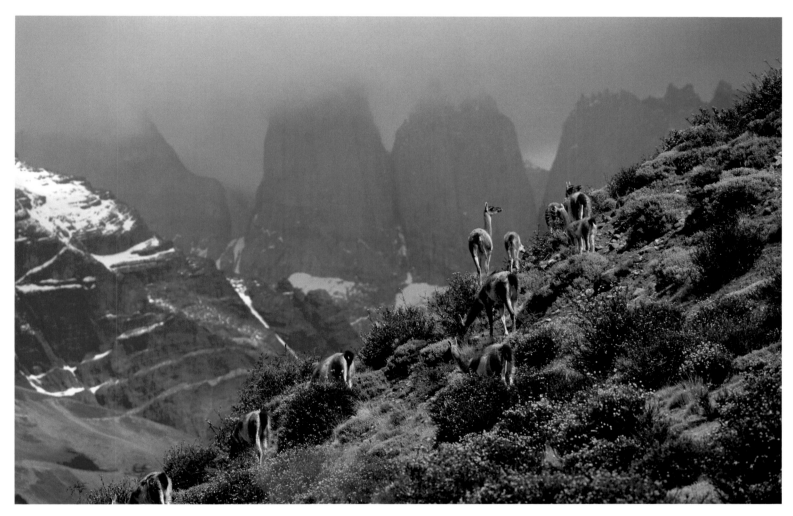

Guanacos (Wild Ancestors of Llamas), Torres del Paine, Patagonia, Chile, 1998

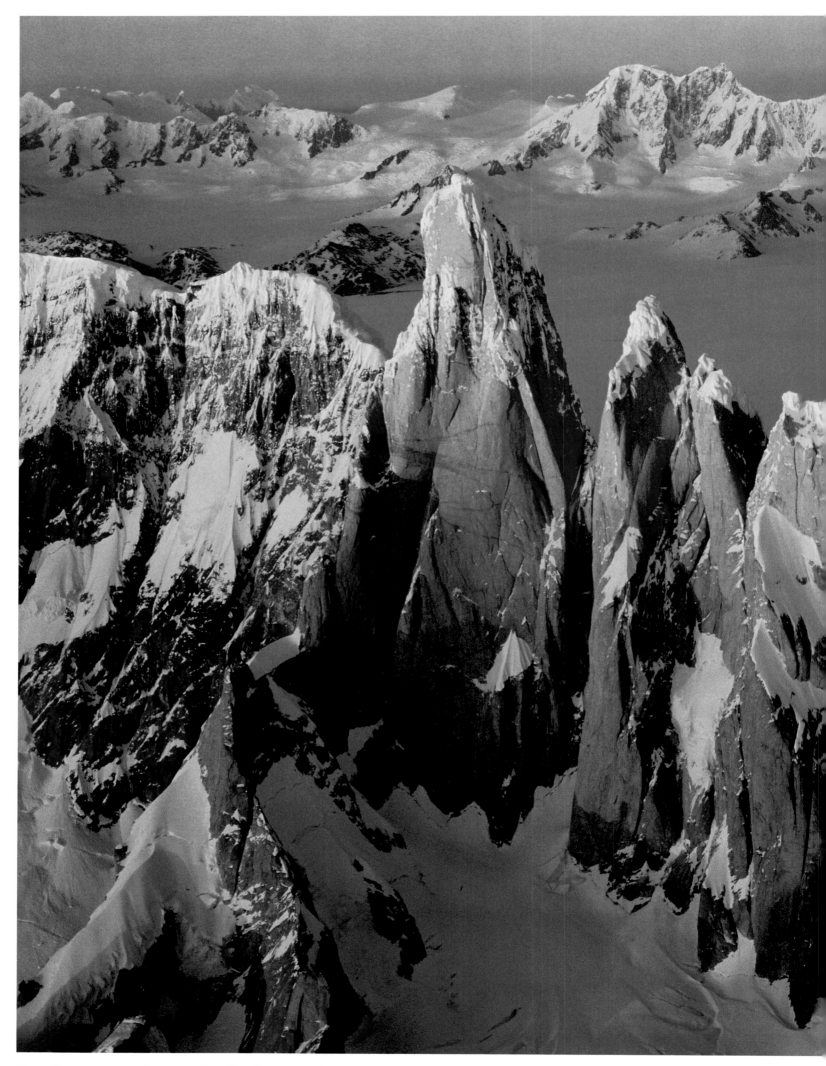

CERRO TORRE FROM THE SUMMIT OF FITZ ROY, PATAGONIA, ARGENTINA, 1985

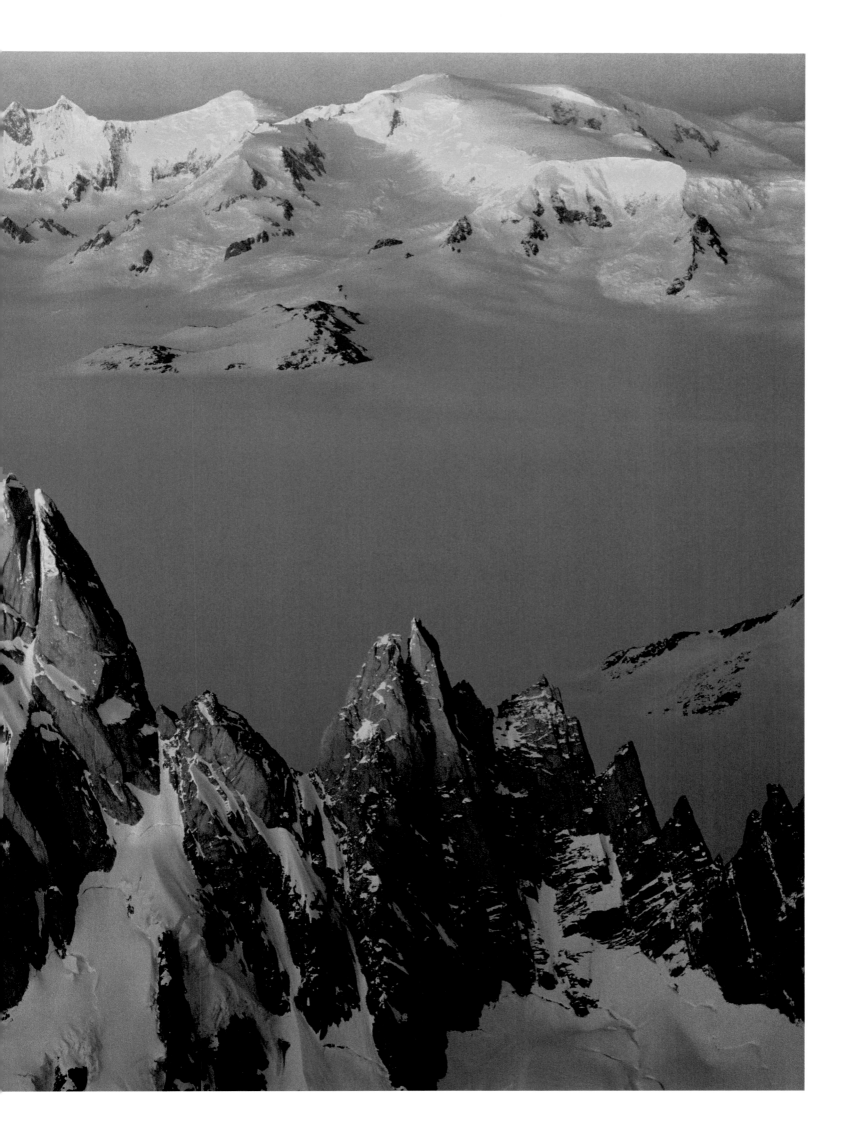

Icebergs near Deception Island, Antarctica, 1992

Midnight Sun on a Tabular Iceberg, Weddell Sea, Antarctica, 1993

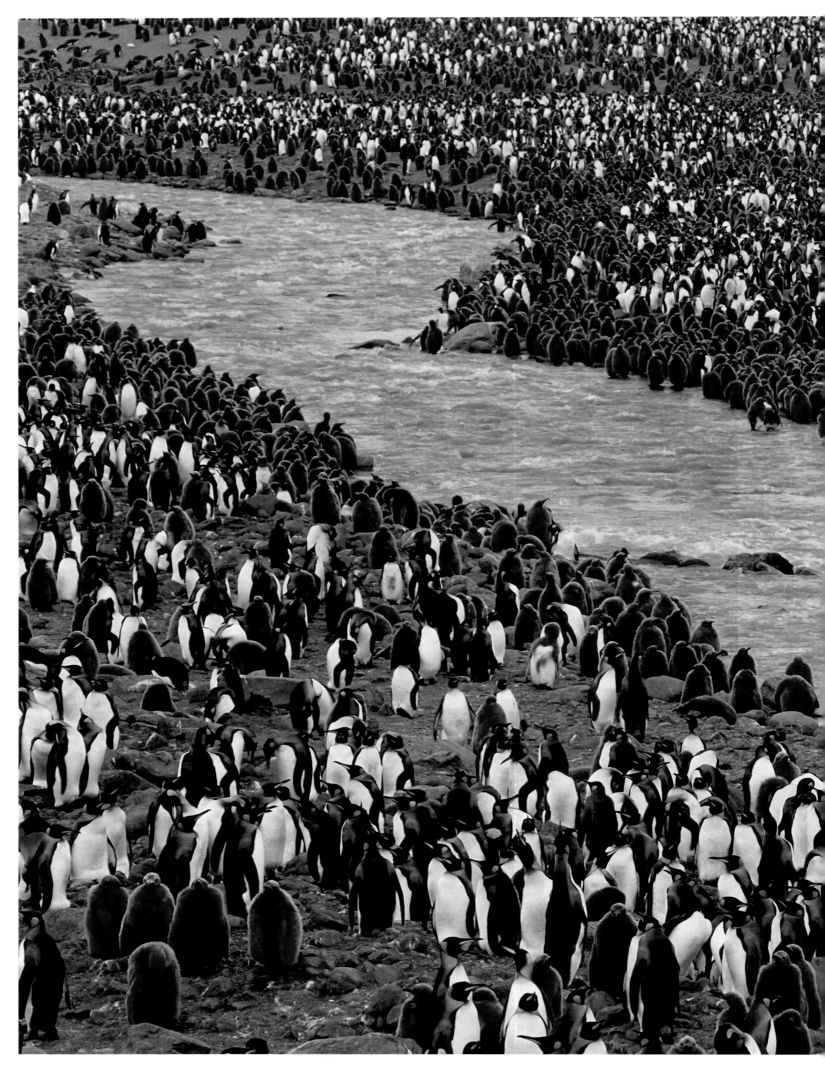

King Penguin Colony, St. Andrews Bay, South Georgia Island, Subantarctic, 1993

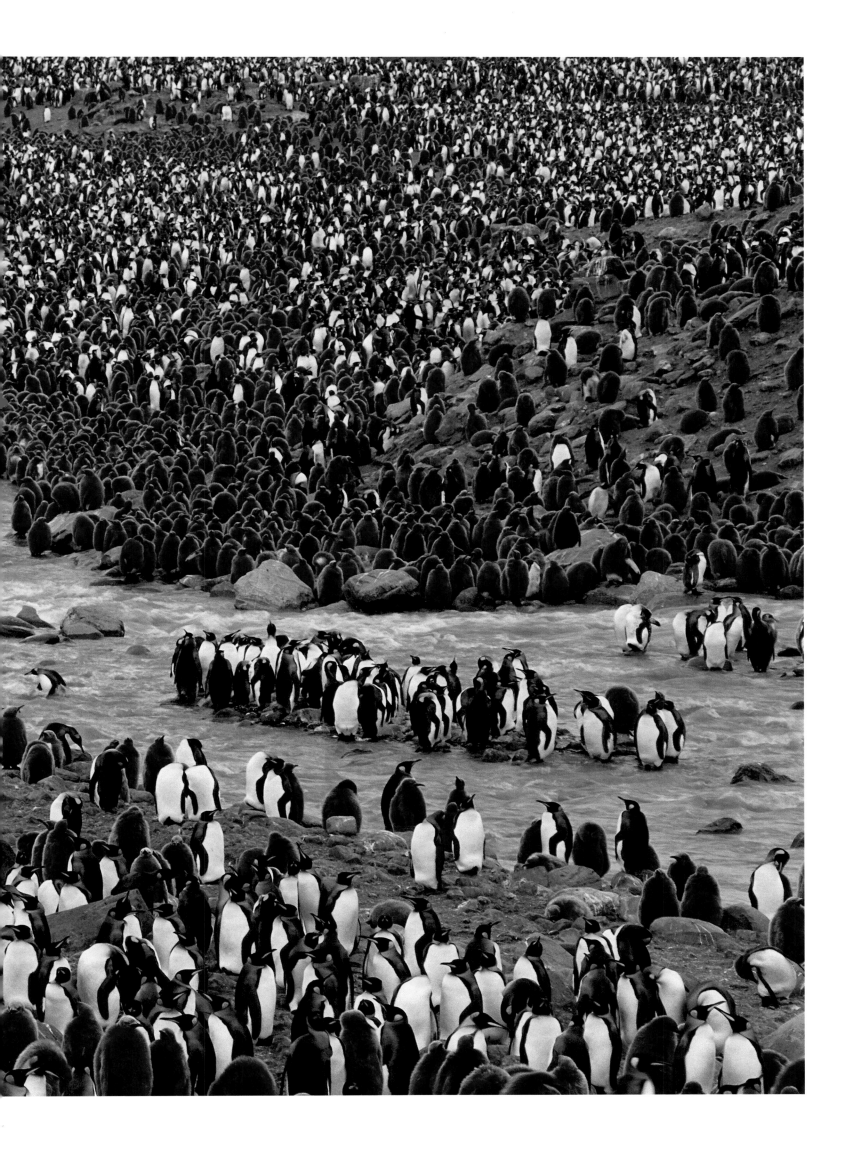

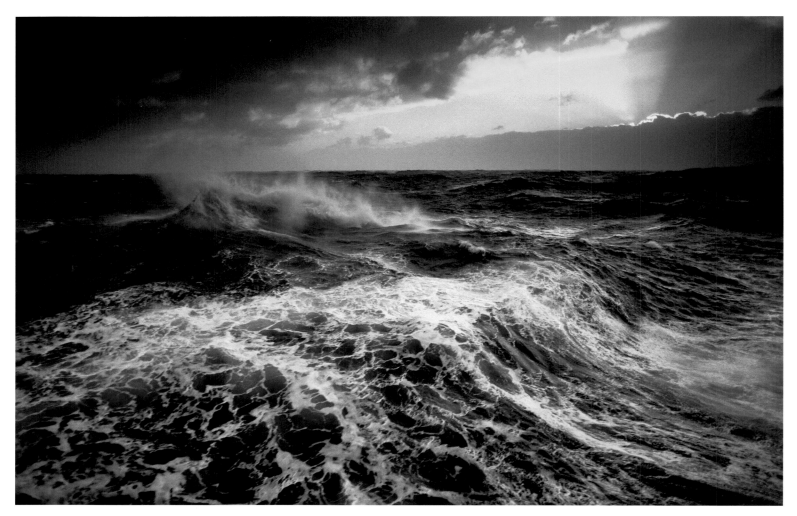

WILD SEAS OF THE DRAKE PASSAGE TO ANTARCTICA, 2002

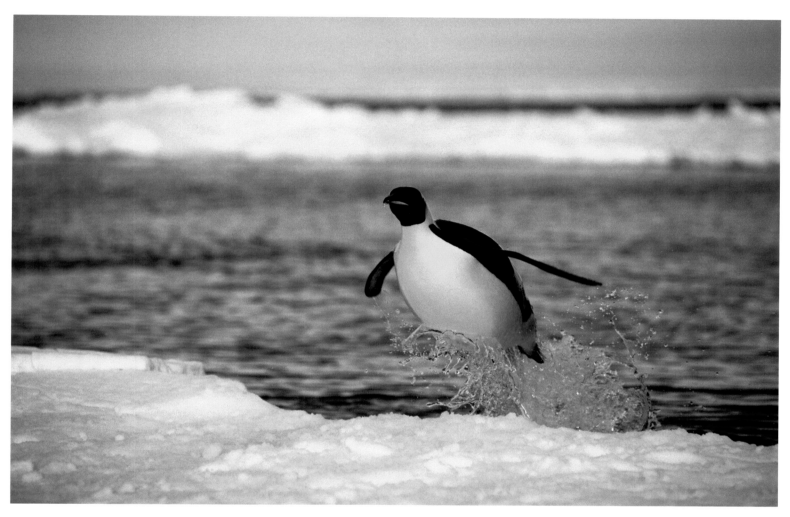

EMPEROR PENGUIN LEAPING THE ICE EDGE, RIISER-LARSEN COLONY, WEDDELL SEA, ANTARCTICA, 1993

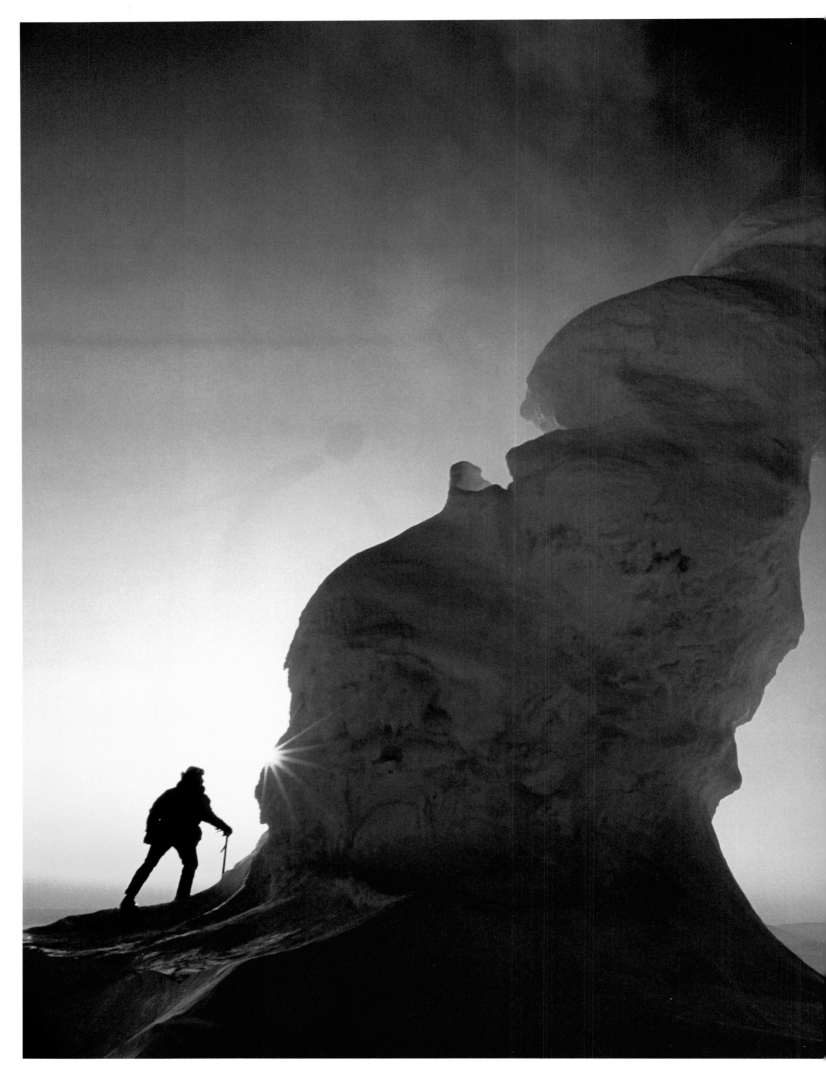

MIDNIGHT ON ICE TOWER RIDGE, MOUNT EREBUS, ROSS ISLAND, ANTARCTICA, 1992

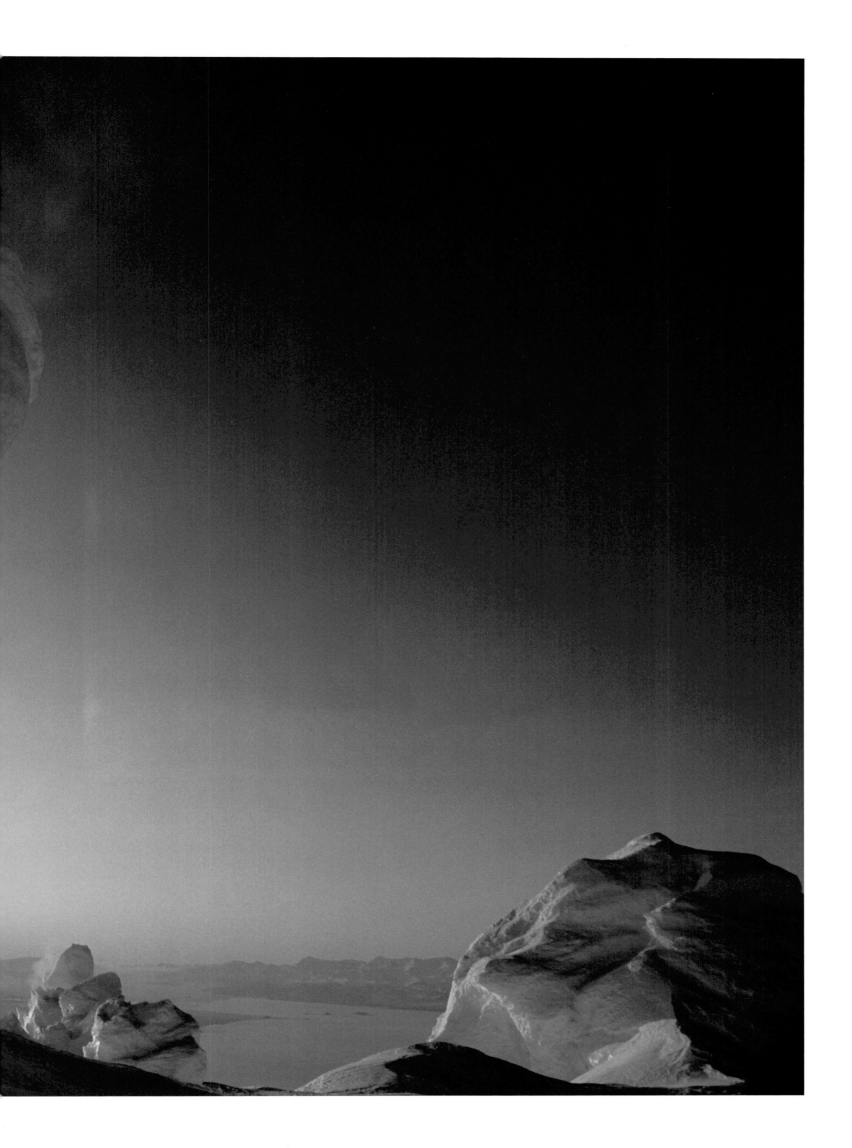

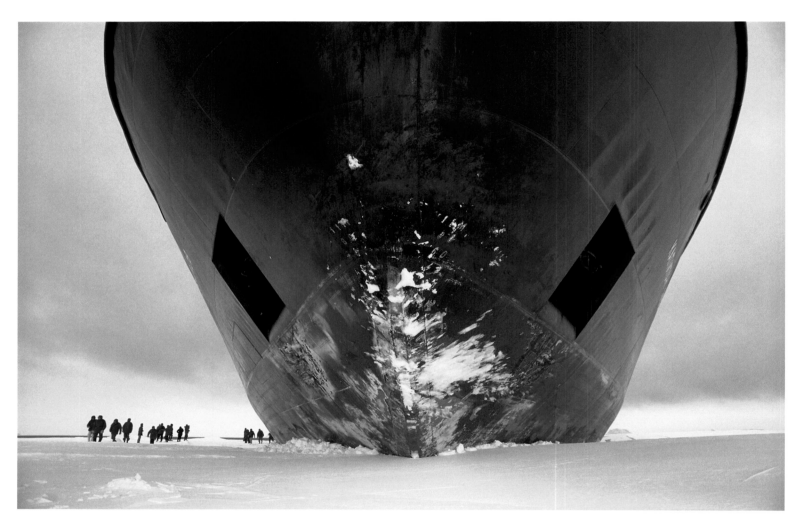

Kapitan Khlebnikov Nuclear Icebreaker in the Weddell Sea, Antarctica, 1993

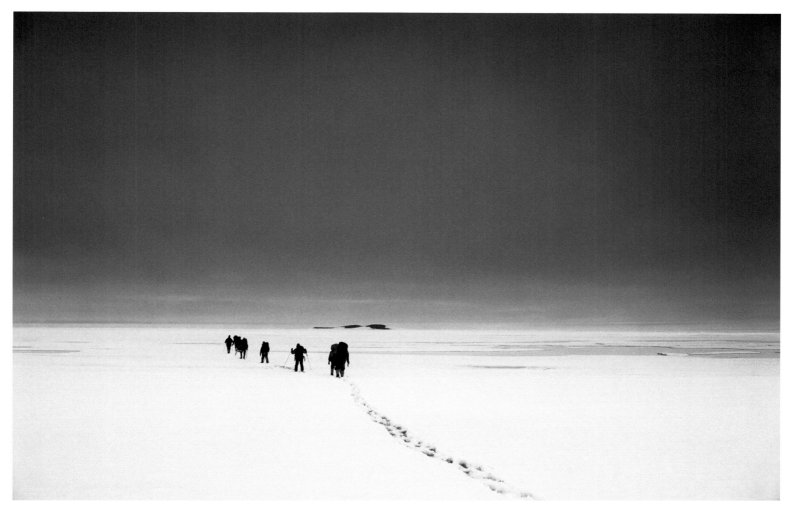

Arctic Ocean Traverse on Expedition Discovering Northernmost Point of Land on Earth, Northeast Greenland National Park, 1996

The Difference between Looking and Seeing

Jimmy Chin and Conrad Anker, my companions on our rickshaw trek across the Chang Tang plateau, stood with me in the rotunda of the National Geographic Society's headquarters in Washington, D.C., admiring the special exhibit of Galen's images taken during our adventure. It was eight months since we had returned from pulling those carts nearly three hundred miles—some of it across country never before seen by anyone from the Western world—following the migration of the *chiru* in our effort to document the calving grounds of this endangered Tibetan antelope. It was only seven months since Galen and Barbara had died in the plane crash.

The prints were large—some of them three by four feet or more—and for each of us they evoked bittersweet memories of our trip. Sweet because for each of us, including Galen, it had been one of the most fulfilling expeditions of our lives; bitter because it had been Galen's last adventure. For the thirty days it took us to follow the *chiru,* pulling our carts across high-altitude steppeland as wide open as an inland sea, I had for thirty nights shared a tent with Galen. When you so suddenly lose someone you have been so close to, it is surreal; at first you can't accept that he won't be calling the next day to invite you to drive to the eastern Sierra for a trail run, a ski, or a climb.

Now the three of us—Jimmy, Conrad, and I—were reliving our adventure with Galen, recalling how exhausted we were in the camp pictured in one of his images on display. Another photograph, depicting us struggling with the carts through a narrow, rocky gorge, reminded us how concerned we were at that moment for the welfare of our carts—our own welfare dependent on whether they lasted until we reached the far side of this untracked wildness, since until then it would be impossible to call for help.

Then we stopped in front of a large print of several basaltic rocks with smooth, faceted faces. The black rocks were huge gemstones rising Stonehenge-like out of the flat hardpan. We were silent for perhaps a full minute before we

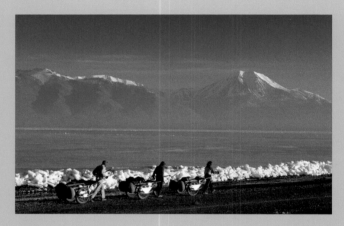

Conrad Anker, Jimmy Chin, and Rick Ridgeway Carting alongside Heishi Beihu Lake, Tibet, 2002

began to comment on how this image, unique among the others Galen had made during our expedition, seemed somehow to capture the wild power of the northwest Chang Tang—the only remaining corner of the Tibetan plateau as yet unoccupied by human beings. We also noted how the image was so quintessentially a Galen Rowell photograph that it was recognizable as his, in the way that a painting by Picasso or Miro doesn't need a caption to be attributed to the artist.

"But where did he take it?" Jimmy asked.

"I was wondering the same thing," Conrad responded. "I don't remember seeing those rocks, do you, Rick?"

"No, and I've been trying to retrace the trip in my mind," I said. "I can't place them."

"It's not like we didn't all walk by them," Jimmy added. "We were together the whole trip."

"That's the thing, isn't it," I replied. "We all walked by them."

Conrad said, "But only Galen saw them."

—*Rick Ridgeway*

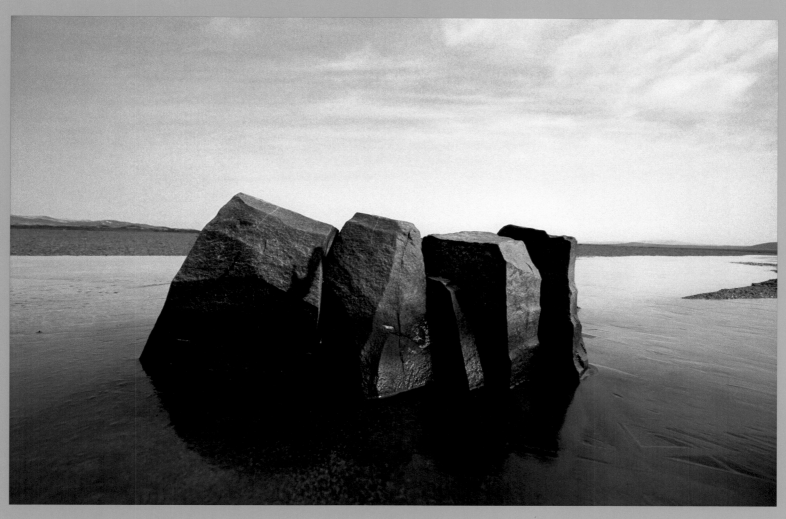

Basaltic Rock Formations, Chang Tang Plateau, Tibet, 2002

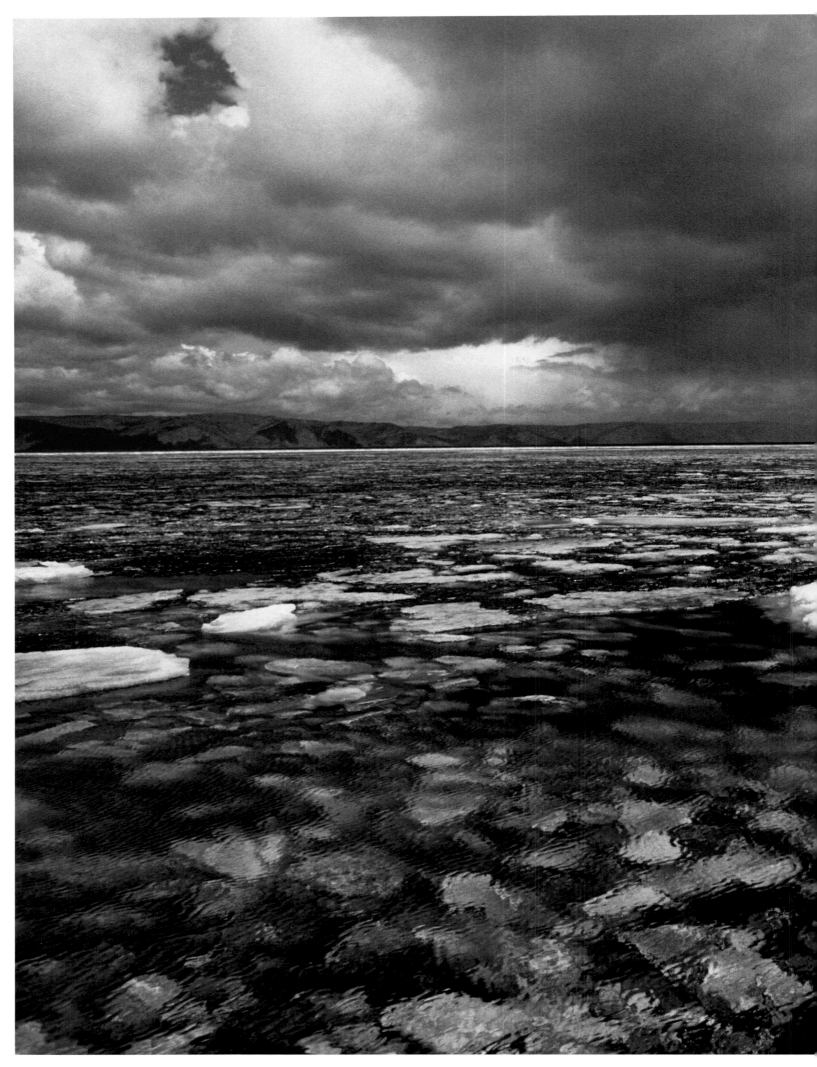

SPRING BREAKUP ON LAKE BAIKAL, THE WORLD'S DEEPEST LAKE, SIBERIA, RUSSIA, 1987

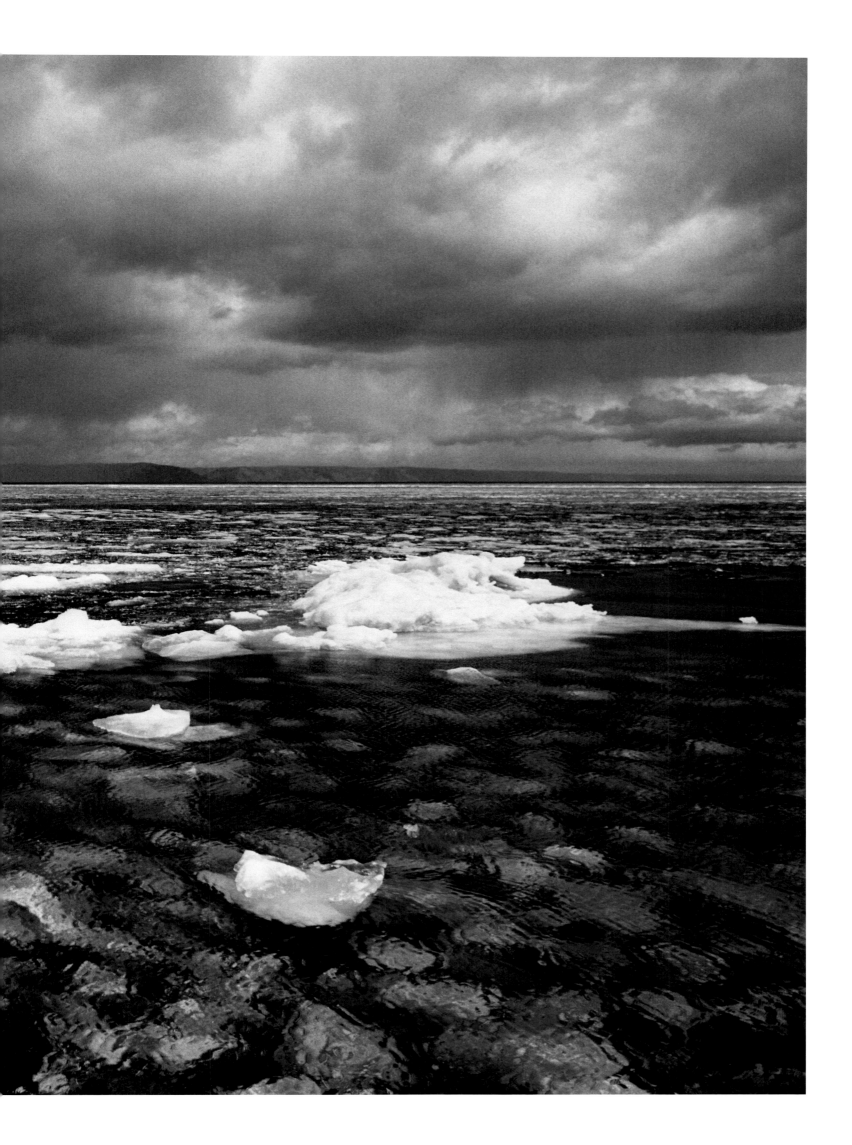

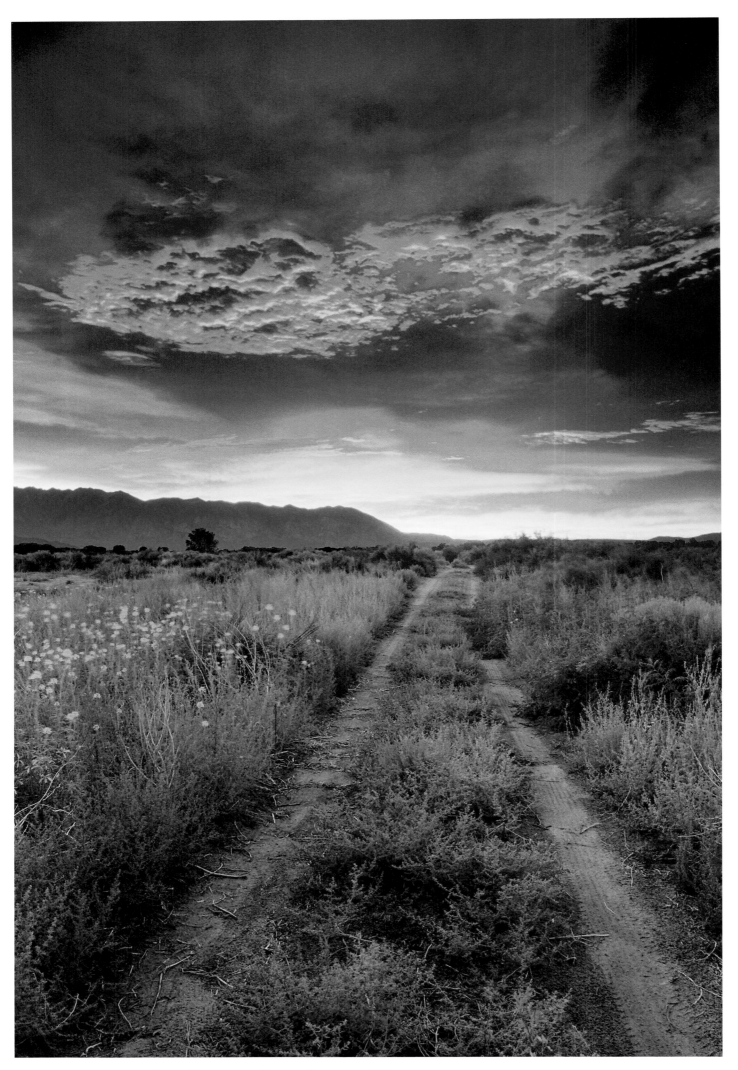

BACK ROAD THROUGH THE OWENS VALLEY, NEAR BISHOP, CALIFORNIA, 2001

COMING HOME

"I've known all along that more of what I am seeking in

the wilds is right here in my home state of California than anywhere else on earth.

But . . . I couldn't say it with authority until I had all those journeys to Tibet, Nepal,

Pakistan, China, South America, Antarctica, and Alaska behind me."

Galen Photographing in Mitchell Canyon, Mount Diablo State Park,
Contra Costa County, California, 1996

Bay Trails and Mountain Light

by Justin Black and Dean Stevens

The Irish author George Moore once wrote, "A man travels the world over in search of what he needs and returns home to find it." This was especially true for Galen Rowell.

His father, Edward, kindled a profound wanderlust in young Galen that would remain with him all his life. Reading his son to sleep with tales of adventure and exploration in the far corners of the world, the professor of rhetoric sparked the lad's imagination with glorious visions of the earth's exotic wonders—the indomitable Himalaya, ice-bound Antarctica, the wild African savannah. It is no wonder, then, that Galen spent the better part of three decades searching for places he had explored in his mind as a child.

Although he gained an early reputation as a California photographer, Galen's first Himalayan expedition in 1975—to K2 in the Karakoram Range—set the stage for his extensive travels to the world's high and wild places. He began to spend many months each year away from home and family in places like Alaska, Tibet, Nepal, Patagonia, and Antarctica. Inspired by Eric Shipton and other mountaineer-explorers, Galen was always pushing himself to new frontiers and achievements, while sharing his experiences with an eager audience through his pioneering adventure photojournalism, essays, books, and lectures.

While Galen's photographs and writings remained rooted in the spirit of adventure, over time his work gained greater artistic depth as he incorporated insights garnered from his climbs, treks, and cultural interactions. His upbringing and his early climbing experience instilled strong conservationist and humanitarian ethics in him. And his appreciation of the places he explored reinforced these principles.

By the late 1970s, Galen's photography had begun a transition from his initial emphasis on adventure to a stronger focus on the natural world in which his adventures unfolded. Rather than photographing adventure for its own sake, he came to treat adventure and landscape as a relationship: the adventure was a part of the landscape, and vice versa.

Galen was certainly conscious of this transition by the time he came up with the concept for *Mountain Light: In Search of the Dynamic Landscape* in the mid-1980s. But the book that

brought his career full circle grew from an idea suggested by his wife and business partner, Barbara, who observed that the Bay Area's many parks and preserves offered more diverse landscapes than some of the world's most touted ecotravel destinations. In *Bay Area Wild* he examined the wild areas and animals of the San Francisco Bay region. Until then he had given priority to faraway places that few people ever have the opportunity to visit. But this book shows his appreciation and intimate knowledge of the natural beauty and unique qualities of places closer to home that he might once have considered mundane. In his introduction, Galen wrote, "Though I had spent decades celebrating the grand design of natural areas around the world in words and photographs, I had looked right past the extraordinarily rich and varied wild hills, valleys, deltas, bay, ocean, islands, and mountains in my own backyard."

While working on *Bay Area Wild,* Galen explored the San Francisco Bay region with the same intense passion and curiosity that earlier had driven him to the Karakoram, Tibet, and Patagonia. Although he had grown up in the Bay Area, Galen found himself astonished by the diverse wild landscapes he discovered. He did more than simply tell the story of how a series of large and relatively pristine greenbelts make one of America's busiest urban areas so special. He captured images that combine the magnificent raw material of the Bay Area's landforms, seascapes, and coastal weather patterns with amazing variations of light, an acute sensitivity to his subjects, and a highly developed compositional aesthetic.

Carrying his Nikon secured in a compact chest pouch and a lightweight tripod in one hand, Galen made frequent trail runs over the ridges of Berkeley's Tilden Regional Park (a short jog from his home), among the redwoods on Marin's Mount Tamalpais, and in other Bay Area nature preserves. As he covered countless miles by road and trail, he built a uniquely personal and comprehensive perspective on the Bay Area's ecological systems. Living conveniently near these landscapes enabled him to return frequently, following the weather and the seasons to photograph his selected locations in their prime. As he returned repeatedly to places that elicited an emotional response in him, his visual interpretations developed into a fully mature artistic expression. Many of Galen's photographs from *Bay Area Wild* rival his best work from the remote corners of the earth.

Although Galen "discovered" his native Bay Area relatively late in his life, he had always considered the Sierra Nevada one of his favorite places. His father had stirred his longing to travel to distant corners of the globe, but his mother, Margaret, a hiker and climber herself, planted the seeds that kept him rooted in the Sierra Nevada.

In many ways, Galen considered the Sierra his home-field Shangri-la. He tried to relocate there in 1979, living for six months in a cabin at Swall Meadows, a small community a few miles north of Bishop. But in the days before the Internet, e-mail, and routine overnight deliveries, his photography business suffered from the isolation. He returned to the Bay Area.

Then, in 2000, Galen and Barbara bought a second home in Bishop. Barbara quickly recognized the potential for a gallery of Galen's work in downtown Bishop along scenic Highway 395. In May 2001 the Bishop branch of Mountain Light Gallery opened in a historic bank building that dates back to the early 1900s. Within a year the Rowells closed the Emeryville gallery and moved their image-licensing business to Bishop: they left the Bay Area behind for good. Galen had spent his life traveling the world only to confirm that the eastern Sierra was the place he loved most.

During his last two years in Bishop, Galen produced some of the strongest, most carefully crafted landscape photography of his career. Although he had a long-established reputation as one of the finest and most emulated landscape photographers of his generation, his career now entered a new phase of artistry. Galen had generally sought out exceptional moments in nature in much the same way that other photojournalists seek out peak moments of human drama. In 2000, however, he approached the magnificent eastern Sierra anew, with a greater sense of patience and deliberation.

With one of North America's most dramatic landscapes now in his backyard, Galen experienced a surge of creative energy, and his new work provided a self-reinforcing upward spiral of inspiration. Every trail run was also a location scouting session. Every time he climbed a local peak he was placing himself and his camera in position to take advantage of unexpected plays of light and weather. As had been the case during the *Bay Area Wild* project, his ability to scout and revisit locations at will gave his photographic ideas time to mature to a new level.

His photograph "Fall Sunrise on the High Sierra over the Owens Valley, California" (see page 233), which Galen attempted on four consecutive mornings before all the elements came together, captures the essence of the place and reveals the subtle change in his style. The best landscape photographs reveal the photographer's artistry while appearing entirely natural and effortless. In this sense, "Fall Sunrise" succeeds brilliantly. It has become his best-selling fine art print.

Arriving once and for all in the eastern Sierra, Galen truly came home. In the foreword of *Yosemite and the Wild Sierra,* released after his death, he wrote:

"Though I have visited many ranges that are higher and found isolated peaks that are more spectacular, I have yet to discover a place with the incredible diversity of beauty and landforms and light that I regularly experience in the High Sierra. I constantly find myself saying, this valley is just like Alaska, that peak is just like Nepal, this arid landscape capped with snow is just like the Karakoram. . . .

"John Muir called the High Sierra 'the Range of Light.' Though he was not a photographer he recognized the way the white granite and snows reflected the glow of eternal sunrises and sunsets. I taught myself how to pursue magical light like clues on a treasure map, and I like to say that the High Sierra was my teacher."

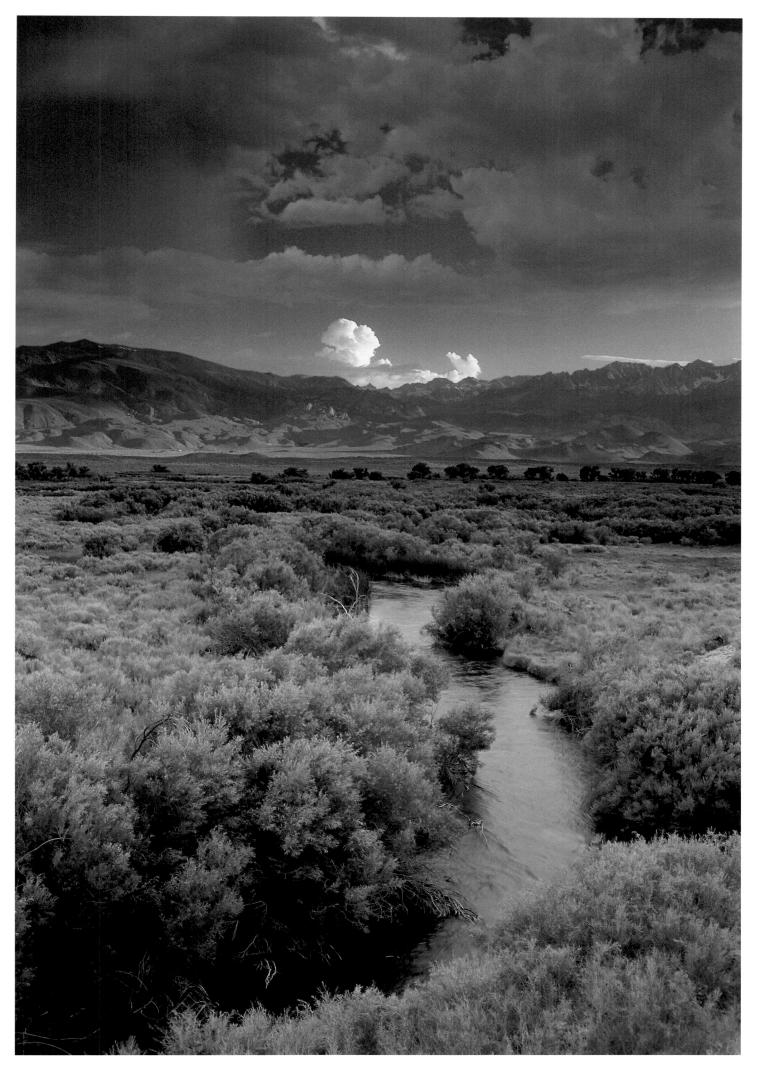

EVENING CLOUDS OVER THE OWENS RIVER, NEAR BISHOP, CALIFORNIA, 2000

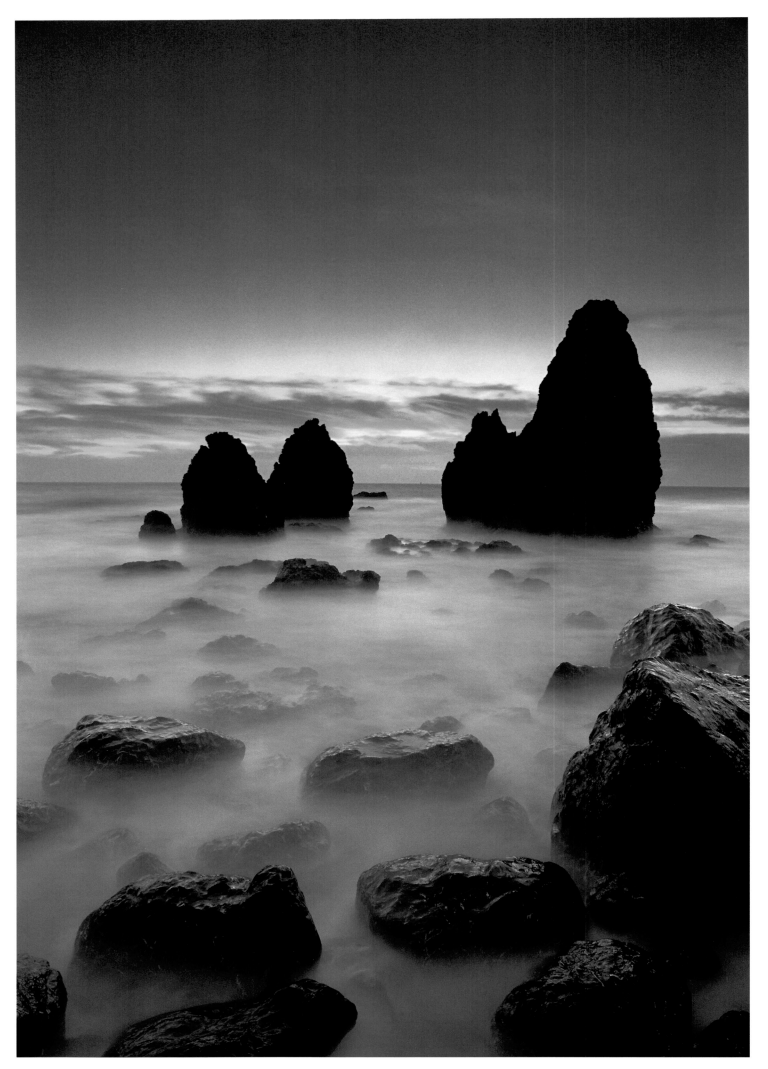

Twilight Surf, Marin Headlands, Golden Gate National Recreation Area, California, 1998

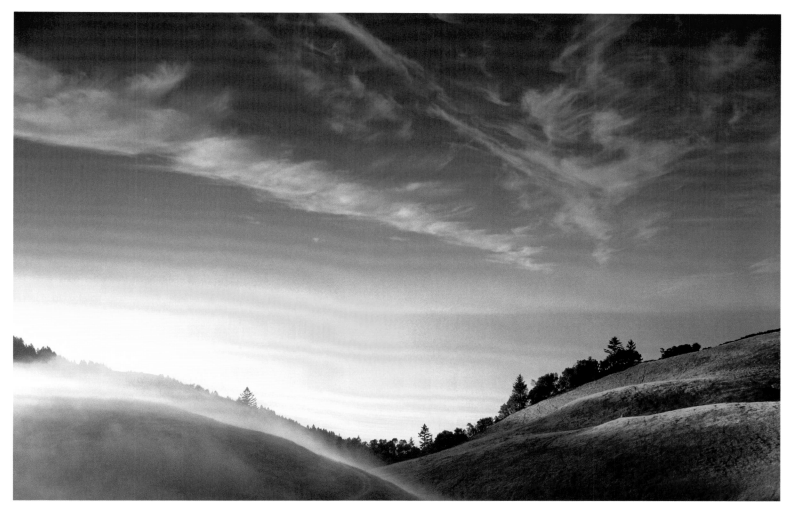

DAWN ON BOLINAS RIDGE, MOUNT TAMALPAIS, MARIN COUNTY, CALIFORNIA, 1996

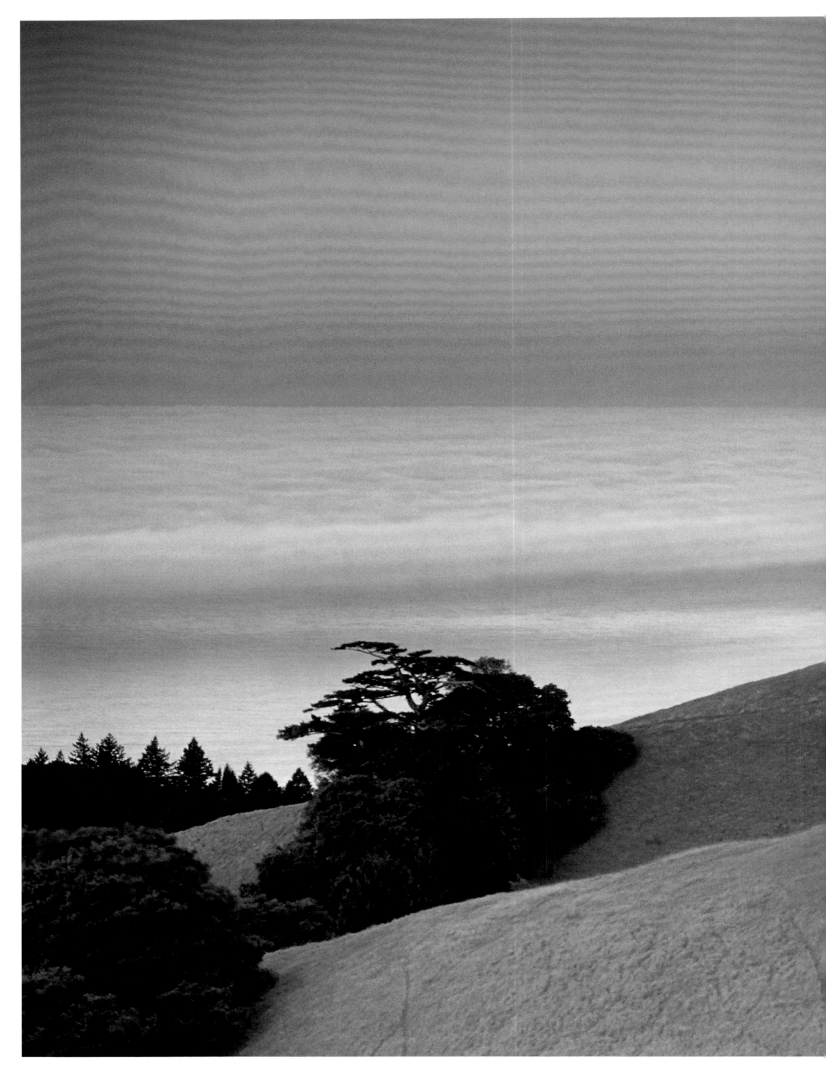

EARTH SHADOW AT DAWN FROM MOUNT TAMALPAIS STATE PARK, MARIN COUNTY, CALIFORNIA, 2001

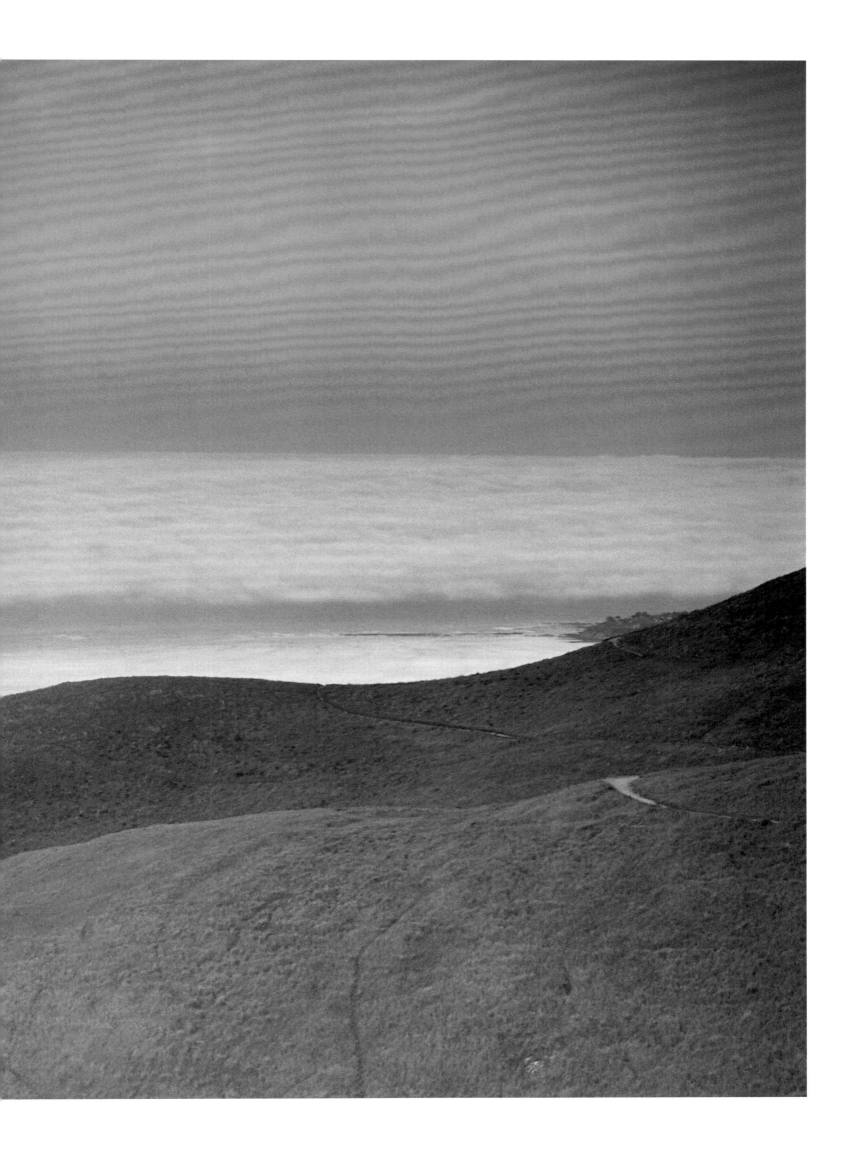

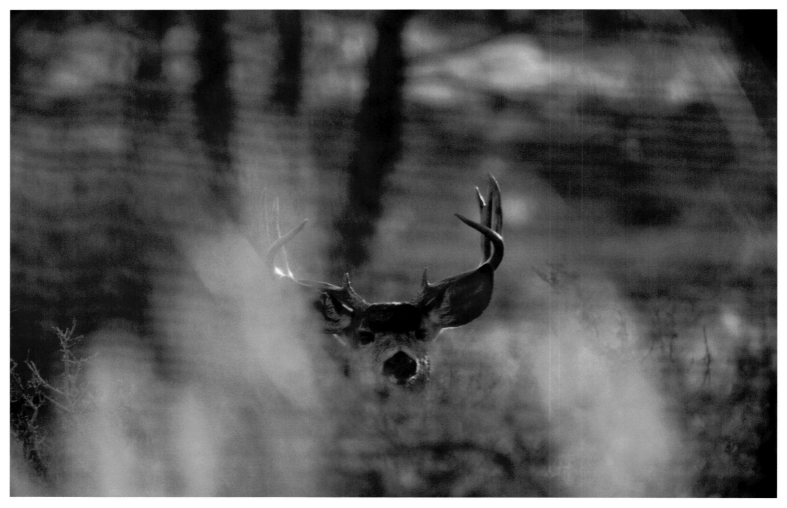

MULE DEER, EASTERN SIERRA, CALIFORNIA, 1979

Coast Redwood and Bigleaf Maple, Muir Woods National Monument, Marin County, California, 1996

GODBEAMS THROUGH MORNING FOG, TILDEN REGIONAL PARK, BERKELEY, CALIFORNIA, 2000

NEW POSSIBILITIES

I first saw this image hanging on the wall of the Mountain Light Gallery when I returned to Bishop, California, my birthplace, for Galen and Barbara's memorial. Despite my sorrow, the photograph took me aback and I was deeply moved by it. Quickly it became one of my personal favorites out of all the pictures Galen created.

Part of the reason I love the scene is that it lovingly captures—in an almost painterly fashion—a sense of the place where I grew up. The background mountain panorama was one of the first things I ever saw, and many of my youthful adventures were set amid rabbitbrush similar to that seen in the foreground. Throughout the forty years I lived in the Owens Valley, this spot remained a favorite place for me to hike, bike, and reflect. Despite my own growing photographic career, however, I never envisioned a photograph remotely like this one. It took Galen and his boundless creative energy to find it.

Notably, this was not an image I would have identified instantly as Galen's. Most of his work exudes a personal power that permeated everything he did: from the enormous physical strength that propelled him to vantages few could reach, to the incessant thought behind his exacting compositions, to his unique eye for lighting that molded a vision radiantly his own. Seldom did I have to look at a credit line to tell whether an image was Galen's.

In light of his distinctive style, this scene caught me by surprise. To me, at least, it signaled a significant shift in his vision, a growing sensitivity to subtleties in the landscape around him. Here, I feel as if the environment itself created the picture and Galen simply used his lifetime of skills to let it speak on its own behalf.

As I learned more from Mountain Light manager Justin Black about how this image was made, I realized that its creation invoked both Galen's power and his growing ability to be artistically intimate. Significantly, it was not just a grab shot but something he had planned over the course of numerous predawn runs, when he always scouted future locations. Odds are that he wasn't certain what he was going to find when he left home that morning, but as always he departed with his camera strapped to his chest and his mind and legs racing toward the possibilities. This particular sunrise is what he found. If it had been cloudy, I doubt that he would have missed the shot. Knowing Galen, he'd have been back again to try it another day.

Given Galen's enduring physical gifts and newfound intimate vision, I find this picture especially poignant—a heart-wrenching hint at a whole new body of work that we otherwise might have seen from him in the future.

—*Gordon Wiltsie*

FALL SUNRISE ON THE HIGH SIERRA OVER THE OWENS VALLEY, CALIFORNIA, 2000

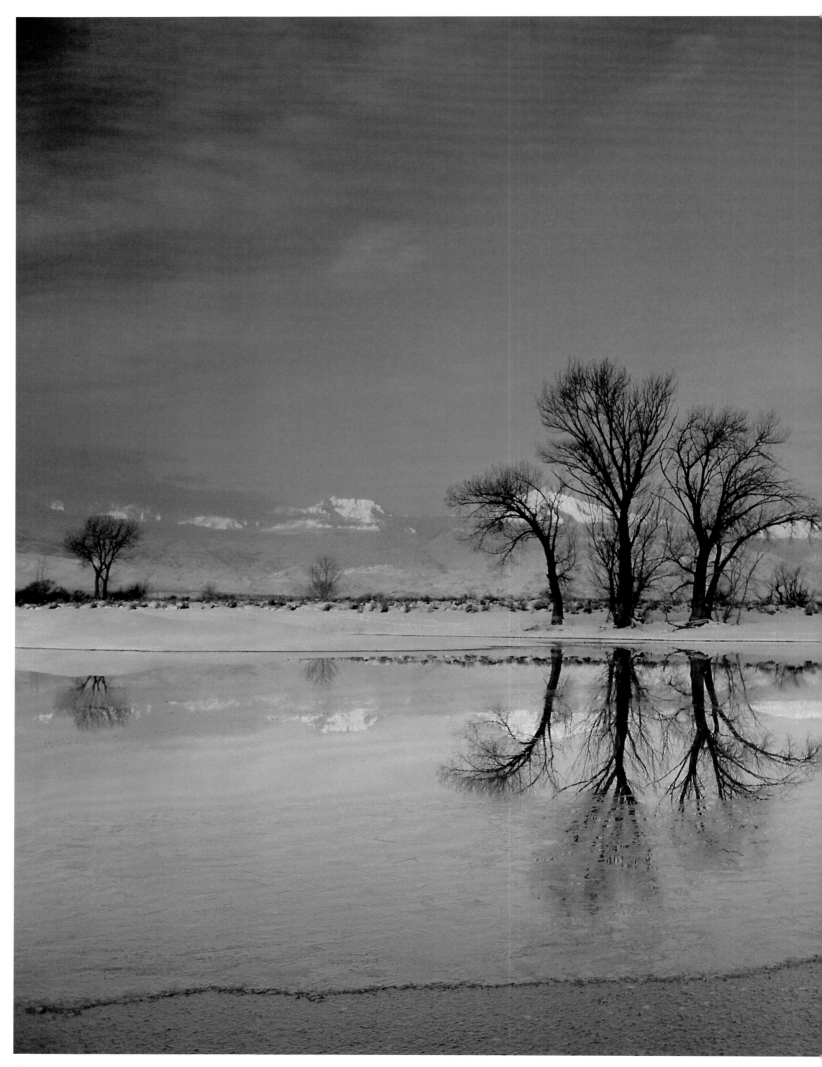

WINTER SUNRISE ON THE EASTERN SIERRA OVER AN OWENS VALLEY POND, CALIFORNIA, 2001

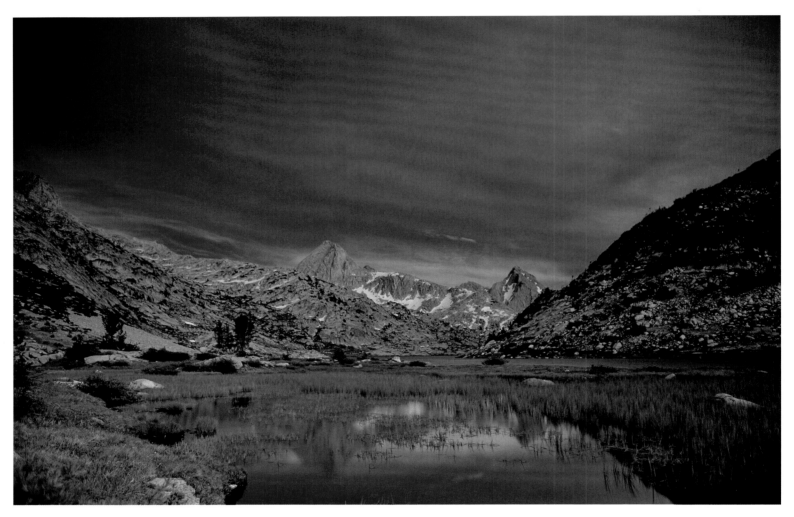

STORMY SUNSET OVER EVOLUTION LAKE, JOHN MUIR TRAIL, HIGH SIERRA, CALIFORNIA, 1997

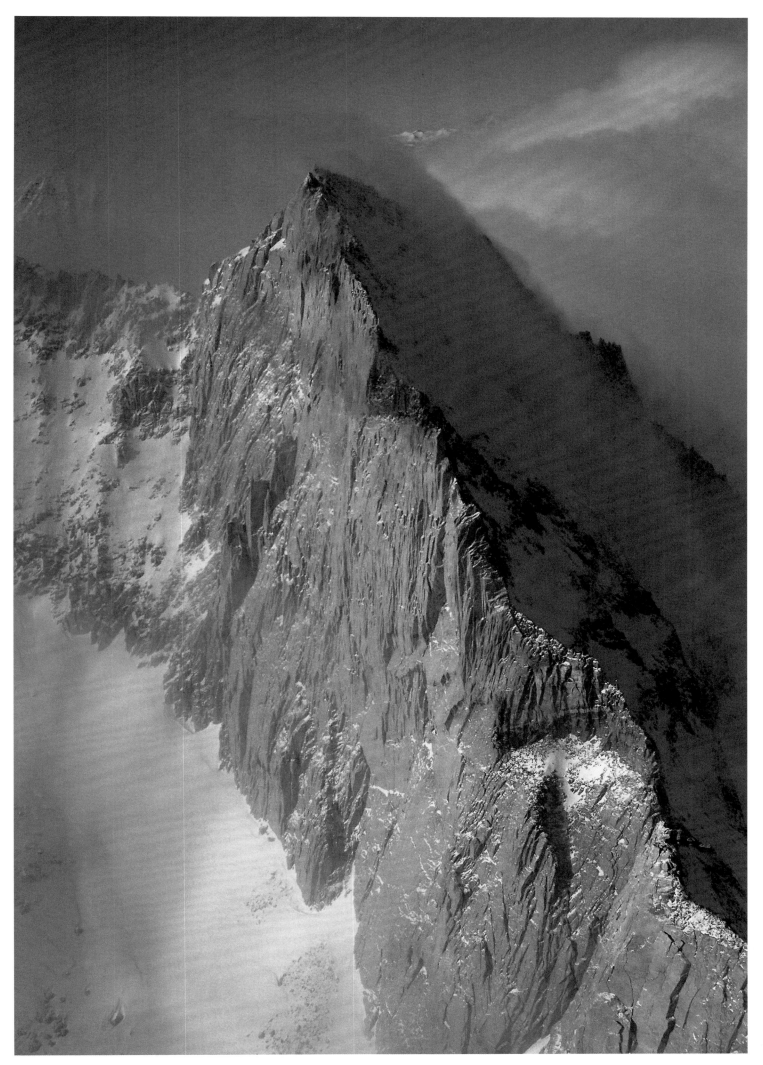

Winter Aerial of Bear Creek Spire, High Sierra, California, 1980

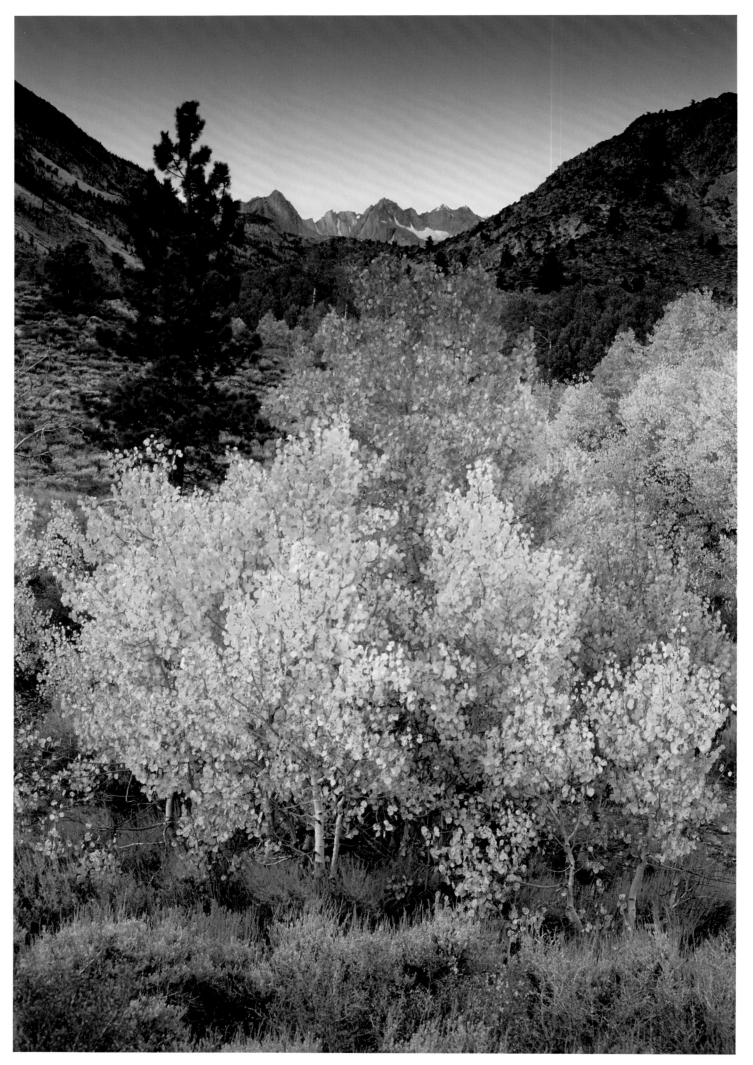

FALL SUNRISE IN BISHOP CREEK CANYON, EASTERN SIERRA, CALIFORNIA, 2000

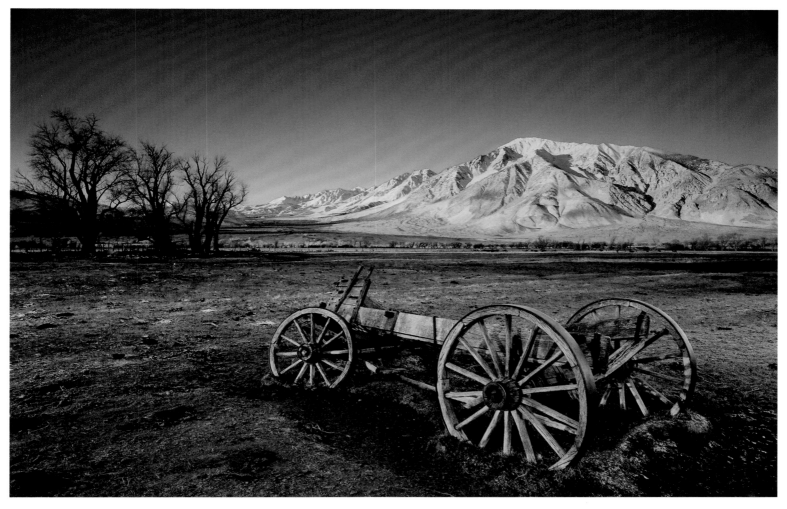

OLD WAGON BENEATH MOUNT TOM, ROUND VALLEY, EASTERN SIERRA, CALIFORNIA, 2002

Snow-bent Aspen Trunks, South Fork of Bishop Creek Canyon, Eastern Sierra, California, 2001

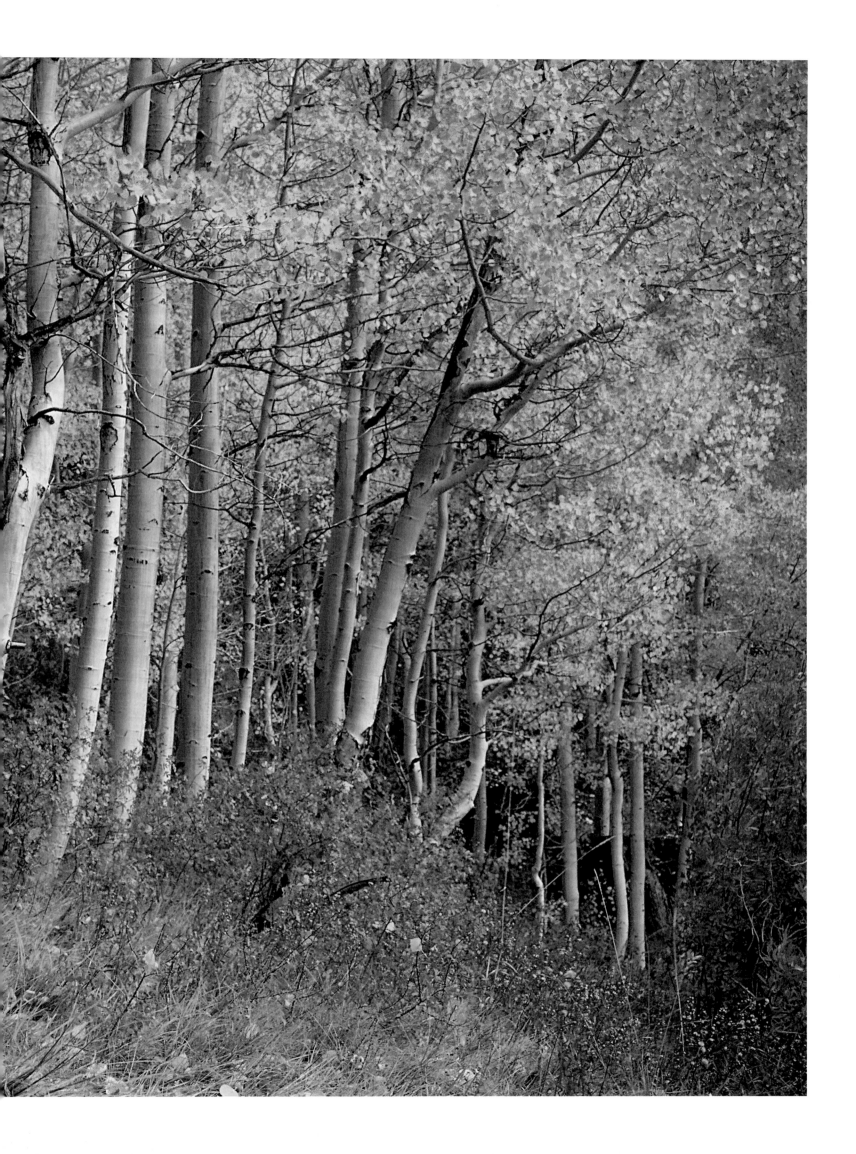

MAKING PICTURES AT THE EDGE

Nature photography is the capture of a rare moment in time. Rendering the intangible, the transitory, a heartfelt gorgeous moment, the camera brings an instant in eternity to the viewer. In this photograph of Mount Whitney, fog and cloud remnants cling to rock spires, with cloud and mountain all gloriously bathed in dawn light. But one thing presents itself immediately to me: this could be any mountain, anywhere in the ranges of the world. It is a photograph of emotions. We are brought to a fabulous place and time emotionally. It is the emotion Galen elicits that is the power behind his photographs.

I am also struck by the energy he expended to reach that power. One mid-July my son Marc and I made a standard ascent of Mount Tyndall, not many miles from Mount Whitney. Arriving at the summit of this Fourteener (one of a handful of peaks in the lower forty-eight that top 14,000 feet) to photograph at sunrise with my 4 x 5 large-format camera, I had time to look over recent entries in the summit logbook. There was Galen. His entry read something like, "Superb climb up east face rock to summit, superb views." It was dated February of that same year.

Galen carried a 35mm camera and went light. But he went everywhere. His gift for capturing the timeless moment after making a rigorous climb to great heights in any part of the world impressed me. His energy and creative sense of timing, his passionate spirit and confidence in his personal vision, combined in bringing him to make photographs at the edge. The edge, both literal and intellectual, mattered to him. Certainly it shows in his photographs, but it also shows in the depth of introspection he expressed in his *Outdoor Photographer* column. Galen's intensive analysis of his own photographs is inspiring to me. Exploring why a photo wasn't up to the image he had in mind when making the exposure, he could acknowledge an ordinary capture of a great subject. That analysis allowed him eventually to make the extraordinary capture, at the same time teaching other photographers why something doesn't work. In this photograph—as with many of Galen's High Sierra images—I find a close relationship with my own work. My wilderness beginnings were childhood pack trips into the Sierra with my parents in the 1950s. My first solo hike was a one-day trek to the summit of Mount Whitney. I carried a Speed Graphic then and hand-held a few harmless images from the ridge at the top. Those soft-focus, midday shots quickly taught me to become more involved with my subject. Galen's forte may well be his involvement with his subject.

So the mountain in the photograph is also my mountain. In spirit, I have shared with Galen many special Sierra moments. I will continue to be enriched by his creative spirit, as I am by the mountain itself.

—*David Muench*

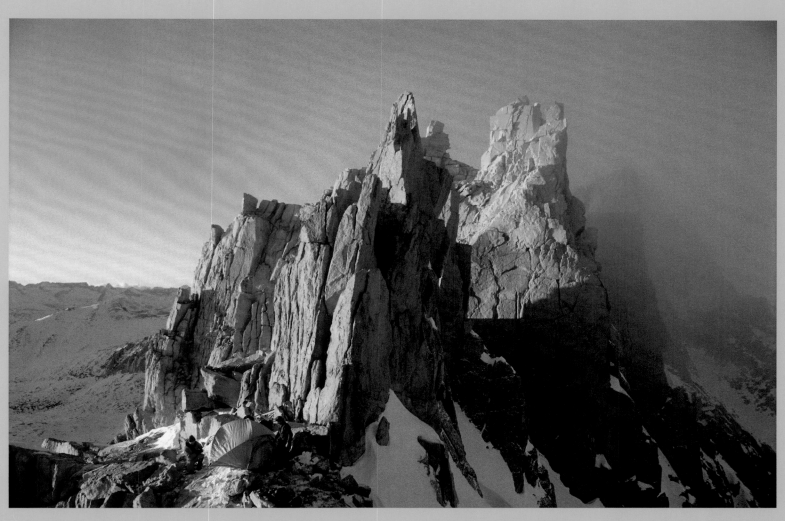

TRAIL CREST ON MOUNT WHITNEY, HIGH SIERRA, CALIFORNIA, 1995

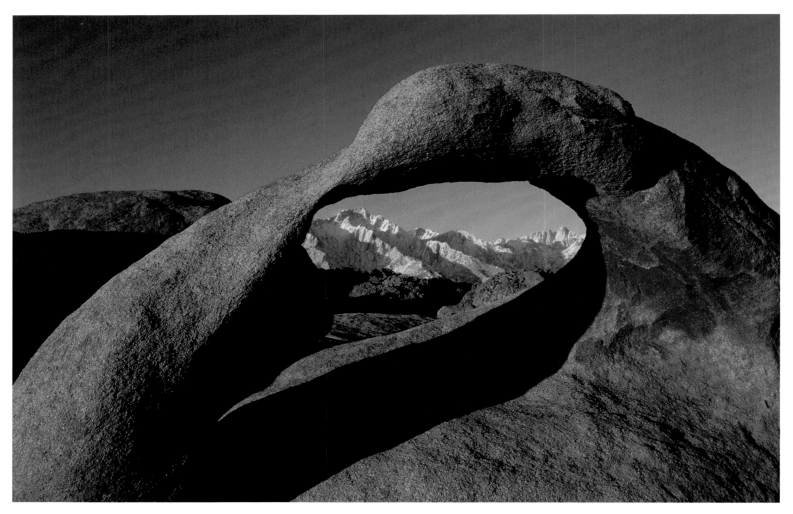

ARCH IN THE ALABAMA HILLS BENEATH MOUNT WHITNEY, OWENS VALLEY, CALIFORNIA, 2001

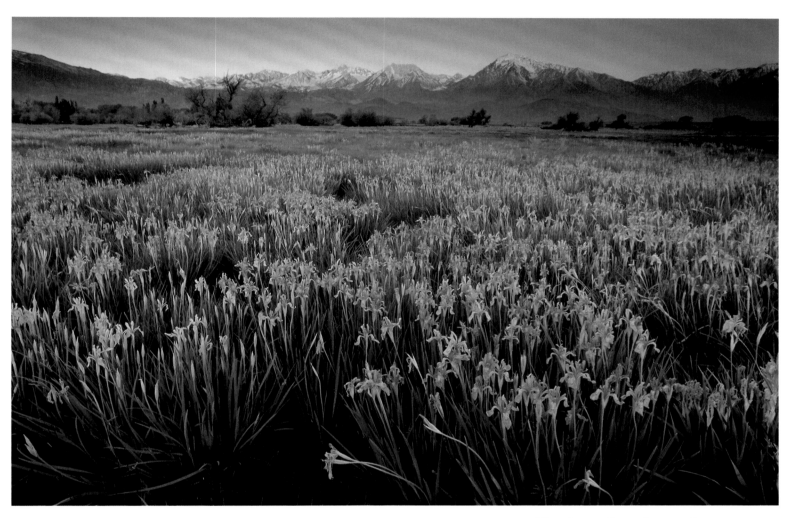

WILD IRIS AT DAWN, BISHOP, CALIFORNIA, 2001

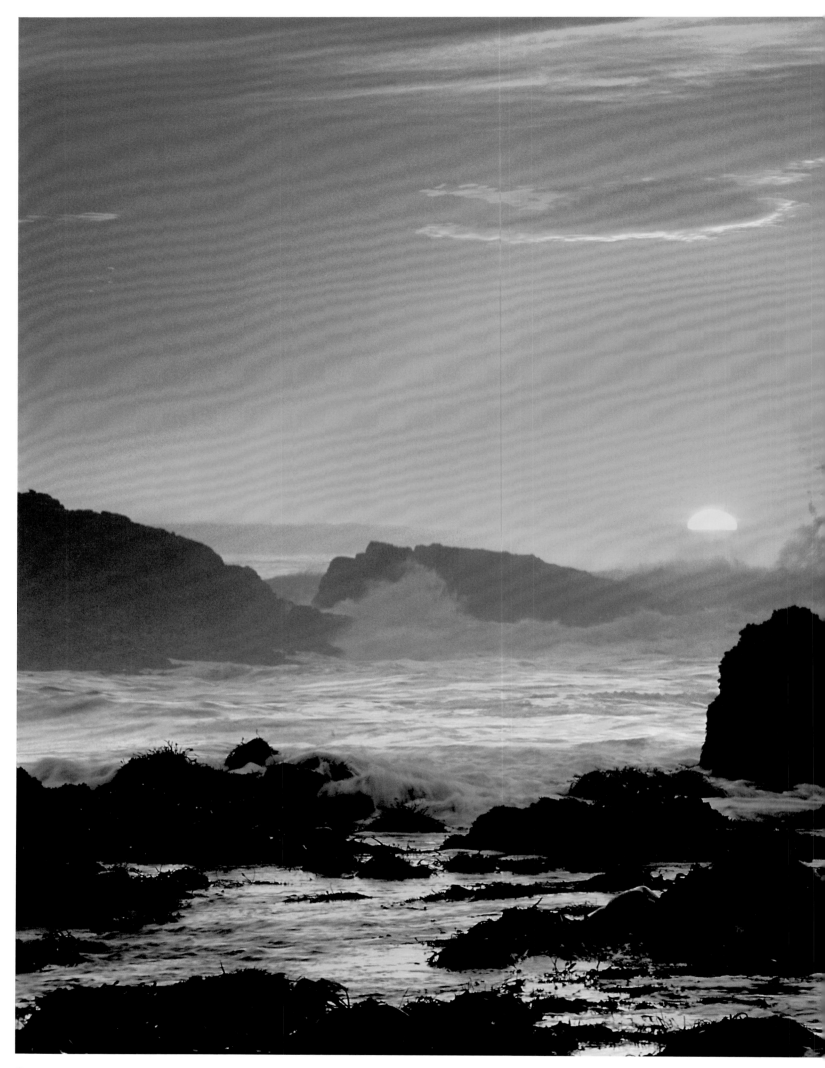

Sunset at Pescadero, San Mateo Coast, California, 1995

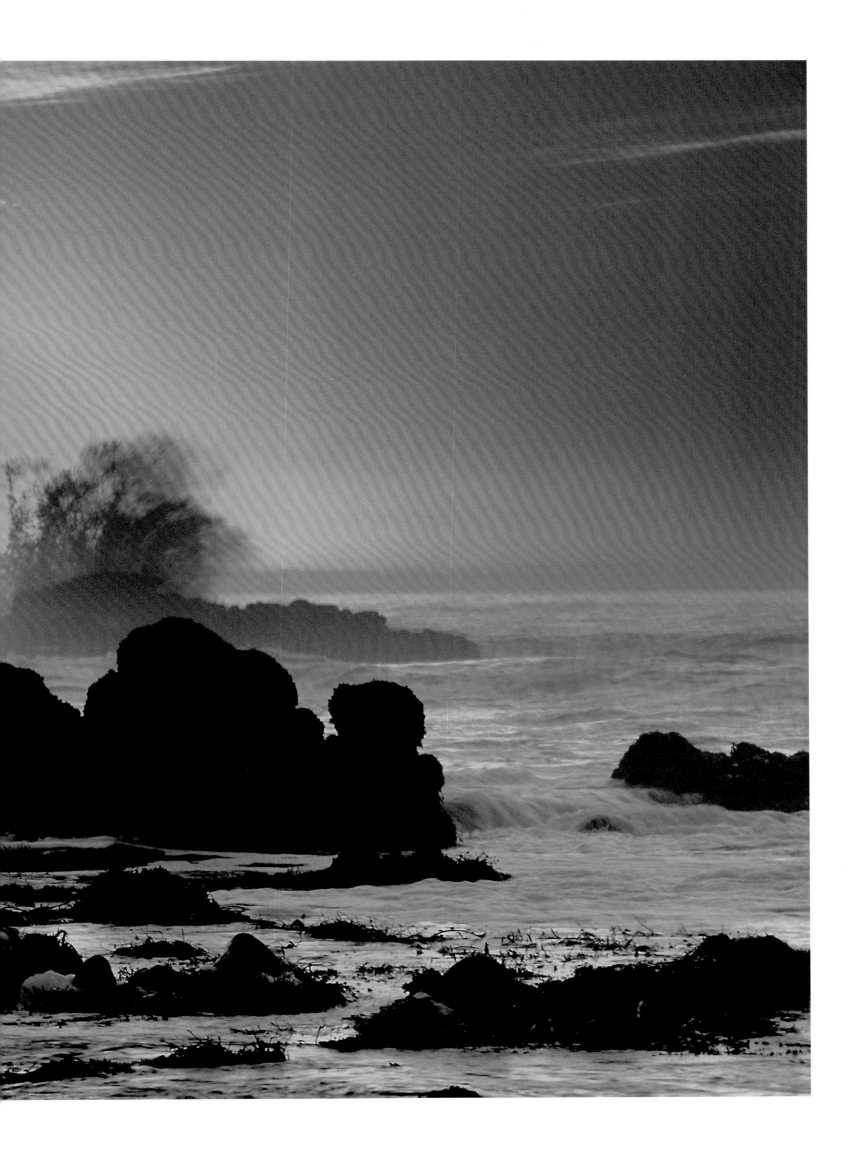

SPLIT ROCK AND CLOUD, EASTERN SIERRA, CALIFORNIA, 1976

The Visionary Landscape

"Our ancestors were far more attuned to the processes of the visionary wilderness than we are today, but there are still shamans among us who know how to escape that limited world of sight that Plato once called a 'prison house.'"

GALEN "CAUSING THE SUN TO SET," MOUNT TAMALPAIS, MARIN COUNTY,
CALIFORNIA, 1998

Transcending Nature

by Frans Lanting

On a rainy autumn day in 2002 I walked into a Minneapolis art museum to see "American Sublime," an exhibition of American landscape painting from the nineteenth century. As I wandered among canvases that depicted scenic wonders of North America, I was struck by parallels between the work of celebrated painters like Albert Bierstadt and Frederic Church and some of Galen Rowell's signature images. I noticed similarities in their use of evanescent light to express peak moments in nature and in their deployment of human figures to give scale and impress upon the viewer that nature dwarfs humankind.

The parallels are not coincidental. Many painters of that era were influenced by transcendentalism, a philosophy that puts nature at the center of human inspiration. More than a century later these ideas have had a profound impact on nature photographers and environmentalists alike.

As a visual artist, Galen Rowell is a modern transcendentalist, in my opinion. The ideas articulated in the nineteenth century by Ralph Waldo Emerson and Henry David Thoreau, and later embraced by John Muir, entered popular culture in the 1960s. In Galen's hometown of Berkeley during the 1960s and 1970s, bookshelves were loaded with the works of contemporary writers who expressed transcendentalist ideas: Loren Eiseley, Gary Snyder, Edward Abbey. Photography books also expressed the sublime in nature, as seen by Ansel Adams, Eliot Porter, Philip Hyde, and others featured in the groundbreaking Sierra Club Exhibit Format series launched by David Brower. Galen was influenced by all of them. Their books lined his library shelves, and he cited them in his own work—and took their ideas as a personal call to action.

Although his personal and professional interests were wide-ranging, Galen's enduring love was landscape photography, and his greatest contributions were in that field. He infused a great American tradition with a new energy that reflected his personality, bringing action to photography and pursuing it with enthusiasm and zeal. Galen was in perpetual motion all his life. His strength and drive enabled him to go farther, higher, and faster than any other photographer I know. He was remarkably disciplined, both physically and mentally. When we worked together in the field, I marveled at the way he moved with absolute focus and economy of motion.

But Galen did not just connect physically with landscapes. His photographic vision grew

out of a unique mix of athletic abilities, technical skills, intellectual understanding, and artistic intuition, which enabled him to identify, chase, capture, and interpret those ephemeral moments when light and landscape interact in ways that transcend specific situations. Galen often looked for light rather than substance to express his peak moments in nature. But unlike nineteenth-century painters who could conjure transcendental moments on an empty canvas, Galen had to work with real landscapes to achieve his imagery. To that end he pioneered a new approach that he defined in his now-classic book *Mountain Light* as "a search for the dynamic landscape." What this credo meant to Galen personally was: Travel light, anticipate opportunities, shoot fast, keep moving, and enjoy yourself.

During the photographic workshops that Galen and I co-taught periodically, I saw how dramatically different his approach was from that of most other landscape photographers. On one occasion we had taken our class to a scenic location north of San Francisco and gathered on a road overlooking hills rolling down to the Pacific. The scene was not terribly exciting, and everyone was waiting for the sun to set. Everyone except Galen. Instead of waiting, he dashed off downslope by himself, knowing he could make the sun go down by changing his vantage point. It worked just as well going up, and he even coined his own battle cry for this kinetic approach: "Let's unset the sunset!"

Galen's technical side was expressed through a deliberate methodology that involved an analytical approach to exposure techniques aided by a technical solution he branded himself: the graduated neutral-density filter, which he used with great success. He popularized his techniques through teaching and writing, especially in his columns for *Outdoor Photographer,* which grew into his books *Galen Rowell's Vision* and *Galen Rowell's Inner Game of Outdoor Photography.*

Intellectually, Galen was fascinated by the physics of light and how that connected with the mechanics of photography. He also explored the physics and psychology of human vision. He spoke to me about bringing these ideas together, combining photography, the outdoors, science, and perception in a philosophical notion he called "the visionary wilderness." Though he never completed that book, his pursuit of the idea, his photographs, and his life are enduring expressions of this grand vision.

If one measure of a person is his ability to reach beyond himself, Galen succeeded on many levels, many times. From a Bay Area car mechanic he became a world-class mountaineer, who then transformed himself into a great photographer, who evolved into an insightful writer, who then matured into an articulate teacher and spokesperson for a range of interests from photography to conservation. His photographs reflect a man who never saw obstacles, only opportunities. He was always striving, always tackling something new, transcending himself.

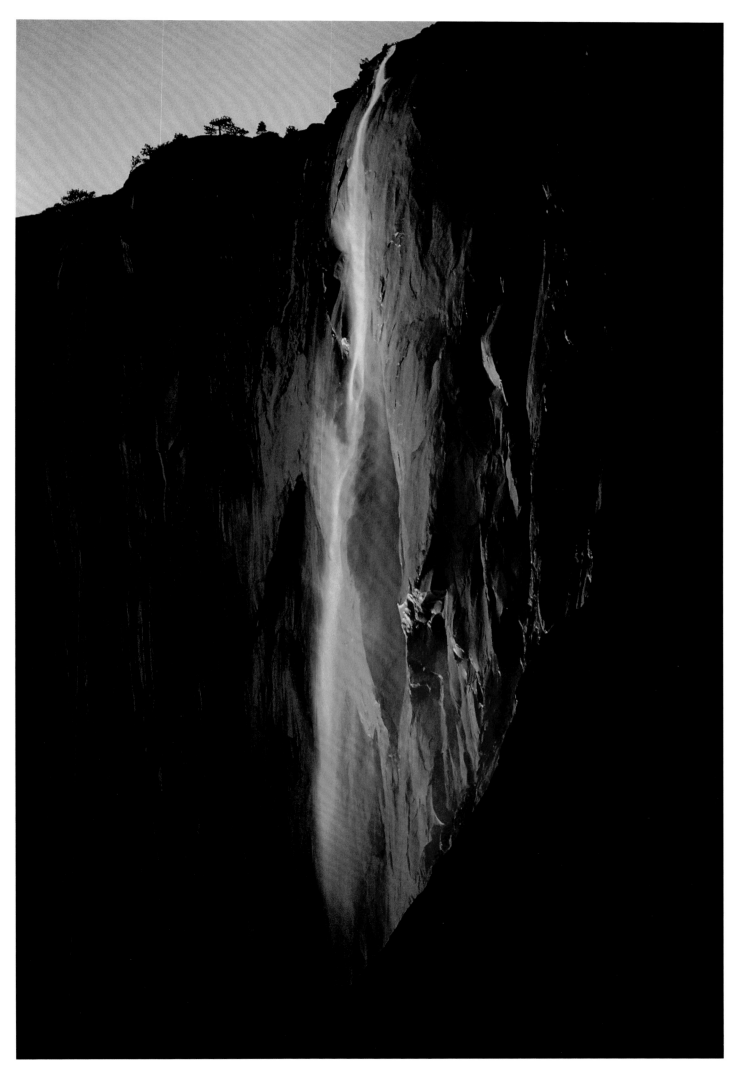

LAST LIGHT ON HORSETAIL FALL, YOSEMITE, CALIFORNIA, 1973

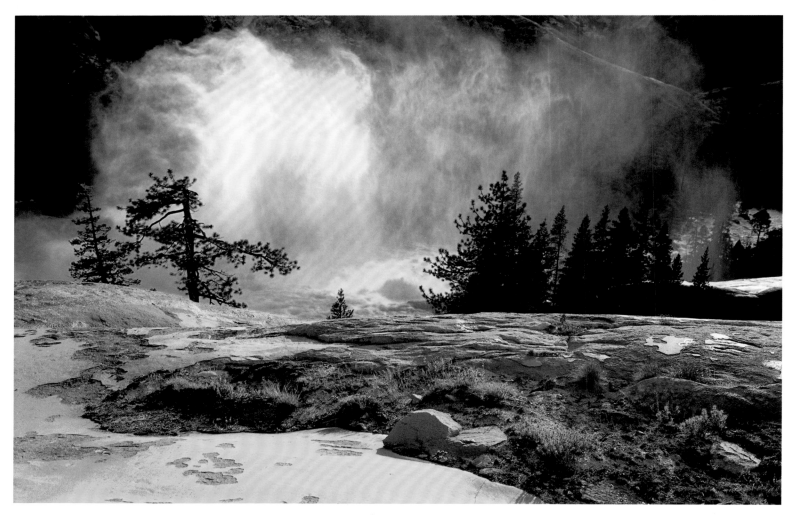

Wildflowers and Mist below Waterwheel Falls, Tuolumne River, Yosemite, California, 1993

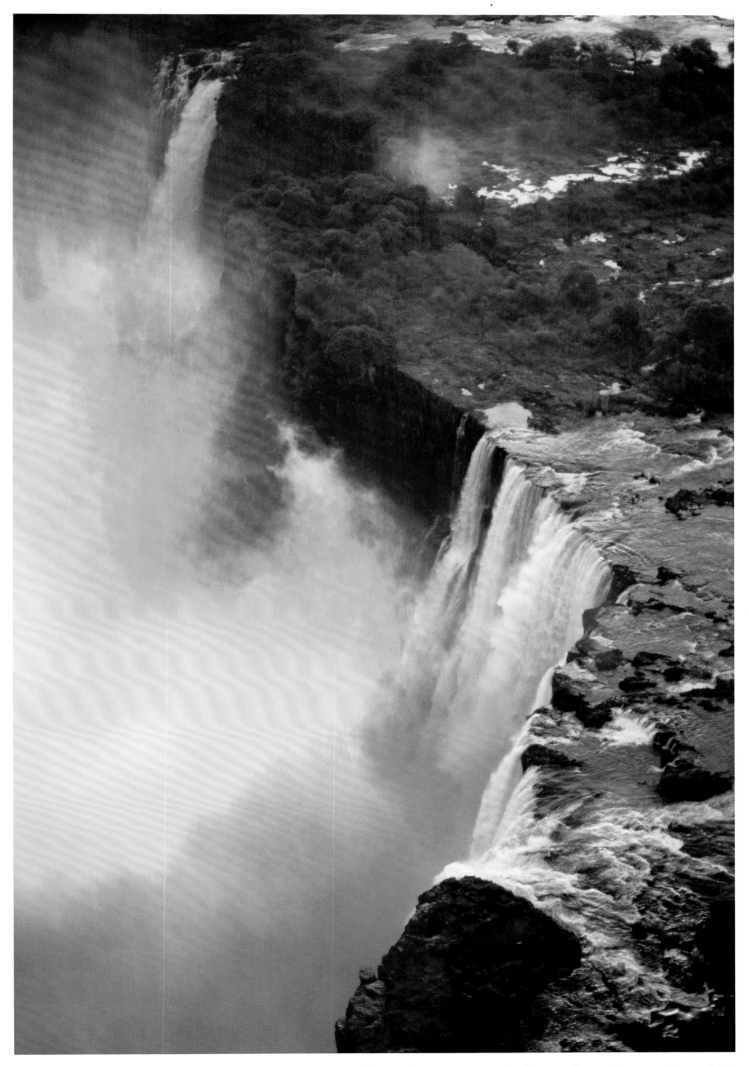

VICTORIA FALLS AT SUNSET FROM THE AIR, ZAMBEZI RIVER, ZIMBABWE, AFRICA, 1994

SPRING DAWN IN TILDEN REGIONAL PARK, BERKELEY, CALIFORNIA, 2000

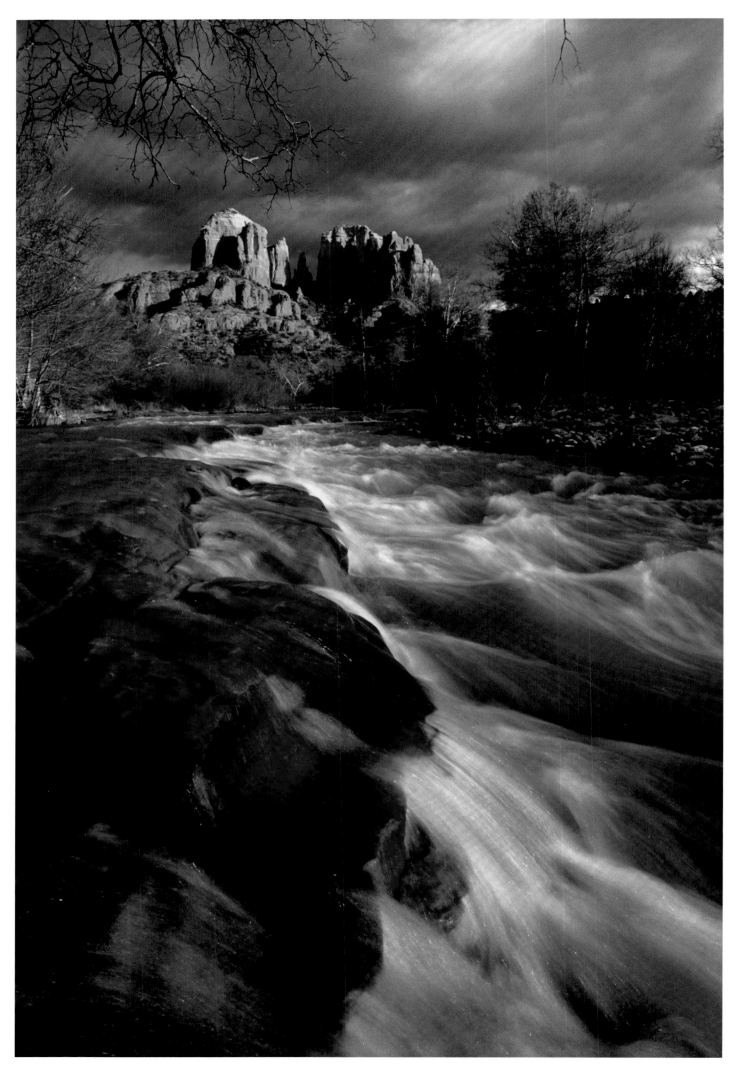

Oak Creek and Cathedral Rock, Oak Creek Canyon, Sedona, Arizona, 1987

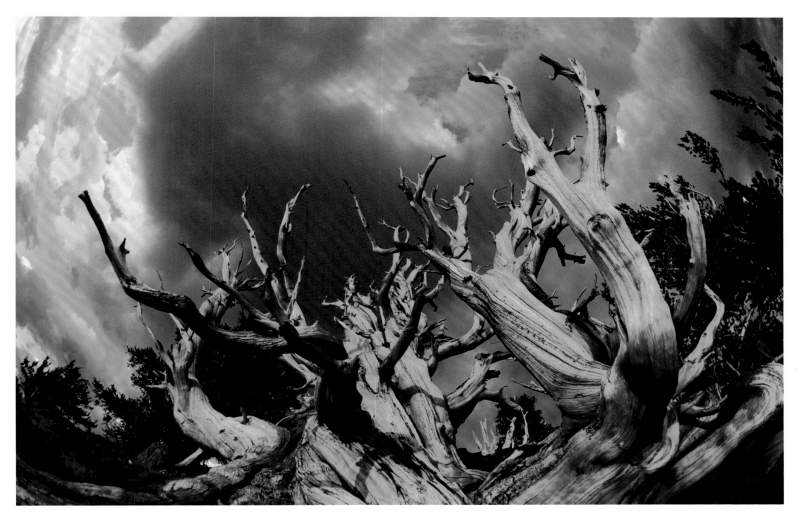

BRISTLECONE PINE AND EVENING STORM, WHITE MOUNTAINS, CALIFORNIA, 1988

ARTIST'S LIGHT

When I began photography, I was wary of artist's light. As a child I had been dragged through art galleries, and early on it became clear to all who knew me that I was far more interested in the potential of the natural world to engage my senses than I was in some visionary world created by an artist. I took it for granted that all painters modified light in order to create their own worlds of fantasy.

I understood exactly why artists wanted to alter light, because I myself couldn't bear to photograph a landscape in ordinary light. Although I had to compromise my ideals to make certain pictures of human activities, I searched out special light to enhance the landforms and the mood of all my landscapes. Within a few years I produced some images that gave me a sense of *déjà vu*. To my surprise I discovered that I had put onto film moods of light and form that bore an uncanny resemblance to the work of certain artists. . . .

After driving all night down the dirt Stewart-Cassiar Highway from Alaska, I stopped by a river's edge as first light poured through rising fog. Rather than photograph objects, such as the forests or the river, I chose to work with just the light and the mist. There in nature I found the tones that I had dismissed as embellishment in the nineteenth-century landscapes of J. M. W. Turner.

Turner is known for his atmospheric landscapes in misty morning light. His paintings depart from the convention of using foliage or people for framing. He deemphasized topography to gain effects of light and tone. One of his famous images is titled *Sun Rising Through Vapour,* and the accuracy of his perceptions led the famous critic John Ruskin to write, "Turner is the greatest landscape painter who ever lived. If truth were all that we required from art, all other painters might cast aside their brushes in despair."

—*Galen Rowell, from* Mountain Light

SUNRISE OVER THE SKEENA RIVER, BRITISH COLUMBIA, CANADA, 1974

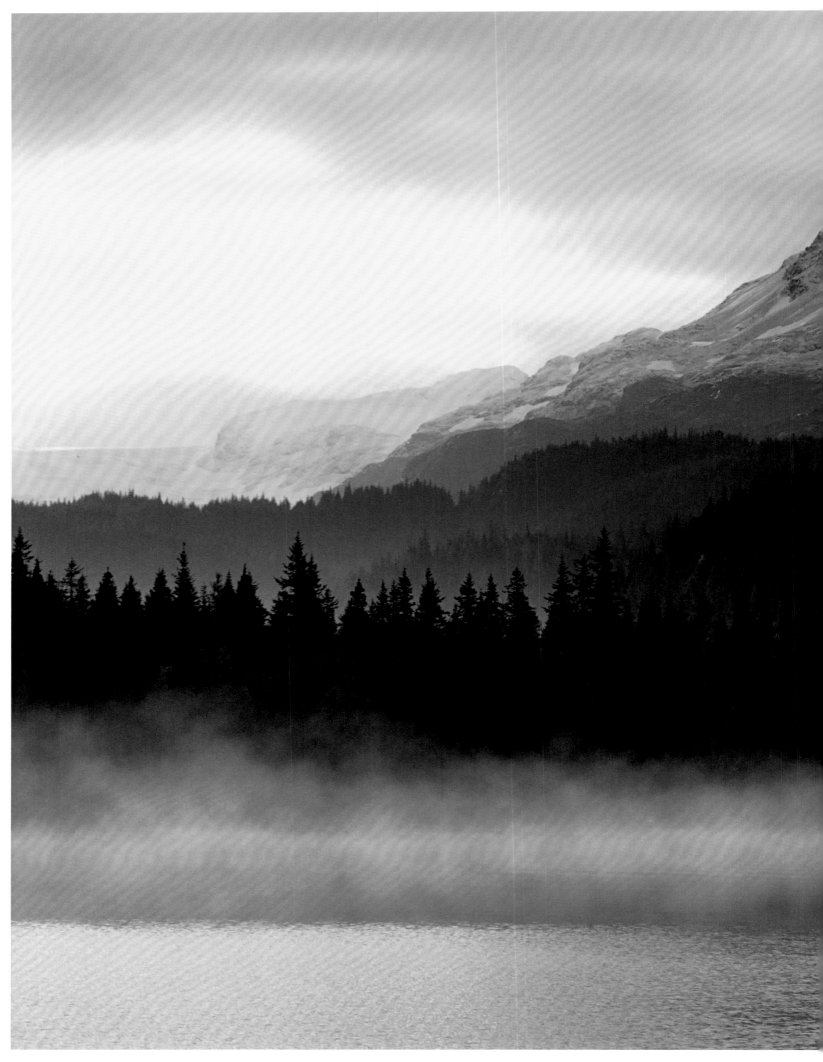

Misty Dawn on Hazel Lake, Kenai Mountains, Alaska, 1991

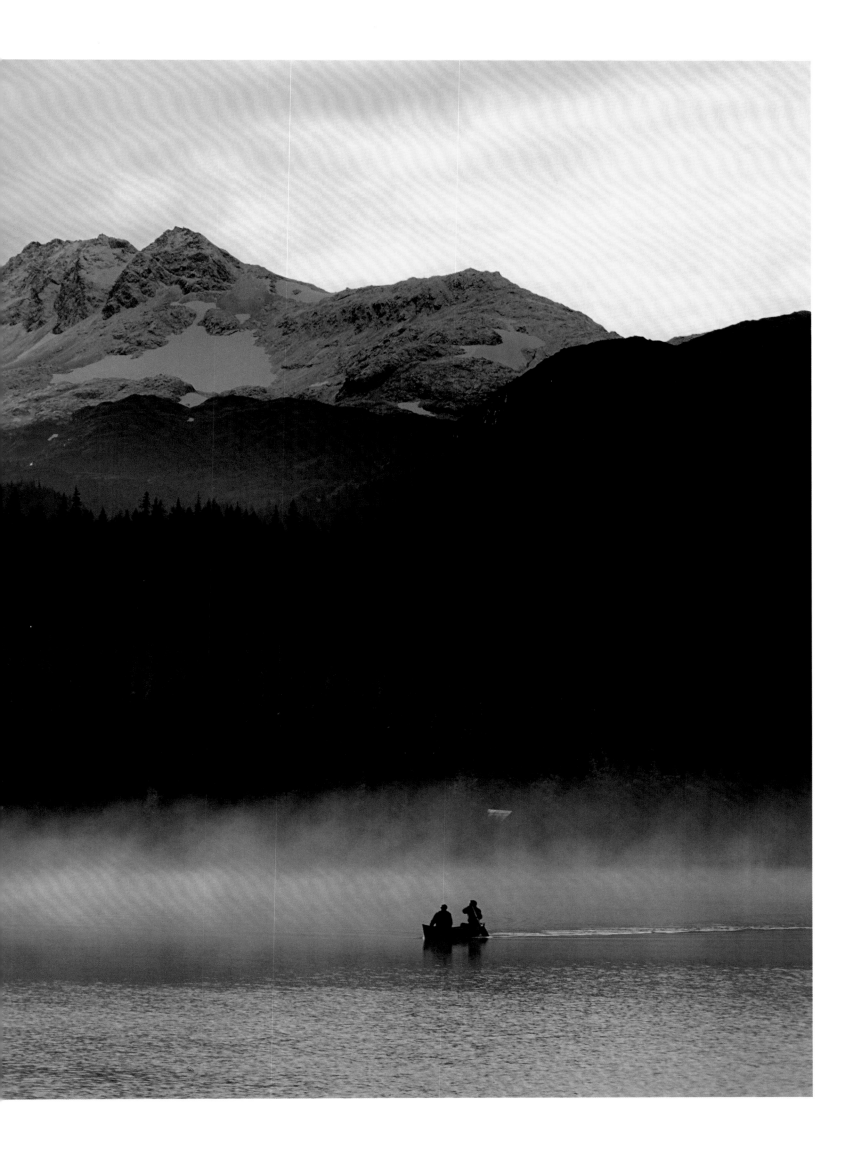

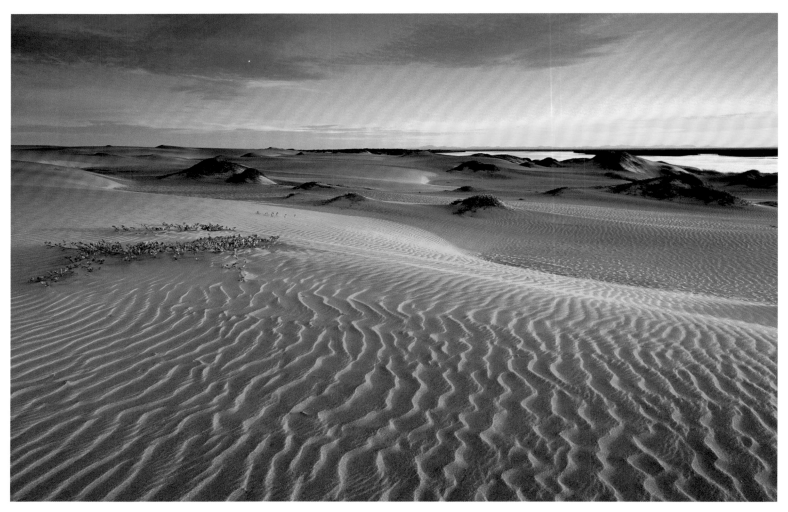

BAJA DESERT BESIDE MAGDALENA BAY, MEXICO, 1994

AERIAL VIEW OF MOUNT DIABLO, CONTRA COSTA COUNTY, CALIFORNIA, 1996

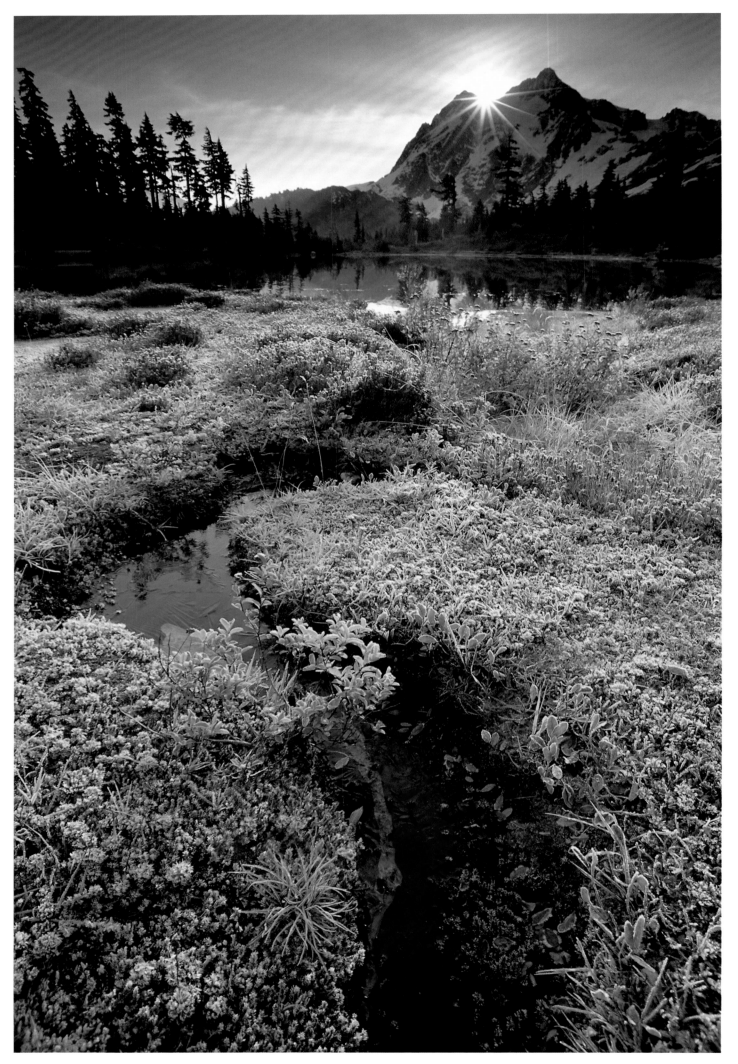

Fall Dawn at Mount Shuksan, North Cascades National Park, Washington, 1998

ROAD BAY, ANGUILLA ISLAND, CARIBBEAN SEA, 1991

LENTICULAR CLOUD OVER SOUTH GEORGIA ISLAND, SUBANTARCTIC, 2002

LENTICULAR CLOUD OVER THE OWENS RIVER, EASTERN SIERRA, CALIFORNIA, 1991

Sunrise at Lake Sherburne, Glacier National Park, Montana, 1999

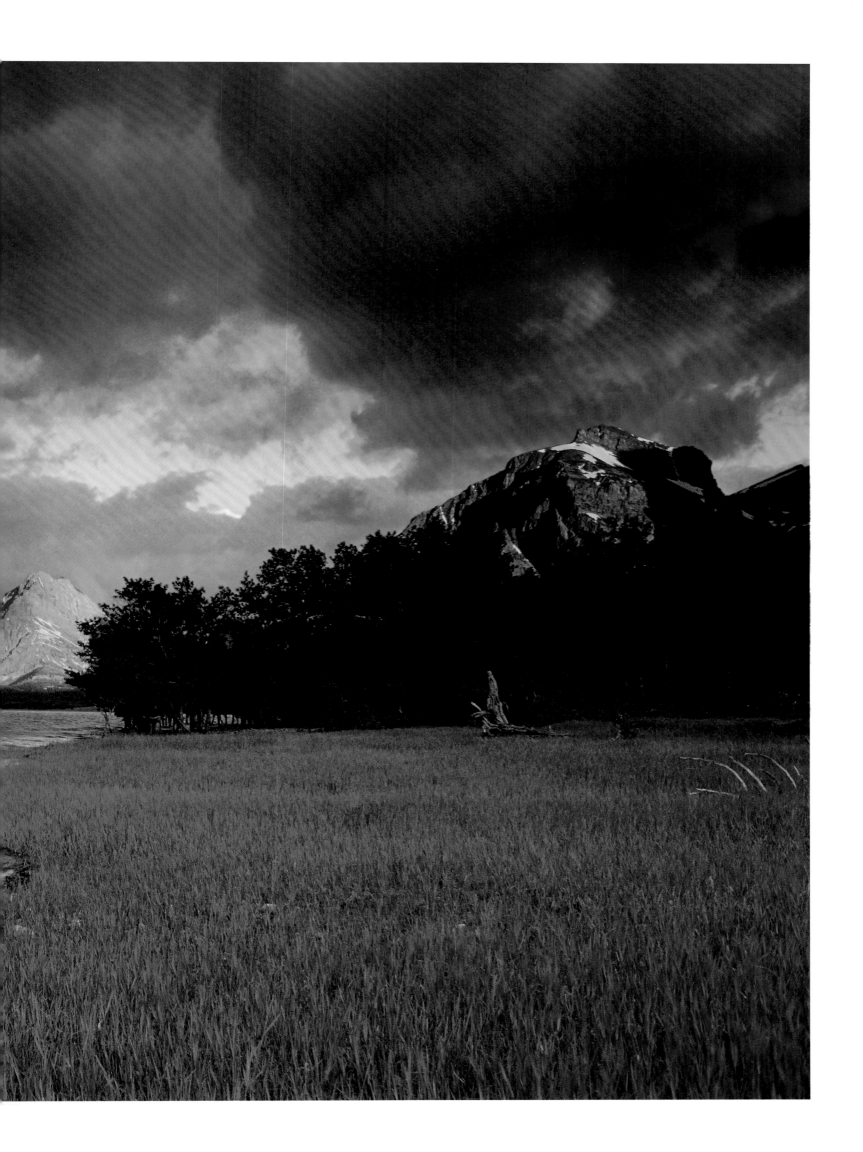

IN GOOD COMPANY

Galen Rowell was well known for his ability to place himself into his own photos for the greatest aesthetic and dramatic effect. Even when his own figure did not appear in the composition, he used the camera lens in the same psychological manner to draw you in. These images always remained in the viewer's memory. He has done exactly that in this photograph of colorful geological detail in Antelope Canyon near Page, Arizona. The colors and patterns are the result of time, wind, and water eroding the Navajo sandstone, which dates from the Jurassic Period.

This image belongs with a relatively small group of otherwise unrelated photographs about which I have a hunch. Walking through the gallery space at Mountain Light in March 2003, I was going slowly, impressed as always with the strength and beauty of Galen's work. While admiring images from Tibet, Alaska, South America, the Antarctic, and his beloved eastern Sierra, I suddenly noticed something about a few images. Aware of both his quiet humor and high regard for his fellow photographers, I became convinced that Galen was enjoying a private game. I walked back through the gallery for a second look, and this time I was certain that I had stumbled on a special Galen Rowell collection.

For there, hanging among all the other prints, were a few in which I believe Galen tried to adopt the vision of certain much-admired photographic colleagues. There had to have been mornings when he rose and said to himself, "Today I will try to see the world as Robert Glenn Ketchum does." Or perhaps the day's challenge was to look through the eyes of Frans Lanting, Jim Brandenburg, Tom Mangelsen, or the lion himself, Ansel Adams. They were all there among his images in the gallery. Somehow I would not be surprised to learn that the morning he created the image of Antelope Canyon, Galen awoke saying, "Today I will try to see in the rock what David Muench sees."

Like the masters of fine art painting, Galen learned from everything and everyone around him. This led to the creation of ever-finer work, with besting himself as the ultimate goal.

—*Jane Kinne*

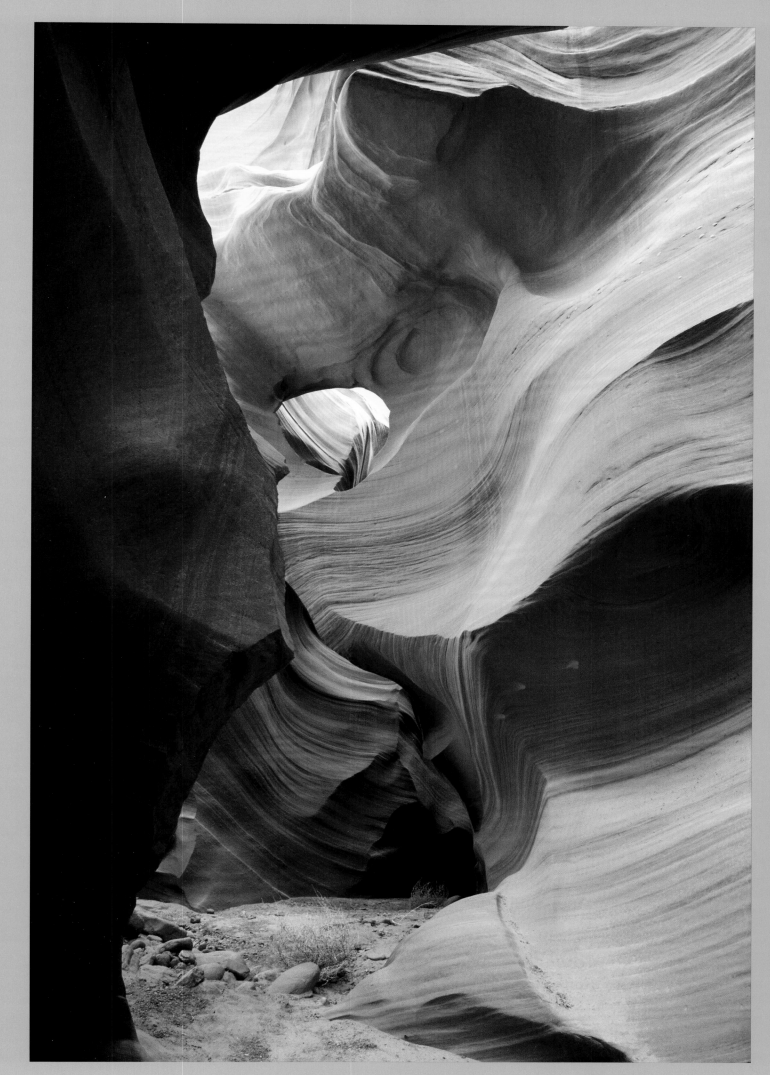

ANTELOPE CANYON, NEAR PAGE, ARIZONA, 1985

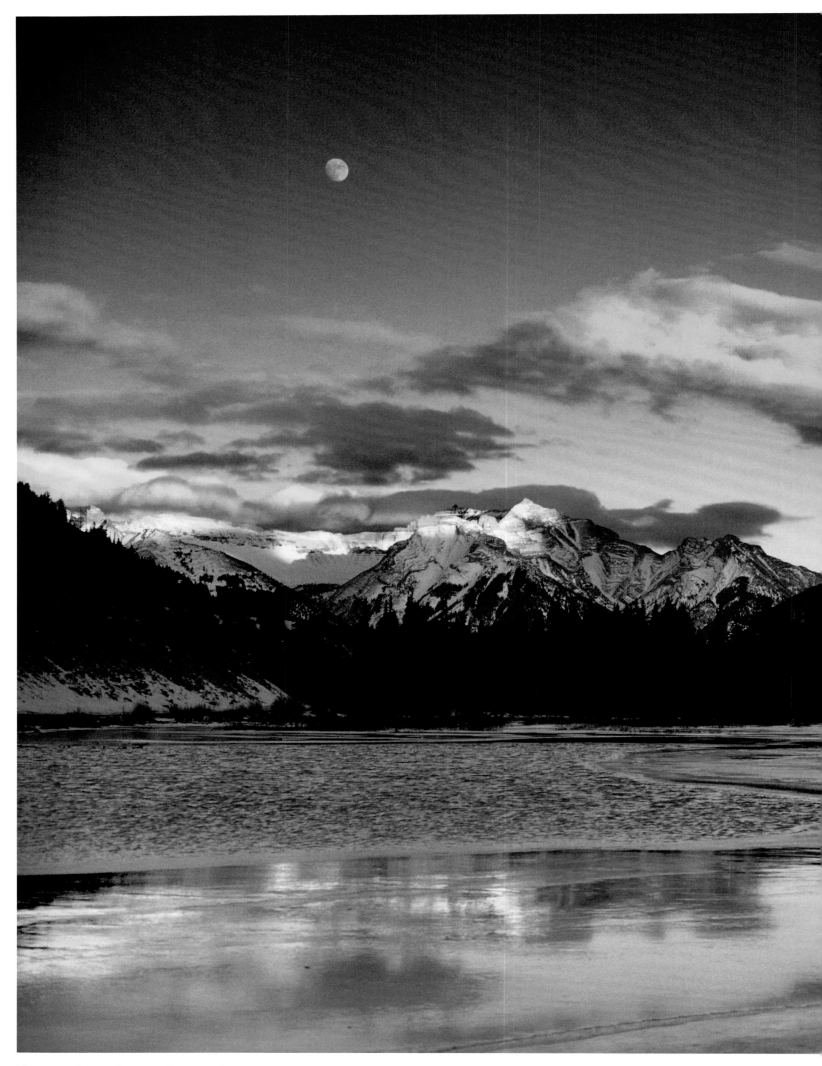

VERMILION LAKES, CANADIAN ROCKIES, CANADA, 1980

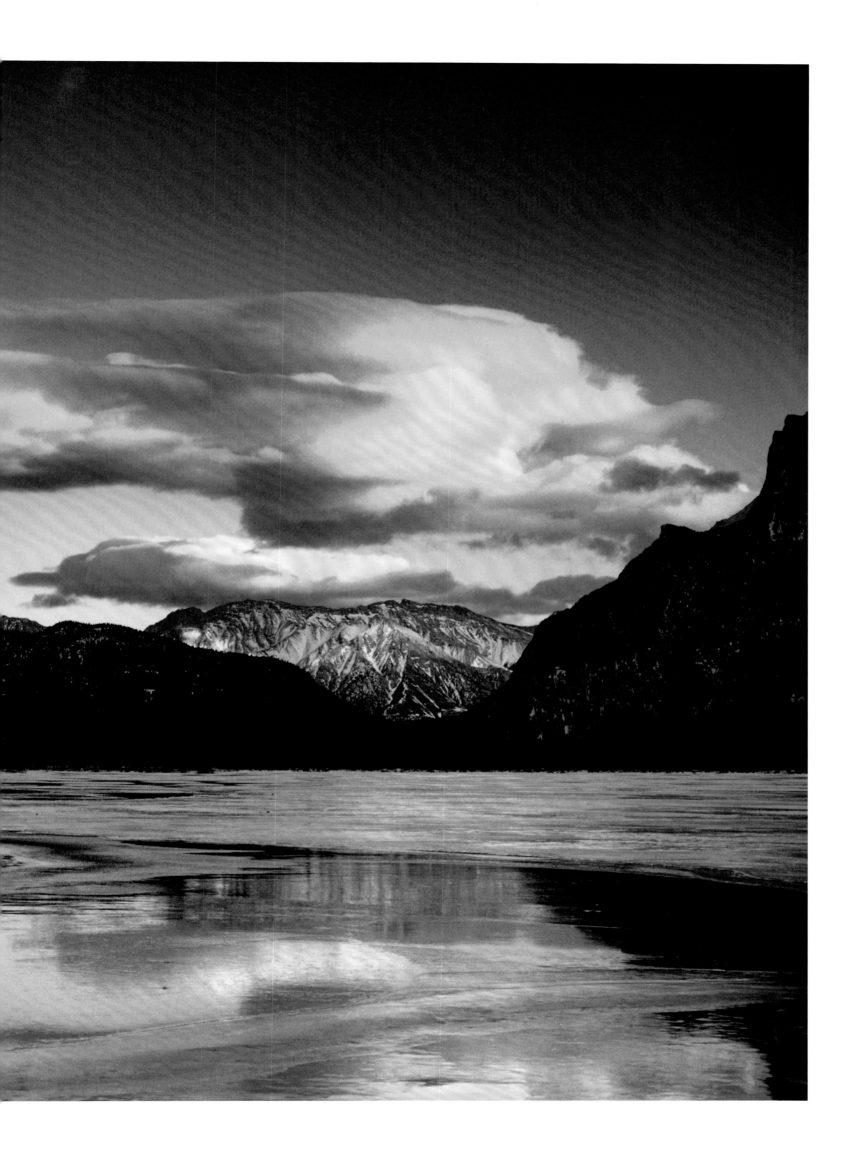

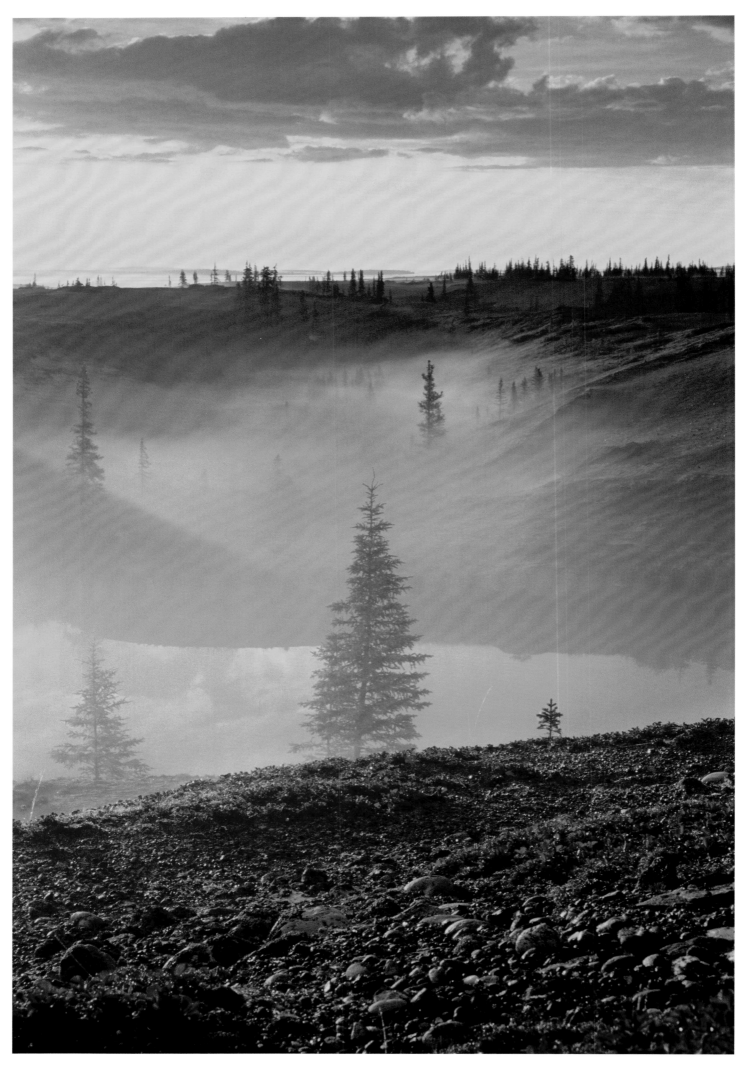

Autumn Mist over the Barrens, Northwest Territories, Canada, 1998

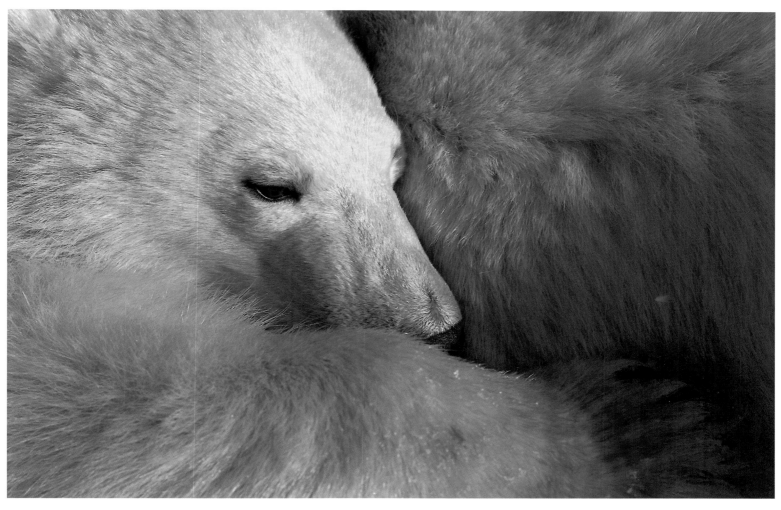

POLAR BEAR CUB RESTING BESIDE ITS MOTHER, CHURCHILL, MANITOBA, CANADA, 1993

MORNING FOG AROUND LAKE BRIONES FROM VOLLMER PEAK, BERKELEY, CALIFORNIA, 2000

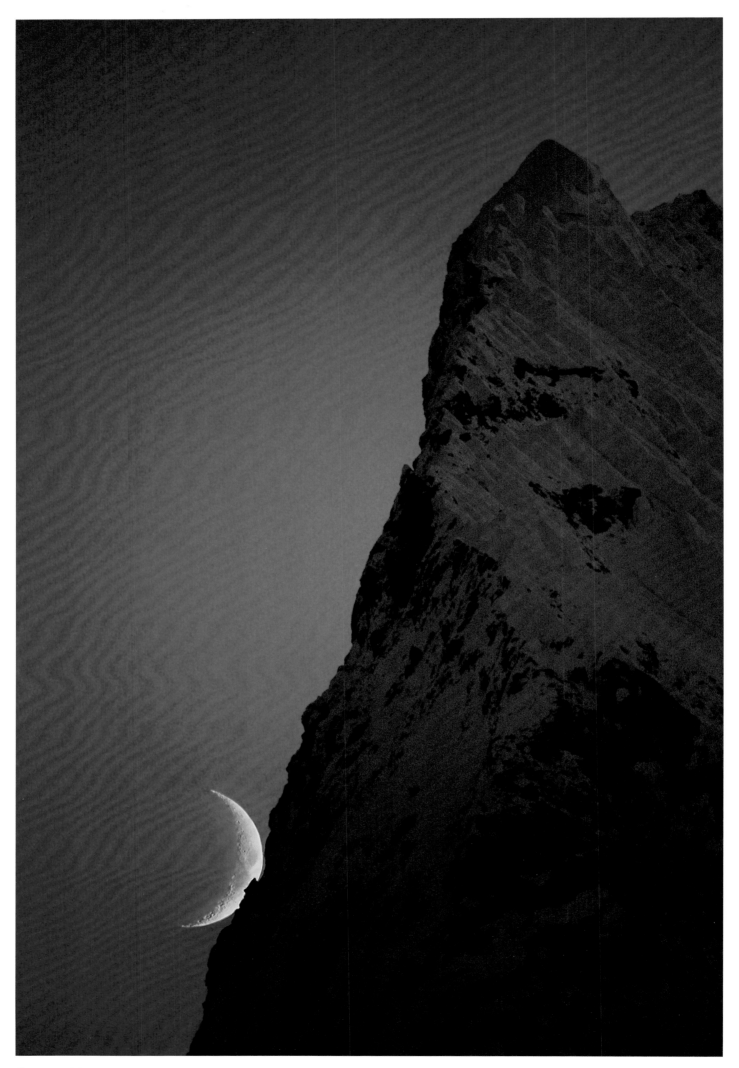

Crescent Moon and Unnamed Peak, Savoia Glacier Region, Karakoram Himalaya, Pakistan, 1975

Galen Rowell's Technique and Equipment

When Galen Rowell began photographing his climbing exploits in the 1960s, his camera of choice was a compact Kodak Instamatic 500 with a tack-sharp Schneider lens. Many of the square Kodachrome slides he made with this camera are documentary treasures of the golden age of Yosemite climbing. In 1968 Galen purchased what he considered his first serious camera, a Nikkormat FTn, which he used until 1977 to make many of his classic images. He remained a loyal Nikon user for the rest of his life. Over the years Galen used the Nikon FM, F3, FM-2, F4, N90, and F100 as his primary cameras. In his later years, he often carried the FE-10, N80, and N65 on lightweight adventures. Galen used a wide range of Nikkor lenses over the course of his career, favoring compact, lightweight designs whenever possible. Among his favorite Nikkors were the 20mm $f4$ AI, 24mm $f2.8$ AI-S, 55mm $f2.8$ AI-S Micro, 85mm $f2$ AI-S, 200mm $f4$ AI, 300mm $f2.8$ AI-S, 500mm $f4$ AI-P, 24–50mm $f3.3$–4.5 AF, 75–150mm $f3.5$ AI-S, 80–200mm $f2.8$ AF, and 80–400mm $f4.5$–5.6 VR. He also used Nikon flash units, Gitzo tripods, and Arca-Swiss, Kirk, and Really Right Stuff ball-heads and accessories. When Galen grew frustrated with the complications of using traditional camera bags on climbs and trail runs, he worked with Photoflex to design a line of camera bags with a variety of special features making them ideal for fast and light adventures.

While predecessors like Ansel Adams, working in black and white, made use of extensive manipulations in darkroom development and printing to render a full range of tone and vibrant contrast in their prints, Galen was compelled to capture finished images in-camera at the time of original exposure, working within the technical limitations of color slide films that were the standard for *National Geographic* and other clients. Ever an innovator, Galen opened up a new world of exposure control to color photographers with the design and development of a signature series of graduated neutral-density filters manufactured by Singh-Ray. Unlike "sunset," "enhancing," and other filters that introduce gimmicky artificial color to photographs, Galen's ND grad filters were truly color neutral, used only to balance exposure and to capture detail within adjacent zones of shadow and highlight that the human eye can see simultaneously but that color slide film cannot otherwise render due to its limited tonal range. His filters have become standard equipment for legions of advanced amateur and professional outdoor photographers.

Until the mid-1980s, Galen used Kodachrome films almost exclusively, preferring the fine grain and color saturation of K25 but making regular use of K64 and K200 when he needed extra film speed for low light or action. In the mid-1980s, Galen began adding some E-6 process slide films to the mix, in particular Fujichrome 50 Professional. With the release of Fujifilm's revolutionary Velvia (ISO 50) in 1990, Galen left his Kodachrome days behind. Velvia remained Galen's primary film for the rest of his life, though he occasionally used other Fuji and Kodak E-6 slide films for specialized applications. While Galen experimented minimally with digital cameras, he never used one seriously, content that quality film and a Nikon offered the most elegant, capable, and practical solution for his work in the field.

Over the course of his career, Galen made prints using a variety of techniques, including traditional Type-C, Cibachrome, and dye-transfer prints and digital Evercolor pigment, LightJet, and Fuji Pictography processes. Galen fully embraced digital printmaking in 1998, when he recognized the precision and control of modern digital printmaking techniques. He was finally able to realize his goal of making prints that accurately captured the content, color, depth, and sharpness characteristics of his original transparencies, a feat that had been virtually impossible given the technical limitations and compromises inherent in traditional color darkroom processes. He began working closely with experts at the cutting edge of digital printmaking to drum scan and digitally master his best work for precisely color-managed printing with the Cymbolic Sciences LightJet 5000 laser enlarger on Fujifilm's highly stable Crystal Archive photographic paper. Staying true to his photojournalist's ethics in an era eager to question the veracity of digital photography, Galen made his prints to represent the reality of the exceptional moments that he witnessed in nature and recorded on film—no more, no less—refusing to remove or add image subject matter. By the time of his death, he had created a digital archive of well over three hundred fine-print master files, many of which were used in the printing of this retrospective.

—*Justin Black*

Biographical Chronology

AUGUST 23, 1940
Born Oakland, California, son of Edward Zbitovsky and Margaret Avery Rowell.

1945–58
Educated at Berkeley, California, public schools.

1957–2002
Technical rock and alpine climber in all the major mountain ranges of the world.

1958–62
Attended University of California, Berkeley (physics major, no degree).

1962
Married Carol Chevez (divorced 1978). Daughter, Nicole Marie (b. 1964), and son, Edward Anthony (Tony) (b. 1968).

Began to photo-document his climbs.

1963–72
Owner, Rowell Auto Service, Albany, California.

1967
First ascent, Great White Throne, Zion National Park, Utah.

1969–74
Made yearly climbing and photography trips to Canada.

1971
Solo first ascent, south face of Bear Creek Spire, Sierra Nevada.

1972
Winter first ascent, Keeler Needle, Sierra Nevada.

1968–2002
Self-employed (initially dba High & Wild Photography until Mountain Light Photography incorporated in 1985) as professional adventure writer and photographer, published regularly in the *American Alpine Journal, Ascent, Audubon, Backpacker, Climbing, Life, Modern Photography, National Geographic, Outdoor Photographer, Outside, Quest, Reader's Digest, Sierra, Sports Illustrated, Summit, Time,* and other journals.

1974
First ascent, southeast face of Mount Dickey, Alaska.

Author and photographer, "Climbing Half Dome the Hard Way," *National Geographic,* June 1974 cover story.

Editor and contributor, *The Vertical World of Yosemite.*

1975
Climber and photographer, American K2 Expedition, Karakoram Himalaya, Pakistan.

1976
Climbing and photography trip, Canada.

1977
Climbing and photography trips, Nepal, New Zealand, India.

First ascent, Great Trango Tower, Pakistan.

Author and photographer, *In the Throne Room of the Mountain Gods.*

1978
First circumnavigation on skis of Mount McKinley, Alaska; also first one-day ascent.

1979
Climbing and photography trip, Norway.

Author and photographer, *High & Wild: A Mountaineer's World.*

1980
First Karakoram ski traverse, Pakistan.

Author and photographer, *Many people come, looking, looking.*

1980–83
Four climbing and photography trips, China and Tibet.

1981
Essayist and photographer, with John McPhee, *Alaska: Images of the Country.*

Married Barbara Cushman, Elko, Nevada.

1982
First ascent, Cholatse, Nepal.

First one-day ascent, Mount Kilimanjaro, Tanzania.

1983
Member, Everest West Ridge Expedition.

First major gallery shows, including International Center of Photography (New York), California Academy of Sciences (San Francisco), and Smithsonian Institution (Washington, D.C.).

Author and photographer, *Mountains of the Middle Kingdom: Exploring the High Peaks of China and Tibet.*

1984–85
Climbing and photography trips, Pakistan, Argentina, Japan, Chile.

1985–95
Contributing photographer to the "Day in the Life of . . ." series (Japan, America, Soviet Union, Spain, California, Italy, Ireland, Hollywood, Thailand).

1985
Began, at Barbara's urging, to teach photographic workshops, a corollary career to continue for the rest of his life.

Mountain Light Photography was incorporated; Galen and Barbara became employees.

1986

Ascent of Fitz Roy, Patagonia, Argentina.

Climbing, exploring, and photography trips, Pakistan, China.

Author and photographer, *Mountain Light: In Search of the Dynamic Landscape.*

1987

Climbing, exploring, and photography trips, Nepal, Tibet, Siberia.

Began to write long-running feature column, "Photo Adventure," in *Outdoor Photographer.*

1988

Climbing, exploring, and photography trips, Canada, Tibet, Argentina, Spain.

Tried in absentia and convicted of sedition, People's Republic of China.

1989

Climbing, exploring, and photography trips, Ecuador, Guatemala, India, Pakistan.

Essayist and photographer, *The Yosemite* (with the original John Muir text).

Photographer, *The Art of Adventure.*

1990

Climbing, exploring, and photography trips, India, Nepal, French Alps, Chile, Ecuador, Peru, Argentina, Italy.

Essayist and photographer, with His Holiness the Dalai Lama, *My Tibet.*

1991

Climbing, exploring, and photography trips, Argentina, Caribbean, Mexico, Ireland, French Alps, Chile, Switzerland, Colombia.

1992

Climbing, exploring, and photography trips, Antarctica, Chile, Argentina, Canada.

1993

Climbing, exploring, and photography trips, Arctic Ocean, Greenland, Canada, Russia, Norway, Siberia, North Pole, Antarctica, the Subantarctic.

Author and photographer, *Galen Rowell's Vision: The Art of Adventure Photography.*

1994

Climbing, exploring, and photography trips, Colombia, Greenland, Mexico, Zimbabwe, Botswana.

1995

Climbing, exploring, and photography trips, Peru, Mexico.

Author and photographer, *Poles Apart: Parallel Visions of the Arctic and Antarctic.*

With Barbara, opened Mountain Light Gallery in Emeryville, California.

1996

Climbing, exploring, and photography trips, Ecuador, Greenland.

1997

Climbing, exploring, and photography trips, South Pacific, Canada.

Author and photographer, with Michael Sewell, *Bay Area Wild: A Celebration of the Natural Heritage of the San Francisco Bay Area.*

1998

Climbing, exploring, and photography trips, Chile, Argentina, Nepal, Canada, Pakistan.

Photographer, with John Doerper, *Coastal California.*

Co-instructor and photographer, *Creative Outdoor Photography with Frans Lanting and Galen Rowell,* video series.

1999

Climbing, exploring, and photography trips, Kenya, Tanzania, Mexico, Italy, South Pacific.

Photographer, with Frans Lanting and David Doubilet, *Living Planet: Preserving Edens of the Earth.*

2000

Climbing, exploring, and photography trips, Canada, South Pacific, Brazil.

Author and photographer, *Galen Rowell's Inner Game of Outdoor Photography.*

2001

Moved, with Barbara, to Bishop, California, where they opened a second Mountain Light Gallery in a former bank building.

Author and photographer, *North America the Beautiful.*

2002

Climbing, exploring, and photography trips, Antarctica, the Subantarctic, the Arctic.

Relocated and consolidated gallery and stock photography business in Bishop, California, closing the Emeryville site.

Photographer, *California the Beautiful.*

Author and photographer, expanded edition, *High & Wild: Essays and Photographs on Wilderness Adventure.*

National Geographic expedition to Tibet to discover the birthing grounds of the *chiru.*

August 11, 2002

Died, with Barbara Cushman Rowell, their pilot and friend Tom Reid, and Carol MacAfee, in crash of a light plane near Bishop, California.

2003

Photographer, *Yosemite and the Wild Sierra.*

Photographer, *Fog City: Impressions of the San Francisco Bay Area in Fog.*

Photographer, with Rick Ridgeway, "275 Miles on Foot through the Remote Chang Tang," *National Geographic,* April 2003.

2004

Photographer, *The Big Open: On Foot Across Tibet's Chang Tang.*

2006

Publication of *Galen Rowell: A Retrospective.*

Published Titles

Galen Rowell: A Retrospective (2006)

Yosemite and the Wild Sierra (2003)

Fog City: Impressions of the San Francisco Bay Area in Fog (2003)

California the Beautiful (2002)

High & Wild: Essays and Photographs on Wilderness Adventure (expanded edition, 2002)

North America the Beautiful (2001)

Galen Rowell's Inner Game of Outdoor Photography (2000)

Living Planet: Preserving Edens of the Earth, with Frans Lanting and David Doubilet (1999)

Coastal California, with John Doerper (1998)

Bay Area Wild: A Celebration of the Natural Heritage of the San Francisco Bay Area, with Michael Sewell (1997)

Poles Apart: Parallel Visions of the Arctic and Antarctic (1995)

Galen Rowell's Vision: The Art of Adventure Photography (1993)

My Tibet, with His Holiness the Dalai Lama (1990)

The Art of Adventure (1989)

The Yosemite, with the original John Muir text (1989)

Mountain Light: In Search of the Dynamic Landscape (1986)

High & Wild: Essays on Wilderness Adventure (expanded edition, 1983)

Mountains of the Middle Kingdom: Exploring the High Peaks of China and Tibet (1983)

Alaska: Images of the Country, with John McPhee (1981)

Many people come, looking, looking (1980)

High & Wild: A Mountaineer's World (1979)

In the Throne Room of the Mountain Gods (1977)

The Vertical World of Yosemite (anthology, 1974)

Notes

Sierra Son

Page 26. Galen on his first *National Geographic* assignment: Galen Rowell, *Mountain Light* (San Francisco: Sierra Club Books, 1986), p. 33.

Page 27. Margaret Rowell on her first encounter with Yosemite: "Margaret Avery Rowell, Master Teacher of Cellists, and Humble Student of Nature" (Berkeley: Regional Oral History Office, Bancroft Library), pp. 18–19.

Page 28. Margaret Rowell on Galen as uncuddly baby: ibid., p. 207.

Page 28. Margaret on Galen as young geologist: ibid., p. 210.

Page 29. Galen on his mother and the High Sierra: Galen Rowell, *High & Wild* (Bishop: Spotted Dog Press, 2002), p. 217.

Page 29. Margaret Rowell on Galen's first Sierra adventure: in "Margaret Rowell, MasterTeacher," p. 212.

Page 30. Galen on Dick Leonard, one of his "phantom mentors": Galen Rowell, *Galen Rowell's Vision* (San Francisco: Sierra Club Books, 1993), p. 227.

Page 30. Galen on David Brower and hot-rodding: ibid.

Page 32. Galen on training for greater climbs: *High & Wild*, p. 35.

Page 33. Galen on Warren Harding, climbing partner: ibid.

Page 33. Layton Kor gets one up on Royal Robbins: ibid., p. 52.

Page 33. Galen on being scared: ibid., p. 38.

Page 34. Galen on just getting on with it: ibid., p. 35.

Page 35. Barbara Rowell on meeting Galen: Barbara Cushman Rowell, *Flying South* (Berkeley: Ten Speed Press, 2002), p. 201.

Page 35. Barbara on being married to a force of nature: ibid., p. 205.

Page 36. Barbara on Galen's work ethic: ibid., p. 41.

Page 36. Galen on unknown China: Galen Rowell, *Mountains of the Middle Kingdom* (San Francisco: Sierra Club Books, 1983), p. xii.

Page 37. Galen on the Golok people: ibid., p. 152.

Page 38. Steve Werner on Galen as archetype: *Galen Rowell's Vision*, p. 9.

Page 38. Galen on seeing his photos in museum shows: *Mountain Light*, p. 3.

Page 39. Galen on "dynamic landscapes:" ibid., p. 2.

Page 39. Galen on photographic vision: ibid., p. 1.

Page 39. Robert Redford on watching Galen at work: Galen Rowell, *High & Wild* (San Francisco: Lexikos, 1983), p. xiv.

Pages 39–40. Galen on Susan Sontag and photography: *Galen Rowell's Vision*, p. 32.

Page 40. Galen on an infinity of subjects to photograph: *Mountain Light*, p. 198.

Page 41. Galen on preserving Tibet: Dalai Lama and Galen Rowell, *My Tibet* (Berkeley: University of California Press, 1990), p. 8.

Page 41. Galen on Heinrich Harrer: *Galen Rowell's Vision*, pp. 228–29.

Page 42. Galen on John Muir: John Muir and Galen Rowell, *The Yosemite* (San Francisco: Sierra Club Books, 1989), pp. 17–18.

Page 45. Galen on his love for the Sierra eastside: *High & Wild* (2002), p. 10.

Page 45. Wynne Benti on a last glimpse of Galen: ibid., rear flap copy.

Section-opening Quotes

Page 53. Epigraph: *Mountain Light* (San Francisco: Sierra Club Books, 1986), p. 49.

Page 81. Epigraph: *In the Throne Room of the Mountain Gods* (San Francisco: Sierra Club Books, 1977), p. 106.

Page 115. Epigraph: *Bay Area Wild* (San Francisco: Sierra Club Books, 1997), p. 149.

Page 151. Epigraph: *Many people come, looking, looking* (Seattle: Mountaineers, 1980), p. 51.

Page 183. Epigraph: *Poles Apart* (Berkeley: University of California Press, 1995), p. 21.

Page 217. Epigraph: Galen Rowell, "Galen Rowell's Artist's Statement," 2001, available at www.mountainlight.com/rowell/gr_artist.html.

Page 249. Epigraph: Michael Powers and Suzanne Cheavens, "Trekking to Adventure with Galen Rowell," *Mountainfreak* (Fall 1999), p. 47.

About the Contributors

John Ackerly began rock climbing at age fourteen and attended Dartmouth College and the American University School of Law. After witnessing massive demonstrations in Lhasa in 1987 and the Chinese government's brutal response, he helped found the International Campaign for Tibet in 1988 and is now its president. He has conducted numerous fact-finding missions to Tibet, published many reports on human rights and environmental issues, and testified before Congress. In 2003 he helped form the Rowell Fund for Tibet to honor Galen and Barbara's legacy in the Tibetan community. Ackerly makes his home in Washington, D.C.

Conrad Anker began exploring the mountains with his parents and grandparents in the Sierra Nevada. His early forays up Dana Peak in Tuolumne Meadows led to climbs of El Capitan, which led to adventures in Alaska, which in turn led to the greater ranges of the Himalaya. With first ascents and new routes in Antarctica and Patagonia, Anker seeks out technically challenging routes. He is coauthor, with David Roberts, of *The Lost Explorer: Finding Mallory on Mount Everest.* He lives in Bozeman, Montana, with his wife and three sons.

Jon Beckmann served in various editorial capacities on the East Coast before moving to San Francisco, where he was the publisher of Sierra Club Books from 1974 to 1995. Since then he has been a publishing consultant, book doctor, and writer. He is the author of *After-Dinner Drinks.* He and his wife, Barbara, an artist and fabric designer, live in Sonoma, California, with their dog, Raclette Barker.

Justin Black studied fine art photography and art history at George Washington University in preparation for a career as a photographer and licensing specialist. In 1999 Galen and Barbara Rowell hired him at Mountain Light Photography, where he managed marketing and licensing of the Rowells' image collection, assisted Galen, and taught seminars on nature photography. He continues to manage the gallery, image collection, and workshop program in Bishop, California, while pursuing new photographic directions inspired by the Rowells' example.

Tom Brokaw, one of the most respected figures in broadcast journalism, joined NBC News in 1966, anchored the *Today* show from 1976 to 1981, and, beginning in 1983, served as anchor and managing editor of *NBC Nightly News* for twenty-one years. He continues to report and create documentaries for NBC, as well as providing commentary on breaking news. His distinguished work has earned him numerous awards, including Peabody, Emmy, duPont, and Edward R. Murrow awards. He is the author of four best-selling books, including the acclaimed *The Greatest Generation* as well as numerous articles, essays, and commentaries for such publications as the *New York Times,* the *Washington Post,* the *Los Angeles Times, Newsweek, Life,* and *National Geographic.* He lives in New York and Montana.

Ed Cooper, originally from New York, "discovered" the mountains on a trip West at age sixteen. He moved from climbing mountains to photographing them, and his black-and-white and, later, color images appeared regularly in alpine journals and climbing magazines in the 1960s, 1970s, and 1980s. His 75,000 large-format color images of U.S. and Canadian landscapes have formed the basis for his stock photography business. Most recently, Cooper has been exploring digital photography, and he continues to make yearly trips into the mountains. He lives with his wife, Debby, in Sonoma, California.

Bert Fox joined *National Geographic* as an illustrations editor in 1996. Since then he has edited dozens of articles, highlighted by a seventy-page cover story celebrating fifty years of mountaineering on Mount Everest. His honors include being named Picture Editor of the Year five times by the University of Missouri in its annual competition. He is also the director of photography for "Child Labor and the Global Village: Photography for Social Change," a five-year documentary project exploring the complex issues behind child labor. Fox lives with his wife, Nanine Hartzenbusch, and their son, Charlie, in Columbia, Maryland.

Andy Grundberg is a critic, curator, teacher, and arts consultant. His writings for the *New York Times* and other publications are collected in the book *Crisis of the Real.* Grundberg has served as director of The Friends of Photography in San Francisco and has organized numerous traveling exhibitions, including *In Response to Place, Photography and Art: Interactions since 1946,* and *Ansel Adams: A Legacy.* He received an Infinity Award for his writings on photography from the International Center of Photography. Grundberg currently lives in Washington, D.C., where he is administrative chair of photography at the Corcoran College of Art and Design.

Bob Hansen has worked in education and conservation for thirty-two years. A graduate of San Francisco State University with a degree in creative arts, Hansen lived in Yosemite while serving as campus director of the Yosemite Institute. Former project director of the Santa Cruz Island Preserve and Southern California field representative for the Nature Conservancy in Santa Barbara, he now serves as president of the Yosemite Fund, where he has been the senior administrative officer for sixteen years. His principal interest is preservation of natural areas for public enjoyment.

Jane Kinne has helped shape professional standards for the use of images in her more than fifty years as a photo agent and consultant. She has been an advisor and agent for nearly 3,000 photographers and is known as the foremost advocate of photographers' rights. Kinne is currently a consultant on appraisals, marketing issues, acquisitions, and legal problems for the photo community and serves as legal chair for the American Society of Picture Professionals and the Picture Archive Council of America and as director of development for the North American Nature Photography Association's Infinity Foundation. She lives in Connecticut with her husband, photographer Russ Kinne.

Frans Lanting has documented wildlife and our relationship with nature for more than two decades and is recognized as one of the foremost nature photographers of our time. His work has been commissioned frequently by *National Geographic,* where he is a photographer-in-residence, and also appears in books, magazines, and exhibitions around the world. His acclaimed books include *Jungles, Living Planet,* and *Eye to Eye.* Lanting has received numerous awards, including the Sierra Club's Ansel Adams Award, as well as being named BBC Wildlife Photographer of the Year and a Fellow of the Royal Photographic Society in London. He lives in Santa Cruz, California, with his wife, writer Christine Eckstrom.

David Muench, maverick and innovator in landscape photography, has dedicated his life to championing the strength and beauty of the natural landscape, preserving its wildness, and celebrating the mystical forces of nature that help shape our destinies. His photographs appear in museum and gallery exhibits, private collections, and more than fifty exhibit-format books, including *Our National Parks, Windstone, Vast & Intimate, Plateau Light,* and, with his son Marc, *Primal Forces* and *American Portfolios.* He lives in New Mexico with his wife, writer Ruth Rudner.

Rick Ridgeway, one of the world's foremost mountaineers and adventurers, is known to many through his writing, photography, and Emmy award–winning filmmaking. He has produced and directed more than forty adventure shows for television, and his articles have appeared in *National Geographic, Outside,* and many other publications. He is the author of six books, including the acclaimed *Seven Summits, The Shadow of Kilimanjaro,* and most recently *The Big Open,* about his expedition to northwest Tibet following the endangered *chiru.* He is currently vice president of marketing and environmental programs for Patagonia. Ridgeway lives with his wife and three children in Ojai, California.

Doug Robinson is a professional mountaineer known internationally for his climbing, guiding, and ski mountaineering, as well as his poetic writings about the mountains and why we climb them. His writing is collected in *A Night on the Ground, A Day in the Open,* and he is currently directing a series of videos that begins with *Go Wild! Half Dome.* Robinson lives in Aptos, California, with his wife, Kristen, and their two children, Tory and Kyra.

Robert Roper is a novelist and nonfiction author who also climbs. His many books include *Cuervo Tales, The Trespassers, Royo County, Mexico Days,* and *In Caverns of Blue Ice.* His biography of Willi Unsoeld, *Fatal Mountaineer,* won the 2002 Boardman Tasker Prize for Mountain Literature. Roper has also written for the *New York Times, Men's Journal, National Geographic Adventure,* and *Outside.* He lives in Baltimore, Maryland, where he teaches in the writing program at Johns Hopkins University.

Steve Roper wrote the first climbing guide to Yosemite Valley and was later co-editor of *Ascent,* the Sierra Club's mountaineering journal. He has written several other hiking and climbing guidebooks but regards his 1994 book, *Camp 4: Recollections of a Yosemite Rockclimber,* as his crowning achievement. This acclaimed book also received the Banff Mountain Book Festival Award for Mountain Literature. Roper is currently the features editor for the *American Alpine Journal.* He lives in Oakland, California, with his wife, Kathy.

Tony Rowell, Galen's son, lives in California's eastern Sierra and serves on the board of directors for Mountain Light Photography, Inc. A photographer in his own right, Tony accompanied his father on several photographic assignments. His work has been published in his father's books and in *Backpacker* and *Outdoor Photographer.* His photographic expeditions have taken him from the Arctic Circle to the mountains of Tibet.

Nicole Rowell Ryan, Galen's daughter, is currently raising two boys, serving on the board of directors for Mountain Light Photography, Inc., and growing wine grapes on her ranch in California's Sierra foothills. Nicole's background includes eleven years working for a private nonprofit corporation dedicated to improving the living conditions in rural communities. Together with her husband, Ray, they manage their vineyards and run a software development company.

George B. Schaller is vice president of the Science and Exploration Program and a field biologist for the Wildlife Conservation Society in New York. His research and conservation efforts over more than four decades have been devoted to various large mammals and documented in his many acclaimed books, including *The Year of the Gorilla, The Deer and the Tiger, The Serengeti Lion,* which won the National Book Award, and *The Last Panda.* Two of his most recent books are *Tibet's Hidden Wilderness* and *Wildlife of the Tibetan Steppe.* Dr. Schaller makes his home in Connecticut.

Dean Stevens has, in the course of his editorial career, written about hiking, camping, fly fishing, and automobiles. In the late 1990s his love of the outdoors in general and the eastern Sierra in particular led him to leave a career in Southern California to eke out a living as a freelance writer and editor based in Bishop, California. In April 2002 he met Galen and Barbara Rowell and started working for Mountain Light Photography, where he currently serves as the company's image-licensing manager.

Steven D. Werner has been a magazine journalist since 1974. His personal experience with the 35mm single-lens-reflex camera as a powerful tool in both photojournalism and photographic art, along with his deep respect for the work of American landscape photographers, led to his founding of *Outdoor Photographer* magazine in 1985. He is president of Werner Publishing Corporation in Los Angeles, publishers of, in addition to *Outdoor Photographer, PCPhoto, Digital Photo Pro, Plane & Pilot, Pilot Journal, Golf Tips, Golf Travel Annual,* and other special-interest magazines. Werner lives with his wife in Pacific Palisades, California.

Gordon Wiltsie is a photographer, writer, and mountaineering guide whose work has taken him to some of the world's wildest and remotest regions, including the Himalaya, the Canadian Arctic, Antarctica, and both geographic poles. For more than thirty years, his writing and photography have appeared regularly in international publications, including *National Geographic, Travel & Leisure, Outside, Geo, Terre Sauvage, Life,* and leading adventure and skiing magazines. Wiltsie, who lives in Bozeman, Montana, with his wife, Meredith, and two sons, credits his early friendship with Galen as a primary inspiration for his own career.

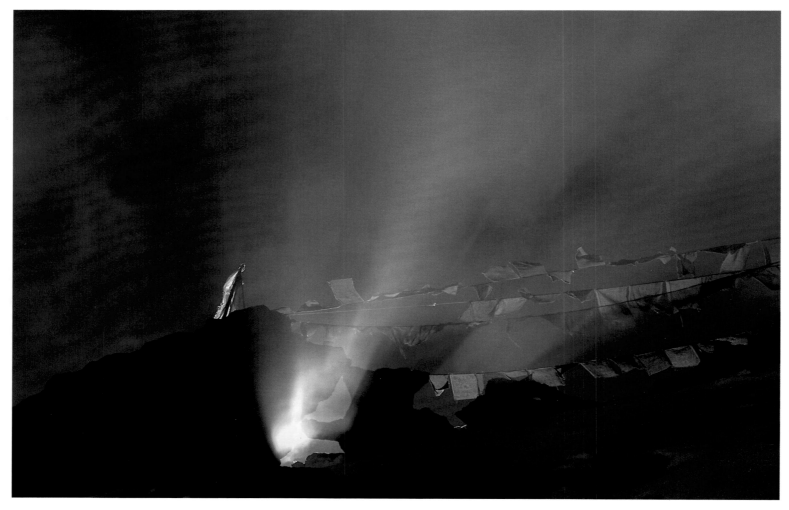

Godbeams through Prayer Flags atop Gokyo Ri, Khumbu Himal, Nepal, 1998